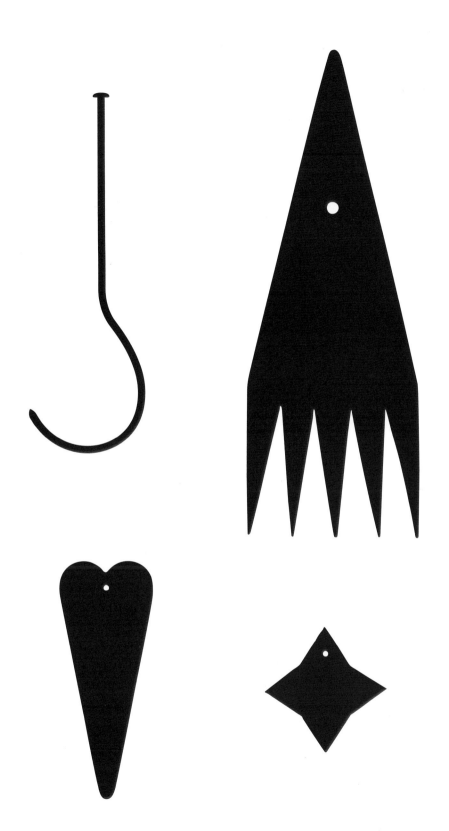

Under the patronage of H. E. Mr. Craig John Hawke,
New Zealand Ambassador to Germany

Unter der Schirmherrschaft S. E. Herr Craig John Hawke,
Botschafter Neuseelands in Deutschland

Die Neue Sammlung

Objectspace

HOOK HAND
HEART STAR

arnoldsche

CONTENTS

Forewords	6	
Angelika Nollert		
Kim Paton		
01 'It Will Become the Life of an Artist'	10	
Petra Hölscher		
02 The Language of Warwick Freeman	26	
Kim Paton		
03 Portals of Power: A Psychology of Auckland Volcanics	62	
Geoff Chapple		
04 The Workshop: A Memoir	70	
Warwick Freeman		
05 When Is a Hook a Hei Matau?	92	
Karl Chitham		
06 The Works	114	
07 Freeman Days	274	
Bronwyn Lloyd		
08 A Workshop Portrait	290	
Sam Hartnett		
Biography, Awards and Prizes, Exhibitions, Selected Bibliography	298	
Bronwyn Lloyd		
Acknowledgements	303	

INHALT

Vorworte
Angelika Nollert
Kim Paton

01 „Es wird das Leben eines Künstlers werden"
Petra Hölscher

02 Die Sprache Warwick Freemans
Kim Paton

03 Portale der Macht: Eine Psychologie des Vulkangesteins von Auckland
Geoff Chapple

04 Erinnerungen an meine Werkstatt
Warwick Freeman

05 Wann ist ein Haken ein Hei Matau?
Karl Chitham

06 Die Werke

07 Freeman-Tage
Bronwyn Lloyd

08 Ein Werkstattporträt
Sam Hartnett

Biografie, Auszeichnungen und Preise, Ausstellungen, ausgewählte Bibliografie
Bronwyn Lloyd

Dank

FOREWORDS

**ANGELIKA NOLLERT
KIM PATON**

VORWORTE

Warwick Freeman (*1953 Nelson, Aotearoa Neuseeland) zählt zu den bedeutendsten und einflussreichsten Schmuckkünstlern der Gegenwart. Seit über 50 Jahren ist sein Schaffen geprägt von der starken Auseinandersetzung mit der Geschichte und Kultur Aotearoa Neuseelands sowie den Naturmaterialien seines Landes wie Muscheln, Vulkangestein oder Grünstein.

Seine Werke, die häufig auch Fundstücke integrieren, zeichnen sich durch eine reduzierte und dennoch komplexe Bildsprache aus. Wie Schriftzeichen oder Embleme erscheinen die abstrakten minimalistischen Formen, denen eine Narration innewohnt. Ihrem archetypischen Charakter ist eine Überzeitlichkeit immanent. Sein Schmuck soll eine „Geschichte über seine Nützlichkeit" erzählen, „wie das Objekt in einem breiten gesellschaftlichen und kulturellen Kontext ‚genutzt' wird."

Freeman zählt zu den Pākehā, zu den Neuseeländern europäischer Abstammung. Als Mitglied der Schmuck-Kooperative Fingers in Auckland initiierte er in den 1980er-Jahren ein Umdenken im neuseeländischen Schmuck. 2004 wurde Freeman zum ersten Vorsitzenden von Objectspace Auckland ernannt, einer führenden staatlichen Galerie für Kunsthandwerk, Design und Architektur. 2013 wurde er zum Gouverneur der neuseeländischen Kunststiftung Te Tumu Toi berufen. Im gleichen Jahr wurde Freeman auf der Sonderschau Schmuck der Internationalen Handwerksmesse München als „Klassiker der Moderne" mit einer Retrospektive geehrt und hielt auf Einladung der Neuen Sammlung einen Vortrag in der Pinakothek der Moderne. 2014 kuratierte er gemeinsam mit Karl Fritsch die Wanderausstellung Wunderrūma, die in der Galerie Handwerk in München eröffnet wurde. Gut zehn Jahre später nun ehrt Die Neue Sammlung Warwick Freeman mit einer Einzelausstellung. Sie setzt damit ihre Tradition von Ausstellungen und Publikationen zu herausragenden internationalen Künstlern im Autorenschmuck fort.

Wir danken den internationalen Leihgebern für ihre vertrauensvolle Zurverfügungstellung ihrer bedeutenden Objekte. Ein herzlicher Dank geht

an die Konservatorin Dr. Petra Hölscher, die mit Warwick Freeman und Kim Paton für die Konzeption und Realisierung von Ausstellung und Katalog verantwortlich zeichnet. Ich bedanke mich bei den Autoren für ihre kenntnisreichen Katalogtexte.

Wir danken arnoldsche Art Publishers für ihre sehr bewährte Verlagstätigkeit. Für ihre großzügige Unterstützung der Publikation sagen wir The Stout Trust, der Blumhardt Foundation und der Museumsstiftung zur Förderung der Staatlichen Bayerischen Museen – Vermächtnis Christof und Ursula Engelhorn einen großen Dank.

Wir freuen uns und sind dankbar für das Privileg, die Publikation gemeinsam mit Objectspace in Auckland herausgeben zu dürfen. Wir danken der Direktorin Kim Paton für die wunderbare Zusammenarbeit. Wir danken Creative New Zealand für ihre ständige Unterstützung im Bemühen, den Austausch zwischen Neuseeland und München zu fördern. Wir fühlen uns sehr geehrt und sind dankbar, dass S. E. Craig John Hawke, Botschafter Aotearoa Neuseelands in Berlin, die Schirmherrschaft der Ausstellung übernommen hat.

Der größte Dank geht an den Künstler selbst. Wie Freeman seine Schmuckwerkstatt als einen Ort der Transformation betrachtet, so möge auch die Ausstellung selbst ein Ort der Verwandlung im Sinne einer Bereicherung von Wissen und Erkenntnis werden.

 Angelika Nollert

Warwick Freeman (born in 1953 in Nelson, Aotearoa New Zealand) is one of today's most important and influential jewellery artists. For over 50 years, his work has been influenced by his in-depth exploration of the history and culture of Aotearoa New Zealand and his country's natural materials, such as seashells, volcanic rock, or greenstone.

His jewellery often integrates found objects and the pieces stand out for their reduced and yet complex visual language. The abstract, indeed, minimalist shapes resemble graphic characters or emblems, each infused with its own narrative. Intrinsic to their archetypal character is their timelessness. Freeman's jewellery is intended to 'tell a story about its utility', about 'how objects are "used" in a broad social and cultural context.'

Freeman is a Pākehā, meaning a New Zealander of European descent. As a member of the Fingers jewellery cooperative in Auckland, in the 1980s he initiated a new direction in jewellery in Aotearoa New Zealand. In 2004, Freeman was Founding Chair of Objectspace in Auckland, a leading public art gallery dedicated to design, craft, and architecture. In 2013, he was appointed a governor of the Arts Foundation of New Zealand Te Tumu Toi. That same year, Freeman was honoured as a 'modern classic' with a retrospective at the special Schmuck jewellery exhibition held as part of Munich's Internationale Handwerksmesse and on that occasion was invited by Die Neue Sammlung to lecture at the Pinakothek der Moderne. In 2014, together with Karl Fritsch he curated the Wunderrūma traveling exhibition that opened in Galerie Handwerk in Munich. A good ten years later, Die Neue Sammlung is hosting a Warwick Freeman solo exhibition, thus continuing its tradition of shows and publications by outstanding international artists in the field of studio jewellery.

We would like to take this opportunity to thank the international lenders for trusting in us and making their important objects available for the exhibition. Our heartfelt thanks go to senior curator Dr. Petra Hölscher, who worked with Warwick Freeman and Kim Paton to develop and realise the exhibition and the accompanying catalogue. I would like to thank the authors for their insightful contributions to the catalogue.

In what has long since become a great tradition, this catalogue is again being brought out by arnoldsche Art Publishers. We are deeply grateful to The Stout Trust, the Blumhardt

Foundation and the Museumsstiftung zur Förderung der Staatlichen Bayerischen Museen – Estate of Christof and Ursula Engelhorn for their generous support.

We are delighted and are most thankful to have the privilege of joining Objectspace in Auckland as co-publishers of this catalogue and would like to thank its director Kim Paton for the marvellous collaboration. We are most grateful to Creative New Zealand for its constant support and effort in promoting fruitful exchange between Aotearoa New Zealand and Munich. We feel very honoured and are most grateful that H. E. Craig John Hawke, Aotearoa New Zealand Ambassador to Berlin, kindly agreed to be patron of the exhibition.

My greatest thanks, of course, go to the artist himself. Just as Freeman considers his jewellery workshop as a place of transformation, so I hope the exhibition also becomes a space of transformation in the sense of enriching our knowledge.

 Angelika Nollert

Compiling the story of Warwick Freeman's life and work has provided many reflections on the advent and development of contemporary jewellery practice in Aotearoa New Zealand, and the profound ties internationally – particularly with Munich – that have supported the field here to flourish and grow.

On behalf of Objectspace, I would like to acknowledge the people who have worked with us to make this major project possible. My sincere gratitude to Director Angelika Nollert and Senior Curator Petra Hölscher for their openness and collaboration; it is a great honour for Objectspace, a small public gallery from Aotearoa New Zealand, to work in partnership with the prestigious Die Neue Sammlung.

In New Zealand this exhibition has been the product of three years of work. I pay special thanks to my colleagues Bronwyn Lloyd, Victoria McAdam and Stephen Brookbanks. New Zealand designers Arch and Jane MacDonnell at Inhouse and photographer Sam Hartnett have also made a beautiful publication. These contributions, along with the wonderful writing commissions, have brought Warwick's work to life on the page. Sincere thanks to Dirk Allgaier and his team at arnoldsche Art Publishers for their esteemed publishing.

Objectspace also acknowledges the support of Creative New Zealand. Its enduring commitment to fostering relationships in Munich over two decades created the path that has led us to Warwick's exhibition. Creative New Zealand has also over many years supported Warwick's practice, including this exhibition. We further acknowledge with gratitude grants from The Stout Trust and the Blumhardt Foundation in support of the publication.

Special thanks to the group of New Zealand patrons led by Sonja Hawkins and Philip Clarke who have gathered around the exhibition and will aid its return to audiences in New Zealand. Thanks also to the enduring advocacy and support of

Anna Miles. Finally, we acknowledge the many institutions and private lenders from around the world who have astutely collected Warwick's work, and are grateful for their generous support for this exhibition.

 Kim Paton

Die Geschichte von Warwick Freemans Leben und Werk zusammenzustellen, hatte zahlreiche Überlegungen zu Auftreten und Entwicklung zeitgenössischen Schmuckschaffens in Aotearoa Neuseeland zur Folge, aber auch zu den tiefgreifenden internationalen Verbindungen - besonders mit München -, die zum Aufblühen und Wachstum des modernen Schmucks hier beigetragen haben.

Im Namen von Objectspace möchte ich mich gerne bei den Menschen bedanken, die mit uns zusammengearbeitet haben, um dieses umfassende Projekt zu realisieren. Mein herzlicher Dank gilt Direktorin Angelika Nollert und Oberkonservatorin Petra Hölscher für ihre Offenheit und das gemeinschaftliche Arbeiten. Es ist eine große Ehre für Objectspace, einer kleinen öffentlichen Galerie in Aotearoa Neuseeland, mit der renommierten Neuen Sammlung zusammenarbeiten zu können.

In Neuseeland war diese Ausstellung das Ergebnis von drei Jahren Arbeit. Besonderer Dank gebührt meinen Kolleginnen und Kollegen Bronwyn Lloyd, Victoria McAdam und Stephen Brookbanks. Die neuseeländischen Designer Arch und Jane MacDonnell von Inhouse und der Fotograf Sam Hartnett haben eine wunderschöne Publikation erschaffen. Ihr Beitrag hat, zusammen mit den gelungenen Textbeiträgen, Warwicks Arbeiten auf den Seiten zum Leben erweckt. Mein herzlicher Dank an Dirk Allgaier und sein Team von arnoldsche Art Publishers für die Veröffentlichung der Publikation.

Objectspace weiß auch die Unterstützung von Creative New Zealand zu schätzen. Deren nachhaltiges Engagement, um über zwei Jahrzehnte lang die Beziehungen zu München zu pflegen, ebnete den Weg, der zu Warwicks Ausstellung führte. Zudem fördert Creative New Zealand Warwicks Kunstschaffen seit vielen Jahren, dazu gehört auch diese Ausstellung. Unser Dank gilt auch The Stout Trust und der Blumhardt Foundation, die die Publikation großzügig gefördert haben.

Ein besonderes Dankeschön an die Gruppe neuseeländischer Förderinnen und Förderer, angeführt von Sonja Hawkins und Philip Clarke, die sich um die Ausstellung zusammengefunden haben und dazu beitragen werden, dass die Ausstellung im Anschluss auch in Neuseeland gezeigt werden kann. Danke auch für das anhaltende Eintreten und die Unterstützung von Anna Miles. Zu guter Letzt danken wir den zahlreichen Institutionen und privaten Leihgeberinnen und Leihgebern aus aller Welt, die Warwicks Arbeiten klugerweise gesammelt haben, für ihre großzügige Unterstützung dieser Ausstellung.

 Kim Paton

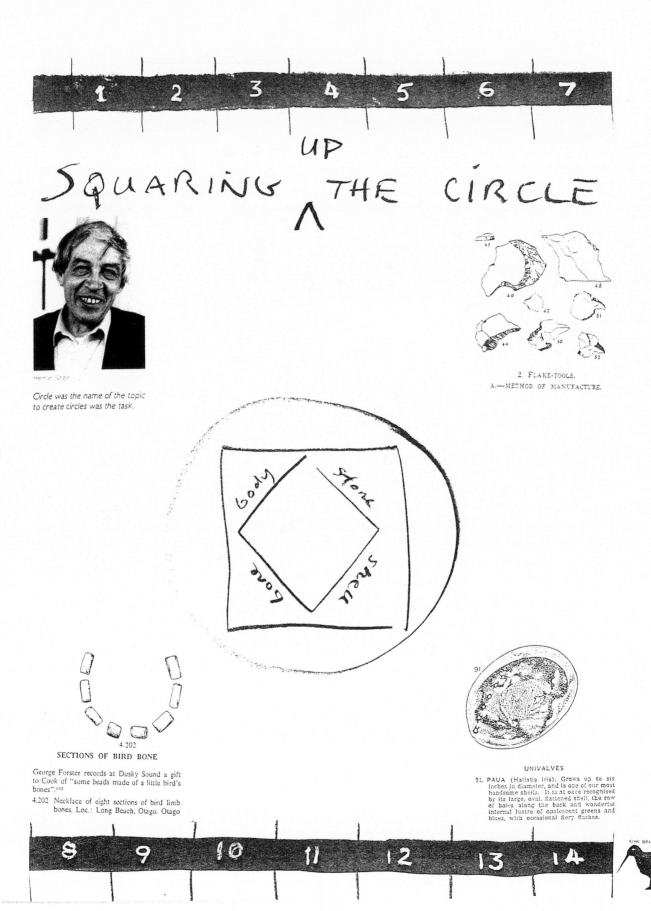

01
'IT WILL BECOME THE LIFE OF AN ARTIST'

PETRA HÖLSCHER

„ES WIRD DAS LEBEN EINES KÜNSTLERS WERDEN"
01

Warwick Freeman, 1988 collage, in the publication: <u>Bone Stone Shell: New Jewellery New Zealand</u>, edited by Geri Thomas, for the exhibition with the same title at Crafts Council Gallery, Wellington

Warwick Freeman, Collage von 1988 für die Publikation: Geri Thomas (Hg.), <u>Bone Stone Shell: New Jewellery New Zealand</u> zur gleichnamigen Ausstellung in Crafts Council Gallery, Wellington

How can you trace something that now, in 2025, took place over forty years ago without seeming presumptuous? Something that took place on a remote continent, something which, for the subject of this publication, namely Warwick Freeman, was hugely important. Something elusive, not really tangible – the innermost thoughts of two artistic figures: On the one hand, Hermann Jünger, academy professor, goldsmith, and (jewellery) artist from Germany. On the other, New Zealander Warwick Freeman, who, at the time the two met, described himself as a 'jewellery maker'.[1] In 1982 Freeman said himself that he was seeking his identity in jewellery: 'I was also reasonably vulnerable in that I had been making jewellery since the early 1970s, pretty much full-time after about the mid-1970s, but I still thought, "there's something else I'm going to do".'[2] This article attempts to address the question of why, even today, New Zealand colleagues never tire of referring to the workshop given by Hermann Jünger back in 1982.[3]

It is more or less well-known that Jünger was a great collector of things: He was inspired by colorful bits of plastic that had paled with the ravages of time, rusted iron sheets, and stones, and he kept hold of them so that at some point he could bring them to light in the making of a jewellery object. For a long time, groups of accumulated stones – like little repositories of memory – lay on the windowsills of his home in Pöring near Munich, greeting visitors on their way to the door. He stored memories of his travels and much more in boxes, each one bearing a strip of linen stamped with its number in red. A list tells us that box no. 90 contains 'Travels AUS NZ USA 1982. Letters · Papers · Concepts · Reactions · Photos'.[4] A real treasure trove, like something you might find in the attic. The documents preserved inside it still convey a very direct picture of Jünger's stay in New Zealand, the 'Land of the Long White Cloud', or Aotearoa as Māori call it in their language. Among them is a handwritten, unpublished concept for an illustrated travelogue. After forty-

two years spent hidden in box no. 90, it turns out to be an atmospheric account of the more than two months he spent in Australia and Aotearoa New Zealand. And what's more, it contains Jünger's record of his thoughts and teaching principles. It's a truly lucky find that gives us a rough idea of why this workshop marked a clear turning point in Warwick Freeman's life and his understanding as a (jewellery) artist.

Having arrived from Australia and made stops in Auckland and Wellington, Jünger flew 'from the south of North Island to the north of South Island', seeing below him 'water, islands, fjords, mountains', and then, 'Nelson came into view, a small provincial town with a small airstrip and the place where the eighth and final workshop would be held.'[5] When the Munich artist penned these lines, he had already spent six weeks giving workshops in Australia, in Melbourne, Canberra, Sydney, Adelaide, and Mittagong. At the instigation of his former student Hendrik Forster, himself a gold- and silversmith who had lived in Australia since 1973, the Queen Elizabeth II Arts Council together with the Goethe-Institut in Melbourne had invited Jünger to Australia. The Goethe-Institut in Wellington, New Zealand, was quick to tag on to these plans in its eagerness to host 'one of the most significant figures to have emerged from the post-war craft movement.' 'He will be giving a workshop in jewellery design at the Nelson Polytechnic from 25 to 29 October 1982. It is planned to have six hours of classes on each of these five days… The emphasis will be on design.'[6]

Jünger was uneasy with the English term 'workshop' because of its usual German translation of 'Werkstatt', but decided to take things as they came.[7] In Australia and New Zealand – or so he wrote home – people were waiting for him and 'for the miracle that was now to take place, for the medicine man who has a spell for everything. At least, that's how it felt.'[8] He soon gathered that the workshop was to be a teaching event, where a teacher would impart some of his personal approach and experience

vermitteln noch heute ein sehr unmittelbares Bild von Jüngers Aufenthalt in Neuseeland, dem „Land der Langen Wolke" oder Aotearoa, wie die Māori es in ihrer Sprache nennen. Darunter ein handschriftliches, unveröffentlichtes Konzept eines bebilderten Reiseberichts. zweiundvierzig Jahre wohlbehütet in Kasten Nr. 90 entpuppt er sich als atmosphärische Darstellung der über zweimonatigen Reise nach Australien und Aotearoa Neuseeland. Mehr noch: Er enthält Jüngers Niederschrift seiner Denk- und Lehrauffassung. Ein wahrer Glücksfund, der uns eine ungefähre Vorstellung davon vermittelt, warum dieser Workshop für Warwick Freeman einen besonderen Einschnitt in seinem Leben und Verständnis als (Schmuck-)Künstler einnimmt.

Von Australien kommend, in Auckland und Wellington zwischengelandet, fliegt Jünger „vom Süden der Nordinsel zum Nordende der Südinsel, unten sah man Wasser, Inseln, Fjorde, Berge und dann kam Nelson in Sicht, eine kleine Provinzstadt, mit kleiner Landebahn, der Platz, an dem der 8. und letzte Workshop stattfindet."[5] Als der Münchner diese Zeilen schreibt, liegen bereits sechs Wochen Australien hinter ihm mit Workshops in Melbourne, Canberra, Sydney, Adelaide und Mittagong. Auf Anregung seines ehemaligen Studenten Hendrik Forster, selbst Gold- und Silberschmied, seit 1973 in Australien wohnhaft, hatten das Queen Elizabeth II Arts Council sowie das Goethe-Institut in Melbourne Jünger nach Australien eingeladen. Kurzerhand schloss sich das Goethe-Institut im neuseeländischen Wellington diesen Plänen an, um „eine der bedeutendsten Persönlichkeiten, die aus der Kunsthandwerkbewegung der Nachkriegszeit hervorgegangen sind," einzuladen. „Er hält vom 25. bis 29. Oktober 1982 einen Workshop zum Thema Schmuck. An jedem dieser fünf Tage sollen sechs Stunden Unterricht stattfinden. […] Der Schwerpunkt wird auf dem Thema Entwurf liegen."[6]

Jünger tut sich schwer mit dem englischen Begriff „Workshop" aufgrund der üblichen deutschen Übersetzung mit „Werkstatt" und beschließt, die Dinge auf sich zukommen zu lassen.[7] In Australien und Neuseeland – so berichtet er nach Hause –

to a small group of participants. Yet his doubts persisted: 'I was looking for an answer to the question, "what is a workshop?"... I thought it required not just discussing things or looking at slides but actually doing something during the time.' Given that the event lasted five days and participants' knowledge levels varied, this would have to be a simple crafting task, he thought. It needed to be possible to compare the resulting 'things', because without a descriptive comparison it would be impossible to recognise differences in quality. The 'comparative observation' was to be the starting point of his deliberations. Without having brought any items with him – the glass-framed slides already weighed his luggage down – Jünger considered a drawing as the basis for the work. This would offer a good starting point for discussion, he thought, thanks to the number of results that could be expected. When no suitable drawing was available, Jünger made use of a sketch of simple pendant shapes, namely: forms made from very different materials that used as many different goldsmithing techniques as possible, designed as jewellery for day-to-day wear (page 15). The ensuing discussion, he thought, would automatically raise questions about three-dimensionality, outline, material, and size, enabling participants to see that a two-dimensional drawing could easily be a starting point for three-dimensional forms. At some point, everyone in the course would understand that it wasn't about producing a finished piece of jewellery, but rather it was much more important to pay attention to quality, which can be achieved in any form, regardless of the material. In other words, one shape, self-contained, whose quality lies in the harmony/tension of outline, plasticity, surface, and colour. Direct usability as a decorative object was of secondary importance: 'The finding seemed... more important than the invention.' At the end of the week, all the results were discussed once again. Participants' initial scepticism had abated. Comparison revealed a variety of individual solutions, even though the task had initially seemed so firmly delineated.[9] Jünger decided to

wartet man auf ihn und „auf das Wunder, das nun passieren wird, auf den Medizinmann, der für alles einen Zauber hat. So jedenfalls kam ich mir vor."[8] Schnell wird ihm bewusst, den Workshop als eine Lehrveranstaltung zu verstehen, bei der ein Lehrer einer kleinen Teilnehmerzahl in kurzer Zeit etwas von seiner persönlichen Haltung und Erfahrung vermittelt. Doch die Zweifel bleiben, „ich suchte nach der Antwort auf die Frage: was ist ein workshop? [...] Ich dachte: es wird notwendig sein nicht nur zu diskutieren oder Dias anzusehen, sondern in dieser Zeit auch etwas zu machen". Bei einer fünftägigen Veranstaltungsdauer und einem unterschiedlichen Kenntnisstand der Teilnehmer müsste dies eine handwerklich einfache Aufgabe sein. Man sollte die entstehenden „Dinge" vergleichen können, denn ohne beschreibenden Vergleich ließen sich Qualitätsunterschiede nicht erkennen. Das „Vergleichende Sehen" wird Ausgangspunkt seiner Überlegungen. Mangels mitgebrachter Objekte – die Glas gerahmten Dias wogen schon schwer im Reisegepäck – denkt Jünger an eine Zeichnung als Arbeitsgrundlage. Sie biete eine gute Diskussionsgrundlage dank der zu erwartenden Anzahl von Ergebnissen. Als keine geeignete Zeichnung zur Verfügung steht, greift Jünger auf eine Skizze einfacher Anhängerformen zurück: Formen aus sehr unterschiedlichen Materialien unter Verwendung möglichst vielfältiger Goldschmiedetechniken, gedacht als täglich zu tragender Schmuck (S. 15). Im Gespräch, so seine Überlegung, käme man von selbst auf Fragen von Dreidimensionalität, Umriss, Material und Größe und erkenne, dass eine zweidimensionale Zeichnung durchaus Ausgangspunkt für dreidimensionale Formen sein könne. Irgendwann hätten alle im Kurs verstanden, dass es nicht darum ging, einen fertigen Schmuck abzuliefern, sondern dass es im Gegenteil viel wichtiger war, sich um die Qualität zu bemühen, die in jeder Form erreichbar ist, ganz unabhängig vom Material. Einer Form, in sich geschlossen, deren Qualität im Einklang/Spannung von Umriss, Plastizität, Oberfläche und Farbe liege. Die direkte Verwendbarkeit als Schmuckobjekt war zweitrangig: „Das Finden schien [...] wichtiger als die Erfindung." Am Ende der Woche wurden noch einmal alle Ergebnisse

Inside title of the publication:
Impulse and Responses: An Exhibition of Contemporary Jewellery, Goethe-Institut New Zealand, 1983

Innentitel der Publikation:
Goethe-Institut Wellington (Hg.), Impulse and Responses: An Exhibition of Contemporary Jewellery, Wellington 1983

Photos, 1982.
Archive Family
of Hermann Jünger

Fotografien, 1982.
Familienarchiv
Hermann Jünger

stick with the approach he had developed in the first workshop in Perth in subsequent meetings.

It was already late October 1982 when Jünger arrived in Aotearoa New Zealand. The participants at the workshop in Nelson included Kobi Bosshard, Warwick Freeman, and Alan Preston.[10] To start with, the task was a simple one: the circle (page 16).[11] According to Jünger, many of them found this too banal. A basic shape, seemingly exhausted as a form – how could anyone reinvent the circle? But by the end of the week, the New Zealanders had had the same experiences as the participants in Australia before them: Even a basic shape could be transformed.[12] Jünger sketched the works that were produced during the workshop for a planned publication, assigning them by name, noting material details, and drawing obvious correlations (pages 18 and 19).

Some of the works were shown in the Impulse and Responses exhibition in Wellington in 1983, which Jünger apparently helped to create, albeit as a remote collaborator. The catalogue includes a heavily abridged version of his original foreword.[13] In the original, we read that upon visiting the Natural History Museum in Perth, Australia, Jünger had discovered what was for him a whole new world – a collection of traditional Aboriginal tools, jewellery, and weapons.[14] He saw utility and cult objects whose nature was entirely aligned with the theme of the workshops: They were captivating due to their high formal quality, which was derived from the limited availability of materials and tools, and the question of function. And they did not require any complicated decor to be convincing. These testimonies to a millennia-old culture led, as he writes, to the buzzword of the workshops becoming 'less is more'. Indeed, in the original text Jünger even expressed his hope that the work with simple forms in the workshop would lead to a better understanding of the high quality of the local Indigenous culture. Was he aware that his words resonated so much with artists such as Warwick Freeman and Alan

diskutiert. Die anfängliche Skepsis der Teilnehmer war gewichen. Der Vergleich zeigte vielfältige, individuelle Lösungen, obwohl die Aufgabenstellung zunächst so begrenzt schien.[9] Jünger beschloss, diese im ersten Workshop in Perth entwickelte Vorgehensweise in den anschließenden Meetings beizubehalten.

Es ist schon Ende Oktober 1982 als Jünger in Aotearoa Neuseeland ankommt. Unter den Teilnehmern des Workshops in Nelson sind Kobi Bosshard, Warwick Freeman und Alan Preston.[10] Die Aufgabe zu Beginn lautet schlicht: der Kreis (S. 16).[11] Vielen erschien sie laut Jünger zu banal. Eine Urform, scheinbar als Form erschöpft, wie sollte man einen neuen Kreis erfinden? Doch am Ende der Woche hatten die Neuseeländer dieselben Erfahrungen gesammelt wie zuvor die Teilnehmer in Australien: Selbst eine Grundform war wandlungsfähig.[12] Jünger skizzierte die während des Workshops entstandenen Arbeiten für eine angedachte Publikation, ordnete sie namentlich zu, notierte Materialangaben und schuf offensichtliche Nachbarschaften (S. 18 und 19).

Einige der Arbeiten wurden in der Ausstellung Impulse and Responses (Impuls und Reaktionen) in Wellington 1983 gezeigt, an deren Konzeption Jünger aus der Ferne anscheinend mitwirkte. Im Katalog findet sich eine stark verkürzte Fassung seines ursprünglichen Vorwortes.[13] Im Original liest man, dass Jünger bei einem Besuch im Naturhistorischen Museum im Australischen Perth eine für ihn völlig neue Welt entdeckt hatte – eine Sammlung von traditionellem Gerät, Schmuck und Waffen der Aborigines.[14] Er sah Gebrauchs- und Kultobjekte, die von ihrem Habitus mit dem Thema der Workshops eins waren: Sie bestachen durch eine hohe formale Qualität, die sich aus dem nur eingeschränkt verfügbaren Material, dem Werkzeug und der Frage nach der Funktion ableitete. Und sie bedurften keiner komplizierten Dekorationen, um zu überzeugen. Diese Zeugnisse einer Jahrtausende alten Kultur führten dazu, wie er schreibt, dass „Weniger ist mehr" zum geflügelten Wort der Workshops wurde. Ja, Jünger sprach im Originaltext sogar die Hoffnung aus, dass das

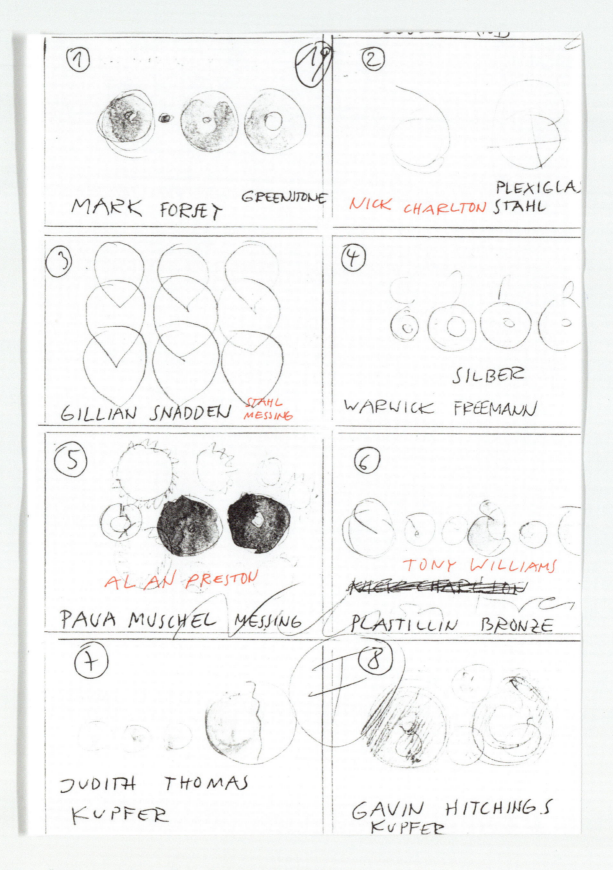

Hermann Jünger, hand-drawn list of the works created
in the workshop in Nelson, New Zealand, in 1982.
Archive Family of Hermann Jünger

„ES WIRD DAS LEBEN EINES KÜNSTLERS WERDEN"

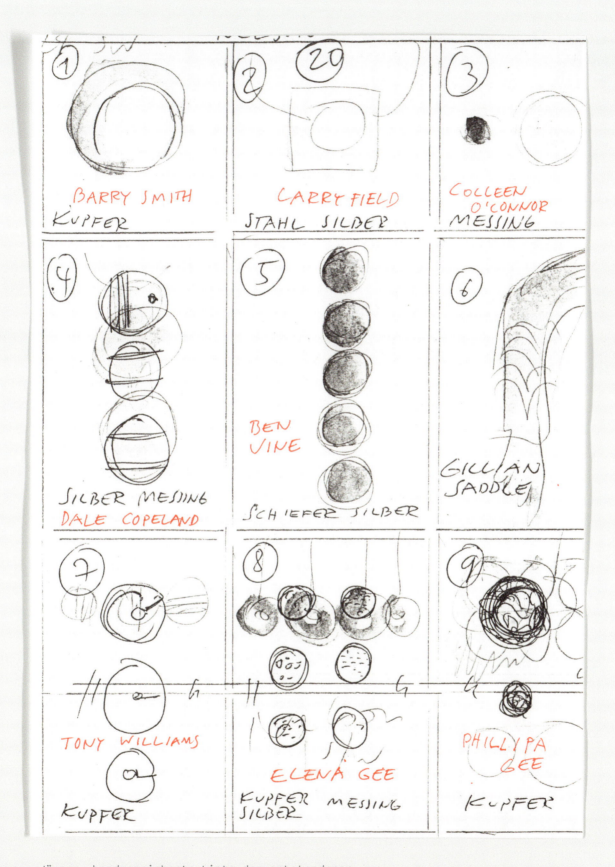

Hermann Jünger, handgezeichnete Liste der entstandenen
Arbeiten im Workshop im neuseeländischen Nelson 1982.
Familienarchiv Hermann Jünger

Preston?[15] How else could we understand Alan Preston's comment on his own work – 'My work is about Aotearoa and our Pacific identity'[16] – in the exhibition catalogue for Impulse and Responses? Freeman and Preston were both part of the driving force behind Fingers gallery's 1981 exhibition Paua Dreams, which was 'widely attributed as being one of the first art gallery exhibitions that brought Aotearoa's natural resources and contemporary jewellery to the forefront.'[17] It was intended to restore the reputation of the iridescent pāua shell after its standing had suffered greatly.[18] One high point of this movement might well be seen as the touring exhibition Bone Stone Shell (1988-93), featuring objects that 'are not used in the European tradition as additive elements and decorative appendages on a framework of metal. Here they are the structure, and their natural forms are strongly imperative in this jewellery.'[19]

Freeman took part in the exhibition with three necklaces, whose reduced nature and subtle simplicity, exquisite craftsmanship, clear forms, and concentration on just one material each (bone, stone, and shell in line with the exhibition title) imbue them with an archaic veracity that is still captivating today (pages 81 and 98-99, 155, 156-157). Freeman preceded his works with the drawing Squaring up the Circle (page 10), whereby his starting point was Jünger's assignment in his workshop on 'The Circle' – by then, six years earlier. Freeman inscribes two squares in a circle that incorporate the terms 'Bone Stone Shell' and now also 'Body': the inversion of the 'homo vitruvianus' of the Renaissance. In that famed drawing, Leonardo da Vinci, like Jünger in his workshop, was concerned with (the structure of) the body and proportions. Freeman also names pairings: body = Jünger, stone = flake tools, bone = bird bone, and shell = pāua. Finally, in the lower-right corner of the page we see the stylised national bird of New Zealand appearing as a logo with the writing 'Kiwi Brand'. All in all, it's a pictorial summary of what made New Jewellery

Arbeiten mit einfachen Formen im Workshop zu einem besseren Verständnis der hohen Qualität der indigenen Kultur vor Ort beitrage. Ob ihm bewusst war, dass er damit bei Künstlern wie Warwick Freeman und Alan Preston offene Türen einrannte?[15] Wie sollte man sonst Alan Prestons Kommentar zu seinen eigenen Arbeiten – „In meiner Arbeit geht es um Aotearoa und unsere pazifische Identität."[16] – im Ausstellungskatalog Impulse and Responses lesen? Freeman und Preston hatten beide 1981 zu den treibenden Kräften gehört, als die Galerie Fingers die Ausstellung Paua Dreams (Pāua Träume) zeigte, „die weithin als eine der ersten Kunstgalerieausstellungen gilt, in denen Aotearoas natürliche Ressourcen und zeitgenössischer Schmuck im Zentrum stehen."[17] Sie sollte die Reputation der irisierenden Pāua-Schneckenschale wiederherstellen, nachdem ihr Ansehen stark gelitten hatte.[18] Als einen Höhepunkt dieser Bewegung darf man wohl die Wanderausstellung Bone Stone Shell (Knochen, Stein, Muschel, 1988-1993) bezeichnen, mit Objekten, die nicht wie „in der europäischen Tradition als additive Elemente und dekorative Anhängsel auf ein Metallgerüst gesetzt werden. Hier sind es die Objekte selbst, die die Form vorgeben. Ihre von der Natur gegebenen Formen sind bei diesem Schmuck wichtiger Ausgangspunkt."[19]

Freeman beteiligte sich mit drei Halsketten, die in ihrer Reduziertheit und subtilen Simplizität, in ihrer perfekten handwerklichen Umsetzung, in ihren klaren Formen und der Konzentration auf nur je ein Material (analog zum Ausstellungstitel: Knochen, Stein, Muschel) durch ihre archaische Wahrhaftigkeit noch heute bestechen (S. 81 und 98-99, 155, 156-157). Seinen Arbeiten voran stellte Freeman die Zeichnung Squaring up the Circle (Die Quadratur des Kreises, S. 10) – Ausgangspunkt ist Jüngers da schon sechs Jahre zurückliegende Aufgabe im Workshop „Der Kreis". Freeman schreibt in einen Kreis zwei Quadrate ein, die die Begriffe „Bone Stone Shell" und neu: „Body" (Körper) aufnehmen: die Umkehrung des „homo vitruvianus" der Renaissance. Auch Leonardo ging es in dieser Zeichnung, wie Jünger in seinem Workshop, um Körper(-bau) und Proportionen.

New Zealand[20] grow into an independent and increasingly recognised member of the international jewellery family at the end of the 1980s. The year 1990 would see two New Zealanders form part of the 'jewellery scene' at the Internationale Handwerksmesse craft fair in Munich for the first time.[21] If Freeman's drawing is anything to go by, Jünger's approach and questions were like the last missing pieces in the mosaic that gave the existing efforts the necessary thrust and ensured the breakthrough.

And what of Warwick Freeman himself? Thanks to the interview with Damian Skinner, we get a rough idea of why Freeman ultimately realised 'that [Jünger] was the real thing, he was up there.'[22] When asked by Skinner to explain this in more detail, Freeman focuses not on Jünger's work, but rather on the personality of Hermann Jünger as the workshop leader and the works that he showed in slide presentations – both his own and those of his students. 'That particular class he had in the early 1980s included Otto Künzli, Therese Hilbert, Daniel Kruger.'[23] All the works shown displayed 'a certain level of quality that was very high. They were a particularly brilliant bunch of students, but there was a sensibility there. It was at a level I could only imagine.' For Freeman, what was especially interesting to see was that Jünger 'wasn't actually teaching them to make jewellery like his, he was teaching them to engage in exactly the same conversation that he was teaching me to have around the work.' The description of this process from the perspective of the workshop participant is reminiscent of the class discussions established at German academies after the Second World War, thanks not least to the 'youth movement of the late 1960s',[24] which Jünger had likewise integrated into his teaching programme in Munich: 'It was a language to describe the process of what was happening. But I started to see that there was actually a way of describing why you choose that one over this one, … you had to find for yourself a way of contributing to that dialogue of why you would agree with him or disagree with him. That

Zusätzlich benennt Freeman Paarungen: body = Jünger, stone = flake tools, bone = bird bone und shell = pāua.[20] In der rechten unteren Blattecke erscheint schließlich der stilisierte Nationalvogel Neuseelands als Logo mit dem Schriftzug „Kiwi Brand". Alles in allem eine bildliche Zusammenfassung dessen, was New Jewellery New Zealand (Neuer Schmuck Neuseeland)[21] Ende der 1980er-Jahre zu einem eigenständigen und mehr und mehr wahrgenommenen Mitglied in der internationalen Schmuckfamilie wachsen ließ. 1990 wird das erste Jahr sein, in dem zwei Neuseeländer an der „Schmuckszene" auf der Internationalen Handwerksmesse in München teilnehmen.[22] Darf man nach Freemans Zeichnung urteilen, dann waren Jüngers Herangehensweise und Fragestellungen so etwas wie die letzten noch fehlenden Steinchen im Mosaik, die den schon bestehenden Bemühungen die nötige Schubkraft gaben und für den Durchbruch sorgten.

Und für Warwick Freeman selbst? Dank des Interviews mit Damian Skinner bekommen wir eine ungefähre Ahnung davon, warum Freeman am Ende realisiert, „that [Jünger] was the real thing, he was up there."[23] Der einzig Wahre, der einzig Richtige, der zurecht an der Spitze steht. Auf Skinners Bitte, dieses genauer zu erklären, sind es nicht Jüngers Arbeiten, die Freeman bemüht, sondern die Beschäftigung mit der Persönlichkeit des Workshopleiters Hermann Jünger und den Arbeiten, die er in Dia-Shows zeigte – eigene wie studentische. „Diese besondere Klasse, die er Anfang der 1980er-Jahre leitete, sah Otto Künzli, Therese Hilbert, Daniel Kruger als Studierende."[24] Alle gezeigten Arbeiten zeichneten sich aus durch „ein bestimmtes und sehr hohes Qualitätsniveau. Es war eine außerordentlich talentierte Gruppe an Studierenden, ausgestattet mit einer hohen Sensibilität. Es war ein Niveau, von dem ich nur träumen konnte." Besonders interessant war für Freeman zu sehen, dass Jünger „ihnen nicht beibrachte, Schmuck zu machen so wie er es tat, sondern vielmehr über die Arbeit zu sprechen, Fragen zu stellen – genauso wie er es auch mir [im Workshop] beigebracht hatte." Die Beschreibung dieser Prozesse aus

started to open some really big doors for me because I'd never had that academic training. … whatever it was, it was that I was having to articulate to myself, not only to Jünger, exactly why I would go this way rather than that way with this piece. … Like how would it be if the corner was so soft rather than hard like you've got it here? Those are the questions you have to ask yourself when you make things all the time, but I'd never had to demonstrate it in front of somebody. I'd never been asked to demonstrate those processes or even think, well I should ask the questions whether it should be hard or soft. … If you could learn these questions, then you knew how to ask them as you worked.'[25] Freeman, when asked by Skinner to sum up what Hermann Jünger's visit meant for his own development, had this to say: 'The road that Hermann put me on was more particularly the one of a working artist. … it was just very much the idea that you could invest in a life in this practice and it would be a worthwhile one. That was the main lesson that Jünger demonstrated.'[26] He made the first step from 'jewellery maker' to (jewellery) artist thanks to Jünger: 'I'm a long way behind, but if I just keep making things this might all add up in that same way. It will become the life of an artist.'[27]

Sicht des Workshopteilnehmers erinnert an die seit dem Zweiten Weltkrieg nicht zuletzt dank der „Jugendbewegung Ende der 1960er Jahre"[25] an deutschen Akademien etablierten Klassenbesprechungen, wie auch Jünger sie in München in sein Lehrangebot integriert hatte: „Es brauchte eine eigene Sprache, um den Herstellungsprozess zu beschreiben. Ich begriff allmählich, dass es eigentlich eine Methode war, zu beschreiben, warum man sich für dieses und nicht für jenes entschieden hatte. […] Man musste für sich selbst einen Weg/eine Argumentationslinie finden, um diesem Dialog etwas beisteuern zu können, etwa warum man ihm zustimmte oder nicht. Das eröffnete mir ganz neue Sichtweisen, weil mir ja eine akademische Ausbildung fehlte. […] was immer es auch war, es war, dass ich nicht nur Jünger gegenüber genau artikulieren musste, warum ich bei einem Stück den einen und nicht den anderen Weg gewählt hatte. […] Wie wäre es etwa, wenn diese Ecke weich und nicht so hart wäre, wie ich sie ausgeführt hatte? Das sind Fragen, die man sich selbst stellen muss, wenn man die ganze Zeit an Objekten arbeitet. Aber ich musste das nie vor jemand anderem klarmachen. Ich wurde nie dazu aufgefordert, diese Prozesse zu beschreiben, geschweige denn der Frage nachzugehen, ob [die Ecke] nun hart oder weich sein sollte. […] Wenn man diese Fragen verinnerlichte, dann konnte man sie auch im Laufe des Arbeitsprozesses selber stellen."[26] Freeman um ein Fazit von Skinner gebeten, was der Besuch von Hermann Jünger für Freemans eigene Entwicklung bedeutet hat, antwortete: „Der Weg, den Hermann mir aufzeigte, war vor allem der eines arbeitenden Künstlers. […] es war einfach die Vorstellung, dass man dank dieser Vorgehensweise in ein [Künstler-]leben investieren könnte und es sich lohnen würde. Das war die wichtigste Lektion, die Jünger mir gezeigt hat."[27] Der erste Schritt vom „Schmuckhandwerker" zum (Schmuck-)Künstler war dank Jünger getan: „Ich habe noch einen weiten Weg vor mir, aber wenn ich weiterhin die Dinge so entwerfe, dann könnte auch für mich all das Realität werden – das Leben eines Künstlers."[28]

„ES WIRD DAS LEBEN EINES KÜNSTLERS WERDEN"

1
Due to the previously unknown archival material found and the brevity required, the article focuses on Hermann Jünger's workshop in Nelson, New Zealand, in 1982, supported by Warwick Freeman's statement about Otto Künzli's workshop held in 1990: 'What Künzli did wasn't far removed from Jünger in terms of the workshop model.', in Damian Skinner, editor, <u>Large Star / Rangitoto Heart: A Birthday Book in Honour of Warwick Freeman</u>, published on the occasion of Warwick Freeman's 55th birthday, 5 January 2008. Rim Books, Auckland 2008, p. 2.

2
Ibid., p. 58.

3
Kevin Murray, 'Crafting Aotearoa: Our Place in the Jewellery World.' Auckland Museum. https://www.aucklandmuseum.com/discover/research/crafting-aotearoa/our-place-in-the-jewellery-world (27.11.2024).

4
I would like to take this opportunity to thank Lene Jünger, who gave me access to these documents.

5
Letter from Hermann Jünger to his family, Nelson, October 27 1982. Archive Family of Hermann Jünger, Pöring.

6
Both quotations: press release of the Goethe-Institut New Zealand, 1983. Archive Family of Hermann Jünger, Pöring.

7
For ease of reading, the following section is a summary with interspersed original quotations from: Reisebericht, 'Aus Werkstatt (Pöring) und Workshops (Australien und Neuseeland),' handwritten manuscript; archive Family of Hermann Jünger, Pöring, Chapter 1 (Arrival in Australia, Perth), pp. 1-8. Quotations from other contexts are noted separately.

8
Letter from Hermann Jünger to his family, Perth, undated, p. 2. Archive Family of Hermann Jünger, Pöring.

9
End of the summary.

10
Other participants were: Nick Charlton, Dale Copeland, Larry Field, Mark Forset, Elena Gee, Philippa Gee, Gavin Hitchings, Colleen O'Connor, Barry Smith, Gillian Snadden, Judith Thomas, Ben Vine, Tony Williams; in: Reisebericht, 'Aus Werkstatt (Pöring) und Workshops (Australien und Neuseeland),' handwritten manuscript; archive Family of Hermann Jünger, Pöring, Chapter 3 (Canberra, Mittagong, Adelaide, Nelson), pp. 19-20.

11
Beginning of the summary: Reisebericht, 'Aus Werkstatt (Pöring) und Workshops (Australien und Neuseeland)', handwritten manuscript; archive Family of Hermann Jünger, Pöring, Chapter 3 (Canberra, Mittagong, Adelaide, Nelson), pp. 19-20.

12
End of the summary.

1
Aufgrund des vorgefundenen, bislang unbekannten Archivmaterials sowie der gebotenen Kürze fokussiert der Artikel den Workshop Hermann Jüngers im neuseeländischen Nelson 1982, unterstützt von Warwick Freemans Aussage über den 1990 gehaltenen Workshop von Otto Künzli: „Was Künzli machte war in puncto Workshop gar nicht so weit entfernt von Jünger", in Damian Skinner (Hg.), <u>Large Star / Rangitoto Heart: A Birthday Book in Honour of Warwick Freeman</u>, anlässlich des 55. Geburtstags von Warwick Freeman veröffentlicht, 5. Januar 2008, Auckland 2008, S. 2.

2
Skinner 2008 (wie Anm. 1), S. 58.

3
Kevin Murray, „Crafting Aotearoa: Our Place in the Jewellery World." Auckland Museum. https://www.aucklandmuseum.com/discover/research/crafting-aotearoa/our-place-in-the-jewellery-world (27.11.2024).

4
An dieser Stelle möchte ich sehr herzlich Lene Jünger danken, die mir den Zugang zu diesen Unterlagen ermöglichte.

5
Brief von Hermann Jünger an seine Familie, Nelson, 27. Oktober 1982 (Familienarchiv Hermann Jünger, Pöring).

6
Beide Zitate: Pressemitteilung des Goethe-Instituts Wellington 1983 (Familienarchiv Hermann Jünger, Pöring).

7
Der leichteren Lesbarkeit wegen ist der nachfolgende Abschnitt eine Zusammenfassung mit eingestreuten Originalzitaten aus: Reisebericht „Aus Werkstatt (Pöring) und Workshops (Australien und Neuseeland)", handschriftliches Manuskript; Familienarchiv Hermann Jünger, Pöring, 1. Folge (Ankunft in Australien, Perth), S. 1-8. Zitate aus anderen Kontexten sind extra vermerkt.

8
Brief von Hermann Jünger an seine Familie, Perth, o. D., S. 2 (Familienarchiv Hermann Jünger, Pöring).

9
Ende der Zusammenfassung.

10
Weitere Teilnehmer waren: Charlton, Dale Copeland, Larry Field, Mark Forset, Elena Gee, Philippa Gee, Gavin Hitchings, Colleen O'Connor, Barry Smith, Gillian Snadden, Judith Thomas, Ben Vine, Tony Williams; in: Reisebericht „Aus Werkstatt (Pöring) und Workshops (Australien und Neuseeland)", handschriftliches Manuskript; Familienarchiv Hermann Jünger, Pöring, 3. Folge (Canberra, Mittagong, Adelaide, Nelson), S. 19-20.

11
Beginn der Zusammenfassung: Reisebericht „Aus Werkstatt (Pöring) und Workshops (Australien und Neuseeland)", handschriftliches Manuskript;

13
Hermann Jünger, unabridged, handwritten manuscript for the foreword in the exhibition catalogue, Goethe-Institut New Zealand, editor, Impulse and Responses: An Exhibition of Contemporary Jewellery, Goethe-Institut New Zealand, 1983. Die Neue Sammlung - The Design Museum would like to thank Creative New Zealand, and in particular Alan Preston and Warwick Freeman, for donating a collection of literature on the history of modern jewellery in New Zealand, including the exhibition catalogue cited here.

14
Summary from: Reisebericht, 'Aus Werkstatt (Pöring) und Workshops (Australien und Neuseeland),' handwritten manuscript; archive Family of Hermann Jünger, Pöring, Chapter 1 (Arrival in Australia, Perth), pp. 2-3.

15
End of the summary.

16
Goethe-Institut Wellington (ed.), Impulse and Responses: An Exhibition of Contemporary Jewellery, unpaginated.

17
Sara MacDonald, 'Hidden Pāua of Collections Online.' Te Papa Blog https://blog.tepapa.govt.nz/2024/06/24/hidden-paua-of-collections-online/ (27.11.2024).

18
From 1946 to 1960, government programmes for Second World War veterans promoted the production of jewellery from pāua shell - 'pāua could only be set in silver or gold to uphold its status as a high-quality New Zealand product.' An export ban imposed at the beginning of the 1960s, which led to an oversupply locally, the expiration of the government programme, and increasing travel activity led to the commercialisation of pāua. As a cheap souvenir, it became synonymous with Aotearoa New Zealand. Summary of and quote from 'Cultural Icon, or Cultural Cringe,' exhibition texts: Pāua: A Contemporary Jewellery Story, curated by Sian van Dyk, The Dowse Art Museum, 19 July-20 November 2022, unpaginated. https://dowse.org.nz/exhibitions-and-events/exhibitions/2022/paua-a-contemporary-jewellery-story (27.11.2024).

19
And it goes on to say: 'The work in this exhibition is characteristic of much contemporary New Zealand jewellery. It is designed for and worn by New Zealanders. The artefacts we treasure, the jewellery we wear and the way we live define our culture. This exhibition is very much an expression of New Zealand', in: John Edgar, 'Bone Stone Shell.' Bone Stone Shell: New Jewellery New Zealand, edited by Geri Thomas. Crafts Council of New Zealand and Ministry of Foreign Affairs, 1988, unpaginated.

20
Subheading of the exhibition Bone Stone Shell.

Familienarchiv Hermann Jünger, Pöring, 3. Folge (Canberra, Mittagong, Adelaide, Nelson), S. 19-20.

12
Ende der Zusammenfassung.

13
Hermann Jünger, ungekürztes, handschriftliches Manuskript zum Vorwort im Ausstellungskatalog: Goethe-Institut New Zealand (Hg.), Impulse and Responses: An Exhibition of Contemporary Jewellery, Wellington 1983. Die Neue Sammlung - The Design Museum dankt Creative New Zealand, vor allem Alan Preston und Warwick Freeman sehr für die Schenkung eines Literatur-Konvolutes zur Geschichte des modernen Schmucks in Aotearoa Neuseeland, darunter auch der hier zitierte Ausstellungskatalog.

14
Zusammenfassung aus: Reisebericht „Aus Werkstatt (Pöring) und Workshops (Australien und Neuseeland)", handschriftliches Manuskript; Familienarchiv Hermann Jünger, Pöring, 1. Folge (Ankunft in Australien, Perth) S. 2-3.

15
Ende der Zusammenfassung.

16
Goethe-Institut Wellington 1983, (wie Anm. 13), o. S.

17
Sara MacDonald, „Hidden Pāua of Collections Online", Te Papa Blog, https://blog.tepapa.govt.nz/2024/06/24/hidden-paua-of-collections-online/ (27.11.2024).

18
Von 1946-1960 wurde mit Regierungsprogrammen für Soldaten des Zweiten Weltkriegs die Herstellung von Schmuck aus der Pāua-Schnecke gefördert - „Pāua konnte nur in Silber oder Gold gefasst werden, um ihren Status als qualitativ hochwertiges neuseeländisches Produkt aufrechtzuerhalten." Ein zu Beginn der 1960er-Jahre verhängtes Exportverbot, welches vor Ort zu einem Überangebot führte, das auslaufende Regierungsprogramm und eine zunehmende Reisetätigkeit führten zur Kommerzialisierung der Pāua. Als billiges Souvenir wurde sie zum Synonym für Aotearoa Neuseeland. Zusammenfassung und Zitat von: „Cultural Icon, or Cultural Cringe", in: Pāua: A Contemporary Jewellery Story, Ausst.-Kat. The Dowse Art Museum, kuratiert von Sian van Dyk (19. Juli bis 20. November 2022), o. S., https://dowse.org.nz/exhibitions-and-events/exhibitions/2022/paua-a-contemporary-jewellery-story (27.11.2024).

19
Und weiter heißt es dort: „Die Arbeiten in dieser Ausstellung sind charakteristisch für einen Großteil des zeitgenössischen neuseeländischen Schmucks. Er ist für Neuseeländer entworfen und wird von diesen getragen. Die Artefakte, die wir hüten, der Schmuck, den wir tragen, und die Art und Weise, wie wir leben, definieren unsere Kultur. Diese Ausstellung

21
New Zealand was represented by Paul Annear and Helen Clair Holmes. Alan Preston was the proposer for artists from New Zealand. Schmuckszene '90. Internationale Schmuckschau. A Special Show as Part of the 42nd Internationale Handwerksmesse, 1990, pp. 14, 36.

22
Damian Skinner, Large Star / Rangitoto Heart: A Birthday Book in Honour of Warwick Freeman, p. 57. The next section is a summary of the interview with original quotes, reprinted in ibid., pp. 57-60.

23
Other participants were Manfred Bischoff, Anderl Kammermeier, Kristine Lorber, Eriko Nagai, and Justine Wein, whose works Hermann Jünger had selected for an exhibition during his stay in Australia in Perth, Victoria, Canberra, and Sydney in 1982; exhibition catalogue, Contemporary German Jewellery. Victoria 1982.

24
Ursula Keltz, Schmuckgestaltung an der Akademie der Bildenden Künste München. Die Klasse für Golödschmiedekunst 1946-1991, PhD [manuscript], (Bonn, 1992), vol. 1 [text volume], p. 175.

25
Damian Skinner, Large Star / Rangitoto Heart: A Birthday Book in Honour of Warwick Freeman, p. 60. On the subject of Jünger, Otto Künzli recalls: 'Yes, we did have it, the class discussion, which even then took place on Wednesday mornings.… The big difference was that with him those of us who had something and had the time could more or less bring some work to the table altogether. With me, everyone had a class discussion for themselves in turn (or sometimes two studies in one morning), so there was plenty of time to show and discuss the work.' Otto Künzli, email to the author, 5 November 2024.

26
Damian Skinner, Large Star / Rangitoto Heart: A Birthday Book in Honour of Warwick Freeman, p. 64.

27
Ibid., p. 58. Text by Warwick Freeman in this publication, p. 70. - The title of this essay is a quote from Damian Skinner, Large Star / Rangitoto Heart: A Birthday Book in Honour of Warwick Freeman, p. 58.

ist in hohem Maße ein Ausdruck von Neuseeland." In John Edgar, „Bone Stone Shell", in: Geri Thomas (Hg.), Bone Stone Shell: New Jewellery New Zealand, eine Ausstellung des New Zealand Ministry of Foreign Affairs zusammen mit dem Crafts Council of New Zealand. Inc., kuratiert von John Edgar, koordiniert von Raewyn Smith, o. S.

20
Übersetzt heißt das: Körper = Jünger, Stein = Steinflocken-Werkzeuge, Knochen = Vogelknochen, Muschel = Pāua.

21
Untertitel der Ausstellung Bone Stone Shell.

22
Neuseeland war vertreten durch Paul Annear und Helen Clair Holmes. Alan Preston war der Vorschlagende für Künstler aus Neuseeland. In: Schmuckszene '90: Internationale Schmuckschau. Sonderschau der 42. Internationalen Handwerksmesse, München 1990, S. 14, 36.

23
Skinner 2008 (wie Anm. 1), S. 57. Der nächste Abschnitt stellt eine Zusammenfassung des Interviews mit Originalzitaten dar, abgedruckt ebd., S. 57-60.

24
Weitere Teilnehmer waren Manfred Bischoff, Anderl Kammermeier, Kristine Lorber, Eriko Nagai und Justine Wein, deren Arbeiten Hermann Jünger für eine Ausstellung während seines Australienaufenthaltes in Perth, Victoria, Canberra und Sydney 1982 ausgesucht hatte; Ausst.-Kat. Contemporary German Jewellery, Victoria 1982.

25
Ursula Keltz, Schmuckgestaltung an der Akademie der Bildenden Künste München: Die Klasse für Goldschmiedekunst 1946-1991, Phil. Diss. (masch. Manuskript), Bonn 1992, Bd. 1 (Textband), S. 175.

26
Skinner 2008 (wie Anm. 1), S. 60. - Zu Jünger berichtet Otto Künzli: „Ja, das gab es, die Klassenbesprechung, die war schon damals am Mittwoch Vormittag. […] Der grosse Unterschied, bei ihm durften wir, wer was hatte und Zeit blieb, mehr oder weniger gemeinsam einige Arbeiten auf den Tisch bringen. Bei mir hatte, der Reihe nach jede und jeder eine Klassenbesprechung für sich (oder auch mal zwei Studies an einem Vormittag), also ausgiebig Zeit die Arbeiten zu zeigen und zu diskutieren.", in: Otto Künzli, E-Mail an die Verf. vom 5.11.2024.

27
Skinner 2008 (wie Anm. 1), S. 64.

28
Ebd., S. 58. - Text von Warwick Freeman in dieser Publikation, S. 70. - Der Titel dieses Essays ist ein Zitat aus Skinner 2008 (wie Anm. 1), S. 58.

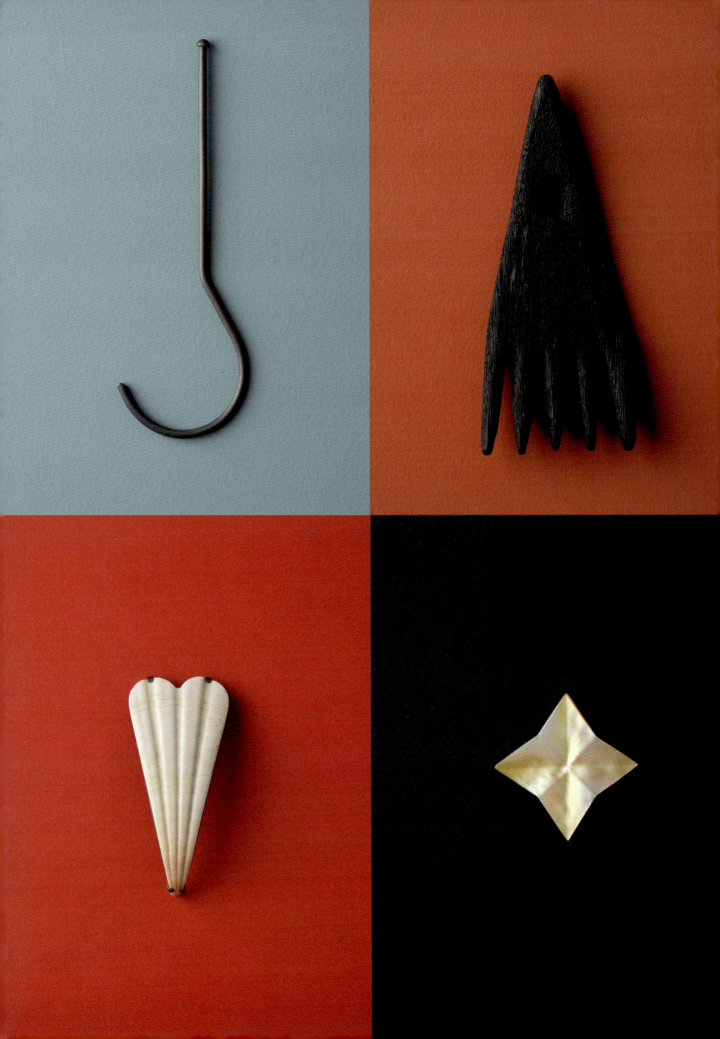

02
THE LANGUAGE OF WARWICK FREEMAN

KIM PATON

DIE SPRACHE WARWICK FREEMANS
02

Pendants and brooches
<u>Hook Hand Heart Star</u>, 2024
Oxidised silver,
burnt wood, scallop shell,
pearl shell
Various dimensions

Anhänger und Broschen
<u>Haken Hand Herz Stern</u>, 2024
Geschwärztes Silber,
gebranntes Holz, Schale der
Jakobsmuschel, Perlmuschel
Verschiedene Maße

The jewellery of Warwick Freeman is bound to language. For fifty years he has been creating works that share a counterpart drawn from a recognisable world. He mines words, objects, signs, and symbols, and over time he has built an expansive vocabulary of forms. You can wear a Warwick Freeman, but you can read it too. Hook hand heart star. Four words. Speak them under your breath, listen to their rhythm – they belong together without us exactly knowing why. His jewellery bears the same punch-the-air quality – it is intimate, acute, and precisely weighted.

Freeman has been making jewellery since the early 1970s, and the timeline of his career has intersected with almost every major development of jewellery in Aotearoa New Zealand. It would be fitting on the occasion of his survey exhibition (which this book accompanies), to tell his story from start to finish. We could canonise him alongside a tidy-edged version of the evolution of the art form, as and when it happened in Aotearoa. A creative life is satisfyingly told as a time-based journey, and we hope we'll find that the creation of ideas, along with wisdom, improves with age. We hope the logic of an artist's work and life will be revealed to us in concert with the cultural turning points and movements of their time.

But what if we let the jewellery do the talking?

With Freeman's jewellery as our guide, chronology is only part of the story. There are time-stamps of note – the bone stone shell period of the 1980s, and his culturally appropriative works a decade later, which are discussed by Karl Chitham in his essay. But his enduring interests have remained tightly focused. Despite enviable success and accolades throughout his career, Freeman would likely reject the suggestion of his own evolution – that he's become smarter, wiser, or better. This creates a challenge for the narrative arc of a survey exhibition, but it is a valuable way to understand his work.

Der Schmuck von Warwick Freeman ist tief in Sprache verwurzelt. Seit fünfzig Jahren erschafft er Arbeiten, die jeweils über ein Gegenstück in einer identifizierbaren Welt verfügen. Er fördert Worte, Gegenstände, Zeichen und Symbole zu Tage und hat im Laufe der Zeit ein umfassendes Formenvokabular zusammengetragen. Man kann einen Warwick Freeman tragen, man kann ihn aber auch lesen. Haken Hand Herz Stern. Vier Worte. Sprechen Sie sie leise aus, lauschen Sie ihrem Rhythmus – sie gehören zusammen, ohne dass wir genau wissen, weshalb. Sein Schmuck weist die gleiche durchdringende Qualität auf – er ist intim, scharfsinnig und präzise gewichtet.

Freeman macht seit Anfang der 1970er-Jahre Schmuck, und die Zeitachse seiner Karriere überschneidet sich mit nahezu jeder wichtigen Entwicklung im Bereich Schmuck in Aotearoa Neuseeland. Anlässlich seiner Ausstellung in München scheint es angebracht, seine Geschichte vom Anfang bis zum Ende zu erzählen. Wir können ihn in die Entwicklungslinie des Schmucks in Aotearoa Neuseeland einordnen. Ein kreatives Leben lässt sich gut als Zeitreise erzählen, und wir hoffen, dass sein Ideenpool dank des zunehmenden Wissens unerschöpflich ist. Wir hoffen außerdem, dass sich uns so die Logik seiner Arbeiten und das Leben eines Künstlers in Übereinstimmung mit den kulturellen Wendepunkten und Bewegungen ihrer Zeit enthüllen.

Aber was, wenn wir den Schmuck sprechen lassen?

Mit Freemans Schmuck als unserem Wegweiser ist die Chronologie nur ein Teil der Geschichte. Es gibt Zeitpunkte, die von Bedeutung sind – etwa die Bone Stone Shell Periode (Knochen Stein Muschel Periode) der 1980er-Jahre, und seine kulturell „aneignenden" Arbeiten ein Jahrzehnt später, die Karl Chitham in seinem Essay erläutern wird. Doch seine durchweg beständigen Interessensgebiete lassen einen klaren Fokus erkennen. Trotz beneidenswerter Erfolge und großer Anerkennung im Laufe seiner Karriere würde Freeman

Ngataringa Bay workshop, 2019
Photo: Sam Hartnett

Werkstatt an der Ngataringa Bay, 2019
Foto: Sam Hartnett

Hook Hand Heart Star documents Freeman's autobiography in an organising strategy of emblematic departments that span the poetic to the categorical. They reveal his determination to return to his focused method of making, drawing out and iterating forms again and again. It is life as a knotty, unresolved map. As art historian Damian Skinner wrote in 2008:

> To look at a retrospective of Freeman's jewellery is to see an artist who is critically re-evaluating and refining the terms of his craft, and the issues and operations of his work in relation to the wider culture, but doing this through a set of preoccupations, materials and motifs that stay remarkably consistent.[1]

This remains equally true today. For five decades, Freeman's curiosity for what it means to live in this place – Aotearoa New Zealand – at this time, has sustained his interest. Through this frame of reference, he has built a language for himself that feels familiar and relatable. Freeman describes this as a 'common means',[2] that it connects with the viewer because we recognise something in it. It is the feeling of having seen something before. In a letter to gallerist Paul Derrez in 1990, Freeman notes:

> As time passes the objects tend to gather more and more words and ideas. Particularly after they have been seen by people, who in turn add their way of seeing the work… It is a fattening process – such connections 'speak' the work into existence, give it more reasons for it to be.[3]

Pākehā

When I was around twelve years old, I bought a small badge from the Peace Shop at the Christchurch Arts Centre in the South Island of New Zealand. A cluster of inner-city neo-gothic buildings that was once the main university campus, the Arts Centre housed a Saturday market that dominated the weekends of my early teens. The Peace Shop had a permanent

Hinweise zu seiner eigenen Entwicklung wohl zurückweisen – dass er vielleicht klüger, weiser oder besser geworden sei. Das stellt eine gewisse Herausforderung für den erzählerischen Bogen einer monografischen Ausstellung dar, ist jedoch eine nützliche Methode, um seine Arbeiten zu verstehen.

Hook Hand Heart Star (Haken Hand Herz Stern) dokumentiert Freemans Werk organisiert in mehr als zwanzig sinnbildliche Bereiche. Sie enthüllen seine Entschlossenheit, immer wieder zu seiner fokussierten Methode zurückzukehren, Formen immer wieder neu zu entwerfen und zu wiederholen. Wie der Kunsthistoriker Damian Skinner 2008 schrieb:

> Eine Retrospektive von Freemans Schmuck zu sehen, bedeutet, einen Künstler zu sehen, der die Begrifflichkeiten seiner Kunst sowie die Themen und Tätigkeiten in Hinblick auf Kultur kritisch neu bewertet und weiterentwickelt. Das macht er über eine Reihe vorherrschender Fragen, Materialien und Motive, die bemerkenswert beständig bleiben.[1]

Das ist auch heute noch unvermindert gültig. Fünf Jahrzehnte lang hat die Frage, was es bedeutet zu dieser Zeit an diesem Ort zu leben – Aotearoa Neuseeland –, sein Interesse wachgehalten. Durch diesen Bezug hat er sich eine eigene Sprache erschaffen, die sich vertraut und nachvollziehbar anfühlt. Freeman beschreibt dies als „gewöhnliches Mittel",[2] um eine Verbindung mit dem Betrachter herzustellen, da wir etwas darin wiedererkennen. Es ist dieses Gefühl, etwas schon einmal gesehen zu haben. In einem Brief an den Galeristen Paul Derrez bemerkt Freeman 1990:

> Mit der Zeit sammeln die Objekte immer mehr Worte [Bedeutungen] und Ideen. Vor allem, nachdem sie von anderen gesehen wurden, die ihrerseits ihre Sichtweise hinzufügen. […] Es ist ein anreichernder Prozess – solche Verbindungen verhelfen der Arbeit ins Leben, verleihen ihr mehr Gründe zu sein.[3]

retail space inside the old music building and its entranceway was flanked with a line of clipboards for signing local petitions. The badge was white, with a peace sign drawn in a gradient rainbow. What it looked like wasn't particularly significant, but I remember a feeling of recognition having it pinned to my jacket. My understanding of the peace sign's political history, or the activist message the Peace Shop promoted, was undoubtedly naive, but I did know that wearing it was signalling something about who I wanted to be.

Freeman is a badge maker. When his grandfather died his grandmother gifted him a tin of badges and medals. In 1985 Freeman mounted the collection in a small display cabinet lined with red felt. He named the assemblage My Grandfather's Jewellery (page 32), and it was included in the 1991 exhibition Share of Sky: Emblems 1985–90 at The Dowse Art Museum. In the exhibition notes, Freeman writes:

> I'm sure he wouldn't have considered these pieces jewellery, but for me they belong to a very strong jewellery tradition – that of creating emblems; emblems that denote membership to a particular group, ranking within that group & also the honouring of its individuals.[4]

This is the emblematic role of jewellery. A form or symbol drawn from the detail of daily life can create meaning from the associations it bears – from the highly recognisable heart, to a fuzzy illuminated star seen in a Miller beer sign. Freeman collects emblems, expanding their fields of reference through material and the making process, and after this abstraction it is of course worn. As Freeman comments in the letter to Paul Derrez, 'It is the contact after the making stage, the public part of its life, that will determine its relevance – its importance in its own time and place.'[5]

In the same year as My Grandfather's Jewellery, the partners of Fingers, a renowned jewellery

Pākehā

Als ich etwa zwölf Jahre alt war, kaufte ich mir im Peace Shop des Christ Church Arts Centre auf der Südinsel Neuseelands einen kleinen Anstecker. Zum Arts Centre, einer Ansammlung neugotischer Gebäude, die einst der Hauptcampus der Universität waren, gehörte auch ein samstäglicher Markt, der die Wochenenden meiner frühen Teenagerjahre beherrschte. Der Peace Shop verfügte über einen Verkaufsraum im alten Musikgebäude und sein Eingang war von einer Reihe von Klemmbrettern gesäumt, auf denen man für lokale Petitionen unterschreiben konnte. Der Anstecker mit einem Peace-Zeichen war weiß, darauf ein Regenbogen mit verlaufenden Farben. Wie er aussah, war gar nicht so wichtig, aber ich erinnere mich an ein Gefühl der Anerkennung, wenn er an meiner Jacke steckte. Mein Wissen um die politische Geschichte des Peace-Zeichens oder die aktivistische Botschaft, die der Peace Shop unterstützte, war zweifellos naiv, aber ich wusste, dass das Tragen des Ansteckers etwas darüber aussagte, wer ich sein wollte.[4]

Freeman macht Anstecknadeln. Als sein Großvater starb, schenkte ihm seine Großmutter eine Kiste mit Ordensabzeichen und Medaillen. 1985 arrangierte Freeman die Sammlung in einer kleinen mit rotem Filz ausgelegten Vitrine und nannte sie My Grandfather's Jewellery (Der Schmuck meines Großvaters, S. 32). Sie war Teil der Ausstellung Share of Sky: Emblems 1985–90 (Teil vom Himmel: Embleme 1985–90), die 1991 im Dowse Art Museum stattfand. In den Anmerkungen zur Ausstellung schrieb Freeman:

> Ich bin mir sicher, dass er diese Stücke nicht als Schmuck betrachtet hätte, aber für mich sind sie Teil einer sehr starken Schmucktradition – jener des Schaffens von Emblemen, also Symbolen, die Zugehörigkeit zu einer bestimmten Gruppe bedeuten, den Rang innerhalb dieser Gruppe und auch die Auszeichnung ihrer Mitglieder.[5]

Dies ist die sinnbildliche Rolle von Schmuck. Eine Form oder ein Symbol, das sich aus dem

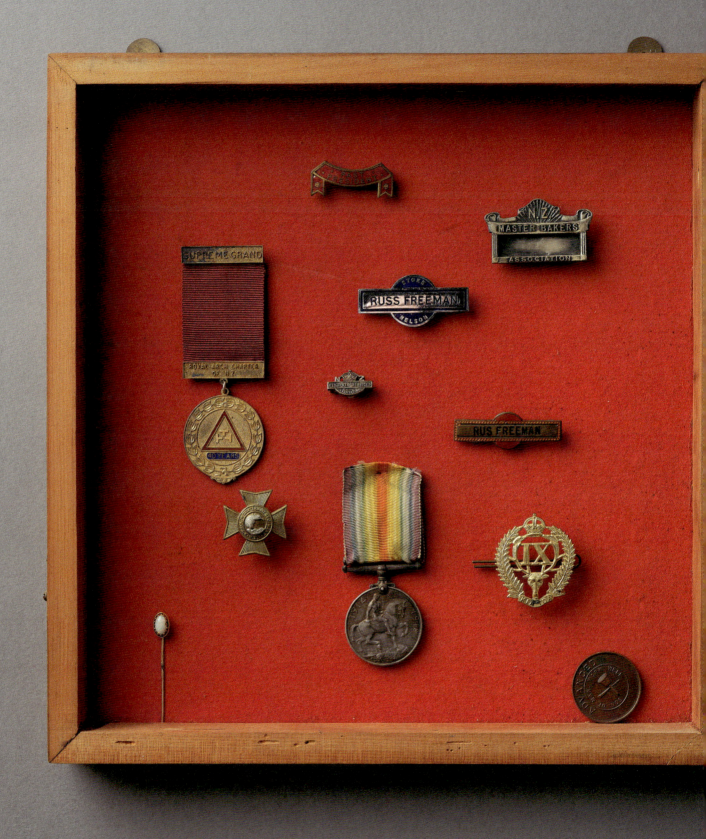

My Grandfather's Jewellery, 1985
Photo: Sam Hartnett

Der Schmuck meines Großvaters, 1985
Foto: Sam Hartnett

cooperative that Freeman joined in 1978, four years after it was established, put together an exhibition on the theme of emblems. For Freeman it seemed obvious to make a pair of service medals for the exhibition. Aotearoa Service (page 35) is a brooch made from pressed copper. Oval shaped, it is decorated with the spiky canopy of two tī kōuka, cabbage trees, and the words 'Aotearoa Service'. Aesthetically, it bears little resemblance to Freeman's well-known work today, as the precursor to working directly with the form of a motif. Here instead he illustrates onto the copper plate, using language directly to emphasise his point. 'Cabbage trees,' he comments, 'are a suitably benevolent and universal motif for this country. The use of the word Aotearoa fixes the time & intention of the medal.'[6]

Jewellery can be propaganda. Symbols of national identity are never wholly representative or even truthful. Freeman's deliberate foil to Aotearoa Service was Aotearoa – Biting the Hand. In making the pair he suggests that if we deem ourselves worthy of a service medal, we probably warrant a disservice medal as well. Freeman has returned to overt symbols of nationalism to acknowledge their relevance, but also the negative associations they carry. Freeman's brooch Poppy (1998; page 259) takes the emblematic form of the iconic poppy used in Anzac Day commemorations, a national day of remembrance in New Zealand and Australia honouring those who served and died in war.[7] For some, wearing the flower is patriotic, for others it valorises war and promotes only one version of the country's history.

Today, instead of the peace sign, a small white butterfly is sometimes pinned to my lapel. First made by Freeman in 1999, the work's subtitle is 'introduced European pest'. The brooch is an interpretation of the *Pieris rapae* butterfly species, originating from Europe and North America and found in New Zealand in the 1930s. The butterfly is the bane of any gardener's life – it will ravage your precious vegetables. Freeman

alltäglichen Leben herleitet, es kann aus den Assoziationen, die es auslöst, eine Bedeutung erhalten – vom sofort erkennbaren Herz bis zu einem unscharfen beleuchteten Stern in einem Schild für Miller Beer. Freeman sammelt Embleme, erweitert und abstrahiert deren Bezugsfelder durch Material und Herstellungsprozess, sodass man sie danach ganz selbstverständlich trägt. Wie Freeman in dem Brief an Paul Derrez bemerkt: „Es ist der Kontakt nach der Herstellungsphase, der öffentliche Teil seines Lebens, der seine Relevanz bestimmt – seine Bedeutung in seiner eigenen Zeit und an seinem eigenen Ort."[6]

Im selben Jahr, in dem My Grandfather's Jewellery entstand, zeigten die Mitglieder von Fingers, einer renommierten Schmuck-Kooperative, der Freeman vier Jahre nach der Gründung im Jahr 1978 beigetreten war, eine Ausstellung zum Thema Embleme. Für Freeman schien es einleuchtend, einige Verdienstmedaillen für die Ausstellung zu machen. Bei Aotearoa Service (S. 35) handelt es sich um eine ovale Brosche aus geprägtem Kupfer, die mit dem stacheligen Blätterdach zweier Kohlbäume (*tī kōuka*),[7] sowie den Worten „Aotearoa Service" geschmückt ist. In ästhetischer Hinsicht erinnert sie nur wenig an Freemans heute bekannten Arbeiten, ist jedoch eine Vorstufe des Arbeitens mit der Form eines Motivs. Hier benutzt er stattdessen die Kupferplatte zur Illustration und setzt dabei Sprache ein, um seinen Standpunkt zu betonen. „Kohlbäume", so erklärt er, „sind ein angemessen wohlwollendes und universelles Motiv für dieses Land. Der Einsatz des Wortes Aotearoa legt Zeit & Zweck der Medaille fest."[8]

Schmuck kann Propaganda sein. Symbole nationaler Identität sind niemals vollständig repräsentativ oder gar wahrhaftig. Freemans bewusstes Gegenstück zu Aotearoa Service war Aotearoa – Biting the Hand (Aotearoa – In die Hand beißen). Mit diesen beiden Arbeiten deutet er an, dass, wenn wir uns einer Verdienstmedaille für würdig halten, wir möglicherweise auch eine „Un-Verdienst"-Medaille benötigen. Freeman hat sich mit den offenkundigen Symbolen des

adopts the white butterfly as an emblem for Pākehā, the Māori word to describe a New Zealander of European descent. For some, the butterfly could be read as an unwanted marker – there are still European New Zealanders today who reject Pākehā as a descriptor simply for its use of te reo Māori, the Māori language. For me, wearing White Butterfly (page 35) acknowledges the name given to me and my ancestors by Māori when we were the 'other' – foreign, exotic, and introduced. The butterfly is a disservice medal. It points pejoratively to the destruction and damage caused by Pākehā through the colonisation process that traces back to that act of naming, and still continues today. Equally though, it signals to cross-cultural relationships that bind Pākehā and Māori today and that have backdropped much of Freeman's career.

Museum

At the same time that Freeman was making My Grandfather's Jewellery and Aotearoa Service, a movement was taking hold that would, in one short decade, be consecrated as the unique New Zealand jewellery style. Artist John Edgar wrote in the catalogue for the 1988 exhibition Bone Stone Shell: New Jewellery New Zealand:

> A growing awareness of our place in the South Pacific has led a number of New Zealand carvers and jewellers to use traditional materials in a contemporary way that acknowledges our bicultural heritage and redefines our values in the twentieth century. These materials and the objects made from them are our homage to the past, our amulets in the present and our treasures for the future.[8]

Work from this time responded to a changing cultural and political environment. The new Labour Government pursued policies that would establish New Zealand as nuclear free, and a growing sense of local culture emerged that foregrounded New Zealand's position within the Pacific and celebrated the unique natural

Nationalismus befasst, um deren Bedeutung zu erkennen, aber auch die negativen Assoziationen, die ihnen zu eigen sind. Seine Brosche Poppy (Mohnblume, 1998, S. 259) weist die symbolische Form der ikonischen Mohnblume auf, die bei den Gedenkfeiern zum Anzac Day (Australian and New Zealand Army Corps) zum Einsatz kommt,[9] einem nationalen Gedenktag in Neuseeland und Australien, bei dem jener gedacht wird, die im Krieg gedient haben und gefallen sind. Einige empfinden das Tragen der Blume als patriotisch, für andere wertet sie den Krieg auf und befördert nur eine Version der Geschichte des Landes.

Heute trage ich anstelle des Peace-Zeichens bisweilen einen kleinen weißen Schmetterling an meinem Revers. Freemans Arbeit von 1999 trägt den Untertitel *introduced European pest* (schleppte die europäische Pest ein). Die Brosche ist eine Interpretation der Schmetterlingsart *Pieris rapae* (Kleiner Kohlweißling), die ursprünglich in Europa und Nordamerika beheimatet war und in Neuseeland erst ab den 1930er-Jahren auftrat. Der Schmetterling ist der Fluch aller Gärtner, vernichtet er doch das wertvolle Gemüse. Freeman greift den weißen Schmetterling als Symbol für Pākehā auf, das Māori-Wort für Neuseeländer europäischer Abstammung. Manche mögen den Schmetterling als unerwünschtes Zeichen interpretieren – es gibt heute immer noch europäische Neuseeländer, die Pākehā als Beschreibung ablehnen, schlicht aufgrund der Māori-Sprache *te reo Māori*. Für mich ist das Tragen des White Butterfly (Weißer Schmetterling, S. 35) eine Anerkennung des Namens, den ich und meine Vorfahren von den Māori erhalten haben, als wir die „Anderen" waren – fremd, exotisch und eingeschleppt. Der Schmetterling ist eine Un-Verdienst-Medaille. Er verweist auf abwertende Weise auf die Zerstörung und den Schaden, den Pākehā durch den Kolonisierungsprozess verursachten und noch immer verursachen. Gleichzeitig weist er auch auf kulturübergreifende Beziehungen hin, die Pākehā und Māori heute verbinden, und die den Hintergrund für einen Großteil von Freemans künstlerischem Weg bilden.

Brooch
Aotearoa Service,
1985
Oxidised copper
5.6 × 6.7 cm

Brosche
Verdienstmedaille,
1985
Geschwärztes Kupfer
5,6 × 6,7 cm

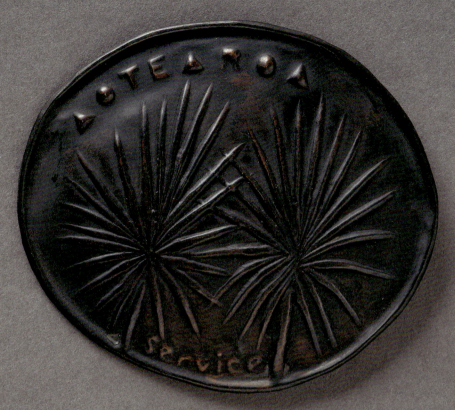

Brooch
White Butterfly,
2000
Silver, paint
1 × 2.1 cm

Brosche
Weißer Schmetterling,
2000
Silber, Farbe
1 × 2,1 cm

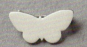

environment. The exhibition sanctioned the legacy of the Bone Stone Shell movement, in part enabled by Ministry of Foreign Affairs funding that saw the show tour internationally to Australia and Asia.

A confluence of exhibitions and activity by jewellers laid the groundwork for Bone Stone Shell's reception. Paua Dreams was staged at Fingers in 1981; a tactical exhibition that sought to reclaim pāua, New Zealand abalone, from the tourist trade, where kitsch jewellery and domestic ornaments had dominated its use. Freeman and his colleagues were also inspired by the permanent collection of Pacific adornment at Auckland Museum. For many Pākehā jewellers of the day, viewing works on display in the museum and later visiting collections would be the first time engaging with Pacific practice. In 1983 Freeman and fellow jeweller Alan Preston gained access to the museum's collection store of Pacific jewellery in preparation for travel to Fiji to deliver a workshop for the Fiji Arts Council teaching souvenir manufacturers working with natural materials. In a novel move, the 1985 exhibition Pacific Adornment at The Dowse Art Museum saw Preston and Freeman select Pacific works from the museum collection, at the request of director James Mack, to be shown alongside their own work.

Access to museum collections created a vital connection to jewellery and culture that would otherwise be out of reach. In a handwritten document headed 'Museum', among Freeman's unpublished commentary, he explains the importance of these encounters:

> Childhood visits to numerous provincial museums provided my self-education and the seeds of my eventual interest in being an object maker. And now, more specifically, the Pacific collection in the Auckland Museum, and in particular the store collection of Polynesian and Melanesian jewellery... This early Pacific work has an unsettling affect on me. When handling it, I am forced to

Museum

Zur gleichen Zeit, als Freeman My Grandfater's Jewellery und Aotearoa Service schuf, bildete sich eine Bewegung aus, die innerhalb von nur einem Jahrzehnt eine neuseeländische Schmucksprache etablieren sollte. Im Katalog zur Ausstellung Bone Stone Shell: New Jewellery New Zealand (Knochen Stein Muschel: Neuer Schmuck Neuseeland, 1988) schrieb der Künstler John Edgar:

> Ein wachsendes Bewusstsein für unseren Ort im Südpazifik hat eine Reihe neuseeländischer Schnitzer und Schmuckhersteller dazu veranlasst, traditionelle Materialien auf zeitgenössische Art und Weise einzusetzen, die unser bikulturelles Erbe anerkennt und unsere Werte im 20. Jahrhundert neu definiert. Diese Materialien und die Objekte, die sie daraus erschaffen, sind unsere Hommage an die Vergangenheit, unsere Amulette in der Gegenwart und unsere Schätze für die Zukunft.[10]

Arbeiten aus dieser Zeit waren eine Reaktion auf ein sich veränderndes kulturelles und politisches Umfeld. Die neue Labour Regierung verfolgte eine Politik, die ein atomkraftfreies Neuseeland anstrebte, zudem bildete sich ein wachsendes Bewusstsein für lokale Kultur aus, das im Vordergrund von Neuseelands Stellung im Pazifikraum stand und die einzigartige Natur feierte. Die Ausstellung würdigte das Erbe der Bone Stone Shell-Bewegung, die gefördert wurde durch Finanzmittel des Außenministeriums, mit deren Unterstützung die Schau international reisen konnte, etwa nach Australien und Asien.

Ausstellungen und Aktivitäten von Schmuckherstellern schufen die Grundlage für die Rezeption von Bone Stone Shell. Schon 1981 inszenierte die Galerie Fingers Paua Dreams (Pāua Träume), eine strategische Ausstellung, mit der die neuseeländische Abalone, *pāua*, zurückgewonnen werden sollte, die als kitschiger Schmuck und häuslicher Zierrat den Touristenhandel dominierte. Freeman und seine Künstler-Kollegen waren zudem von der permanenten Ausstellung pazifischer

confront my own cleverness. Its realness up against the perceived superficiality of being a jewellery maker now. I am moved by the direct use of materials and the sense of responsibility the work embodies.⁹

Influenced by this approach to materials, Freeman's work from this period responds to the form and structure already present in the shell, wood, or bone, which he describes as the 'given' of the materials. In his necklace Whitebait (1982; page 38), for instance, he utilises the existing curved rims of pāua shells as the central form of the necklace:

> I like the lack of freedom because already it presents reasons – the limitations become reasons for the piece. Many of my best pieces in shell had used these limitations, 'the given' as the reason for their existence. The Paua Whitebait Necklace and the Paua Layer Bracelet are so totally dependent on the given curves inherent in the paua shell that their strength, both literally and visual comes from that fact.¹⁰

A collaborative project between Damian Skinner and Warwick Freeman in the early 2000s interrogated Freeman's adoption of 'the given' as a strategy. The project culminated in a touring exhibition beginning in the Netherlands, travelling to Germany, and then to five museums across New Zealand between 2004 and 2007. The exhibition and its accompanying publication, Given (2004), foreground 'given' with its binary opposite 'taken'. For instance, is something given from the natural environment, or is it in fact taken? The slippage of meaning between these two words highlights the role and potential absence of permission. Bone Stone Shell and Pacific Adornment saw Freeman and many of his contemporaries draw on cultures that were not their own. As they had limited (if any) connection to Pacific jewellers or knowledge holders, the museum became the intermediary, transacting the given and taken for Pākehā jewellers. Writing on Freeman's

Schmuckelemente im Auckland Museum inspiriert, und für viele der Pākehā-Schmuckmacher der Zeit waren diese im Museum ausgestellten Arbeiten oder spätere Sammlungen die erste Auseinandersetzung mit dem pazifischen Erbe. Während der Reisevorbereitungen nach Fidschi, wo sie in einem Workshop vor Ort für das Fiji Arts Council, Souvenirherstellern das Arbeiten mit Naturmaterialien beibringen sollten, hatten Freeman und sein Kollege Alan Preston 1983 die Gelegenheit, die Bestände an pazifischem Schmuck im Museum zu sehen. Im Rahmen der Ausstellung Pacific Adornment (Pazifischer Schmuck, 1985) im Dowse Art Museum wählten Preston und Freeman auf Aufforderung von Direktor James Mack erstmals pazifische Arbeiten aus der Museumssammlung aus, die neben ihren eigenen Arbeiten gezeigt werden sollten.

Der Zugang zur Museumssammlung etablierte eine grundlegende Verbindung zu Kultur und Schmuck des pazifischen Raumes. In einem handschriftlichen Dokument mit der Überschrift „Museum" erläutert Freeman die Bedeutung dieses Kontaktes:

> Kindheitsbesuche in zahlreichen Provinzmuseen lieferten mir eine autodidaktische Ausbildung und legten den Grundstein für mein schlussendliches Interesse daran, Dinge zu machen. Und jetzt insbesondere die Pazifik-Sammlung im Auckland Museum, und hier besonders die Sammlung von polynesischem und melanesischem Schmuck […]. Diese frühen pazifischen Arbeiten stimmen mich sehr nachdenklich. Wenn ich mich damit beschäftige, dann bin ich gezwungen, mich mit meiner eigenen künstlerischen Aussage auseinanderzusetzen. Ihre Authentizität steht im Gegensatz zu der vermeintlichen Oberflächlichkeit, die heute viele Schmuckmacher mit sich tragen.¹¹

Von dieser Herangehensweise an Materialien geprägt, reagieren Freemans Arbeiten aus dieser Periode auf die Form und Struktur, die in Muschel, Holz oder Stein bereits vorhanden sind, was er als das „Gegebene" („given") der Materialien

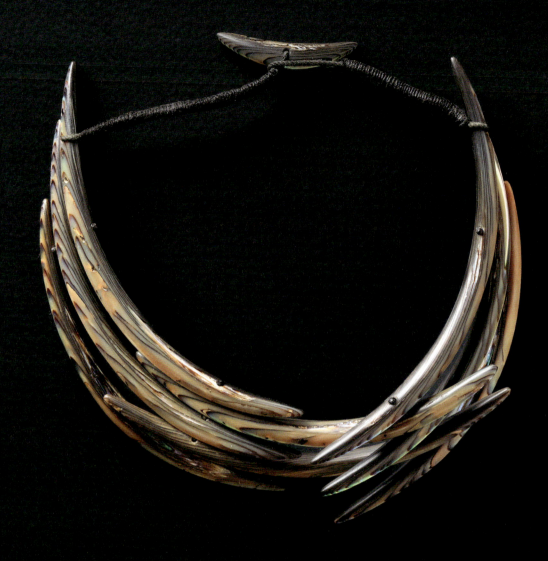

Necklace
Whitebait, 1982
Pāua shell, cord
14 × 16 cm

Halsschmuck
Weißfisch, 1982
Schalenränder der
Pāua-Schnecke, Kordel
14 × 16 cm

Pāua Layer Bracelet (1985; page 154), Skinner suggests:

> There is no commensurability of meaning between the original made for its 19th century Melanesian audience and Freeman's work, made for a principally Pākehā audience in 1980s Aotearoa. But this process of mis-reading doesn't automatically imply ignorance of Pacific adornment; and it doesn't necessarily result in an abuse of cultural forms that are specific and meaningful to the cultures that made them.[11]

While a decade later the cultural appropriation of Māori taonga[12] was being interrogated, particularly in contemporary art contexts, in its time much of the work from the Bone Stone Shell period escaped deep scrutiny. Skinner notes, and Freeman would agree, that the ready adoption of form and methods of making from the Pacific, without wider understanding of the cultural context they were made within, is problematic. Freeman later describes this as the 'responsibility of influence'.[13]

Freeman has roamed the territory of the 'given' for much of his career, his use of the found and the ready-made is exhaustive. Throughout, he has remained critically engaged with his influences, as though he is in conversation with the ancestry – culture, references, associations – they might bring. The museum was an evocative source amidst the milieu of identity politics that he and many others were steeped in at the time. In the four decades that have passed since Bone Stone Shell, the movement has continued to provide a tidy way to capture and tell the story of a formative period of contemporary jewellery in Aotearoa. However, Freeman has long sustained a focus on the emblematic references embodied in materials. His regular use of bone, wood, stone, and shell was not, as some have claimed, a wholesale rebuke of Western traditions of metal working. It is more usefully understood as a broadening of his vocabulary, which has endured over time.

bezeichnet. In seinem Halsschmuck Whitebait (Weißfisch, 1982, S. 38) setzt er zum Beispiel die bestehenden gewölbten Ränder der Pāua-Muscheln als zentrale Form ein:

> Ich mag den Mangel an Freiheit, weil er bereits Gründe liefert – die Einschränkungen werden zu Gründen für das Stück. Viele meiner besten Stücke aus Muschelschalen haben sich diese Einschränkungen zunutze gemacht, das „Gegebene" wurde zum Grund für ihre Existenz. Das Paua Whitebait Necklace [Pāua-Weißfisch Halsschmuck] und das Paua Layer Bracelet [Pāua-Scheiben Armschmuck] sind so völlig abhängig von den charakteristischen Rundungen der Pāua-Muschel, dass ihre – sowohl buchstäbliche als auch visuelle Stärke – dieser Tatsache entspringt.[12]

Ein Gemeinschaftsprojekt zwischen Damian Skinner und Warwick Freeman Anfang der 2000er-Jahre hinterfragte Freemans Übernahme des „Gegebenen" als Strategie. Das Projekt gipfelte in einer Wanderausstellung, die in den Niederlanden begann, dann nach Deutschland reiste und zwischen 2004 und 2007 weiter zu fünf Museen in ganz Neuseeland. Die Ausstellung und die begleitende Publikation Given (2004) stellt „given" (Gegeben) seinem Gegenteil „taken" (Genommen) gegenüber. Ist etwas von der Natur zum Beispiel gegeben oder wurde es tatsächlich eher genommen? Die unterschiedliche Bedeutung der beiden Begriffe betont die Rolle und das mögliche Fehlen einer Erlaubnis. Bone Stone Shell und Pacific Adornment zeigten auf, wie Freeman und viele seiner Zeitgenossen sich bei Kulturen „bedienten", die nicht ihre eigenen waren. Da sie (wenn überhaupt) nur über eingeschränkte Beziehungen zu Schmuckmachern oder Wissensträgern aus dem Pazifikraum verfügten, wurde das Museum zum Wissensmittler. Skinner schreibt über Freemans Pāua Scheiben Armschmuck (1985, S. 154):

> Es gibt keine vergleichbare Bedeutung zwischen dem Original, das für ein melanesisches Publikum des 19. Jahrhunderts geschaffen

Emblem

The poetic origins of Hook Hand Heart Star (2024; page 26) can be traced back to 1987, when Freeman first grouped four forms together in a vertical arrangement. Made entirely from silver, Fern Fish Feather Rose (page 42) includes an elongated fern, a curved fish form, a feather that mimics the arch of the small fish and a single rose-head without a stem. Freeman describes the work as a poem; it can be read as much as it is seen. For Freeman, the ability for the viewer to access his work and make their own reading of a piece of jewellery has always been critical. It is both an act of generosity and a responsibility for his audience. Fern Fish Feather Rose saw, for the first time, multiple emblems drawn together. In doing so, a reading of the work is created across the pieces and the viewer can build connections between each form.

For Fern Fish Feather Rose, Freeman's givens are again drawn from the natural world. Instead of utilising the material as the readymade, Freeman focuses on emblematic representations that continue to uncover issues of cultural identity. Fern, fish, and feather can be read as symbols of indigenous flora and fauna, signifiers of a growing local culture. Rose, though, exists within the quad as a deliberate interloper, a literal thorn in the side. Like the white butterfly, it operates as a reference to an introduced species, this one a recognisable and tired trope of Englishness.

For Freeman, the work is an expression of his own tension. To be Pākehā is to acknowledge both where we have come from and who we want to be. New Zealand academic Alison Jones writes in her memoir, This Pākehā Life:

> Pākehā is a complicated and politicised term in modern usage. It is a tuna-term, a slippery eel of a word; it wriggles easily away from one's grasp. Sometimes it is a general descriptive category to name the white people inhabiting New Zealand;

wurde, und Freemans Arbeiten, die im Aotearoa der 1980er-Jahre für ein Pākehā-Publikum entstanden. Doch dieser Prozess impliziert nicht automatisch Ignoranz für pazifischen Schmuck; auch resultiert er nicht notwendigerweise aus einem Missbrauch kultureller Formen, die für die Kulturen spezifisch und von Bedeutung sind.[13]

Obwohl die kulturelle Aneignung von Māori *taonga*[14] ein Jahrzehnt später, vor allem im Kontext zeitgenössischer Kunst, hinterfragt wurde, entgingen in jener Zeit zahlreiche Arbeiten der Bone Stone Shell-Periode eingehenderer Überprüfung. Skinner bemerkt, und Freeman würde dem wohl zustimmen, dass die vorschnelle Übernahme von Formen und Herstellungsmethoden aus dem pazifischen Raum ohne ein umfassendes Verständnis des kulturellen Kontextes tatsächlich problematisch ist. Freeman sollte das später als „Verantwortung von Einflussnahme" bezeichnen.[15]

Seine gesamte Karriere über bewegte sich Freeman im Bereich des „Gegebenen", sein Arbeiten mit Fundstücken und Ready-made ist vielfältig. Er setzte sich dabei zu jeder Zeit kritisch mit den Einflüssen auseinander, die auf ihn einwirkten, als befände er sich in Austausch mit der Abstammung – Kultur, Referenzen, Assoziationen. Das Museum war eine atmosphärische Quelle inmitten des Milieus von Identitätspolitik, in die er und viele andere jener Zeit verstrickt waren. In den vier Jahrzehnten, die seit Bone Stone Shell vergangen sind, erweist sich die Bewegung immer noch als gute Möglichkeit, die Geschichte einer prägenden Periode zeitgenössischen Schmucks in Aotearoa Neuseeland festzuhalten und zu erzählen. Freeman hielt den Fokus auf die symbolischen Verweise lange aufrecht, die in den Materialien verkörpert sind. Sein regelmäßiger Einsatz von Knochen, Holz, Stein und Muschel war jedoch nicht, wie bisweilen behauptet wird, eine pauschale Verurteilung der westlichen Tradition von Metallarbeiten. Vielmehr sollte er als Erweiterung seines Vokabulars begriffen werden, das durch Zeitlosigkeit charakterisiert ist.

sometimes it refers to an identity, a form of self-understanding that arises from close engagement with Māori-as-Māori.[14]

Jones submits that for Pākehā to face their relationship to Māori is to acknowledge their own story is intertwined with the 'real and symbolic violence of New Zealand settlement.'[15] Freeman posits in Fern Fish Feather Rose that the fervour for a new emerging identity tied to place cannot (and need not) expel the settler histories of Pākēha and that instead they exist together in the tension of the same space.

Another complicating factor in relation to the emblematic grouping of Fern Fish Feather Rose is the matter of the wearer. While on exhibition or display the work is seen (and read) in its curated group of four, but to wear it you can only select one at a time. As Damian Skinner writes in Given: 'Here you have to choose which one to wear and in doing so, you indicate, consciously or not, a position about how you will understand and partake in an identity-forming exercise.'[16]

The impact of Fern Fish Feather Rose is its entanglement with language, as Freeman explains in a set of notes he wrote to accompany his exhibition Share of Sky: Emblems 1985–90 at The Dowse Art Museum in 1991:

> As symbols ferns, fish, feathers and roses are very common – they have both specific and general meanings for almost everybody. Although in this combination they have a particular meaning for me, their universality leaves them open to individual interpretation… But at the same time by such devices as their grouping… I hope to create an atmosphere around them that suggests they can be read specifically as if I had written Aotearoa or New Zealand all over them.[17]

If Fern Fish Feather Rose is a poem, Insignia (pages 122–123) is a sentence. First exhibited at Bowen Galleries, Wellington, in 1997, the work expands on the simple grouping device,

Emblem

Die poetischen Ursprünge von Hook Hand Heart Star (2024, S. 26) lassen sich auf das Jahr 1987 zurückführen, als Freeman erstmals vier Formen in einem vertikalen Arrangement gruppierte. Das aus Silber bestehende Fern Fish Feather Rose (S. 42) umfasst einen länglichen Farn, eine geschwungene Fischform, eine Feder, die den Bogen eines kleinen Fisches nachempfindet, und eine einzelne Rosenblüte ohne Stiel. Freeman beschreibt die Arbeit als ein Gedicht, das genauso gut gelesen wie gesehen werden kann. Für ihn ist die Fähigkeit des Betrachters, visuell auf seine Arbeiten zuzugreifen und eigenen Interpretationen eines Schmuckstückes nachzuspüren, seit jeher von entscheidender Bedeutung. Er empfindet es sowohl als Akt der Großzügigkeit als auch als Verantwortung gegenüber seinem Publikum. In Fern Fish Feather Rose sind erstmals verschiedene Symbole miteinander vereint. So entsteht eine Interpretation der Arbeit über die einzelnen Stücke hinaus und der Betrachter kann Verbindungen zwischen den einzelnen Formen feststellen.

Bei Fern Fish Feather Rose bezieht Freeman seine „givens" erneut aus der Natur. Anstatt das Material als Ready-made zu verwenden, konzentriert sich Freeman auf eine sinnbildliche Darstellung, die weiterhin Themen kultureller Identität aufdeckt. Farn, Fisch und Feder lassen sich als Symbole einheimischer Flora und Fauna interpretieren, Anzeichen einer wachsenden nationalen Kultur. Die Rose existiert innerhalb der Vierergruppe als bewusster Eindringling, ein buchstäblicher Stachel im Fleisch. Wie der weiße Schmetterling dient sie als Verweis auf eine eingeschleppte Spezies, in diesem Fall ein erkennbarer und abgedroschener Ausdruck des Englischseins per se.

Für Freeman stellt Fern Fish Feather Rose einen Ausdruck seiner eigenen Spannung dar. Pākehā zu sein heißt auch anzuerkennen, woher wir kommen und wer wir sein wollen. Die neuseeländische Wissenschaftlerin Alison Jones schreibt in ihren Erinnerungen:

Brooches
Fern Fish Feather Rose,
1987
Silver
Fern: 2.8 × 18 cm

Broschen
Farn Fisch Feder Rose,
1987
Silber
Farn: 2,8 × 18 cm

drawing together a sequence of six brooches in a frieze formation. The work reads (from left to right): a sandstone and quartz Shield, a jasper Red Spot, a greenstone Karaka Leaf, a pearl-shell Eye, a turtle-shell Bird, and a tilted Skull made of cow bone. Placing the works together in a line, Insignia similarly suggests that it is communicating in the manner of language. Together, the works look like glyphs. For Freeman, the sentence has endured as a worthy device for expanding the potential of the emblem's reading.

If an emblem can be recognised for its symbolic meaning – take a love heart, plant type, or skull – then to draw it into a grouping is to invite the viewer to draw their own meaning from it. A motif may be universal, or recognisable only within the bounds of its country or as a niche cultural reference. While Fern Fish Feather Rose sees Freeman tightly control the curation of the group and its subsequent reading, for Insignia, and the various long and short sentences that have followed, the groupings are freer. As part of the jewellery games Freeman plays, from any given selection of pieces he will find a rhythm within the group. Never literal, the arrangement could be motivated by a visual or verbal sensibility or material considerations. It is the game of discovering 'little rhythms where you could almost imagine there was language, like it was a meaningful sentence you were using.'[18]

Freeman's Life Sentence is a longer form of Insignia, made up of sixteen individual brooches produced over a period of three years. It was included in the Fourth New Zealand Jewellery Biennale, curated by Deborah Crowe for The Dowse Art Museum in 2001, accompanied by a three-word artist's statement, 'Can't you read?'. As much as a refusal to provide a ubiquitous artist's statement, Freeman is asking his audience to participate in a conversation, while acknowledging that their ability to access the work and read his signs and symbols is a requirement of the success of the work:

Pākehā ist im modernen Gebrauch ein komplizierter und politisierter Begriff. Er ist ein „Tuna-Term", ein schlüpfriger Aal von einem Wort; er windet sich ganz leicht aus dem Griff. Manchmal ist es eine allgemeine beschreibende Kategorie, um die weißen Menschen zu bezeichnen, die Neuseeland bevölkert haben; manchmal bezieht er sich auf eine Identität, eine Form des Selbstverständnisses, das einer engen Auseinandersetzung mit Māori-als-Māori entspringt.[16]

Wenn sich Pākehā ihrer Beziehung zu den Māori stellen, erkennen sie laut Jones an, dass ihre Geschichte mit der „realen und symbolischen Gewalt der neuseeländischen Besiedlung" verflochten ist.[17] In seinem Werk vertritt Freeman die Ansicht, dass der Eifer für eine neu entstehende, mit dem Ort verbundene Identität die Geschichte der Pākehā nicht verdrängen kann (und muss), sondern, dass sie stattdessen in der Spannung desselben Raumes zusammen existieren.

Ein weiterer komplizierter Faktor in Zusammenhang mit der symbolischen Gruppierung von Fern Fish Feather Rose ist die Frage des Trägers. In Ausstellungen wird die Arbeit als zusammengestellte Vierergruppe gesehen (und interpretiert), beim Tragen muss man sich jedoch für eine der Broschen entscheiden. Wie Damian Skinner in Given schreibt: „Hier muss man wählen, welche [Brosche] man trägt, und nimmt dabei, bewusst oder unbewusst einen Standpunkt ein, wie man an dieser identitätsbildenden Übung teilnehmen möchte und sie auffasst."[18]

Die Wirkung von Fern Fish Feather Rose liegt in ihrer Verflechtung mit Sprache, wie Freeman in einer Reihe von Notizen erläutert, die er begleitend zu seiner Ausstellung Share of Sky: Emblems 1985-90 im Dowse Art Museum (1991) verfasste:

> Als Symbole sind Farn, Fisch, Feder und Rose sehr gewöhnlich – sie haben für fast alle Menschen sowohl besondere als auch allgemeine Bedeutungen. Obwohl sie in dieser Kombination eine bestimmte Bedeutung für

The process of calling it language or even a visual language – that suggests you are communicating, it suggests an exchange I suppose. I'm accepting a responsibility of that exchange and so when... the talk starts coming back my way, I absorb it and then send it back again as the meaning of the piece.[19]

Over many years, Freeman has committed to the process of the audience reading his sentences as they will. They may skip over some forms and pick up on the ones that have meaning to them. In the final step of this process, works are viewed, purchased, and worn by viewers singularly, and the emblematic function of the piece shifts to represent the wearer as an expression of their own allegiance to an idea.

Wall work

Sentences are a continuing exhibition device for Freeman, and four new ones have been made (or written) for Hook Hand Heart Star. They highlight installation as an exhibition method that is also evident in other large-scale thematic groupings.

Dead Set (2003–06; page 46), for example, is made up of 121 silver-capped pendants made from animal parts and wall mounted to create a 1200mm-wide circle. Freeman collected the animal parts over several years, and he describes finding them in much the same manner as collecting stones for North Cape to Bluff (pages 220–221) during travel throughout Aotearoa. From the beach came the pilot whale's teeth, the porcupine fish's spines, and the gannet's beak. From the road, the magpie's feet, and from the forest, the horse's teeth. An imposing work, Dead Set draws on European jewellery traditions and the centuries-old practice of wearing animal parts, but equally the work functions as an incongruous map, documenting the status of a staggering array of indigenous and introduced animal species as well as parts from the only two animals in Aotearoa that provide any threat to humans – the wild pig's tusk and the shark's tooth.

mich haben, lässt ihre Universalität Spielraum für individuelle Betrachtungen. [...] Doch gleichzeitig hoffe ich durch solche Kunstgriffe wie ihre Anordnung [...], eine Atmosphäre um sie herum zu schaffen, die andeutet, dass sie in spezifischer Art und Weise gelesen werden können, als hätte ich Aotearoa oder Neuseeland darüber geschrieben.[19]

Wenn Fern Fish Feather Rose ein Gedicht ist, dann ist Insignia (S. 122-123) eine Sentenz. Erstmals ausgestellt 1997 in den Bowen Galleries in Wellington, erweitert die Arbeit die einfache Gruppierung um eine Folge von sechs Broschen zusammengestellt als Fries. Die Arbeit besteht (von links nach rechts) aus: einem Shield (Schild) aus Sandstein und Quarz, einem Red Spot (Roter Punkt) aus Jaspis, einem Karaka Leaf (Karaka-Blatt)[20] aus Grünstein, einem Eye (Auge) aus Perlmuschel, einem Bird (Vogel) aus Schildkrötenpanzer und einem schräggestellten Skull (Totenschädel) aus Rinderknochen. Durch die Platzierung der Arbeiten in einer horizontalen Linie legt Insignia zudem nahe, dass es in Form einer Sprache kommuniziert. Zusammen sehen die Arbeiten wie Glyphen aus. Für Freeman hat sich die Sentenz als ein nützliches Werkzeug bewährt, um die Möglichkeiten der Lesart eines Symbols zu erweitern.

Lässt sich ein Sinnbild aufgrund seiner symbolischen Bedeutung wiedererkennen – man denke nur an ein Herz der Liebe, eine Pflanzenart oder einen Totenschädel – dann ist die Aufnahme in eine Gruppierung gleichbedeutend mit der Einladung an den Betrachter, seine eigene Bedeutung daraus zu ziehen. Ein Motiv kann allgemeingültig oder nur innerhalb der Grenzen eines Landes oder als kultureller Nischenbezug wiedererkennbar sein. Während Freeman in Fern Fish Feather Rose die Gruppe und die darauf folgende Interpretation genau festlegt und kontrolliert, sind für Insignia und die verschiedenen längeren und kürzeren Sentenzen, die dieser Arbeit folgen, die Anordnungen freier gestaltet. Als Teil dieses Spiels mit Schmuck, kann Warwick Freeman aus jeder beliebigen Auswahl von Stücken einen Rhythmus innerhalb der Gruppe finden. Das

Freeman's recognition from audiences, collectors, and museums beyond the field of jewellery has contributed to his acclaim in New Zealand. A top art student at Nelson College, he had an interest in and aptitude for several creative paths, and in the decade following high school, painting or architecture could easily have claimed him. Originally interested in going to art school in London, it was only a missed application, thwarted by a postal strike in the UK, that changed the course of things to come. The OE continued, minus the education, and on his travel back to New Zealand it was time spent in Afghanistan that sparked an interest in jewellery, when he experienced the social and cultural relationship with adornment there. He saw the way jewellery as a material culture was a part of how people lived and looked.

Jewellery appeared at the right time for Freeman to forge a self-taught path on his return to New Zealand, picking up making from a friend and then through dedicated time spent with studio jeweller Jens Hansen. His breadth of interest and curiosity across creative disciplines – craft, fine art, architecture – is evident in his jewellery. Freeman gives equal weight to the craft of making, the act of wearing, and the theoretical heavy-lifting of his work, and it is particularly evident in his sentences and wall-based installations.

Dust (2011; page 208) is an installation that poetically charts the residue of making. It is made up of sixty rectangular tiles in a grid, each painted with the accumulated dust created from the materials he has used to make jewellery over forty years. Dust is an extraordinary exercise in record keeping. The work's material list reads like a love letter to the land – quartz, concretion, lapis lazuli, volcanic sinter, carnelian, scoria, argillite – chronicling the rocks, minerals, and shells that have given so much to Freeman's jewellery. Discussing Dust in a 2013 lecture held at the invitation of Die Neue Sammlung – The Design Museum in the Pinakothek der Moderne he said:

niemals wörtlich zu nehmen, kann womöglich durch eine visuelle oder verbale Empfindsamkeit oder durch materielle Überlegungen motiviert sein. Es ist das Spiel des Entdeckens „kleiner Rhythmen, bei denen man sich fast schon vorstellen kann, dass es eine Sprache gibt, als wäre es eine sinnvolle Sentenz, die man benutzt".[21]

Freemans Life Sentence (Lebenslanger Satz) ist eine längere Form von Insignia und besteht aus sechzehn individuellen Broschen, die im Laufe von drei Jahren entstanden. Die Arbeit war im Rahmen der Fourth New Zealand Jewellery Biennale zu sehen, die Deborah Crowe 2001 für das Dowse Art Museum kuratierte, und wurde von einem Künstlerstatement in drei Worten begleitet: „Can't you read?" (Können Sie nicht lesen?). Freeman bringt damit seine Weigerung zum Ausdruck, ein stets allgegenwärtiges Künstlerstatement abzugeben. Und er fordert sein Publikum auf, sich an einem Gespräch zu beteiligen, während er gleichzeitig eingesteht, dass die Fähigkeit des Publikums, sich Zugang zum Werk zu verschaffen und seine Zeichen und Symbole zu lesen, eine Voraussetzung für den Erfolg der Arbeit ist:

> Der Prozess, es als Sprache oder sogar als visuelle Sprache zu bezeichnen – der andeutet, dass man kommuniziert, das deutet, denke ich, einen Austausch an. Ich übernehme die Verantwortung für diesen Austausch und wenn […] das Gespräch zu mir zurückkommt, nehme ich es auf und schicke es als Bedeutung des Stückes zurück.[22]

Über viele Jahre hat Freeman sich dem Prozess verpflichtet, dass das Publikum seine Sentenzen so liest, wie es möchte. Sie lassen vielleicht ein paar Formen aus und suchen sich jene heraus, die für sie von Bedeutung sind. Im letzten Schritt dieses Prozesses werden die Arbeiten einzeln betrachtet, gekauft und von den Betrachtern einzeln getragen. Damit verlagert sich die symbolische Funktion des Stückes – es repräsentiert jetzt den Träger in seiner Zugehörigkeit zu einer Idee.

Installation
Dead Set II, 2006
Animal parts, oxidised
silver caps
120 × 120 cm
The Suter Art Gallery
Te Aratoi o Whakatū,
Nelson

Installation
Reihe von toten
Dingen II, 2006
Tierteile, oxidierte
Silberkappen
120 × 120 cm
The Suter Art Gallery
Te Aratoi o Whakatū,
Nelson

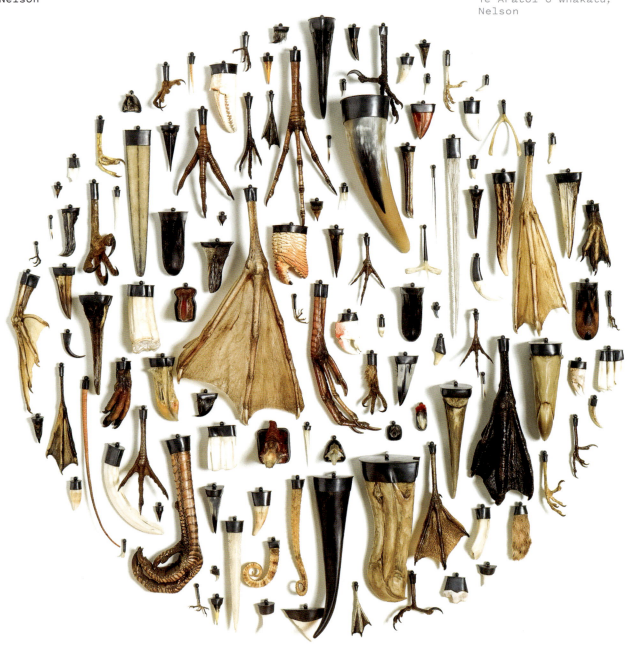

we could say there are 60 paintings here – but my conceptual claim is that this is not painting. After all, the hole could mean it is a pendant. So, it's 60 pieces of jewellery. I'd give too much away if I called it painting – and for no gain as far as I can see – it may be a contrary point of view but for me, in the applied arts, contrariness is sometimes political.[20]

Found

A companion word to *given* in Freeman's lexicon could be *found*. In 1998 Freeman made a piece called Weka Nest (page 50). A native bird, the weka is naturally inquisitive and is known for its love of acquiring shiny treasures. The bird shares similarities with New Zealand's unofficial national bird, the kiwi – brown, flightless, and with no tail. Freeman found affinity with the weka both for its scavenging habits that reflect something of his own methodology, and for its potential as an alternative symbol of national identity.

The kiwi is the prevailing emblem of New Zealand. It has been adopted as a moniker for New Zealanders as a national people, and, beyond naming, has even come to imply the temperament of a people (good natured, easy going). The naming of Kiwis didn't originate in New Zealand but can be traced back to the First World War as a nickname given to New Zealand soldiers. As an image and name, it belongs to everyone, used for sports teams and on currency. It is also deployed politically – debates about migration and racism often resort to accusations of not being Kiwi enough.

Freeman took up the weka as a personal emblem. Like the kiwi, the weka could be understood broadly but lacked the prosaic recognition of its counterpart. In 1988 he made sets of buttons incised with the text 'Weka brand', putting the emblem to work in the humblest of adornment objects. Writing about Freeman's Weka buttons for the publication

Wandarbeiten

Sentenzen bleiben auch weiterhin ein probates Ausstellungsmittel für Freeman – für Hook Hand Heart Star hat er vier neue geschaffen (beziehungsweise geschrieben). Sie heben die Installation als eine Ausstellungsmethode hervor, die auch in anderen großformatigen thematischen Gruppierungen zu finden ist.

Dead Set (Reihe von toten Dingen, 2003-2006, S. 46) umfasst zum Beispiel 121 aus tierischen Teilen bestehende Anhänger mit silbernen Kappen, die so an einer Wand montiert wurden, dass sie einen Kreis mit einem Durchmesser von 1,2 Metern ergeben. Freeman sammelte die Tierteile im Laufe mehrerer Jahre, und er beschreibt ihr Auffinden in etwa so wie das Sammeln von Steinen für North Cape to Bluff (Vom Nordkap nach Bluff, S. 220-221) während seiner Reisen durch Aotearoa Neuseeland. Am Strand fand er den Zahn eines Grindwals, den Stachel eines Igelfisches und den Schnabel eines Tölpels. Von der Straße stammt die Kralle der Elster und aus dem Wald der Pferdezahn. Die imposante Arbeit Dead Set verweist auf eine europäische Schmucktradition und die jahrhundertealte Praxis des Tragens von Tierteilen. Gleichzeitig fungiert das Werk jedoch auch als inkongruente Karte, die den Status einer überwältigenden Ansammlung einheimischer und eingeschleppter Tierarten dokumentiert, darunter auch Teile der einzigen beiden Tiere, die in Aotearoa Neuseeland gefährlich für den Menschen sein könnten, nämlich den Hauer eines Wildschweins und den Zahn eines Haifisches.

Freemans Anerkennung durch Publikum, Sammler und Museen über den Bereich von Schmuck hinaus hat zu seinem hohen Ansehen in Neuseeland beigetragen. Als hervorragender Kunststudent am Nelson College hatte er zahlreiche Interessen und dank seines Talents wären ihm verschiedene kreative Wege offen gestanden. Im Jahrzehnt nach seinem Schulabschluss waren auch Malerei und Architektur Möglichkeiten, die er hätte ergreifen können. Ursprünglich hatte er überlegt, eine Kunstschule in London zu absolvieren. Nur eine

Owner's Manual in 1995, art historian Julie Ewington commented:

> Men wear buttons, masculine sobriety admits little jewellery… but buttons congregate in forgotten drawers, fascinating debris of a past life, possible clues to his history. Odd shirt studs, buttons naming brands, occasional souvenirs of cadet corps and wars, individual counters of conformity.[21]

Expanding on the weka theme, Freeman's Weka Nest (1998) brought together a group of nine oxidised silver objects – a button, part of a comb, a key, a spoon, a ring, a twist of wire, a dice, a tack, and a toy plane. The assemblage of things reimagines the hierarchy of objects, positing that if we care to look at the world like the weka might, the most mundane of objects can intrigue or exert an emblematic power.

Freeman has collected the readymade from the world around him with a resourceful curiosity. A stone found on a beach, the heart shape found in the curves of a kawakawa leaf. Freeman hunts the isotypes and iconography of advertising and packaging, and shapes and forms that repeat both in nature and the human world have remained a high-yielding source of ideas.

In the latter case, his novel Box pendant (2009; pages 140–141) is a representation in jet of the form of a found flattened matchbox. A hole in the upper mid-section of the black pendant is used to thread the braided black cord through. The shape has an anthropomorphic quality, with the side flaps of the box looking like arms held at the side of a body. The rules of Freeman's found lexicon are evocative and playful. He collects stars, hearts, and faces.

Faces can be discovered in the roots of trees, in the root canals of an extracted horse's tooth, or in the holes in a stone worn away by the sea. Colleague and friend Otto Künzli has over the past two decades played along. Leaf Face (2004; page 265), remade from tortoise shell,

aufgrund eines Poststreiks in Großbritannien verloren gegangene Anmeldung vereitelte diese Pläne und veränderte den Lauf der Dinge. Der Auslandsaufenthalt wurde fortgesetzt, die Ausbildung nicht. Auf dem Weg zurück nach Neuseeland verbrachte er einige Zeit in Afghanistan, wo sein Interesse an Schmuck geweckt wurde, als er dort die soziale und kulturelle Beziehung zum Schmuck erlebte. Er sah die Art und Weise, wie Schmuck als materielle Kultur ein Teil des Lebens und des Aussehens der Menschen war.

Der Schmuck trat zum richtigen Zeitpunkt in Freemans Leben und so folgte er nach seiner Rückkehr nach Neuseeland einem autodidaktischen Weg, lernte von einem Freund das Machen und verbrachte viel Zeit mit dem Juwelier und Schmuckhersteller Jens Hansen. Sein breitgefächertes Interesse und seine Neugier auf verschiedenste kreative Disziplinen – Kunsthandwerk, bildende Kunst, Architektur – kommen in seinem Schmuck zum Ausdruck. Freeman misst der Kunst der Herstellung ebenso großes Gewicht bei wie dem Akt des Tragens und dem theoretischen Ansatz seiner Arbeiten – besonders kommt das in seinen Sentenzen und wandbasierten Arbeiten zum Ausdruck.

Dust (Staub, 2011, S. 208) ist eine Installation, in der der bei der Herstellung seiner Arbeiten anfallende Staub poetisch aufgeladen werden. Sie besteht aus sechzig rechteckigen Fliesen in einem Raster, jeweils bemalt mit dem zusammengesammelten Staub der Materialien, die er im Laufe von mehr als vierzig Jahren zur Herstellung von Schmuck eingesetzt hat. Dust stellt somit eine außerordentliche Übung in der Kunst der Dokumentation dar. Die Materialliste der Arbeit liest sich wie eine Liebeserklärung an das Land – Quarz, Konkretion (mineralischer Körper im Gestein), Lapislazuli, vulkanischer Sinter, Karneol, Schlacke, Tonstein – eine Chronik der Steine, Mineralien und Muscheln, die Freemans Schmuck so sehr geprägt haben. In einer Erörterung von Dust anlässlich eines Vortrags in der Pinakothek der Moderne, 2013, sagte er:

comes from a leaf Otto sent him, and the large Mask (2007; page 174) is drawn from a piece of car exhaust Otto found on the street in Munich and posted to him. Freeman's rigorous selection process is noteworthy:

> The sourcing of objects for remaking – what qualifies and what doesn't isn't an exact process, there is plenty of accident. I often find it on the footpath. But it does have rules. Essentially the found object I am looking for produces a recognition that I can only describe as possessing something that relates to our deep memory – various shapes that have an identity – a character we might refer to as archetypal. My found objects usually come from banal sources. But I'm listening for an earlier echo of that shape. Sometimes that echo is familiar for a particular reason.[22]

That echo is apparent in a work like Cutter (2010; page 53). The breastplate-shaped pendant made of a flat piece of jasper has two holes along the straight upper edge through which a braided black cord is threaded. Its source is the found template of a tissue-box cutter, the pop-out insert that allows you to draw a tissue from its box, and yet the earlier echo of the work connects to a Fijian breastplate held in the Auckland Museum collection that Freeman greatly admires. Through its making, the oyster shell has undergone two simple actions: two holes for the cord to go through and saw-tooth cuts around its edge. Cutter shares this simplicity of intervention. The pendant has a flat top and a serrated curve, and the teeth allude to a tool rather than a decorative object.

Cutter demonstrates Freeman's method of distinguishing a keeper – a simple found form needs to possess a deeper association to be worthy of reworking. In this instance, Cutter shares territory with the appropriation that underpinned Bone Stone Shell, requiring Freeman to exercise his judgement on the source of his ready-mades that hold multiple

Wir könnten sagen, dass dies hier sechzig Gemälde sind - aber mein konzeptioneller Anspruch lautet, dass es sich hier nicht um Malerei handelt. Schließlich könnte das Loch auch bedeuten, dass es Anhänger sind. Es sind also sechzig Schmuckstücke. Ich würde zu viel preisgeben, wenn ich behauptete, es sei Malerei - und soweit ich das sehe, ohne etwas dabei zu gewinnen - es ist vielleicht ein konträrer Standpunkt, aber für mich ist in der angewandten Kunst das Konträre bisweilen politisch.[23]

Gefundenes

Ein Begleitwort zu „given" in Freemans Lexikon könnte „found", also gefunden, sein. 1998 schuf Freeman eine Arbeit mit dem Titel Weka Nest (S. 50). Die Wekaralle, ein einheimischer Vogel, ist von Natur aus neugierig und bekannt für ihre Liebe zu glänzenden Schätzen. Der Vogel weist einige Ähnlichkeiten mit dem inoffiziellen neuseeländischen Nationalvogel, dem Kiwi, auf – beide sind braun, flugunfähig und haben keinen Schwanz. Freeman fühlte eine Art Verwandtschaft zur Wekaralle, nicht nur aufgrund ihrer Neigung, Dinge zu durchstöbern, sondern auch aufgrund ihres Potenzials als alternatives Symbol nationaler Identität.

Der Kiwi ist das vorherrschende Symbol Neuseelands. Er wurde nicht nur als Spitzname für die Einwohner Neuseelands als Nationalvolk aufgegriffen, sondern steht abgesehen vom Namen auch für das Temperament eines Volkes (freundlich, entspannt). Die Namensgebung Kiwi hatte ihren Ursprung nicht in Neuseeland, sondern lässt sich zurückverfolgen bis zum Ersten Weltkrieg, als Spitzname für neuseeländische Soldaten. Als Bild und Name gehört er allen, wird für Sportmannschaften ebenso genutzt wie auf der Währung. Auch politisch wird er eingesetzt – Diskussionen über Migration und Rassismus bedienen sich oft des Vorwurfs, nicht Kiwi genug zu sein.

Freeman griff die Wekaralle als persönliches Symbol auf. Wie der Kiwi lässt sich auch die Wekaralle in einem umfassenderen Sinn begreifen,

Pendants
Weka Nest, 1998
Oxidised silver
Various dimensions

Anhänger
Weka Nest, 1998
Geschwärztes Silber
Verschiedene Maße

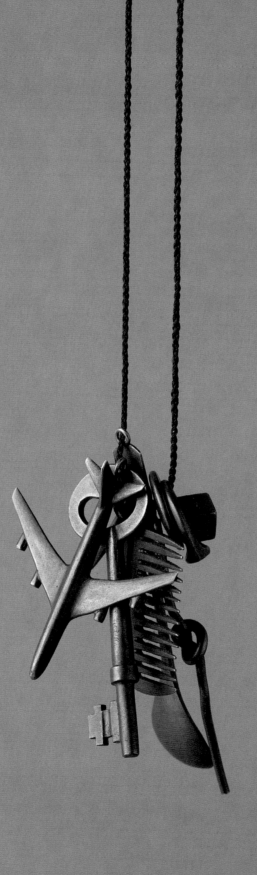

or divergent readings within their form. It can be an uneasy conflation.

In a 2015 interview with Kellie Riggs for Current Obsession, Freeman identified Cutter as a piece that tests the line of the given and the taken.[23] By acknowledging the influence of both sources, the work is situated in the lineage going back to the 1980s, but through its abstraction Freeman moves Cutter on. The work reminds us that no symbol – shape, form, motif – is neutral. Our influences are complex and, crucially, we each bear varied and intertwined strands of knowledge that for Freeman impact the work's making and how it is read.

Ngataringa Star (page 54), made in 1990, was one of Freeman's first stars. You bear the shape of it on your body. Purse together your thumbs and index fingers and hold them up to the light. Stars are everywhere, and along with the hook, heart, and circle they form some of Freeman's most enduring emblematic works. The star motif emerged in his practice in the late 1980s in the work Star Heart (1989; page 178), where it was attached to a scoria heart – another of Freeman's signature motifs of the period. Since this time, Freeman has continued to develop a project called 'I collect stars', where he finds readymade four-pointed star shapes in the natural and manmade environment, and which he sometimes fabricates into jewellery. Like the kiwi and the heart, the star's heavy use had rendered it a cliché, but Freeman finds potency in its commonness. A star is as familiar to us as the word – we know it, we can see it. In its material reimagining Freeman can rebuild its relevance, and even layer in new associations and meaning.

The first two stars in his collection were found in New York: Soft Star (1991; pages 54 and 187) has the same smooth-edged silhouette as a neon Miller beer sign, while Hard Star (1992; pages 54 and 186) is uplifted from the American Citibank logo. Both brooches illustrate Freeman's powers of abstraction. Soft Star is made of

es fehlt ihr jedoch an der prosaischen Anerkennung des Ersteren. 1988 schuf Freeman eine Reihe von Knöpfen mit der Aufschrift „Weka Brand" und verewigte das Symbol damit auf dem schlichtesten aller Schmuckelemente. In der Publikation Owner's Manual schrieb die Kunsthistorikerin Julie Ewington dazu:

> Männer tragen Knöpfe, das männliche Selbstverständnis erlaubt nur wenig Schmuck […]. Knöpfe versammeln sich in vergessenen Schubladen, faszinierende Überbleibsel eines vergangenen Lebens, mögliche Hinweise auf seine Geschichte. Seltsame Manschettenknöpfe, Knöpfe mit Markenzeichen, allfällige Erinnerungsstücke an Kadettenkorps und Kriege, individuelle Spielsteine der Konformität.[24]

Freemans Weka Nest (1998), eine Weiterführung des Weka-Themas, führt eine Gruppe von neun oxidierten Silberobjekten zusammen – einen Knopf, den Teil eines Kammes, einen Schlüssel, einen Löffel, einen Ring, ein Stück Draht, einen Spielwürfel, einen Reißnagel und ein Spielzeugflugzeug. Diese Ansammlung von Dingen interpretiert die Hierarchie von Objekten neu und setzt voraus, dass wir – würden wir uns bemühen, die Welt wie eine Wekaralle zu sehen – die alltäglichsten Gegenstände als faszinierend oder als Träger symbolischer Macht empfinden könnten.

Mit erfinderischer Neugier sammelt Freeman Ready-mades aus der ihn umgebenden Welt. Ein am Strand gefundener Stein, die Herzform in der Rundung eines Kawakawa-Blattes. Freeman sucht die Isotypen und die Ikonografie von Werbung und Verpackung – Gestalten und Formen, die sich sowohl in der Natur als auch in der menschlichen Welt wiederholen, sind für ihn nach wie vor eine ergiebige Quelle der Inspiration.

Aus dieser menschlichen Welt stammt sein origineller Anhänger Box (2009, S. 140-141), die Darstellung einer gefundenen abgeflachten Streichholzschachtel aus Jet. Ein Loch im mittleren Bereich der Oberseite des schwarzen Anhängers dient zum Durchfädeln der schwarzen geflochtenen

pearl shell and has curved 'points', rendering its appearance almost foamy. The elegant and striking Hard Star is a black brooch made from stainless steel with elongated points. Both works bear close resemblance in form to their templated sources and yet share almost nothing else in common. It is a confounding before and after – two corporate logos transformed as inimitably wearable jewellery.

Freeman's methods for returning to materials and emblematic forms have persisted. He has been smart (and lucky) enough to create a set of parameters for himself that have endured as working guides. Take the star, with all its sources: a child's drawing, the night sky, a beer sign, the garden, a corporate bank, the deep knowledge of Polynesian navigation. Each carries associations: some from the blink-and-you-miss-it moments of daily life, and others imbedded deeply in culture and the natural world. They are in turn abundant and productive. As Julie Ewington observes:

> Positive and negative work together, partners in obligatory relationships that admit both opposition and harmony. Flip-flop, back and forth. These transactions are compulsive, energetic and productive. A pattern is not merely another isolated decoration. Each gives birth to the next, Ngataringa Star begets Green Star, begets Pearl Pillow, begets Flower Star... Patterns amount, eventually, to entire lineages that express the society that uses them. Making depends on patterns. Patterns make us.[24]

The quotation 'share of sky', which Freeman used to title four solo exhibitions between 1989 and 1991, comes from Janet Frame's book The Carpathians (1988). In it, a character laments to a visitor from New York the lack of things happening in her small New Zealand town. She consoles herself by looking skyward and claiming her own 'fair share of sky.'[25] Freeman's Ngataringa Star (page 54), found within his own fingers and thumbs, sees him claiming his share

Kordel. Die Form weist eine anthropomorphe Eigenschaft auf, wirken doch die Seitenklappen der Schachtel wie Arme, die eng an den Körper gehalten werden. Die Regeln von Freemans „found"-Wortschatz sind sinnträchtig und verspielt. Er sammelt Sterne, Herzen und Gesichter.

Diese Gesichter finden sich in den Wurzeln von Bäumen, in den Wurzelkanälen eines gezogenen Pferdezahns oder in den Löchern eines vom Meer abgenutzten Steins. Im Laufe der vergangenen beiden Jahrzehnte hat der Kollege und Freund Otto Künzli das Spiel mitgemacht. Das aus Schildkrötenpanzer gefertigte Leaf Face (Blatt-Gesicht, 2004, S. 265) wurde durch ein Blatt angeregt, das Otto Künzli ihm zuschickte. Die große Mask (Maske, 2007, S. 174) bezieht sich auf das Stück eines Auspuffs, das Künzli in München auf der Straße fand und ihm ebenfalls schickte. Freemans strenger Auswahlprozess ist dabei bemerkenswert:

> Die Auswahl von Objekten, um daraus Schmuck zu machen – was kommt infrage und was nicht – ist kein exakter Prozess und es gibt jede Menge Zufälle. Oft finde ich etwas auf dem Fußweg. Aber es gibt Regeln. Im Grunde genommen sollte das gefundene Objekt, nach dem ich suche, einen Wiedererkennungswert besitzen, den ich nur beschreiben kann als etwas, das mit unserer tiefen Erinnerung zusammenhängt – verschiedene Formen, die eine Identität haben – einen Charakter, der sich als archetypisch bezeichnen ließe. Meine gefundenen Objekte stammen zumeist aus banalen Quellen. Aber ich lausche auf ein früheres Echo dieser Form. Bisweilen ist dieses Echo aus einem bestimmten Grund vertraut.[25]

Dieses Echo wird in einer Arbeit wie Cutter (Messer, 2010, S. 53) deutlich. Der Anhänger in Form einer Brustplatte besteht aus einem flachen Stück Jaspis und weist an der geraden oberen Kante zwei Löcher auf, durch die eine geflochtene Schnur gezogen wird. Ihr Ursprung ist das gefundene Mittelteil einer Taschentuchbox, der Teil, den man an den gestanzten Linien herausbricht, um

Pendant
Cutter, 2010
Jasper
5 × 10 cm
Warwick Freeman and
Die Neue Sammlung -
The Design Museum

Anhänger
Messer, 2010
Jaspis
5 × 10 cm
Warwick Freeman und
Die Neue Sammlung -
The Design Museum

THE LANGUAGE OF WARWICK FREEMAN

Brooch
Ngataringa Star, 1990
Pearl shell, paint
6 × 5.9 cm

Brosche
Ngataringa Stern, 1990
Perlmuschel, Farbe
6 × 5,9 cm

Notebook
Soft Star, Hard Star,
1990

Notizbuch
Weicher Stern, Harter
Stern, 1990

of sky too, and that is exactly what he has been doing ever since. From his place in Aotearoa, in the Pacific, he has simultaneously looked up and out and all around him, while keeping his head down firmly at the jewellery bench. He chose jewellery and he has remained loyal to it. Whatever the conceptual reasoning for a piece, whatever its depth of associations, or implied cleverness, Freeman has always demanded it be worn and seen in its own right. The singular startling joy of Freeman's language building is the door it opens for the wearer.

> I have had a working lifetime of seeing my work co-opted into people's lives. Badly worn – occasionally upside down. Whatever my precious conceptual imagination had intended for it – whatever the intended narrative I had attached to it, the owner often has other plans. Rather than feel bruised or abused mostly I get to feel the love.[26]

Dotted throughout Freeman's archive of personal writings are lists and manifestos. Beautiful, pointed writing that could fill a good book all on its own. This private archive documents Freeman over a fifty-year stretch making sense of his work and what motivates him. He writes about the wider world of craft and art, the everyday life that his jewellery belongs in, and the strange and wondrous emblematic language that he has formed. It seems fitting that Warwick Freeman should have the last word:

> Jewellery should, confer dignity, bestow beauty, arouse an erotic response, signal intent, protect the wearer, evoke anger, insult the intelligence, say something, lack ambition, offer certainty, fulfil desire, confront apathy, convey spirituality, make the wearer look foolish, reflect the spirit of the age, provide status, provoke annoyance, communicate willingness, emancipate the wearer, make a stand, show a zest for life, be indifferent to what others think, claim national significance, encourage daring, be geometric, be floppy…[27]

der Box Taschentücher entnehmen zu können. Dennoch stellt das frühere Echo eine Verbindung zu einer fidschianischen Brustplatte aus der Sammlung des Auckland Museum her, die Freeman sehr bewundert: Durch die Herstellung wurde die Austernschale zwei einfachen Aktivitäten unterworfen – es wurden zwei Löcher für die Schnur gebohrt und der Rand mit Sägezahnschnitten versehen. Auch Cutter weist diese einfachen Eingriffe auf. Der Anhänger hat einen flachen oberen Rand und ein gezahntes Rund. Die Zähne lassen eher an ein Werkzeug als an ein Schmuckobjekt denken.

Cutter ist ein Beleg für Freemans Methode zur Kennzeichnung eines Trägers – eine einfache gefundene Form muss eine tiefere Assoziation aufweisen, um der Überarbeitung würdig zu sein. Cutter gehört zum Themenbereich Aneignung, das Bone Stone Shell zugrunde lag. Dadurch war Freeman gezwungen, sein Urteil auf Grundlage seiner Ready-made-Thematik zu fällen, dass eine Form unterschiedliche Interpretationen zulässt. Das können auch schwierige Verbindungen sein.

In einem 2015 geführten Interview mit Kellie Riggs für Current Obsession identifizierte Freeman Cutter als ein Stück, das die Grundsätze von „given" und „taken" auslotet.[26] Durch die Anerkennung der Einflüsse beider Quellen wird die Arbeit in einer Abstammungslinie verwurzelt, die bis in die 1980er-Jahre zurückreicht, dank der Abstraktion geht Freeman mit Cutter jedoch noch weiter. Die Arbeit erinnert uns daran, dass kein Symbol – Gestalt, Form, Motiv – neutral ist. Die Einflüsse, denen wir alle unterliegen, sind komplex und jeder von uns verfügt über verschiedene und miteinander verflochtene Wissensstränge. Für Freeman kann es sich auf die Entstehung des Werks auswirken und auf die Art und Weise, wie es gelesen wird.

Stern

Ngataringa Star (Ngataringa Stern, S. 54) aus dem Jahr 1990 war einer von Freemans ersten Sternen. Seine Form tragen wir alle an unserem Körper. Man braucht bloß Daumen und Zeigefinger

Finger Star, 1990
Photo: Warwick Freeman

Finger-Stern, 1990
Foto: Warwick Freeman

aneinander zu pressen und sie gegen das Licht zu halten. Sterne sind überall, und zusammen mit Haken, Herz und Kreis bilden sie einige von Freemans beständigsten symbolischen Arbeiten. Das Stern-Motiv tauchte Ende der 1980er-Jahre in seinem Werk Star Heart (Stern Herz, 1989, S. 178) auf: Ein Stern ist an einem Herzen aus *scoria* (vulkanischer Schlacke) befestigt – ein weiteres von Freemans charakteristischen Motiven der Epoche. Seit dieser Zeit hat Freeman sein Projekt „I collect stars" (Ich sammle Sterne) weiterentwickelt, für das er in der Natur sowie in der vom Menschen geschaffenen Welt vierzackige Sternformen findet, und bisweilen in Schmuck einarbeitet. Wie der Kiwi und das Herz hat auch die intensive Nutzung des Sterns diesen zu einem Klischee gemacht, Freeman sieht jedoch gerade in seiner Häufigkeit eine starke Wirkung. Ein Stern ist uns ebenso vertraut wie das Wort – wir kennen ihn, wir können ihn sehen. In seiner materiellen Neuinterpretation kann Freeman dessen Relevanz nachformen und sie sogar in neuen Assoziationen und Bedeutungen einbauen.

Die ersten beiden Sterne seiner Sammlung fand er in New York: Soft Star (Weicher Stern, 1991, S. 54 und 187) weist die gleiche glattkantige Silhouette auf wie das neonfarbene Zeichen von Miller Beer, während Hard Star (Harter Stern, 1992, S. 54 und 186) vom Logo der American Citibank inspiriert ist. Beide Broschen illustrieren Freemans Abstraktionsvermögen. Soft Star besteht aus Perlmuschel und weist gerundete „Spitzen" auf, die die Arbeit fast wie Schaum erscheinen lassen. Bei Hard Star handelt es sich um eine schwarze Brosche von faszinierender Eleganz, die aus Edelstahl mit gelängten Spitzen besteht. Beide Arbeiten erinnern in ihrer Form stark an ihre Vorlagen, weisen ansonsten jedoch kaum Ähnlichkeiten auf. Es handelt sich um ein verwirrendes Vorher-Nachher – zwei Firmenlogos, die in einzigartigen, tragbaren Schmuck verwandelt wurden.

Freemans Methoden der Rückkehr zu Materialien und symbolhaften Formen haben sich bewährt. Er war klug genug (und hatte das Glück), eine Reihe von Parametern für sich selbst zu erschaffen,

die ihm bis heute als Leitfaden dienen. Man nehme nur den Stern mit all seinen Quellen: eine Kinderzeichnung, der nächtliche Himmel, ein Bierlogo, der Garten, eine Kommerzbank, das tief verwurzelte Wissen polynesischer Navigation. Jede einzelne bringt Assoziationen mit sich: die oft unbemerkten Augenblicke des alltäglichen Lebens, und andere, die tief in Kultur und Natur eingebettet sind. Sie sind wiederum im Überfluss vorhanden und produktiv. Wie Julie Ewington bemerkt:

> Positiv und negativ arbeiten zusammen, Verbündete in verbindlichen Beziehungen, die sowohl Widerstand als auch Harmonie zulassen. Hin und her, vor und zurück. Diese Transaktionen sind zwingend, energetisch und produktiv. Ein Muster ist nicht einfach nur eine weitere isolierte Dekoration. Jedes bringt das nächste hervor: Ngataringa Star [Ngataringa Stern] bringt Green Star [Grüner Stern] hervor, bringt Pearl Pillow [Perl-Kissen] hervor, bringt Flower Star [Blüten-Stern] hervor [...]. Muster [und Formen] münden schlussendlich in ganze Entwicklungslinien, die die Gesellschaft ausdrücken, die sie verwendet. Das Machen hängt von Mustern ab. Muster machen uns.[27]

Das Zitat „share of sky" („Teil vom Himmel"), das Freeman zwischen 1989 und 1991 als Titel für vier Einzelausstellungen benutzte, stammt aus Janet Frames Buch The Carpathians (1988). Darin beschwert sich eine Figur bei einer Besucherin aus New York darüber, dass in ihrer kleinen Stadt in Neuseeland nicht viel passiert. Sie tröstet sich selbst, indem sie in den Himmel blickt und ihren „gerechten Anteil am Himmel" einfordert.[28] Mit Ngataringa Star (S. 54), den er in seinen eigenen vier Fingern findet, fordert auch Freeman seinen Anteil am Himmel, und das ist genau das, was er immer schon getan hat. Von seinem Zuhause in Aotearoa Neuseeland, im Pazifik, hat er gleichzeitig hinauf und hinaus und um sich herum geblickt, während er seinen Kopf immer fest nach unten auf die Werkbank gerichtet hatte. Er wählte den Schmuck und blieb diesem immer treu. Was auch immer die konzeptuelle Begründung für ein Stück war, was auch immer die Tiefe der Assoziationen oder die angedeutete Gewandtheit, Freeman forderte stets, dass sein Schmuck getragen und für sich selbst gesehen wird. Die einzigartige und erstaunliche Freude an Freemans Sprachgebäuden ist die Türe, die sie Trägern öffnet.

> Ich hatte ein Arbeitsleben, um zu sehen, wie meine Arbeiten sich in die Leben der Menschen einfügten. Falsch getragen – gelegentlich verkehrt herum. Was auch immer meine kostbare konzeptionelle Vorstellung für sie vorgesehen hatte – was auch immer die beabsichtigte Erzählung war, die ich mit ihr verband, die Besitzer hatten oft andere Pläne. Anstatt mich verletzt oder missbraucht zu fühlen, kann ich die Liebe spüren.[29]

Verstreut in Freemans Archiv persönlicher Texte finden sich Listen und Manifeste. Wunderschöne, pointierte Texte, die alleine schon ein Buch füllen würden. Dieses private Archiv dokumentiert Freeman über eine Epoche von fünfzig Jahren, wie er seinen Arbeiten Sinn verleiht und was ihn motiviert. Er schreibt über die weite Welt von Kunsthandwerk und Kunst, vom alltäglichen Leben, von dem sein Schmuck Teil ist, und die seltsame und wunderbare symbolische Sprache, die er erschaffen hat. Es scheint nur angemessen, dass Warwick Freeman das letzte Wort hat:

> Schmuck sollte Würde verleihen, Schönheit schenken, erotische Gefühle wecken, Absichten signalisieren, die Träger beschützen, Ärger hervorrufen, die Intelligenz beleidigen, etwas aussagen, es an Ehrgeiz fehlen lassen, Sicherheit bieten, Sehnsüchte erfüllen, Apathie bekämpfen, Spiritualität beschwören, den Träger albern aussehen lassen, den Zeitgeist widerspiegeln, Status verleihen, Unmut provozieren, Bereitschaft vermitteln, den Träger emanzipieren, Widerstand leisten, Lebensfreude ausdrücken, gleichgültig der Meinung anderer gegenüber sein, nationale Bedeutung beanspruchen, Mut machen, geometrisch sein, „floppy" sein [...].[30]

DIE SPRACHE WARWICK FREEMANS

1
Damian Skinner, editor, Large Star / Rangitoto Heart: A Birthday Book in Honour of Warwick Freeman, published on the occasion of Warwick Freeman's 55th birthday, 5 January 2008. Rim Books, Auckland 2008, p. 2.

2
In an undated handwritten statement about his work Scallop Blossom (1994; page 133) in Warwick Freeman's Unpublished Commentary file, he describes the common means of the work: a particular place and souvenired materials, and the way a piece like Scallop Blossom has a sense of obviousness about it, 'a commonsense perhaps. It can leave the viewer with the feeling they've seen it before, even the feeling they could have thought of it themselves. It's in that gap of shared recognition I go looking for pieces like this.' The phrase 'common means' is borrowed from a quote Freeman admired by English sculptor Richard Long, who once said, 'I like common means given the simple twist of art.' The uncited source appears in a handwritten manifesto of sorts titled 'What Are You Doing Here?' in which Freeman defines the territory of contemporary jewellery in the following categories: Common Means, Found Materials, Common Shapes, and Jewellery 'after my own heart'. Warwick Freeman archive, Unpublished Commentary, Folder 1.

3
Warwick Freeman, letter to Paul Derrez, 5 April 1990. Warwick Freeman archive, Unpublished Commentary, Folder 1.

4
Warwick Freeman, notes prepared for The Dowse Art Museum in 1991 relating to his exhibition Share of Sky: Emblems 1985-90. Warwick Freeman archive, Unpublished Commentary, Folder 1.

5
Warwick Freeman, letter to Paul Derrez, 5 April 1990.

6
Warwick Freeman, notes prepared for The Dowse Art Museum in 1991 relating to his exhibition Share of Sky: Emblems 1985-90.

7
The poppy also symbolises the memory of those who died in the First and Second World Wars in England, Canada and France.

8
John Edgar, 'Bone Stone Shell.' Bone Stone Shell: New Jewellery New Zealand, edited by Geri Thomas. Crafts Council of New Zealand and Ministry of Foreign Affairs, 1988, unpaginated. Quoted in Damian Skinner, Given: Jewellery by Warwick Freeman. Starform, 2004, p. 16.

9
Warwick Freeman, handwritten document titled 'Museum.' Warwick Freeman archive, Unpublished Commentary, Folder 1.

10
Warwick Freeman, handwritten document describing his Paua Whitebait Necklace and Paua Layer Bracelet. Warwick Freeman archive, Unpublished Commentary, Folder 1.

1
Damian Skinner (Hg.), Large Star / Rangitoto Heart: A Birthday Book in Honour of Warwick Freeman, anlässlich des 55. Geburtstags von Warwick Freeman veröffentlicht, 5. Januar 2008, Auckland 2008, S. 2.

2
In einer undatierten, handschriftlichen Bemerkung zu seiner Arbeit Scallop Blossom (Jakobsmuschel-Blüte, 1994, S. 133) beschreibt Freeman die gewöhnlichen Mittel der Arbeit: ein bestimmter Ort und Erinnerungsstücke, und die Art und Weise, wie ein Stück wie Scallop Blossom ein Gefühl von Selbstverständlichkeit an sich hat, „vielleicht einen Allgemeinsatz. Es kann den Betrachter mit dem Gefühl zurücklassen, er habe es schon einmal gesehen, sogar das Gefühl, das hätte er sich auch selbst ausdenken können. In dieser Lücke gemeinschaftlicher Anerkennung suche ich nach solchen Dingen". Die Phrase „gewöhnliche Mittel" („common means") ist ein Zitat des englischen Bildhauers Richard Long, das Freeman gefiel. Dieses lautet: „Mir gefallen gewöhnliche Mittel mit dem einfachen Dreh der Kunst". Die nicht zitierte Quelle findet sich in einer Art von handschriftlichem Manifest mit dem Titel „What Are You Doing Here?", in dem Freeman das Territorium zeitgenössischen Schmucks in folgende Kategorien definiert: Gewöhnliche Mittel, Gefundene Materialien, Gewöhnliche Formen und Schmuck „ganz in meinem Sinn". Archiv Warwick Freeman, unveröffentlichte Kommentare, Mappe 1.

3
Warwick Freeman, Brief an Paul Derrez, 5.4.1990, Archiv Warwick Freeman, unveröffentlichte Kommentare, Mappe 1.

4
Schilderung der Verfasserin, Kim Paton, aus ihrer Jugend.

5
Warwick Freeman, Notizen für das Dowse Art Museum, 1991, zu seiner Ausstellung Share of Sky: Emblems 1985-90. Archiv Warwick Freeman, unveröffentlichte Kommentare, Mappe 1.

6
Freeman 1990 (wie Anm. 3).

7
Die Māori verwenden die Baumwurzel des Kohlbaums als Medizin, Nahrungs- und Süßungsmittel, zur Korbherstellung und als Angelschnüre.

8
Freeman 1991 (wie Anm. 5).

9
Die Mohnblume steht auch in England, Kanada und Frankreich für das Gedenken der im Ersten und Zweiten Weltkrieg Gefallenen.

10
In John Edgar, „Bone Stone Shell", in: Geri Thomas (Hg.), Bone Stone Shell: New Jewellery New Zealand, eine Ausstellung des New Zealand Ministry of Foreign Affairs zusammen mit dem Crafts Council of New Zealand. Inc., kuratiert von John Edgar, koordiniert von Raewyn Smith, o. S. Zit. n. Damian Skinner, Given: Jewellery by Warwick

11
Damian Skinner, Given: Jewellery by Warwick Freeman, p. 32.

12
A taonga is a treasure and is applied to anything considered to be of value, including socially or culturally valuable objects, resources, phenomena, ideas, and techniques. All translations of te reo Māori (Māori language) words in the footnotes are based on entries in Te Aka Māori Dictionary, https://maoridictionary.co.nz.

13
Warwick Freeman, transcript from a lecture titled 'Free Gift - The Responsibility of Influence', delivered to an audience in Amsterdam alongside his exhibition Free Gift at Galerie Ra, 2003. He showed the audience a slide of his work Tiki Face (1991; page 92), alongside a slide of a hei tiki in a museum collection and a plastic Air New Zealand tiki gifted to passengers in the 1970s. Freeman made the following comment: 'As a New Zealander I can no more exempt or disengage myself from this conversation than I can from any other and participate in the politics of being a New Zealander. The relationship is another "Free Gift" - it is both a privilege, but it also has a cost - to use this influence has a responsibility.' Warwick Freeman archive, Unpublished Commentary, Folder 2.

14
Alison Jones, This Pākehā Life: An Unsettled Memoir.

Freeman, Auckland 2004, S. 16.

11
Warwick Freeman, handschriftliches Dokument mit dem Titel „Museum". Archiv Warwick Freeman, unveröffentlichte Kommentare, Mappe 1.

12
Warwick Freeman, handschriftliches Dokument mit Beschreibung seines Paua Whitebait Necklace und seines Paua Layer Bracelet. Archiv Warwick Freeman, unveröffentlichte Kommentare, Mappe 1.

13
Skinner 2004 (wie Anm. 10), S. 32.

14
Als taonga werden Schätze im Sinne von gesellschaftlich oder kulturell wertvollen Objekten, Ressourcen, Ideen, Phänomenen oder Techniken bezeichnet. Alle Übersetzungen aus der māorischen Sprache oder te reo Māori in den Anmerkungen basieren auf Einträgen aus dem Onlinewörterbuch Te Aka Māori Dictionary (https://maoridictionary.co.nz).

15
Warwick Freeman, Transkription eines Vortrages mit dem Titel „Free Gift: The Responsibility of Influence," Amsterdam, im Rahmen seiner Ausstellung Free Gift (Kostenloses Geschenk) in der Galerie Ra, 2003. Er zeigte dem Publikum ein Dia seiner Arbeit Tiki Face (Tiki-Gesicht, 1991, S. 92) neben einem Dia eines hei tiki in einer Museumssammlung und einem tiki aus Plastik, das Air New Zealand seinen Passagieren in den

Bridget Williams Books, 2020, p. 8.

15
Ibid, p. 9.

16
Damian Skinner, Given: Jewellery by Warwick Freeman, p. 44.

17
Notes for Share of Sky: Emblems 1985-90, The Dowse Museum 1991.

18
Damian Skinner in Large Star / Rangitoto Heart: A Birthday Book in Honour of Warwick Freeman, p. 125.

19
Ibid.

20
Warwick Freeman, lecture transcript, 'All About Me.' Delivered at the invitation of Die Neue Sammlung - The Design Museum at the Pinakothek der Moderne, Munich, 10 March 2013. Warwick Freeman archive, Lectures Folder, p. 13.

21
Warwick Freeman, Patrick Reynolds, and Julie Ewington, Owner's Manual: Jewellery by Warwick Freeman. Starform, 1995, unpaginated.

22
Warwick Freeman, lecture transcript, 'All About Me,' p. 13.

23
Kellie Riggs, 'Distance from the Stars: An Interview with Warwick Freeman.' Current Obsession, issue 4, 2015, p. 91. https://www.current-obsession.com/distance-from-the-stars (2.12.2024).

24
Julie Ewington, 'Making Patterns.' Owner's Manual:

1970er-Jahren als Geschenk überreicht hatte. Freeman kommentierte: „Als Neuseeländer kann ich mich dieser Diskussion ebenso wenig entziehen oder mich davon lösen, wie von jeder anderen und mich an der Politik beteiligen, die das Neuseeländersein mit sich bringt. Die Beziehung ist ein weiteres ‚kostenloses Geschenk' - sie ist einerseits ein Privileg, ist andrerseits jedoch auch mit Kosten verbunden - diesen Einfluss zu nutzen, ist mit Verantwortung verbunden." Archiv Warwick Freeman, unveröffentlichte Kommentare, Mappe 2.

16
Alison Jones, This Pākehā Life: An Unsettled Memoir, Wellington 2020, S. 8.

17
Ebd., S. 9.

18
Skinner 2004 (wie Anm. 10), S. 44.

19
Freeman 1991 (wie Anm. 5).

20
Der Karaka-Baum ist auch als neuseeländischer Lorbeer bekannt.

21
Warwick Freeman in Skinner 2008 (wie Anm. 1), S. 125.

22
Ebd.

23
Warwick Freeman, Transkription des Vortrags „All About Me." Gehalten auf Einladung der Neuen Sammlung - The Design Museum in der Pinakothek der Moderne, München, 10.3.2013. Archiv Warwick Freeman, Mappe Vorträge, S. 13.

Jewellery by Warwick Freeman.

25
Janet Frame, The Carpathians. Century Hutchinson, 1988, p. 63.

26
Warwick Freeman, the final page of a handwritten manifesto from 2013 titled 'Poetry and Pragmatism.' Warwick Freeman archive, Unpublished Writing, Manifestos, Quotes, Commentary, Lists, Alphabets, Folder 2.

27
Warwick Freeman, handwritten manifesto 'Jewellery Should….' Warwick Freeman archive, Unpublished Writing, Manifestos, Quotes, Commentary, Lists, Alphabets, Folder 1.

24
Warwick Freeman, Patrick Reynolds, Julie Ewington, Owner's Manual: Jewellery by Warwick Freeman, Auckland 1995, o. S.

25
Freeman 2013 (wie Anm. 23), S. 13.

26
Kellie Riggs, „Distance from the Stars: An Interview with Warwick Freeman", in: Current Obsession, Nr. 4, 2015, S. 91, https://www.current-obsession.com/distance-from-the-stars/ (2.12.2024).

27
Julie Ewington, „Making Patterns", in: Freeman 1995 (wie Anm. 24).

28
Janet Frame, The Carpathians, Auckland 1988, S. 63.

29
Warwick Freeman, die letzte Seite eines handschriftlichen Manifests von 2013 mit dem Titel „Poetry and Pragmatism", unveröffentlichte Texte, Manifeste, Zitate, Kommentare, Listen, Alphabete, Mappe 2.

30
Warwick Freeman, handschriftliches Manifest „Jewellery Should…", Archiv Warwick Freeman, unveröffentlichte Texte, Manifeste, Zitate, Kommentare, Listen, Alphabete, Mappe 1.

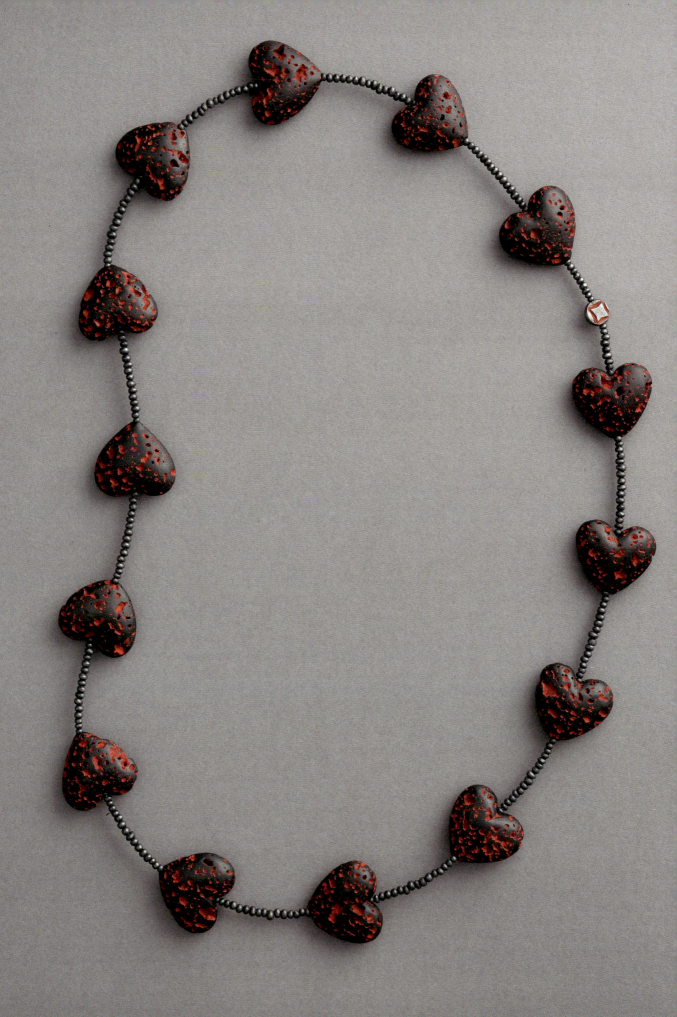

03
PORTALS OF POWER: A PSYCHOLOGY OF AUCKLAND VOLCANICS

GEOFF CHAPPLE

PORTALE DER MACHT: EINE PSYCHOLOGIE DES VULKANGESTEINS VON AUCKLAND
03

Necklace
Heart Lei, 1990
Scoria, paint, oxidised silver
Hearts: 2.8 × 3 cm
The Dowse Art Museum,
Lower Hutt, purchased 1993

Halsschmuck
Herzen-Kranz, 1990
Vulkanische Schlacke, Farbe,
geschwärztes Silber
Jedes Herz: 2,8 × 3 cm
The Dowse Art Museum,
Lower Hutt, erworben 1993

Personally, I like the presence of Auckland's hot spot, 90 kilometres down. I like that it corresponds in size to the city itself – huge, unknowable, utterly dark. I like that it can impose its terms upon Auckland, that from time to time it lets go a molten droplet, primed with sufficient volatiles to rise upwards at motorway speeds and severely shock the surface. That it can proceed from that explosive moment to build a great edifice, and finally cap that structure with its familiar dusty-red signature. The riddled red stone of the summits. The roughness of its touch.[1]

Such are my affections around Auckland's volcanics, prejudices even, and certainly it took me a while to find the kind of offbeat scholar who might confirm the majority of them, and venture new ones of his own. In 2015 I was writing a book on New Zealand's geology, Auckland came into the frame, and around the same time, by chance, I met Warwick Freeman. I pressed him on his interest in the local volcanic rock.

'Not the science of it,' he said, 'but the social thing. How people respond to the rock, and how they use the rock.'[2]

We ventured out next day to fossick on tidal flats at the foot of Mount Victoria, and I saw he was several steps ahead of my simple curiosity. We were looking for volcanic bombs,[3] or fragments of bombs, but back in the workshop he had a hydrochloric acid bath to dissolve the encrusted shell off these old volcanic ejecta, and the tools to turn them into useful adjuncts of vernacular architecture. Basalt drawer-pulls, or door handles, shapes that reified some larger, more obscure process – the insertion of volcanic rock into social settings. He had diamond saws to dissect the stone, and handed me a thin round of aerated basalt, as full of cellular holes as any crosscut vascular system. He backed and encircled those discs with silver, polished the faces of them with oil, and fitted them with clasps. If you wanted a direct material relationship with the volcanic landscape, then

Mir persönlich gefällt die Präsenz von Aucklands „Hot Spot", 90 Kilometer tief im Erdreich. Mir gefällt, dass er in seiner Größe der Stadt selbst entspricht – riesig, unerkennbar, in absoluter Dunkelheit. Mir gefällt, dass er Auckland seine Bedingungen aufzwingen kann, dass er von Zeit zu Zeit einen geschmolzenen Tropfen hervorbringt, ausgestattet mit ausreichend flüchtigen Bestandteilen, um mit Lichtgeschwindigkeit nach oben zu steigen und die Oberfläche massiv zu erschüttern. Dass er, ausgehend von diesem explosiven Momentum, ein großes Gefüge errichten kann, um es schließlich mit seiner vertrauten staubig roten Signatur zu krönen. Dem durchlöcherten roten Gestein der Gipfel. Mit der ganzen Rauheit seiner Berührung.[1]

Das sind meine Gedanken zu Aucklands Vulkangestein, Klischees vielleicht. Es hat eine ganze Weile gedauert, ehe ich jenen unkonventionellen Wissenschaftler ausfindig machen konnte, der den Großteil davon bestätigte und selbst noch ein paar eigene Gedanken dazu beitrug. 2015 schrieb ich ein Buch über die Geologie von Neuseeland, und Auckland kam ins Spiel – etwa um diese Zeit lernte ich zufällig Warwick Freeman kennen. Ich fragte ihn, was ihn am lokalen vulkanischen Gestein so interessiere.

„Nicht die Wissenschaft daran", sagte er, „sondern die soziale Komponente. Wie Menschen auf das Gestein reagieren und wie sie das Gestein einsetzen."[2]

Am folgenden Tag machten wir uns auf, um Wattflächen am Fuße des Mount Victoria zu erkunden, und ich erkannte, dass er meiner schlichten Neugier ein paar Schritte voraus war. Wir suchten nach vulkanischen Bomben,[3] oder Fragmenten von Bomben. Zurück in der Werkstatt löste er unter Einsatz eines Salzsäurebades die verkrustete Hülle von diesen alten vulkanischen Auswürfen. Dort hatte er auch das Werkzeug, um sie als nützliche Ergänzung traditioneller Innenarchitektur einzusetzen. Als Schubladen- oder Türgriffe aus Basalt sind es Formen, die einem größeren, unbestimmten Prozess Gestalt verleihen – die Eingliederung vulkanischen Gesteins

Torpedo Bay from
Devonport wharf,
Auckland, 1890
Courtesy of Torpedo
Bay Navy Museum,
Auckland

Torpedobucht vom
Devonport-Kai aus,
Auckland, 1890
Courtesy Torpedo Bay
Navy Museum, Auckland

Double Sphere Ring, 2019
Volcanic basalt,
oxidised silver
Sphere: 2.3 cm diameter;
band: 2.3 cm diameter

Doppelkugel-Ring, 2019
Vulkanischer Basalt,
geschwärztes Silber
Kugel: Dm. 2,3 cm,
Ringschiene: Dm. 2,3 cm

here it was in miniature – small but intense, an ornament, a brooch.

I judged him the right man to tackle the wider investigation, and we walked out of Devonport soon after, into the vexed arena of Auckland's psychogeography. We walked across a city marked everywhere by eruptive violence, trying to discern the influence of such widespread volcanic product. The buildings: this volcanic bluestone church, these hand-knapped basalt kerbstones. This high scoria wall the Central Police Station inflicts on the citizens below.

We walked across wide ground-level craters and the soft green rise of their tuff rings. We walked across the lava flows, invisible now under the built environment. We walked over the great cones that define whole suburbs: Maungawhau Mount Eden, the suburb so prettily arrayed around its eponymous cone that journeymen drinking soy lattes within cafés at the mountain's base often adopt the default description for Auckland's distinct volcanic locales – the perfidious, overly comfortable 'sense of place'. The psychogeography we were attempting was more – manic. We beheld in the cold stone mountains the intense blackbody radiation[4] of their progenitor, active and brooding far, far below. We tipped our hats to past uses of the mountains, admiring the astonishing physical labours of early Māori, who'd girdled the cones with defensive terraces, and piled stones to conserve heat in the gardens below. We recalled, within the demands of their own time, the city- and nation-building settlers who'd embedded water reservoirs in the summits, or stripped whole scoria cones for railway ballast or drainage ditches. We noted the contemporary Māori determination to hallow the summits, to return them to their past, to ban vehicles and dropkick exotic trees right off the slopes. Thus, the psychogeography of Auckland, its cones and vents, and the strong emotions they evoke – love, fear, greed, anger, indifference, resentment, respect.

in soziale Rahmenbedingungen (wie z.B. in der Archltektur). Er hatte Diamantsägen, um den Stein aufzuschneiden, und gab mir eine dünne Scheibe von mit Luftporen durchsetztem Basalt, so voll mit zellförmigen Löchern wie der Querschnitt durch irgendein Gefäßsystem. Er hinterlegte und rahmte diese Scheiben mit Silber, polierte ihre Oberflächen mit Öl und versah sie mit Schließen. Wenn man also auf der Suche nach einer direkten materiellen Beziehung zur vulkanischen Landschaft war, dann bekam man sie hier in Miniaturform – klein, aber verdichtet, ein Ornament, eine Brosche.

Ich hielt ihn für den richtigen Mann, um weitere Untersuchungen in Angriff zu nehmen, und bald darauf marschierten wir aus Devonport hinaus in die umstrittene Arena der Psychogeografie von Auckland. Wir gingen durch eine Stadt, die allerorten von eruptiver Gewalt geprägt ist, und versuchten, den Einfluss eines so weit verbreiteten vulkanischen Werkstoffs festzustellen. Die Bauten: diese vulkanische Kirche aus basaltischem Blaustein. Diese handgespaltenen Basaltbordsteine. Diese hohe Mauer aus *scoria* (vulkanischer Schlacke), die das zentrale Polizeirevier den Bürgern darunter zumutet.

Wir gingen über breite, ebenerdige Krater und über die sanften grünen Erhebungen ihrer Tuffsteinringe. Wir gingen über die Lavaflüsse, die unter der bebauten Umgebung heute nicht mehr zu sehen sind. Wir gingen über die riesigen Kegel, die ganze Außenbezirke definieren: Maungawhau Mount Eden, der Vorort, der sich so reizend um den gleichnamigen Kegel legt, dass Wanderer, die in den Cafés am Fuße des Berges ihre Sojalatte genießen, oft die Standardbeschreibung für Aucklands ausgeprägte vulkanische Schauplätze übernehmen – die hinterhältige Bequemlichkeit des Gefühls einer „Ortskenntnis". Die Psychogeografie, die wir anstrebten war eher manisch. In den kalten Steinbergen bemerkten wir die intensive Schwarzkörperstrahlung[4] ihres Ahnen, aktiv und brütend, weit weit unter uns. Wir zogen unseren Hut vor früheren Nutzungen der Berghänge, bewunderten die erstaunliche, alles abverlangende körperliche Arbeit der frühen Māori, die die Kegel

Volcanic rock is geology's only rock near vertical at its inception, and scoria – basaltic froth if you like – is more vertical yet. A wildly aspirant rock, emerging at speed, soaring high, then, in a comic-book cloud of puffs, losing upon the instant its volatile propellant. The CO_2, the fluorine, the sulphur, the H_2O gases, all flee. It's full of holes, falling, spent. This tiny Icarus.

'Spell scoria backwards,' said Warwick, as we walked finally through Ihumātao, out by Auckland's International Airport, around the stump of the Ōtuataua volcano, and across the adjacent stonefields. I tried and failed to come up with anything intelligible. 'A-I-R-O-C-S,' said Warwick. 'Air rocks.'

If scoria was to have a theme song, said Warwick, it'd be that Van Morrison anthem to love. The song that spells out the girlfriend's name letter by letter, G-L-O-R-I-A, and follows along with a thunderous chorus – GLORIA. A short step, then, to S-C-O-R-I-A and its suitably thunderous chorus. To say Warwick likes this rock is to seriously downplay the love affair he has with it. If you pressed him on the point, he'd say that scoria rocks, and that his various excursions with it are simply playful. Yet it's a commonplace that cities obscure their geography, and that technology in general diminishes the power of natural features. Part of Warwick's particular artisan's ju-jitsu suggests an underlying purpose, to use that muffling technology against itself, with an artisan's tools to unmuffle those natural features, and to offer them back, sliced and diced, for reappraisal.

It's a skilful endeavour, this attempt to do more than look at the volcanoes, but actually to see them. I once drove the Australian poet Les Murray to the top of Mount Victoria, gestured to the city that lay at our feet, and asked him what he made of Auckland. He was a hero of mine, high functioning, a borderline autistic, a seer of sorts. He looked past the city sprawl, past the yachts, past the Skytower, and delivered a big, bold, and basic judgement.

mit Wehrterrassen umschlossen und Steine aufgeschichtet hatten, um die Wärme für die darunter liegenden Gärten zu speichern. Wir erinnerten uns an die Siedler, die im Rahmen der Anforderungen ihrer eigenen Zeit, die Stadt und Nation errichteten und Wasserreservoirs in die Gipfel einließen, oder ganze Kegel aus vulkanischer Schlacke für Gleisschotter und Entwässerungsgräben abtrugen. Wir bemerkten die aktuelle Entschlossenheit der Māori, die Gipfel zu ehren, sie in ihre Vergangenheit zurückzuführen, Fahrzeuge zu verbieten und exotische Bäume von den Hängen zu verbannen. Das ist also die Psychogeografie von Auckland, seine Kegel und Schlote, und die starken Emotionen, die diese hervorrufen – Liebe, Angst, Gier, Wut, Gleichgültigkeit, Feindseligkeit, Respekt.

In der Geologie ist Vulkangestein die einzige Gesteinsart, die bei ihrer Entstehung beinahe senkrecht ist, und vulkanische Schlacke – Basaltschaum, wenn man so will – ist noch vertikaler. Ein ungeheuer aufstrebendes Gestein, das rasch entsteht, hoch aufsteigt und dann in einer comicartigen Rauchwolke augenblicklich seinen flüchtigen Treibstoff verliert. Das CO_2, das Fluor, der Schwefel, die H_2O-Gase, sie alle fliehen. Es ist von Löchern durchzogen, stürzt herab, ist erschöpft. Dieser winzige Ikarus.

„Buchstabiere ‚scoria' einmal rückwärts", forderte Warwick mich auf, als wir schließlich durch Ihumātao gingen, draußen beim Internationalen Flughafen von Auckland, rund um den Stumpf des Vulkans Ōtuataua, und über die angrenzenden Steinfelder. Ich versuchte es, kam jedoch auf keine vernünftige Lösung. „A-I-R-O-C-S", sagte Warwick. „Air rocks – Luftgestein."

Hätte *scoria,* also vulkanische Schlacke, eine Erkennungsmelodie, so Warwick, dann wäre es Van Morrisons Hymne an die Liebe. Das Lied, das den Namen der Freundin buchstabiert, Buchstabe für Buchstabe, G-L-O-R-I-A, gefolgt von einem donnernden Chor – GLORIA. Ein kleiner Schritt, dann, auf S-C-O-R-I-A, und seinen ebenso donnernden Refrain. Zu behaupten, Warwick mag

'It's been boiling like a pot of old porridge.'
Was boiling, will boil again, some time or another. Meantime, long live whatever shrines we raise to the astonishing volcanic landscape we live in, and what's that brooch you've got pinned to your chest? Well, you know, it's a small volcano, in the instant of its eruption.

1
Originally published by Objectspace in 2018 on the occasion of Warwick Freeman's In Praise of Volcanoes, an installation commissioned for the gallery's outdoor exhibition space.

2
Conversation between Warwick Freeman and the writer, 2015.

3
Volcanic bombs are ejected high into the air, often red hot and malleable during eruptions. As they cool they often retain the fluid shapes of that initial ejection.

4
Blackbody radiation is dependent on temperature. Magma and lava usually have a temperature range between 700-1,400 Celsius, a high blackbody range that places them at the hot end of thermal radiation, spilling from the infra-red to the visible spectrum as a red-hot fluid force that can create new landforms.

1
Der Text wurde ursprünglich 2018 von Objectspace veröffentlicht, anlässlich von Warwick Freemans In Praise of Volcanoes, einer Installation und Auftragsarbeit für den Außenbereich der Galerie.

2
Im Text nicht extra ausgewiesene Zitate entstammen verschiedenen Erinnerungsprotokollen des Verfassers aus dem Jahr 2015.

3
Vulkanische Bomben werden bei Eruptionen hoch in die Luft geschleudert, oft glühend heiß und verformbar. Wenn sie abkühlen, behalten sie oft die flüssige Form des ursprünglichen Auswurfs.

4
Unter Schwarzkörperstrahlung versteht man die Wärmestrahlung eines Schwarzen (idealisierten) Körpers, d. h. die Strahlung eines Körpers, der alle Strahlen absorbiert.

diesen Stein, wäre eine ernsthafte Verharmlosung der Liebesbeziehung, die er mit diesem unterhält. Würde man ihn darauf ansprechen, würde er wohl sagen, dass die vulkanische Schlacke, und seine unzähligen Versuche damit, einfach nur Spielerei seien. Dennoch ist es eine Binsenwahrheit, dass Städte ihre Geografie verschleiern, und dass Technologie im Allgemeinen die Macht natürlicher Merkmale mindert. Ein Teil von Warwicks besonderem Künstler-Jiu-Jitsu deutet auf seine Absicht hin, diese Technologie mit den Mitteln des Künstlers gegen sich selbst einzusetzen, um die natürlichen Eigenschaften zu stärken, und sie – feinsäuberlich sortiert und ausgewertet – zu einer neuen Beurteilung vorzulegen.

Es ist ein komplexes Unterfangen, dieser Versuch, die Vulkane nicht nur anzuschauen, sondern sie tatsächlich zu sehen. Einmal begleitete ich den australischen Dichter Les Murray auf den Gipfel des Mount Victoria, wies auf die Stadt, die uns zu Füßen lag und fragte ihn, was er von Auckland halte. Er war einer meiner Helden, hochbegabt, ein Borderline-Autist, eine Art von Seher. Er blickte über die sich ausbreitende Stadt, über die Yachten, über den Sky Tower, und bot mir dann eine große, gewagte und grundlegende Beurteilung:

„Es brodelt wie ein Topf mit altem Porridge."

Hat gebrodelt, wird wieder brodeln, früher oder später. Bis dahin mögen all die Heiligtümer erhalten bleiben, die wir für die staunenswerte vulkanische Landschaften errichten, in der wir leben. Und was ist das für eine Brosche da, an deiner Brust? Ach weißt du, das ist ein kleiner Vulkan, im Augenblick seines Ausbruchs.

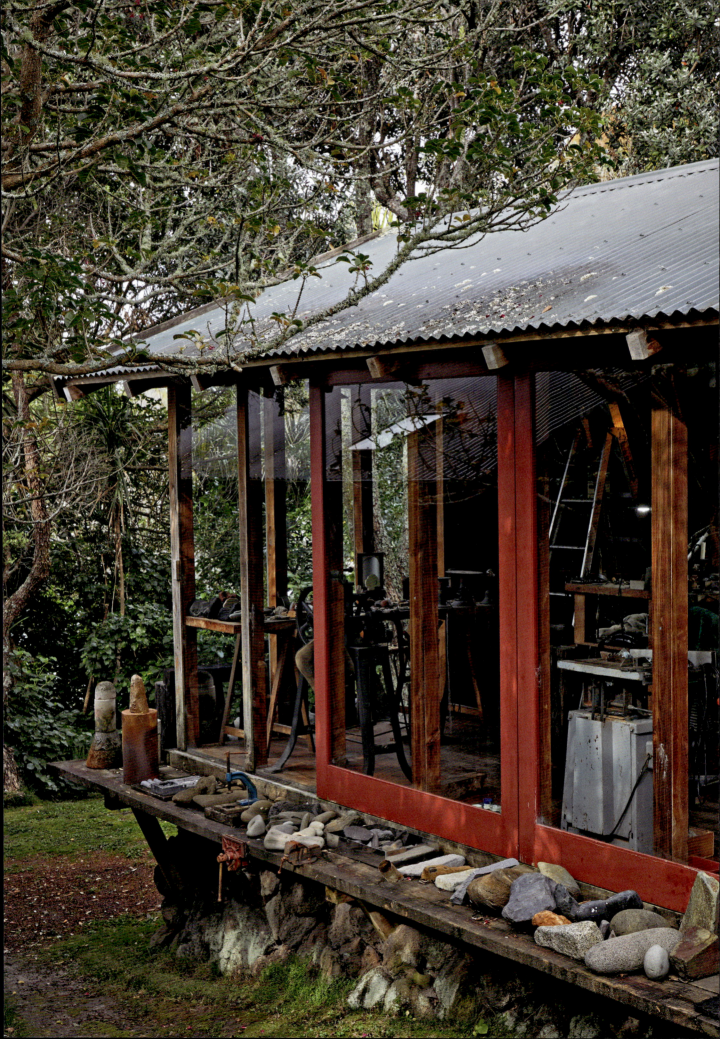

04
THE WORKSHOP: A MEMOIR

WARWICK FREEMAN

ERINNERUNGEN AN MEINE WERKSTATT 04

Biting the hand

It begins in the bay where the workshop was located.
Ngataringa Bay, sometimes spelled Ngautaringa Bay.
'Ringa' meaning hand. Possibly named for the narrow headlands that project into the bay like the fingers on a hand. Or once did. Today the spaces between the fingers have been filled in by large areas of reclaimed land. Some as a rubbish tip (since closed and now a park) and others for storage and training facilities of the New Zealand Navy.

One more likely naming story, one that relates to the Ngautaringa spelling – ngau, to bite; ringa, hand – is that it was the place where a precocious child bit the hand of a Māori rangatira (chief); an act that violated his mana (prestige) and would have put the child's fate in question.[1]

Recently I saw an imagined depiction of the child in a painting by New Zealand artist Tony Fomison. The painting was titled Ngauteringaringa (page 73). Fomison's painting depicted the child with his tongue poking out and his thumb against the side of his head in that classic childhood 'stuff you' gesture. We don't know what happened to the child. But we do know about the later offences commited in the bay; the reclamation, the toxic discharges from both the Navy's industrial activities and the rubbish dump that continues to leak, poisoning the remaining mangrove estuary.

Ngataringa Bay is where Nat and I and our family lived for forty-seven years. Before the reclamation, the sea would have lapped at our property's boundary. My workshop would have been 20 metres from the high-tide mark. I built it. It was a long, thin, gabled building measuring 10 × 4 metres. It answered to more than one vernacular architectural source: its heavy barge boards resembled the amo[2] of the wharenui, the Māori meeting house; the sliding

ERINNERUNGEN AN MEINE WERKSTATT

Tony Fomison (1939-1990)
Ngauteringaringa, 1980
Oil paint, jute,
particle board
19.2 × 14.3 cm
Courtesy of the
Tony Fomison Estate

Tony Fomison (1939-1990)
Ngauteringaringa, 1980
Ölfarbe, Jute,
Spanplatten
19,2 × 14,3 cm
Courtesy Tony Fomison
Estate

Ngataringa Bay
workshop, 2019
Photo: Sam Hartnett

Werkstatt an der
Ngataringa Bay, 2019
Foto: Sam Hartnett

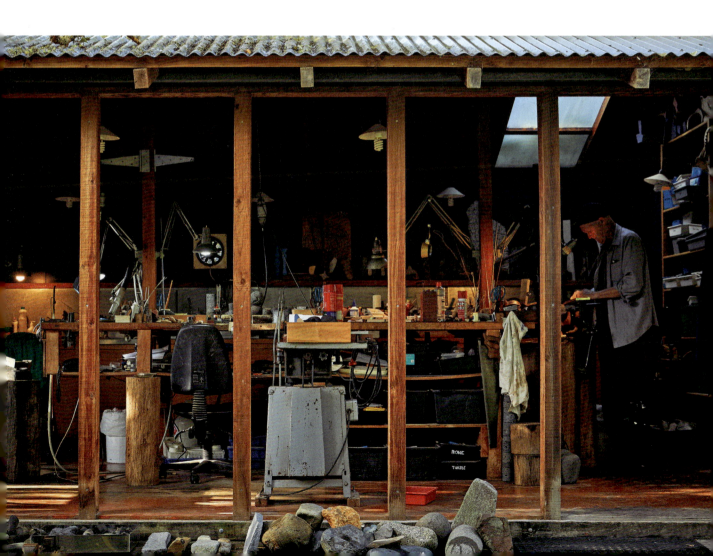

barn-style doors and corrugated-iron exterior, the New Zealand rural farm shed; and it had a touch of Japanese with its post-and-beam construction and narrow verandah (engawa). I attached my jeweller's bench to its central poles.

Serendipity

I had come to this workshop-based method of working in the 1970s. As a practice it took its permission from the international contemporary craft movement, but in the early 1970s in New Zealand it was also informed by a hippy ethos, the ethos of self-sufficiency – making a living from one's hands was an asset to this lifestyle. That ethos also promoted self-teaching. Besides, in the 1970s training institutions didn't exist in New Zealand and there were very few workshops I could have approached to learn contemporary jewellery making. And as I had no long-term commitment to the craft, I wouldn't have chosen either of those options anyway.

So, with a little knowledge I had garnered from an old school-friend about jewellery making, I gathered tools and skills around me, making myself up as a craftsman jeweller, whatever those times said that should look like. I was also harbouring an artistic instinct that I knew had to go somewhere; that sense of necessity was in me, I knew its weight, but I never thought jewellery had big enough shoulders.

The beginning of that understanding didn't come until ten years later, when goldsmith and professor at the Akademie der Bildenden Künst in Munich, Hermann Jünger, visited New Zealand in 1982. At a workshop he held in Nelson, organised by the Goethe-Institut and the Queen Elizabeth II Arts Council, I heard the language of making. It was being used by Jünger to describe making jewellery, but it had a resonance that I understood could be applied to any art making – a call and response between the mind and the hands. Jünger's own work, and the images he showed of his students'

Seine schweren Ortgänge am Dach[3] ähnelten den *amo*[4] der māorischen Gemeinschaftshäuser (*wharenui*), die Schiebetüren im Scheunenstil und die Wellblechfassade ließen an den Schuppen eines neuseeländischen Bauernhofs denken, und die Holzskelettbauweise mitsamt der schmalen Veranda (*engawa*) verliehen der Konstruktion einen Hauch von Japan. An ihren Mittelpfosten brachte ich mein Werkbrett an.

Glücklicher Zufall

Zu der werkstattbasierten Arbeitsweise war ich in den 1970er-Jahren gekommen. Sie verdankte ihre praktische Daseinsberechtigung der damaligen internationalen Kunsthandwerkbewegung, war im Neuseeland der frühen 1970er-Jahre aber auch von einem Hippie-Ethos geprägt, dem Ethos der Autarkie: Mit den eigenen Händen seinen Lebensunterhalt zu verdienen, war ein Vorzug dieses Lebensstils. Dasselbe Ethos förderte auch den Autodidakten in mir. Außerdem gab es in den 1970er-Jahren in Neuseeland keine Ausbildungseinrichtungen und nur sehr wenige Werkstätten, in denen ich hätte lernen können, wie man zeitgenössischen Schmuck herstellt. Doch weil ich mich nicht langfristig auf das Handwerk festlegen wollte, hätte ich ohnehin keine dieser Möglichkeiten gewählt.

Mit ein wenig Wissen über die Schmuckherstellung, das ich einem alten Schulfreund verdankte, versammelte ich also Werkzeuge und Fertigkeiten um mich und erklärte mich zum Schmuckhandwerker, wie auch immer das damals auszusehen hatte. Außerdem hegte ich eine künstlerische Begabung, von der ich wusste, dass sie irgendwo hin musste; dieses Gefühl von Notwendigkeit lag wie ein schweres Gewicht auf meinen Schultern, und ich glaubte nicht daran, dass Schmuck mir diese Last von den Schultern nehmen könnte.

Das begann sich erst zehn Jahre später zu ändern, als Hermann Jünger, Goldschmied und Professor an der Akademie der Bildenden Künste München, 1982 Neuseeland besuchte. In einem vom Goethe-Institut und dem Queen Elizabeth II Arts Council

work, took me over a line of understanding – jewellery's shoulders were big enough.

Contemporary craft was at a stage of development in the later part of the twentieth century that saw it making forays into contemporary art practice. It was trying to shed much of its traditional artisan history and utility as a decorative art so it might gain notice as a contemporary art practice. At the end of the 1980s I read a text by British craft writer Peter Dormer, in which he said: 'The irrelevance of craft work has caused it to mutate from being the livelihood of working-class artisans into an activity of self-expression for middle-class aesthetes and quasi artists.'[3]

That's me, I thought, as I prepared to leave for my first exhibition with Paul Derrez at Galerie Ra in Amsterdam. In the early 1970s I had chosen craft over art because in the hippy era, when I started, there was some vague suggestion that craft was a useful activity that could be practised as necessity, a craftsman making things that people need to live with. But by the end of the 1980s I had already altered my making practice to one more like that of Dormer's 'quasi artists'. The exhibition with Galerie Ra happened because I was in an exhibition in Australia and my exhibition piece was purchased by the National Gallery of Australia. It was seen there by Galerie Ra's director Paul Derrez during a visit in 1988. Jünger, and now Derrez; serendipity was already an active partner in my workshop practice.

The exhibition in Amsterdam was called Share of Sky, named for an image I had made of my forefingers and thumbs creating a small four-pointed star at my fingertips, pointed at the sky over Ngataringa Bay. My share of sky (page 56).

I made many four-pointed star works for that exhibition. In the years after, the four-pointed star became a signature – it recurred in diverse forms and different materials. I began to collect images of four-pointed stars.

organisierten Seminar, das er in Nelson gab, hörte ich die Sprache des Machens. Sie wurde von Jünger verwendet, um das Schmuckmachen zu beschreiben, doch in meinen Ohren klang es so, als könnte sie auf jede Form des Kunstschaffens angewandt werden – ein Frage- und Antwortspiel zwischen Hirn und Hand. Jüngers eigenes Werk und die Bilder, die er von den Arbeiten seiner Schüler zeigte, öffneten mir die Augen: Schmuck konnte das Gewicht tragen.

Das zeitgenössische Kunsthandwerk erreichte im späteren 20. Jahrhundert ein Stadium, in dem es zunehmend in die Kunst der Gegenwart eindrang. Es versuchte einen Großteil seiner traditionellen handwerklichen Geschichte und seines Nutzens als angewandte Kunst abzustreifen, um als zeitgenössische Kunst wahrgenommen zu werden. Ende der 1980er-Jahre las ich einen Text des britischen Autors und Kunsthandwerkexperten Peter Dormer, der darin schrieb: „Die Belanglosigkeit des Kunsthandwerks hat dazu geführt, dass aus der Lebensgrundlage von Handwerkern aus der Arbeiterklasse ein Mittel der Selbstdarstellung für Mittelschichtästheten und Quasikünstler geworden ist."[5]

Das bin ich, dachte ich, während ich mich auf die Abreise zu meiner ersten Ausstellung bei Paul Derrez in der Galerie Ra in Amsterdam vorbereitete. Anfang der 1970er-Jahre hatte ich das Kunsthandwerk der Kunst vorgezogen. In der Hippie-Ära bekam ich eine vage Vorstellung davon, dass das kunsthandwerkliche Arbeiten eine sinnvolle und notwendige Tätigkeit war. Bis zum Ende der 1980er-Jahre hatte sich meine Schaffenspraxis längst so weit verändert, dass sie eher derjenigen von Dormers „Quasikünstlern" glich. Die Präsentation in der Galerie Ra fand statt, weil ich in einer Ausstellung in Australien vertreten gewesen war und die National Gallery of Australia mein Werk erworben hatte. Dort sah es der Leiter der Galerie, Paul Derrez, während eines Besuchs im Jahr 1988. Erst Hermann Jünger – und jetzt Paul Derrez: Der glückliche Zufall spielte in meiner Werkstattarbeit schon damals eine aktive Rolle. Die Ausstellung in Amsterdam hieß Share of Sky

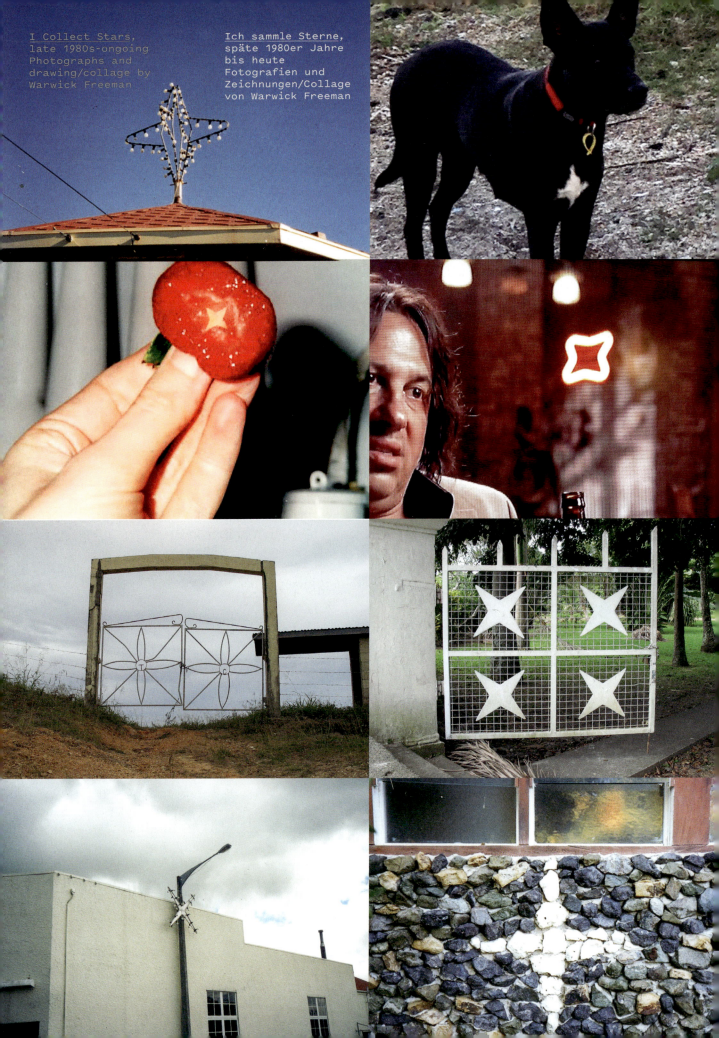

I Collect Stars, late 1980s-ongoing
Photographs and drawing/collage by Warwick Freeman

Ich sammle Sterne, späte 1980er Jahre bis heute
Fotografien und Zeichnungen/Collage von Warwick Freeman

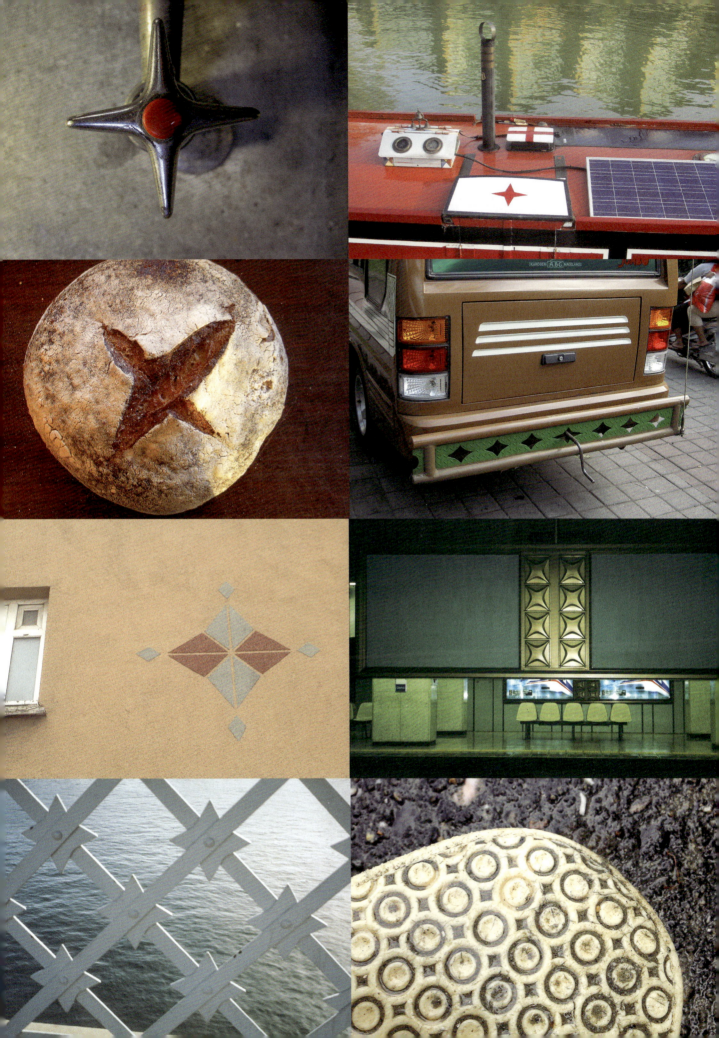

Left: Adze, Ngataringa Bay workshop, 2019
Photo: Sam Hartnett

Links: Adze (Spaltwerkzeug) aus der Werkstatt an der Ngataringa Bay, 2019
Foto: Sam Hartnett

Below left: Midden, Ngataringa Bay workshop, 2019
Photo: Warwick Freeman

Unten links: Müllgrube, Werkstattgelände an der Ngataringa Bay, 2019
Foto: Warwick Freeman

Pin
Garden Star, 2004
Pearl shell
3 × 3 cm
The Rotasa Collection Trust, San Francisco

Nadel
Garten-Stern, 2004
Perlmuschel
3 × 3 cm
The Rotasa Collection Trust, San Francisco

A layered life

But back to the workshop's beginnings in the bay. Before the settlement had a rubbish dump, the early residents of our house dealt with their refuse in the only way available – items no longer of any use were buried on the property where they lived. The excavation for the workshop foundations uncovered layers of rubbish from the earlier occupants. Archaeologists call these middens. Most of the midden I dug into consisted of the discarded material from the early-twentieth-century occupants. It was rubbish buried by the people that built and lived in the house my family and I now lived in.

One layer yielded items of an even earlier occupant of the property: a Māori stone adze, and a piece of obsidian that would have been used for making cutting blades (page 78). Both were discarded as rubbish because the introduction of iron by European colonists had made them redundant.

Over the years we lived there we left our own layers on the land. Newer middens of occupation. I buried the refuse from my own workshop, the off-cuts of stone and shell and the failed pieces. In doing so I added another layer to the land's archaeological record – a twentieth-century New Zealand contemporary jeweller worked here.

Once when I was digging the garden outside the workshop, I dug into a midden I had buried ten years earlier. From it I unearthed the remnant off-cut of an old work: a pearl-shell star shape cut from the centre of Soft Star (page 187). Discarded at the time, it was now transformed by its time underground – the edges had softened and coloured. I made a new four-pointed star work (page 78).

The household compost bin was another kind of midden. One day when the bin was broken up, dozens of chicken-wing bones tumbled out with the friable composted material. Still intact but

(Teil vom Himmel). Sie war nach einem Bild benannt, auf dem ich mit den Fingerspitzen von Daumen und Zeigefingern einen kleinen vierzackigen Stern geformt hatte, der auf den Himmel über der Ngataringa Bay deutete. Mein Teil vom Himmel (S. 56).

Für die Ausstellung schuf ich eine ganze Reihe von vierzackigen Sternen. In den Jahren darauf wurde der vierzackige Stern zu meinem Markenzeichen – er wiederholte sich in verschiedenen Formen und Materialien. Ich begann Bilder von vierzackigen Sternen zu sammeln.

Ein Leben in Schichten

Aber zurück zu den Anfängen der Werkstatt in der Ngataringa Bucht. Bevor die Siedlung eine Müllkippe bekam, behandelten die früheren Bewohner unseres Hauses ihren Abfall auf die einzig vorhandene Weise – was nicht mehr von Nutzen war, vergruben sie auf ihrem Grundstück. Bei den Erdarbeiten für die Werkstattfundamente wurden ihre Abfälle schichtweise ans Licht geholt. Archäologen sprechen von Müllgruben. Ein Großteil der Müllgrube, die ich aushub, bestand aus Material, das die Bewohner aus dem frühen 20. Jahrhundert weggeworfen hatten. Dieser Müll war von Menschen vergraben worden, die das Haus gebaut und bewohnt hatten, in dem meine Familie und ich jetzt lebten.

In einer Schicht kamen Gegenstände zum Vorschein, die einem noch früheren Bewohner des Areals gehört hatten: ein māorisches Querbeil mit Steinklinge und ein Stück Obsidian, das für die Klingenherstellung verwendet wurde (S. 78). Beide wanderten auf den Müll, weil das von den europäischen Kolonisten eingeführte Eisen sie überflüssig gemacht hatte.

Über die Jahre, die wir dort lebten, hinterließen wir auf dem Grundstück unsere eigenen Schichten. Neuere Müllgruben der Inbesitznahme. Ich vergrub die Abfälle aus meiner Werkstatt, den Verschnitt von Steinen und Muscheln und die misslungenen Stücke. Auf diese Weise fügte ich dem archäologischen Gedächtnis des

stained brown from being in the earth. I made a beaded necklace of bird bones (page 81).

Inside, the workshop was accumulating its own layers. The empty benchtops had become layered with my work sketches. My system of sketching three-dimensionally, sometimes in a soft material like wood, but also sometimes in stone, produces many small objects: sometimes gestural and only vaguely suggestive of a finished piece, sometimes almost completely realised.

As a friend once told me, sometimes we make things to see what they look like after they have been made. An inefficient process, but it was the way I worked.

The sketches accumulate. Taking up bench space, one idea blending with another, their boundaries confused by the confined space. Eventually the constraints of space mean these layers of experimentation are swept off to make more room. Some into a bucket and then outside to become another midden, some put in a box, labelled with the name of the piece and put in a drawer and closed like one would a sketch book of working drawings.

The music producer Rick Rubin, writing on creativity, produced a list of aphorisms called 'thoughts not conducive to work.' Amongst them he writes 'never finishing projects.'[14]

My workshop is littered with the 'never finished'. There are many reasons for the work to stop. Material failure looms largest, but sometimes it's a failure of belonging. I make most of my pieces as editions. Not large editions, usually fewer than ten, sometimes only one or two. This means each piece has a reference to other works in the edition. They are never the same, variations inherent in the handmaking process cause differences, though usually it's the variations in the colour and nature of the material that create difference. But they all must answer to the same criteria in a lineup. They can be different, but not better or worse.

Landes eine weitere Schicht hinzu – hier hat ein neuseeländischer Goldschmied im 20. Jahrhundert zeitgenössischen Schmuck hergestellt.

Einmal, als ich den Garten vor der Werkstatt umgrub, stieß ich auf eine Müllgrube, die ich zehn Jahre zuvor angelegt hatte. Daraus förderte ich den übrig gebliebenen Rest einer alten Arbeit zutage: einen aus der Mitte von Soft Star (Weicher Stern, S. 187) herausgeschnittenen Stern aus Perlmutt. Damals für unbrauchbar befunden, hatte die Zeit unter der Erde ihn verändert – die Kanten waren weich und farbig geworden.

So wurde aus dem vierzackigen Stern ein neues Schmuckstück (S. 78).

Unser Kompostbehälter für den Haushalt war eine andere Art von Müllgrube. Als er eines Tages aufgebrochen wurde, purzelten mit der krümeligen Komposterde auch Dutzende von Hühnerflügelknochen heraus. Noch unversehrt, aber von der Erde braun gebeizt. Die Vogelknochen wurden zu einem Halsschmuck (S. 81).

Im Inneren sammelte die Werkstatt ihre eigenen Schichten an. Auf den leeren Werkflächen stapelten sich meine Arbeitsskizzen. Mein System des dreidimensionalen Skizzierens, manchmal in einem weichen Material wie Holz, manchmal aber auch in Stein, erzeugt viele kleine Objekte: mal gestisch und nur vage ein fertiges Stück andeutend, mal fast vollständig umgesetzt.

Wie ein Freund mir einmal sagte, stellen wir manchmal Dinge her, um herauszufinden, wie sie aussehen, nachdem sie hergestellt wurden. Ein ineffizientes Verfahren, aber so habe ich gearbeitet.

Skizzen häufen sich. Brauchen Platz auf dem Werkbrett, während eine Idee in die andere übergeht und ihre Grenzen durch den beengten Raum verschwimmen. Irgendwann führen die räumlichen Engpässe so weit, dass die Schichten des Experimentierens abgeräumt werden müssen, um neuen Platz zu schaffen. Einige wandern in einen Eimer und anschließend nach draußen,

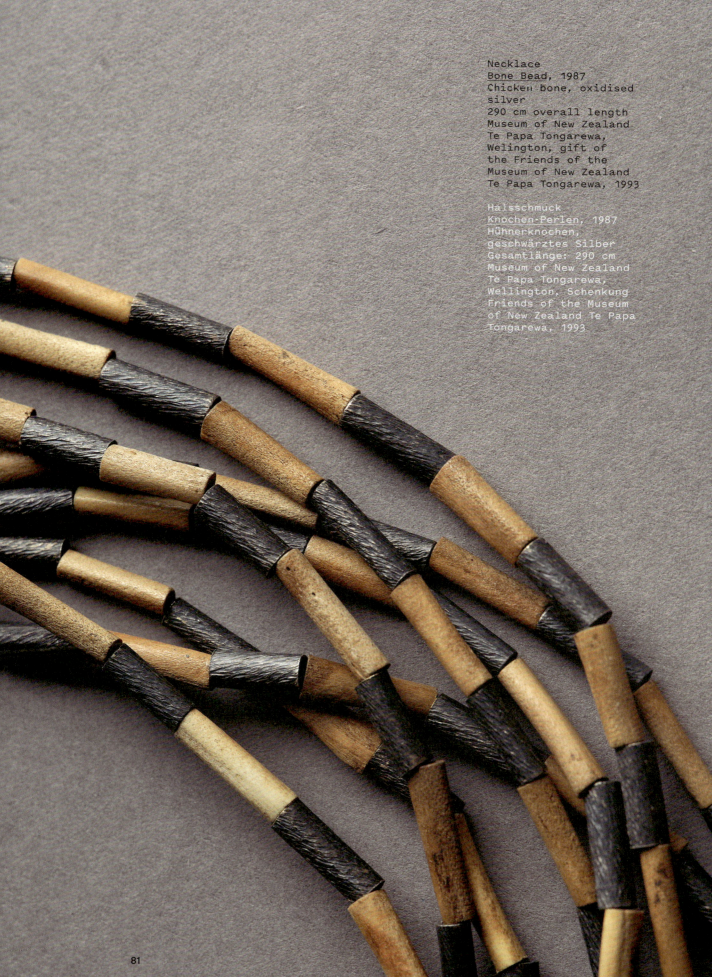

Necklace
Bone Bead, 1987
Chicken bone, oxidised silver
290 cm overall length
Museum of New Zealand
Te Papa Tongarewa,
Welington, gift of
the Friends of the
Museum of New Zealand
Te Papa Tongarewa, 1993

Halsschmuck
Knochen-Perlen, 1987
Hühnerknochen,
geschwärztes Silber
Gesamtlänge: 290 cm
Museum of New Zealand
Te Papa Tongarewa,
Wellington, Schenkung
Friends of the Museum
of New Zealand Te Papa
Tongarewa, 1993

Left: Metal templates
Photo: Sam Hartnett

Links: Metallschablonen
Foto: Sam Hartnett

Below left: Drawing
Karaka Leaf, 1998
Karaka leaf, paper, ink, graphite
59.4 × 42 cm
Photo: Sam Hartnett

Unten links: Zeichnung
Karaka-Blatt, 1998
Karaka-Blatt, Papier, Tinte, Grafit
59,4 × 42 cm
Foto: Sam Hartnett

Below right: Installation
Dust, 2011
Plywood, synthetic, natural and metallic dusts, binder
100 × 120 cm

Unten rechts: Installation
Staub, 2011
Sperrholz, synthetischer, natürlicher und metallischer Staub, Bindemittel
100 × 120 cm

To ensure consistency over an edition I make a template for each work. Sometimes the templates grow on the trees outside my workshop. For two works I just picked their leaves and drew around them.

The workshop makes dust. Layers of it. Dust from wood, metal, stone, plastic, and many more materials. I collected the dust from each material, for no reason, until, in 2011, I made a record of the materials (over sixty) I had used to make jewellery by mixing the dust of each with a binder and painting it onto a small rectangle of wood (pages 82 and 208). Then arranged them on the wall in a way that is reminiscent of a sample rack of laminates in a hardware store. But also – because of the hole they were suspended from – possibly pendants.

Tools

The materials and the sketches share space with the basic tech needed to shape them. The traditional cut-away jeweller's bench with its hammers and hand tools. A diamond saw and disc laps for hard stones. A drill press and bandsaw for softer materials like plastic and wood. Simple machines for simple tasks like cutting, drilling, and grinding. The fundamental tasks needed for making, whether by hand or machine.

Another of Rick Rubin's list of thoughts not conducive to work is the belief that your work 'will require specific tools or equipment to be done.' I agree; technology may be conducive to creativity, but it is not at the heart of it. I find whenever I put a technology before an idea the idea usually suffers.

I accept the workshop's authority. When I step inside the workshop it tells me what I can make – a restriction I have come to understand, respect, and answer to. 'This is what you can make' isn't a nostalgia for simple technology. It's not an antidote to the smartphone that is a constant in my pocket. It's more about my understanding

um zur nächsten Müllgrube zu werden, andere verschwinden in einer Schachtel. Mit dem Namen des Stücks beschriftet, wird sie in eine Schublade gelegt und diese dann verschlossen wie ein Skizzenbuch mit Arbeitszeichnungen.

Der Musikproduzent Rick Rubin erstellte für sein Buch über Kreativität eine Liste von Aphorismen mit dem Titel „Gedanken und Gewohnheiten, die der Arbeit nicht zuträglich sind". Dazu gehört für ihn auch, „Projekte nie zu Ende zu bringen".[6] Meine Werkstatt ist übersät von „nie zu Ende Gebrachtem". Es gibt viele Gründe, eine Arbeit abzubrechen. Fehler im Material sind das größte Problem, doch manchmal fehlt es auch an Zugehörigkeit. Die meisten meiner Stücke plane ich als Kleinserien. Nicht groß, meist keine zehn Teile umfassend, manchmal nur eins oder zwei. Das bedeutet, dass jedes Stück Bezüge zu anderen Arbeiten in der Kleinserie aufweist. Sie sind niemals gleich, Schwankungen in der handwerklichen Fertigung führen zu Unterschieden, auch wenn es in der Regel die Schwankungen in Farbe und Beschaffenheit des Materials sind, die den Unterschied ausmachen. Doch sie alle müssen in einer Gegenüberstellung den gleichen Kriterien genügen. Sie können unterschiedlich sein, aber nicht besser oder schlechter.

Um die Konsistenz einer Serie sicherzustellen, fertige ich für jedes Stück eine Vorlage an. Gelegentlich wachsen die Vorlagen an den Bäumen vor meiner Werkstatt. Für zwei Arbeiten habe ich einfach ihre Blätter abgepflückt und ihre Umrisse nachgezeichnet.

Die Werkstatt erzeugt Staub. Schichtenweise. Staub von Holz, Metall, Stein, Kunststoff und vielen anderen Materialien. Von jedem einzelnen von ihnen habe ich den Staub gesammelt, einfach so, bis ich 2011 einen Katalog der Materialien schuf, die ich zur Schmuckherstellung verwendet hatte (es waren über sechzig). Dafür vermischte ich den Staub der einzelnen Materialien mit einem Bindemittel und trug ihn jeweils auf ein kleines rechteckiges Holzstück auf (S. 82 und 208). An der Wand wurden die Rechtecke dann so angeordnet, dass sie an

of the nature of transformation and wanting to stay connected to it.

The act of transformation that can take place with very simple actions. A fundamental action like drilling a hole (as in the panels in Dust) is one of the earliest technical skills we developed. That simple action, by creating a point of suspension, can make any material a piece of jewellery. That technique is probably why jewellery is so prominent in our early material culture.

I've never believed the workshop way of working is in any sense an aesthetic of opposition to the industrial. I often try for an industrial look. The workshop can achieve that look. The workshop can achieve many looks. The workshop is very versatile. To be honest, it is good at faking. What the workshop could do, I could do. What I could do is what the workshop could do.

Finding the place

By the accident of distance from everywhere else, Aotearoa was the last sizeable land mass to be discovered by humans – 900 years ago by Polynesian seafarers, 250 years ago by Europeans. So, the gap between the stone-tool culture of the Polynesians and the arrival of the iron-tool culture of the Europeans is very narrow.

I had a childhood interest in the pre-European manufacture of stone tools by Māori. A childhood home was in an area where such tools were manufactured. The stone had been moved from quarry sites in the hills to a sandspit where the flaking and final shaping was done. Two hundred and fifty years was not enough time to bury the evidence of that activity very far below the surface. This was most evidenced by areas of stone flakes – a sign that someone had been on this spot making a tool. Chipping the stone (knapping) by striking it with a hammer stone is how tools had been made for millions of years, but these ones were made

ein Musterregal für Bodenbeläge im Baumarkt erinnerten. Aber möglicherweise – wegen des Lochs, an dem sie aufgehängt waren – auch an Anhänger.

Werkzeuge

Die Materialien und Skizzen teilen sich den Raum mit der Technik, die erforderlich ist, um sie zu formen. Dazu zählen das traditionelle Werkbrett mit seinen Hämmern und sonstigen Handwerkzeugen. Eine Diamantsäge und Schleifscheiben für harte Steine. Eine Tischbohrmaschine und eine Bandsäge für weichere Materialien wie Kunststoff und Holz. Simple Maschinen für einfache Aufgaben wie schneiden, bohren und schleifen – die elementaren Aufgaben des Machens, ob von Hand oder maschinell.

Der Arbeit abträglich ist laut Rick Rubin auch der Glaube, „besonderes Werkzeug oder eine bestimmte Ausstattung zu benötigen, um die Arbeit tun zu können". Das stimmt. Die Technik mag der Kreativität zuträglich sein, sie steht jedoch nicht im Mittelpunkt. Ich stelle fest, dass immer dann, wenn ich eine Technik über eine Idee stelle, die Idee in der Regel leidet.

Ich akzeptiere die Autorität der Werkstatt. Wenn ich die Werkstatt betrete, sagt sie mir, was ich machen kann – eine Einschränkung, die ich mit der Zeit verstehen und respektieren gelernt habe und der ich mich beuge. „Nur das kannst du machen" ist keine Sehnsucht nach einfacher Technik. Es ist kein Gegengift für das Smartphone, das ich ständig in der Tasche habe. Es geht eher darum, dass ich die Natur der Transformation begreifen und mit ihr verbunden bleiben möchte – den Akt der Verwandlung, der mit sehr einfachen Tätigkeiten vollzogen werden kann.

Eine essenzielle Tätigkeit wie das Bohren eines Lochs (wie in die Täfelchen von Dust) ist eine der ältesten technischen Fertigkeiten, die wir entwickelt haben. Mit dieser einfachen Handlung lässt sich jedes Material in ein Schmuckstück verwandeln, denn jetzt kann man es aufhängen. Diese Technik

only a few hundred years ago. The stone adze I excavated from only a few feet under my new workshop floor thirty years ago was a poorly finished tool, but any stone held in a hand of the right size and shape could become a tool. The transformation required can be very minimal.

From that experience I learned a fundamental lesson about the transformation of a material from one notion to another – from a material without a function to one with a function. This interest in the minimal transformation of a material has always followed me through my making. Our past speaks of tools and adornment. I once made a necklace from the flakes produced by knapping (pages 98–99).

Finding the face

Another transformation that happens in the workshop begins with the found. The identification of an archetypal resonance in a found object can be the beginning of transformation.

'I'm looking for the face I had before the world was made.'[5]

I look for this in the found object. Sometimes the transformation has already been started on the object by the action of nature, wind, and water, by insects and waves, the action of oxidation, processes that transform and shape materials before they even reach me. But chosen by me because I recognise a form that feels familiar, usually not associated with the contemporary iteration I find, but an archetypal form – a sign from the past.

The object I find may have a banal contemporary association, but it also has an older, distant echo. Like the way the surrealists drew attention to the poetry in found objects – rocks, shells, bones, and wood. Of course, they weren't the first to see it, to find the face, but they did name it – objet trouvé.

ist wahrscheinlich der Grund für die herausragende Stellung, die Schmuck in unserer frühen materiellen Kultur einnimmt.

Ich habe nie geglaubt, dass die Art und Weise, wie in einer Werkstatt gearbeitet wird, in irgendeiner ästhetischen Opposition zur industriellen Fertigung steht. Oft bemühe ich mich um einen industriellen Look. Die Werkstatt kann diesen Look erreichen. Die Werkstatt kann viele Looks erreichen. Die Werkstatt ist sehr vielseitig. Ehrlich gesagt ist sie gut im Vortäuschen. Was die Werkstatt könnte, könnte ich auch. Was ich könnte, könnte auch die Werkstatt.

Den Ort finden

Weil Aotearoa Neuseeland so weit von allem sonst entfernt lag, war es die letzte größere Landmasse, die von Menschen entdeckt wurde – vor neunhundert Jahren von polynesischen Seefahrern, vor zweihundertfünfzig Jahren von den Europäern. Die Lücke zwischen der Steingerätekultur der Polynesier und der Ankunft der europäischen Kultur mit ihren Eisenwerkzeugen ist also sehr klein.

Als Kind hat mich die voreuropäische Herstellung von Steinwerkzeugen durch die Māori interessiert. Ein Haus meiner Kindheit lag in einem Gebiet, aus dem solche Werkzeuge kamen. Das Rohmaterial war aus Steinbrüchen in den Hügeln auf eine Landzunge transportiert, dort bearbeitet und in seine endgültige Form gebracht worden. Zweihundertfünfzig Jahre reichten nicht aus, um die Zeugnisse dieser Tätigkeit besonders tief unter der Oberfläche zu begraben. Den deutlichsten Hinweis lieferten Bereiche mit Steinsplittern, sogenannten Abschlägen – ein Zeichen, dass jemand an dieser Stelle ein Werkzeug hergestellt hat. Den Stein zu bearbeiten (zu behauen), indem man mit einem Schlagstein auf ihn einwirkt, das ist die Methode, mit der seit Jahrmillionen Werkzeuge hergestellt wurden. Doch diese hier waren nur wenige Hundert Jahre alt. Das steinerne Querbeil, das ich vor dreißig Jahren kaum einen Meter unterhalb meiner neuen Werkstatt aus dem Boden holte, war ein dürftig gearbeitetes Werkzeug, aber konnte nicht jeder in der Hand gehaltene Stein in der richtigen Größe

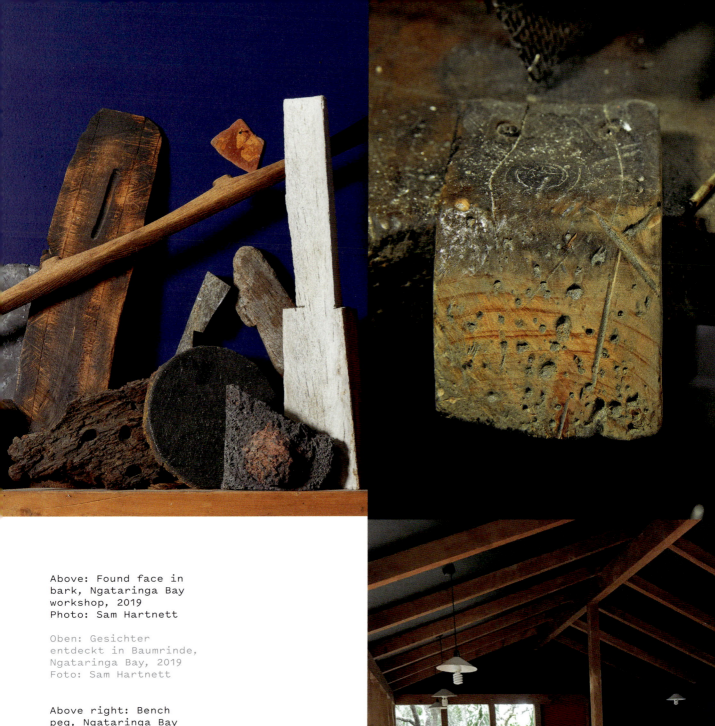

Above: Found face in bark, Ngataringa Bay workshop, 2019
Photo: Sam Hartnett

Oben: Gesichter entdeckt in Baumrinde, Ngataringa Bay, 2019
Foto: Sam Hartnett

Above right: Bench peg, Ngataringa Bay workshop, 2019
Photo: Sam Hartnett

Oben rechts: Bankzapfen in der Werkstatt an der Ngataringa Bay, 2019
Foto: Sam Hartnett

Right: The Ngataringa Bay workshop empty, 2019
Photo: Warwick Freeman

Rechts: Die Werkstatt an der Ngataringa Bay nach ihrer Auflösung, 2019
Foto: Warwick Freeman

Finding the space

The jeweller's bench peg is my sounding block, a mute receiver of my thoughts while at work. The bench is a place to discover how clever you are, how useless you are. Not a place for arguments about modes of production, the viability of hands versus other technology, but a place to think, a place to learn about myself. I've looked at these blocks for so long now that I've developed an affection for them – this has extended to keeping them after they are worn out.

Their deformation records a history of thousands of things made. The marks of subtraction, the filing, the burning, the drill holes, are testament to construction. The wear on the bench peg is not only a record of time spent on making but also of time spent thinking at the bench.

As maker, that thinking involves creating your own narrative about the role you have chosen for yourself. For me that has been about building a narrative around my own concept of 'usefulness'.

The capacity of an object to generate a story about its usefulness is important to me. I'm not suggesting usefulness is only about an object's function. For me it's a sensibility belonging to how it is 'used' in a broad social and cultural context. I recall that writer and teacher Pravu Mazumdar once observed that jewellery has an anthropological reflection. To me, sometimes that reflection is dazzling. I feel like an animal caught in the headlights of a car on the road of our material history.

At the bench peg I hear others' voices. They never asked for the job, but I let my colleagues, alive and dead, sit on my shoulder and whisper in my ear. Hermann Jünger, Otto Künzli, Onno Boekhoudt, Dorothea Prühl, Kobi Bosshard, Alan Preston, and others. My gratitude for what they have brought to my art form provides a reference point. I want to look them in the eye. They are part of the scaffold I surround my work with, made up of metaphors, references, quotes, und Form zum Werkzeug werden? Oft bedarf es nur einer kleinen Veränderung.

Diese Erfahrung war wie eine Lehrstunde für mich, eine Lektion über die Verwandlung eines Materials von einem Zustand in einen anderen – von einem Material ohne Funktion in ein Material mit Funktion. Seither begleitet mich das Interesse an der minimalen Veränderung von Materialien durch mein gesamtes Schaffen. Unsere Vergangenheit spricht von Werkzeugen und Verschönerung. Ich habe eine Halskette aus Abschlägen gemacht (S. 98–99).

Das Gesicht finden

Eine andere Verwandlung, die in der Werkstatt vor sich geht, beginnt mit dem Gefundenen. Das Erkennen eines archetypischen Widerhalls in einem Fundstück kann der Anfang einer Verwandlung sein. „Ich suche das Gesicht nur, das ich hatte / Vor Erschaffung der Welt."[7]

Ich suche danach im gefundenen Objekt. Manchmal hat die Verwandlung des Objekts bereits begonnen – durch das Zutun der Natur, durch Wind und Wasser, Insekten und Wellen, durch Oxidation und andere Prozesse, die Materialien verändern und formen, bevor sie mich überhaupt erreichen. Aber ich wähle sie aus, weil ich eine Form erkenne, die mir vertraut vorkommt: üblicherweise keine, die mit dem aktuell vorgefundenen Fundstück zusammenhängt, sondern eine tradierte Urform – ein Zeichen aus der Vergangenheit.

Das Objekt, das ich finde, mag in der Gegenwart banal wirken, doch es hat auch ein älteres, ein fernes Echo. So wie die Surrealisten die Aufmerksamkeit auf die Poesie in gefundenen Objekten lenkten – in Steinen, Muscheln, Knochen und Holz. Natürlich waren sie nicht die ersten, die das sahen, die das Gesicht fanden, aber sie gaben ihm einen Namen – *objet trouvé*.

Den Raum finden

Der Feilnagel an meinem Werktisch ist mein Resonanzboden, ein stiller Empfänger meiner

and influences; all contributing to the permission a piece needs to leave the workshop.

I might collect bench pegs, but I don't romanticise the workshop – it's a place of work. After fifty years it's still the best place to make my work. The workshop is a tool: on a good day it lets me make the things I think of; on a bad day it takes more than it gives.

In his book McCahon Country, Justin Paton writes: 'Anything is possible in art. But only a few things feel necessary.'[6]

Most things are possible in the workshop, but its other great virtue is that, given time, it is the place where I can resolve whether what I'm making feels necessary – a place where I can consider my jewellery's usefulness.

There is another guiding principle I apply to my work. I call it – 'what looks right'. When a piece has a sense of economy, an aptness, perhaps some grace, I say, 'it looks right'. I have a rubber stamp of a slogan I culled from an old cosmetic advertisement, 'beauty is your duty'. We are loath to apply such imperatives today, but let's agree that when something is true to itself, we can call it beautiful. I feel that call.

We left the Ngataringa Bay house in 2019. The workshop was emptied of all the signs of my time there as a jeweller. Empty of all its layers, including the benches. The only sign I had been there was this trail worn on the floor, the record of my daily trip from the workshop door to my bench.

Gedanken während der Arbeit. Die Werkfläche ist ein Ort, um herauszufinden, wie schlau und zugleich nutzlos man ist. Kein Ort für Diskussionen über Fertigungsmethoden, die Brauchbarkeit von Händen gegenüber anderen Technologien, sondern ein Ort zum Nachdenken, ein Ort, um mehr über mich selbst zu lernen. Ich schaue mir diese Feilnägel jetzt schon so lange an, dass ich eine Zuneigung zu ihnen entwickelt habe – die so weit geht, dass ich sie aufbewahre, wenn sie abgenutzt sind.

Ihre Verformung dokumentiert eine Geschichte von Tausenden von Dingen, die hier gefertigt wurden. Die Spuren des Abtragens, Feilens und Brennens, die Bohrlöcher, alles zeugt von Konstruktion. Die Abnutzung des Feilnagels steht nicht nur für die Zeit, die ins Machen geflossen ist, sondern auch für die Zeit, die man am Werkbrett mit Denken verbracht hat.

Für den Schaffenden bringt dieses Denken die Aufgabe mit sich, die Rolle, die man für sich selbst gewählt hat, in eine Erzählung zu gießen. Für mich hieß das, eine Erzählung rund um meine Vorstellung von „Nützlichkeit" zu konstruieren.

Die Fähigkeit eines Objekts, eine Geschichte über seine Nützlichkeit zu erzählen, ist mir wichtig. Ich sage nicht, dass es bei Nützlichkeit nur um die Funktion eines Objekts geht. Für mich zählt vielmehr ein Gefühl dafür, wie das Objekt in einem breiten gesellschaftlichen und kulturellen Kontext „genutzt" wird. Ich erinnere mich an die Worte des Autors und Dozenten Pravu Mazumdar, der einmal feststellte, dass Schmuck ein anthropologisches Spiegelbild besitzt. Was mich betrifft, blendet dieses Spiegelbild manchmal. Ich fühle mich wie ein Tier, das auf der Straße unserer materiellen Geschichte im Scheinwerferlicht eines Autos gefangen ist.

Am Feilnagel höre ich fremde Stimmen. Sie haben mich nie darum gebeten, doch ich lasse meine Kollegen, die lebenden und die toten, auf meiner Schulter sitzen und mir etwas ins Ohr flüstern. Hermann Jünger, Otto Künzli, Onno Boekhoudt, Dorothea Prühl, Kobi Bosshard, Alan Preston und andere. Meine Dankbarkeit für das, was sie zu

meiner Kunstform beigesteuert haben, bildet einen Bezugspunkt. Ich möchte ihnen in die Augen sehen. Sie sind Teil des Gerüsts, mit dem ich meine Arbeit umgebe. Es besteht aus Metaphern, Bezügen, Zitaten und Einflüssen, die alle dazu beitragen, dass ein Stück die benötigte Erlaubnis erhält, die Werkstatt zu verlassen.

Ich sammle vielleicht Feilnägel, aber ich bin kein Romantiker – die Werkstatt ist ein Arbeitsplatz. Nach fünfzig Jahren ist sie noch immer der beste Ort, um meine Arbeit zu machen. Die Werkstatt ist ein Werkzeug: An guten Tagen lässt sie mich die Dinge tun, die ich im Kopf habe, an schlechten nimmt sie mehr, als sie gibt. In seinem Buch McCahon Country schreibt Justin Paton: „In der Kunst ist alles möglich. Doch nur wenige Dinge fühlen sich notwendig an."⁸

In der Werkstatt sind die meisten Dinge möglich. Ihr anderer großer Vorteil aber ist, dass sie, wenn ich Zeit habe, zu dem Ort wird, an dem ich herausfinden kann, ob sich das, was ich mache, notwendig anfühlt – einem Ort, an dem ich über die Nützlichkeit meines Schmucks nachdenken kann.

Daneben gibt es noch ein Grundprinzip, das ich auf meine Arbeit anwende. Ich nenne es: „was richtig aussieht". Wenn ein Stück auf das Wichtigste reduziert ist, angemessen und vielleicht ein wenig anmutig wirkt, dann sage ich: „Es sieht richtig aus." Ich habe da diesen Stempel mit einem Slogan aus einer alten Kosmetikwerbung: „Beauty is your duty" (Schönheit ist Ihre Pflicht). Wir verwenden solche Imperative heute nur noch ungern, aber einigen wir uns doch darauf, dass etwas, das sich selbst treu ist, schön genannt werden kann. Das ist es, was ich fühle.

2019 verließen wir das Haus an der Ngataringa Bay. Aus der Werkstatt wurden sämtliche Spuren der Zeit entfernt, die ich als Goldschmied dort verbracht hatte. Alle Schichten beseitigt, einschließlich der Werkbretter. Der einzige Hinweis auf meine einstige Anwesenheit war dieser ausgetretene Pfad auf dem Holzboden, Zeugnis meiner täglichen Strecke von der Werkstatttür zu meinem Werkbrett.

1
David Simmons, Maori Auckland. Bush Press, 1987, p. 73.

2
The amo are two upright supports or side posts at the front of the wharenui representing legs. All translations of te reo Māori (Māori language) words in the footnotes are based on entries in Te Aka Māori Dictionary, https://maoridictionary.co.nz.

3
Peter Dormer, 'Vermeer's Lace Maker.' Design after Modernism: Beyond the Object, edited by John Thackara. Thames & Hudson, 1988, p. 135.

4
Rick Rubin, The Creative Act: A Way of Being. Canongate, 2023, p. 139.

5
W. B. Yeats, 'Before the World Was Made.' Collected Poems of W. B Yeats. MacMillan, 1933, p. 308.

6
Justin Paton, McCahon Country. Penguin Random House, 2019, p. 6.

1
David Simmons, Maori Auckland, Auckland 1987, S. 73.

2
Ästuare sind die Mündungsbereiche großer Flüsse ins Meer, in denen sich – unterstützt von Ebbe und Flut – das Süßwasser der Flüsse mit dem Salzwasser des Meeres vermischt.

3
Ortgang bezeichnet die sichtbare Dachstärke am Hausgiebel.

4
Unter amo versteht man die kurzen, massiven, meist reich mit Schnitzereien verzierten Bretter an der Vorderseite des wharenui, die symbolisch das Dach tragen. Alle Übersetzungen aus der māorischen Sprache oder te reo Māori in den Anmerkungen basieren auf Einträgen aus dem Onlinewörterbuch Te Aka Māori Dictionary (https://maoridictionary.co.nz).

5
Peter Dormer, „Vermeer's Lace Maker", in: John Thackara (Hg.), Design after Modernism: Beyond the Object, London 1988, S. 135.

6
Rick Rubin, kreativ: Die Kunst zu sein, mit Neil Strauss, aus dem Englischen von Judith Elze, München 2023, S. 147-148.

7
William Butler Yeats, „Vor Erschaffung der Welt", in: Ders., Die Gedichte, hg. von Norbert Hummelt, hier übersetzt von Gerhard Falkner und Nora Matocza, München 2005, S. 305.

8
Justin Paton, McCahon Country, Auckland 2019, S. 6.

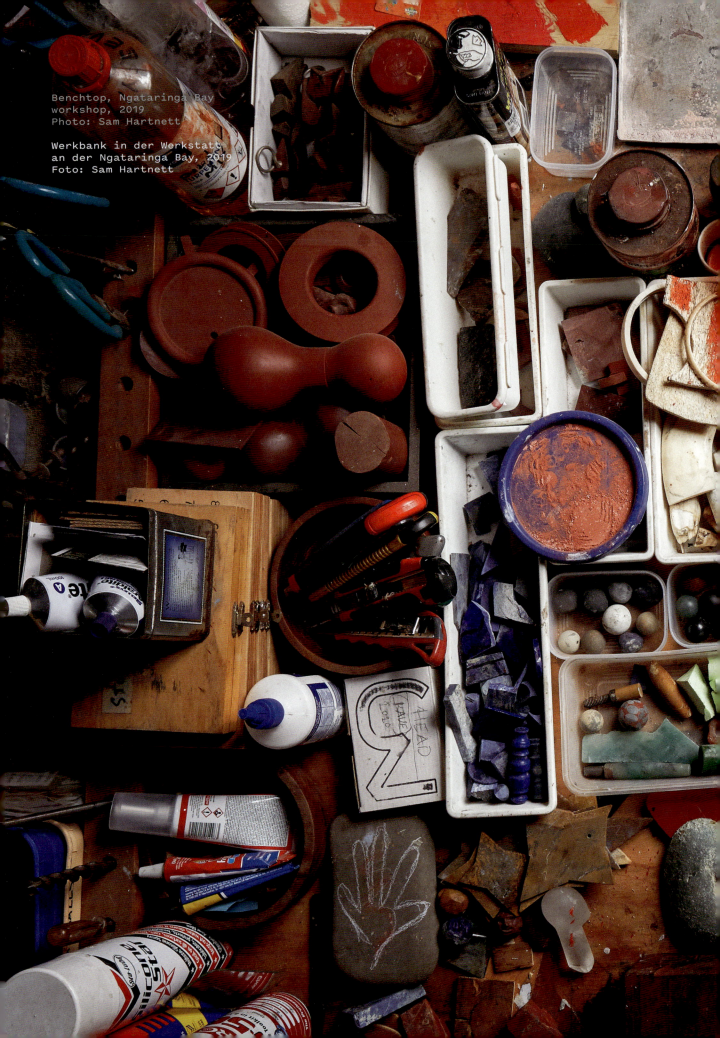

Benchtop, Ngataringa Bay
workshop, 2019
Photo: Sam Hartnett

Werkbank in der Werkstatt
an der Ngataringa Bay, 2019
Foto: Sam Hartnett

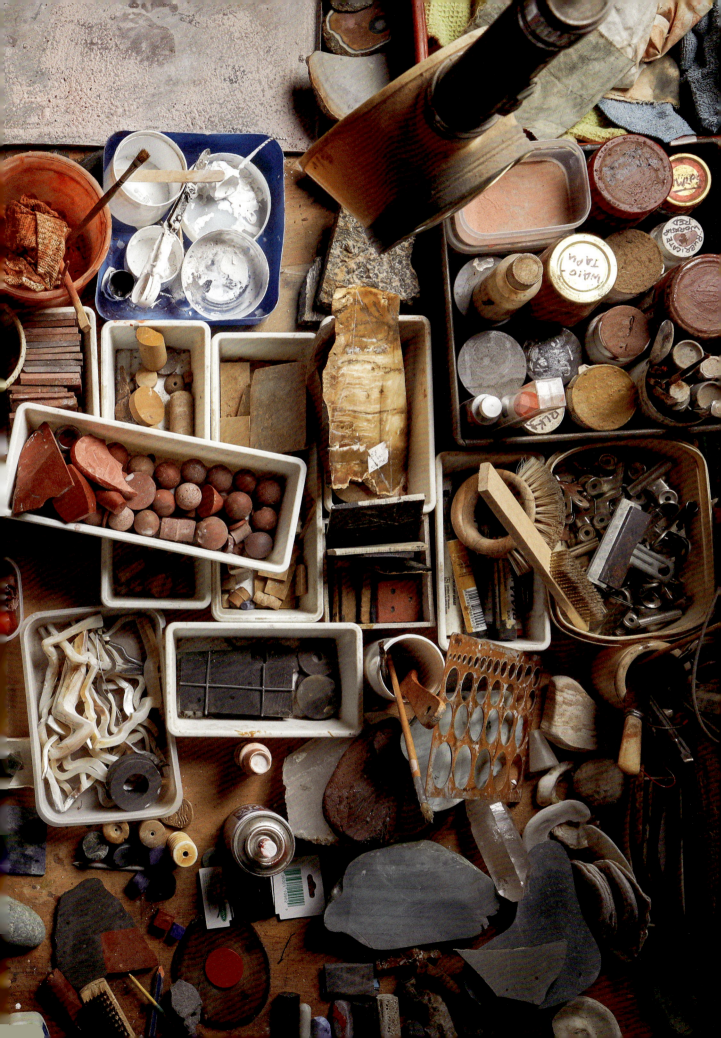

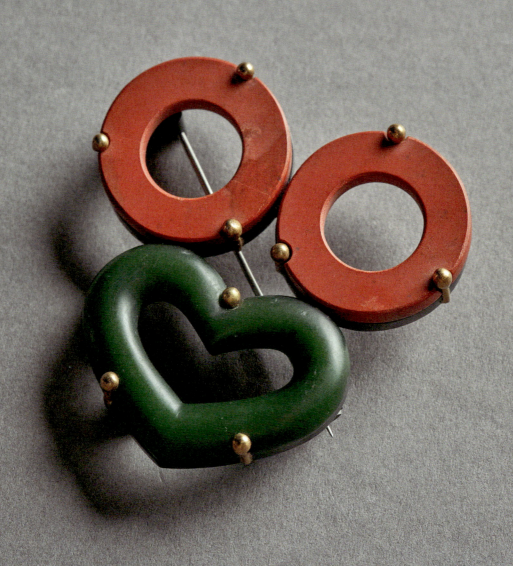

05
WHEN IS A HOOK A HEI MATAU?

KARL CHITHAM

WANN IST EIN HAKEN EIN HEI MATAU?
05

Brooch
<u>Tiki Face</u>, 1991
Jasper, nephrite, gold,
oxidised silver
5.3 × 5.5 × 1.3 cm
Museum of New Zealand Te Papa
Tongarewa, Wellington,
purchased 2009

Brosche
<u>Tiki-Gesicht</u>, 1991
Jaspis, Nephrit, Gold,
geschwärztes Silber
5,3 × 5,5 × 1,3 cm
Museum of New Zealand Te Papa
Tongarewa, Wellington,
erworben 2009

When presented with an opportunity to write about Warwick Freeman's work I was delighted. For me, his jewellery practice represents the epitome of essentialism – an example of how to distill an idea to its bare minimum and present it back to the world in a perfectly formed state. Beyond my personal fanboy reaction, what I was initially struck by was the problem of interpretation. Freeman's pieces each hold their place in the world with surety and confidence. They are a concentrated moment that is simultaneously a closed loop of harmony and balance, while offering a litany of possible readings.

Add to this the challenge of the topic that this essay was originally commissioned to address, which was the question of how Freeman's practice overlapped with, or engaged in, notions of cultural appropriation. I was surprised by this particular line of inquiry, having never considered Freeman or his practice within this context. It is also fair to say that this subject has been well and truly cross-examined in essays, articles, and books. However, there is a nagging thought, like the incessant sound of a grinder on stone, that keeps resurfacing when I think of Freeman's jewellery, and that is the ongoing conversation of culture and how it is unpacked and reconstructed in Aotearoa New Zealand. For the purposes of this essay, these two ideas are actually the same line of inquiry – what is it about Freeman's works that encourages these moments of tension and self-reflection, and ultimately leaves you wanting to know more?

Like Freeman, I am Pākehā,[1] the product of white settler ancestors who travelled from Western Europe to build a new life on the other side of the world. I am also Māori, a member of the Indigenous population of Aotearoa New Zealand with centuries of whakapapa,[2] which continues to suffer considerable trauma because of colonisation. Like so many other mixed-race individuals, I have a constant internal battle to define my cultural identity, combined with an annoyingly overzealous aspiration to

gain some epiphanous insight into how I might locate myself in the world. So it is with some consternation and no shortage of curiosity that I have followed the journey of many Pākehā in Aotearoa who have been trying to do the same thing. Although the difference here is obviously the fact that Pākehā are the dominant racial group and represent for many Māori and Moana Oceania[3] peoples a direct line to a difficult and sometimes horrific settler past that still has ramifications for those cultural groups today.

Being Pākehā is not necessarily the sole definition of Freeman's practice, although he, and others, have referenced it multiple times as a point of friction and discovery over the decades. Therefore, a discussion of what *it is* certainly assists in defining the context within which his work is made and exists. While Pākehā might share common lineage with Western Europe, they would likely describe Aotearoa New Zealand as where they are from and the place they are proud to call home. But this term does not always help to define who they are, apart from describing who they are not. Pākehā, a group that art historian and frequent Freeman collaborator Damian Skinner describes as a 'slippery ethnicity',[4] are not Indigenous to Aotearoa New Zealand, and through time and distance are often not connected to the geographic and/or cultural origins of their ancestors. So, by default, they are not indigenous to anywhere. This lack of an emphatic identity for Pākehā is at the crux of many of the conversations about cultural appropriation in this country. How do you describe the people, place, and traditions that make up your homeland, influence your perspective on the world, and inspire you, without crossing that invisible line?

In an interview with Skinner, Freeman related an exchange that took place the first time he showed his work Tiki Face (1991; page 92). A friend of his was unsure if she, as a Pākehā, could purchase and wear his brooch. She turned to her Māori friend and asked if she thought it was appropriate. The woman replied, 'You like it, you buy it, what

noch immer stark traumatisiert ist. Wie so viele andere Menschen gemischter Abstammung führe ich einen ständigen inneren Kampf um meine kulturelle Identität, gepaart mit dem unerfreulich übereifrigen Streben nach einer offenbarenden Erkenntnis, die mir helfen könnte, mich in der Welt zu verorten. Darum verfolge ich mit einiger Entgeisterung und jeder Menge Neugier den Weg vieler Pākehā in Aotearoa Neuseeland, die genau dasselbe versuchen – wobei der Unterschied hier offensichtlich in der Tatsache besteht, dass die Pākehā die beherrschende ethnische Gruppe bilden und für viele Māori und Angehörige der *Moana Oceania*[3] eine direkte Verbindung zu einer schwierigen und bisweilen entsetzlichen Besiedlungsgeschichte darstellen, die in diesen kulturellen Gruppen bis heute nachwirkt.

Pākehā zu sein, ist nicht unbedingt das einzige Kriterium, um Freemans Schaffen zu definieren, auch wenn er und andere im Laufe der Jahrzehnte immer wieder darauf verwiesen haben – als Reibungspunkt und als Erkenntnismoment. Aus diesem Grund ist eine Erörterung der Frage, was dieses Sein *ausmacht*, sicherlich hilfreich, um den Kontext abzustecken, in dem seine Arbeit entsteht und existiert. Während Pākehā vielleicht ihre westeuropäische Abstammung teilen, würden sie auf die Frage, woher sie kommen, wahrscheinlich Aotearoa Neuseeland antworten und dieses Land mit Stolz als ihre Heimat bezeichnen. Doch dieser Begriff hilft nicht immer zu definieren, wer sie sind, sondern umschreibt lediglich, wer sie nicht sind. Der Kunsthistoriker Damian Skinner, der häufig mit Freeman zusammenarbeitet, nennt die Pākehā eine „schwer zu fassende Bevölkerungsgruppe".[4] Sie sind keine Ureinwohner Aotearoa Neuseelands und besitzen aufgrund der Zeit und Entfernung oft keine Verbindung zu den geografischen und/oder kulturellen Wurzeln ihrer Vorfahren. Darum sind sie von Haus aus nirgendwo einheimisch. Dieses Fehlen einer eindeutigen Identität der Pākehā ist der entscheidende Punkt vieler Diskussionen über kulturelle Aneignung in diesem Land. Wie beschreibt man die Menschen, den Ort und die Traditionen, die die eigene Heimat bilden, die die eigene Sicht auf die Welt beeinflussen und die

does it mean to me?'⁵ For Freeman, this was an example of how little resonance this work held for the Māori woman. In this instance she wasn't registering Tiki Face as being from her culture, regardless of the obvious similarities in visual language, so therefore she had no opinion on whether or not the other woman should buy it and wear it. While the Māori woman's indifference could be unpacked further, both sides of this conversation are fascinating. For me it is the Pākehā woman's motivations that are the most interesting aspect of this anecdote. The idea that she 'needed' her friend's permission to own a work by a Pākehā maker because it resembled a Māori cultural object highlights for me the complicated nature of Freeman's practice. Tiki Face in this instance became the nexus for the knotty complexities of cultural confusion that come with being Pākehā.

Freeman has repeatedly interrogated the territory that comes with being a white New Zealander of a certain generation. His work is complicit in this ongoing investigation and, by default, those that collect his work are also implicated. There was a lot at play in the seemingly innocuous encounter described above that was likely not obvious at the time. Pākehā academic Amanda Thomas suggests that 'many people have written about the importance of discomfort as an emotion as Pākehā work at decolonisation. When we feel this discomfort, it can be bound up with shame, guilt and tension.'⁶ Based on research and first-hand accounts, the Pākehā woman's harmless question in Freeman's recounting is born from a complex stew of feelings, including an innate sense of fear at doing the 'wrong' thing in the eyes of non-Pākehā (with the added potential of being 'called out' for it), and also a sense of guilt that has become strongly associated with white privilege and the need to atone for the unjust actions of their colonial ancestors. As blogger Debra Hunt reflects of her own Pākehā journey, 'I have been forced to acknowledge how much of my psyche, my identity, my upbringing, my sense of entitlement to New Zealand, are wound up in the

einen inspirieren, ohne diese unsichtbare Linie zu übertreten?

In einem Interview mit Damian Skinner erzählte Freeman von einem Dialog, den er mitangehört hatte, als seine Arbeit Tiki Face (Tiki-Gesicht, 1991, S. 92) zum ersten Mal ausgestellt wurde. Eine Freundin von ihm war sich unsicher, ob sie, als Pākehā, diese Brosche würde kaufen und auch tragen können. Also wandte sie sich an ihre māorische Freundin und fragte diese, ob das ihrer Meinung nach angemessen wäre. Die Freundin gab zurück: „Wenn du sie magst, dann kauf sie, was habe ich damit zu tun?"⁵ Freeman sah hierin ein Beispiel für die geringe Wirkung, die seine Brosche bei der Māori auslöste. Sie erkannte Tiki Face trotz der offensichtlich ähnlichen Bildsprache nicht als Teil ihrer Kultur und hatte daher keine Meinung dazu, ob die andere Frau das Schmuckstück kaufen und tragen sollte oder nicht. Während man die Gleichgültigkeit der Māori weiter aufschlüsseln könnte, erscheinen beide Seiten der Unterhaltung gleichsam faszinierend. Für mich sind die Beweggründe der Pākehā der interessanteste Aspekt der Erzählung. Die Vorstellung, dass sie die Erlaubnis ihrer Freundin „brauchte", um eine von einem Pākehā geschaffene Arbeit zu besitzen, weil diese einem māorischen Kulturgegenstand ähnelte, unterstreicht in meinen Augen den komplexen Charakter der künstlerischen Praxis Warwick Freemans. Tiki Face wurde hier zum Dreh- und Angelpunkt der komplizierten Vielschichtigkeit einer kulturellen Verwirrung, die das Dasein als Pākehā mit sich bringt.

Freeman hat die Rolle, die man als weißer Neuseeländer einer bestimmten Generation unweigerlich einnimmt, wiederholt hinterfragt. Nicht nur seine Arbeit ist Teil dieser laufenden Untersuchung, auch die Sammler seiner Stücke werden automatisch mit einbezogen. In die oben geschilderte, scheinbar unverfängliche Begegnung spielte vieles hinein, was damals vermutlich noch nicht evident war. Die Wissenschaftlerin und Pākehā Amanda Thomas meint, dass „viele Menschen über die Wichtigkeit des Unbehagens als Emotion bei der Arbeit der Pākehā an der Dekolonisierung

Hei tiki pendant, maker
and date unknown
Museum of New Zealand
Te Papa Tongarewa,
Wellington, purchased
1990

Hei tiki-Anhänger,
Künstler und
Herstellungszeitraum
unbekannt
Museum of New Zealand
Te Papa Tongarewa,
Wellington, erworben 1990

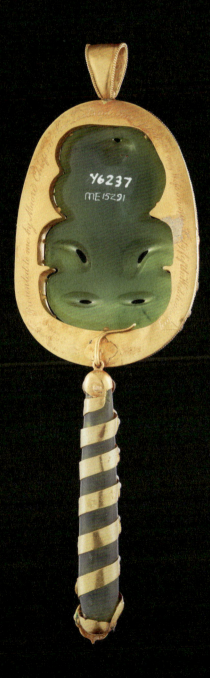
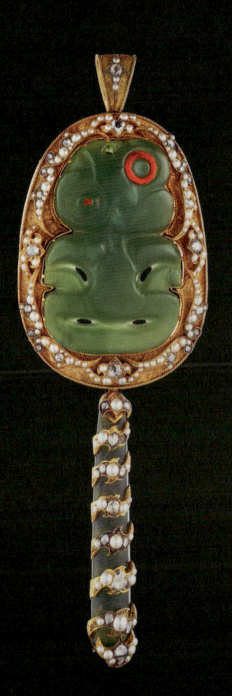

WHEN IS A HOOK A HEI MATAU?

Necklace
<u>Flake</u>, 1986
Argillite, cord, silver
50 cm overall length
Museum of New Zealand
Te Papa Tongarewa,
Wellington, gift of the
Friends of the Museum
of New Zealand Te Papa
Tongarewa, 1993

Halsschmuck
<u>Splitter</u>, 1986
Argillit (Tongestein),
Kordel, Silber
Gesamtlänge: 50 cm
Museum of New Zealand
Te Papa Tongarewa,
Wellington, Schenkung
Friends of the Museum
of New Zealand Te Papa
Tongarewa, 1993

WANN IST EIN HAKEN EIN HEI MATAU?

colonialist narrative. I had been blind to my own white privilege.'7 However, for me the strength of Tiki Face is not what it may or may not say about appropriation or Pākehā coming to grips with their emotions, it is the conversation it raises about how we 'read' Freeman's work in a nation that is still struggling with its own identity crisis.

One of the inspirations for Tiki Face is a hei tiki,[8] claw-set onto a gold backing-plate decorated with pearls and diamonds, with a pounamu kuru[9] suspended below, from the collections of the Museum of New Zealand Te Papa Tongarewa (page 97). Intended to be worn as a pendant, presumably at important occasions, this piece is a fraught symbol of colonial conflict. Owned by Major General Thomas Pratt, who spent eight months in New Zealand as commander of colonial forces fighting against Māori in New Plymouth, this 'jewel' is the epitome of the phrase 'rubbing salt in the wound'. A hei tiki is the embodiment of a tupuna,[10] so to have it owned, mounted, and embellished by an individual who was trying to kill and forcibly expel Māori from their lands is intensely problematic. While some might view the mounting of this hei tiki with 'precious' metals and stones as an acknowledgement of its importance, a perspective I would seriously question, what I think it actually does is take away some of its mauri and mana[11] – as if it needed these Western materials to enhance it and add to its significance.

In a formal way, Freeman's brooch has distilled the core elements of the ostentatious original into three simple considerations, extracting the modes that represent each culture's histories in the sparest of gestures – a pair of bright-red jasper circles as eyes and a dark-green heart-shaped pounamu mouth, and, finally, a series of precise gold claws attaching the features to a backing frame. Two adornment traditions have been brought together in a thoughtful union. Māori academic Rangihīroa Panoho suggests that 'Cross cultural dialogue... is inevitable but the ways in which cultural material is taken, and what is given in return, these are

geschrieben haben. Wenn wir dieses Unbehagen spüren, kann es mit Scham, Schuld und Spannungen verbunden sein."[6] Forschungen und Berichten aus erster Hand zufolge entsteht eine harmlose Frage wie die der Pākehā in Freemans Nacherzählung aus einem komplexen Gefühlsgeflecht, zu dem sowohl ein angeborenes Gefühl der Angst gehört, in den Augen der Nicht-Pākehā das „Falsche" zu tun (mit dem zusätzlichen Risiko, dafür „angeprangert" zu werden), als auch ein Gefühl der Schuld, das inzwischen eng mit dem weißen Privileg und dem Bedürfnis verknüpft ist, das von den kolonialen Vorfahren begangene Unrecht wiedergutzumachen. So reflektiert die Bloggerin Debra Hunt über ihren eigenen Weg als Pākehā: „Ich musste anerkennen, wie sehr meine Psyche, meine Identität, meine Erziehung, mein gefühlter Anspruch auf Neuseeland in das kolonialistische Narrativ verstrickt sind. Ich war blind für mein eigenes weißes Privileg."[7] Aus meiner Sicht liegt die Stärke von Tiki Face jedoch nicht darin, was es womöglich über Aneignung oder über die ernsthafte Beschäftigung der Pākehā mit ihren Gefühlen aussagt oder nicht aussagt, sondern in der Debatte, die es darüber auslöst, wie wir Freemans Werk in einer Nation „lesen", die noch immer mit ihrer eigenen Identitätskrise zu kämpfen hat.

Für Tiki Face stand unter anderem ein *hei tiki*[8] in Krappenfassung auf goldenem Träger mit Perlen und Diamantbesatz aus der Sammlung des Museum of New Zealand Te Papa Tongarewa Pate, an dem ein aus *pounamu* gefertigter *kuru*[9] baumelt (S. 97). Das Objekt, das vermutlich bei wichtigen Anlässen als Anhänger getragen werden sollte, stellt ein belastetes Symbol des Kolonialkonflikts dar: Weil es dem britischen Generalmajor Thomas Pratt gehörte, der acht Monate in Neuseeland verbrachte und als Befehlshaber der Kolonialstreitkräfte in New Plymouth gegen die Māori kämpfte, ist dieses „Juwel" der Inbegriff der Redewendung „Salz in die Wunde streuen". Ein *hei tiki* verkörpert bei den Māori einen *tupuna*.[10] Dass eine Person, die versucht hat, Māori zu töten und gewaltsam von ihrem Land zu vertreiben, ein solches Objekt sowohl besitzt als auch fassen

the key concerns and require sensitivity in their handling.'¹² Far from being some form of misuse or a dilution of cultural values through oversimplification, Tiki Face is an attempt at trying to understand how Māori and Pākehā lineages of making can come together in a respectful way while highlighting what is unique and intensely challenging about the place this brooch comes from.

Taking this line of inquiry in a slightly different direction, I am curious about works that have borrowed from Western histories and traditions yet are somehow not included in the same dialogue around appropriation. On the face of it, the answer seems obvious – if the reference appears to be from a non-colonised dominant culture there seems to be no tension or conflict at play. An interesting case in point is a work by Freeman called Flake Necklace (1986; pages 98–99). When I first encountered this piece, my immediate thought was that it resembled the product of tool production from the pre-neolithic period of human evolution found across sites in Europe. However, the information that accompanies this neckpiece suggests that Freeman was actually responding to Māori pre-colonial findings from a midden on his family property in Nelson. This is then where the friction reappears. I am intrigued by how our personal bias shifts from situation to situation. Do these works represent any inappropriate plagiarising from another culture, or are they simply a contemporary exploration of materials that resembles another object that just happens to be from a non-Western culture? Freeman has talked about this to some degree in an interview with Skinner. Asked about his study of and influence from Indigenous jewellery, Freeman replied:

> Let's say we talk in terms of great jewellery collections in history, whether its [sic] court jewellery of Europe, the pre-Columbian gold of the Americas, the Greek and Roman work. I've seen so many of these collections and I have no hesitation in including the work of Polynesian and Micronesian, Pacific peoples...

und verzieren lässt, ist daher hochproblematisch. Die bisweilen vertretene Sichtweise, das Fassen dieses *hei tiki* mit „kostbaren" Metallen und Steinen erkenne seine Wichtigkeit an, ziehe ich ernsthaft in Zweifel, denn tatsächlich beraubt es ihn seines *mauri* und *mana*¹¹ – so als bräuchte es diese westlichen Materialien, um den *hei tiki* aufzuwerten und seine Bedeutung zu mehren.

In formaler Hinsicht reduziert Freemans Brosche die Kernbestandteile der prahlerischen Vorlage auf drei einfache Überlegungen und arbeitet die Ausdrucksformen der verschiedenen Kulturgeschichten in sparsamsten Gesten heraus. Ein Paar leuchtend roter Jaspisringe bildet die Augen, eine Herzform aus dunkelgrünem *pounamu* den Mund, und eine Reihe von präzise gesetzten goldenen Krappen fixiert sämtliche Elemente auf einem Trägerrahmen. So wurden zwei Schmucktraditionen zu einer wohldurchdachten Einheit zusammengeführt. Der māorische Wissenschaftler Rangihīroa Panoho führt aus: „Der interkulturelle Dialog […] ist unvermeidlich, doch die Art und Weise, wie kulturelles Material genommen wird und was dafür gegeben wird, das sind die Hauptprobleme, die einen sensiblen Umgang erfordern."¹² Weit davon entfernt, eine Form des Missbrauchs oder eine Verwässerung kultureller Werte durch zu starke Vereinfachung darzustellen, ist Tiki Face vielmehr ein Versuch, eine Antwort auf die Frage zu finden, wie sich Schaffenslinien der Māori und der Pākehā auf respektvolle Weise vereinigen lassen, und dabei hervorzuheben, was an dem Herkunftsort dieser Brosche einzigartig und extrem herausfordernd ist.

Lenkt man die Frage in eine etwas andere Richtung, dann rücken Arbeiten ins Blickfeld, die zwar Anleihen bei westlicher Geschichte und westlichen Traditionen nehmen, aber dennoch nicht in die Aneignungsdebatte einfließen. Warum das so ist, scheint auf den ersten Blick offensichtlich: Stammt die Vorlage erkennbar aus einer nicht kolonisierten dominanten Kultur, dann bestehen allem Anschein nach keine Spannungen oder Konflikte. Ein interessantes Beispiel hierfür ist Freemans Flake Necklace (Splitter-Halsschmuck, 1986, S. 98–99).

WHEN IS A HOOK A HEI MATAU?

Brooch
Pink Monkey Bird, 2020
Otago rhodonite
3.5 × 6.3 × 0.5 cm
Private Collection
Rae-ann Sinclair,
Lake Hāwea and Sydney

Brosche
Rosaroter Affenvogel, 2020
Otago Rhodonit
3,5 × 6,3 × 0,5 cm
Privatsammlung Rae-ann Sinclair, Lake Hāwea und Sydney

in this pantheon, these great moments of jewellery. I always engage with it as a viewer, but as a knowledgeable viewer, as an aware viewer. I'm trying to see where this question can lead and obviously it has to come back to why I started using these materials in a particular moment. To say that it was a direct engagement with the Pacific is a bit too literal a reading of what happened.[13]

What I take from this is once again the idea of intention. While there is certainly an engagement with non-Western jewellery traditions that comes from living and working in Aotearoa, and Freeman has been very candid about having researched individual works, materials, and techniques, there is not a sense that this has been done with the objective of replicating or imitating the original. Knapping or 'flaking' is not unique to Māori or Indigenous cultural traditions, but because of location and associated histories it is the more explicit reference that tends to come to the fore, colouring our interpretation of what we are seeing. In fact, in almost every case Freeman's pieces can be read in two ways; implying one thing while being grounded in another.

A work like Pink Monkey Bird (2020; page 102) seems to walk this frustratingly indeterminate line with great success. Here, Freeman has consciously incorporated the partial silhouette of a manaia[14] combined with other rounded shapes created with a French curve drafting template. The title, taken from a David Bowie lyric, has been linked to gay slang, but beyond that seems to completely embody the notion of hybridity. This brooch is an example of the human brain's fascinating ability to try to make meaning out of what is in effect a nonsensical collection of shapes. To some degree this piece is closely aligned with the problems identified by Austrian philosopher Ludwig Wittgenstein, and his musings on the now famous rabbit–duck illusion.[15] Wittgenstein was interested in the correlation between seeing and interpreting, and the way in which we individually attribute meaning to an object or image. He called this the

Als ich diese Arbeit zum ersten Mal sah, war mein spontaner Gedanke, dass sie den Werkzeugen aus der präneolithischen Periode der menschlichen Evolution ähnelt, die an verschiedenen Orten in Europa gefunden wurden. Doch laut Begleitinformation war dieser Halsschmuck tatsächlich eine Reaktion Freemans auf Funde aus vorkolonialer Zeit, die er in einer māorischen Müllgrube auf dem Grundstück seiner Familie in Nelson gemacht hatte. An diesem Punkt taucht die Reibung wieder auf. Mich fasziniert, wie sich unsere persönliche Voreingenommenheit von Situation zu Situation verändert. Stellen diese Arbeiten ein irgendwie unangemessenes Plagiat einer anderen Kultur dar, oder sind sie nur eine zeitgenössische Materialerkundung, die aussieht wie ein anderes Objekt, das zufällig aus einer nichtwestlichen Kultur stammt? Freeman äußerte sich dazu in einem Interview mit Skinner. Auf die Frage, inwieweit er indigenen Schmuck studiert und ob dieser ihn beeinflusst, entgegnete er:

> Nehmen wir an, wir sprechen von den großen Schmucksammlungen der Geschichte: dem europäischen Hofschmuck, dem präkolumbianischen Gold Amerikas, den Arbeiten der Griechen und Römer. Ich habe so viele dieser Sammlungen gesehen und überhaupt keine Bedenken, das Werk der Polynesier und Mikronesier, der pazifischen Völker […] in dieses Pantheon aufzunehmen, diese großen Momente der Schmuckkunst. Ich setze mich stets als Betrachter damit auseinander, aber als sachkundiger Betrachter, als bewusster Betrachter. Ich versuche zu erkennen, wohin diese Frage führen kann, und offenbar muss sie zu den Anfängen zurückgeführt werden, zu dem besonderen Moment, in dem ich begann, diese Materialien zu verwenden. Zu behaupten, es hätte sich dabei um eine direkte Auseinandersetzung mit der Pazifikregion gehandelt, wäre eine etwas zu wörtliche Lesart dessen, was damals geschah.[13]

Was ich daraus ableite, ist einmal mehr der Gedanke der Absicht. Während die Beschäftigung mit nichtwestlichen Schmucktraditionen sicherlich

'aspect perception' and suggested that while we may attribute the same perception of a thing, we each also bring a different 'aspect' to our reading of it. Regardless of Freeman's influence or intention for the work, it is the viewer's personal prejudice and related life experiences that dictate whether they see a manaia made from Otago rhodonite (incidentally the region associated with many early Māori rock drawings featuring various bird-like forms), or a pink monkey bird, or something else entirely.

This game of semiotics seems to be accentuated in Freeman's practice through the continuous push and pull of materials and how they are manifested or shaped into specific forms. The two become intrinsically entwined in ways that can be both passive and simultaneously provocative. So that raises the question of whether we should be applying the term 'intentional ambiguity' as a replacement for appropriation in relation to Freeman's work. Isn't it the liminal shiftiness of his practice that is both attractive and confounding? In Hanger Hook (2009; page 105), a faithful copy of part of a disposable plastic hanger used primarily to display underwear in a retail setting is carved from whalebone and oriented to resemble a kapeu,[16] a Māori pounamu pendant that was historically used by mothers to aide with nursing newborn babies. As with Tiki Face, this work is not the object Māori would relate to their own cultural histories. There are very clear visual similarities, but even then, is that enough of a connection to assign a cultural meaning to what is in essence a very simple universal form? In other instances it may be considered coincidence or happenstance, but Freeman's practice is intrinsically laced with purpose. He is thoughtful, and lingers over each work, researching relational threads and trialling materials and orientations. There is nothing accidental in his jewellery. When asked about Mouth (2000; page 107), he has been explicit about this process:

> The petrified wood allows it to come closer to a reading similar to Tiki Face, which in effect means it can be read as one of the mouth

auch auf das Leben und Arbeiten in Aotearoa Neuseeland zurückgeht – und Freeman spricht sehr offen darüber, einzelne Werke, Materialien und Techniken eingehend erforscht zu haben –, entsteht nicht der Eindruck, als habe er dabei die Absicht gehabt, das Original nachzubilden oder zu imitieren. Das Verfahren, durch Behauen von Stein Abschläge herzustellen, ist nicht auf die māorische oder indigene Kulturtradition beschränkt, doch aufgrund des Ortes und der damit verbundenen Geschichte sind es die eindeutigen Bezüge, die sich tendenziell in den Vordergrund drängen und unsere Auslegung des Gesehenen einfärben. Tatsächlich können Freemans Stücke fast immer auf zwei Arten gelesen werden, wenn sie das eine andeuten, aber im anderen verwurzelt sind.

Eine Arbeit wie Pink Monkey Bird (Rosaroter Affenvogel, 2020, S. 102) scheint diesen entmutigend unbestimmten Spagat mit großem Erfolg zu bewältigen. Bewusst hat Freeman hier die unvollständige Silhouette einer *manaia*[14] mit anderen abgerundeten Formen kombiniert, für die er eine Burmester-Schablone[15] verwendet. Der aus einem Liedtext von David Bowie entlehnte Titel wurde mit dem Soziolekt der Queeren Community in Verbindung gebracht, ist darüber hinaus jedoch ein Inbegriff der Hybridität. Diese Brosche steht beispielhaft für die faszinierende Fähigkeit des menschlichen Gehirns, aus einer faktisch sinnfreien Ansammlung von Formen eine Bedeutung herauszulesen. In gewisser Weise ist das Stück eng mit den Problemen verknüpft, die der österreichische Philosoph Ludwig Wittgenstein in seinen Überlegungen zum berühmt gewordenen „H-E-Kopf" identifiziert hat, jener Zeichnung, die man als Hasen oder Entenkopf sehen kann.[16] Wittgenstein interessierte sich für den Zusammenhang zwischen Sehen und Interpretieren und für die Frage, wie wir einem Gegenstand oder Bild eine individuelle Bedeutung zuschreiben. Er nannte dies die „Aspektwahrnehmung" und führte dazu aus, dass wir eine Sache vielleicht identisch wahrnehmen, sie aber jeweils anders deuten, einen anderen „Aspekt" in den Vordergrund stellen. Unabhängig von Freemans Einfluss oder der Absicht, die er bei einer Arbeit verfolgt, sind es das

Pendant
Hanger Hook, 2009
Bone
9.5 × 1 cm

Anhänger
Kleiderbügelhaken, 2009
Knochen
9,5 × 1 cm

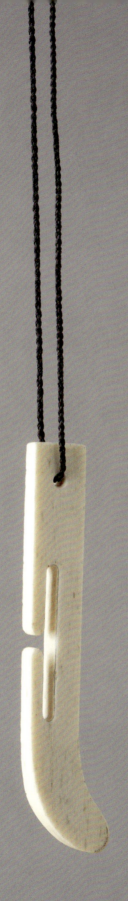

forms from Māori wood carving, and that is why it is called Mouth. And the petrified wood, I mean I could have made it out of wood but the stone as it is now retains some of the character of wood, but it shifts it just that little bit more. It's not like I'm disguising its sources, I'm just moving something, I'm asking people, can you see it too? Can you look at this and see what I'm seeing? Do we share enough common visual language, and is that common visual language only going to be between me and some other people that live in Aotearoa? It's a symbolic language that we can understand because of our common language. We're talking about the currency of shapes really.[17]

An earlier work called Bone Hook (1993; page 243) actively tackles the complexity of this dilemma of meaning. In the mid-1980s hei matau[18] were all the rage as signifiers of Māori culture and collective national pride in Aotearoa. I remember growing up in an environment where obvious symbols of our culture such as the hei matau were rare and something to be coveted. Made mostly from readily available cow bone, rather than the hard-to-come-by whalebone examples in museums, these taonga[19] were considered by many Māori to be a connection to a lineage that often felt very distant from everyday life, particularly if, like most of us, you lived in the city. Hei matau were also adopted by some Pākehā, who may have felt that this pendant visibly demonstrated an affinity and bond with Aotearoa and its Indigenous population.

Surrounded by water, Aotearoa New Zealand has developed a strong association with fishing as an industry, but even more so as a pastime. Over recent decades there have been considerable tensions created through the process of honouring obligations under Te Tiriti o Waitangi,[20] the founding document of bicultural relations between the New Zealand Government as a member of the Commonwealth and Māori. Read as part of this complex morass of histories, connotations, and expectations, Bone Hook, a carved bone reproduction of a

persönliche Vorurteil und die damit korrelierenden Erfahrungen im Leben des Betrachters, die bestimmen, ob wir eine *manaia* aus Rhodonit sehen, abgebaut in der Region Otago (zufällig jener Region, die mit zahlreichen māorischen Felsenmalereien von verschiedenen vogelähnlichen Formen verknüpft ist), oder einen rosafarbenen Affenvogel oder etwas völlig anderes.

Dieses Spiel mit der Semiotik scheint in Freemans Schaffen durch die permanente Abstoßung und Anziehung von Materialien und durch die Art und Weise betont zu werden, wie diese auftreten oder bestimmte Formen annehmen. Beide Auslegungen sind so untrennbar miteinander verschlungen, dass ihre Verbindung gleichzeitig sowohl passive Gestalt annehmen als auch zum Widerspruch herausfordern kann. Das wiederum wirft die Frage auf, ob wir im Hinblick auf Freemans Werk nicht besser von „absichtlicher Mehrdeutigkeit" als von Aneignung sprechen sollten. Ist es nicht gerade die grenzgängerische Wendigkeit seiner Arbeitsweise, die sowohl anzieht als auch verwirrt? Für Hanger Hook (Kleiderbügelhaken, 2009, S. 105) schnitzte Freeman aus Fischbein einen Teil eines Einwegplastikbügels originalgetreu nach, der hauptsächlich zur Präsentation von Unterwäsche im Einzelhandel dient, und richtete ihn so aus, dass er einem *kapeu*[17] ähnelt, einem māorischen Anhänger aus *pounamu*, der früher von Müttern getragen wurde, um ihnen beim Stillen ihrer Neugeborenen zu helfen. Wie schon die Brosche Tiki Face ist auch diese Arbeit kein Gegenstand, den Māori auf ihre eigene Kulturgeschichte beziehen würden. Die optischen Ähnlichkeiten sind unübersehbar, doch reichen sie als Verbindung aus, um einer im Kern sehr einfachen universellen Form eine kulturelle Bedeutung zuzuweisen? Während man in anderen Fällen von Zufall oder Fügung sprechen könnte, verfolgt Freeman immer einen Zweck. Er handelt bedächtig und verweilt bei jedem Werk, um Beziehungsstränge zu untersuchen und mit Materialien und Ausrichtungen zu experimentieren. An seinem Schmuck ist nichts Zufälliges. Auf eine Frage nach Mouth (Mund, 2000, S. 107) äußerte er sich ausführlich zu dieser Vorgehensweise:

WANN IST EIN HAKEN EIN HEI MATAU?

Brooch
Mouth, 2000
Petrified wood,
oxidised silver
3 × 7.4 × 1 cm

Brosche
Mund, 2000
Versteinertes
Kauriholz, geschwärztes
Silber
3 × 7,4 × 1 cm

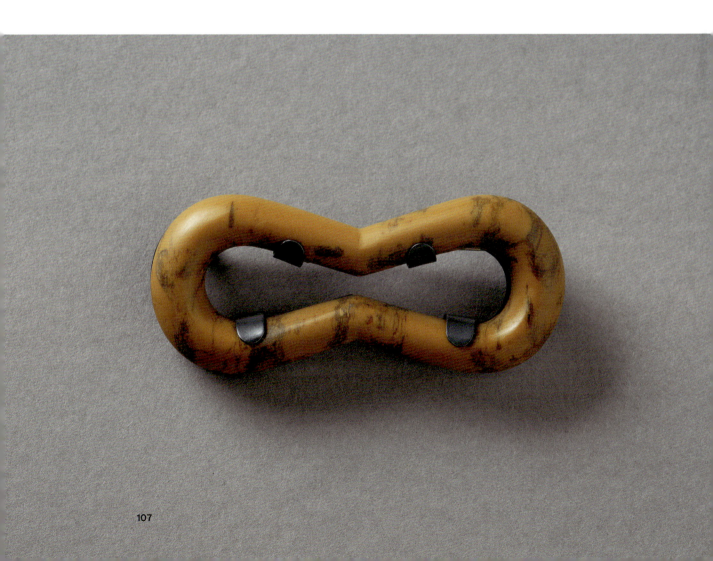

WHEN IS A HOOK A HEI MATAU?

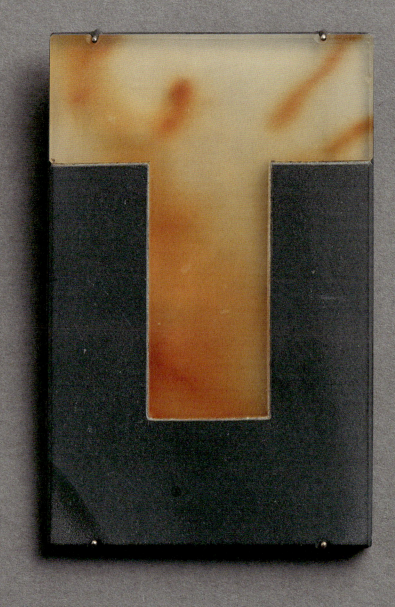

Brooch
TU, 2004
Carnelian, basalt,
oxidised silver
7.5 × 5.5 cm
Auckland Museum Tāmaki
Paenga Hira, Auckland,
purchased 2008

Brosche
TU, 2004
Karneol, Basalt,
geschwärztes Silber
7,5 × 5,5 cm
Auckland Museum Tāmaki
Paenga Hira, Auckland,
erworben 2008

modern steel fishhook, takes on the unenviable task of reflecting both the overlap and the clash of a shared national history. Freeman has considered his own memories in relation to the genesis of this work and another related work called 4 Bits of Fish (1993; page 242). Among his recollections of these works is the Māori pūrākau[21] that describes the origin of the North Island of Aotearoa as Te Ika a Māui or The Fish of Māui. As Freeman remembers:

> Naming the landscape is part of the process of occupying it in your own way. The myth that gives the North Island of New Zealand its name is a Māori one, but as a small child of Pākehā birth I was taught these stories amongst the mix of European ones (King Arthur, Snow White, etc). I was acknowledging the place the Māori stories had in my understanding of the world I occupied – I lived in a Māori land.[22]

Much more than a nostalgic comment on Freeman's childhood, or our maritime past, both works begin to dig into the heart of what it means to live in this country, sharing space with one another and attempting to appreciate viewpoints that have grown out of being from this place – not transplanted from somewhere else.

During a recent visit to Freeman's workshop, I came across a work that for me really expressed this sense of being more than a cultural dichotomy, while embracing the unique quality of living in and being from Aotearoa New Zealand. Like many of Freeman's works, TU (2004; page 108) was inspired by the form of a found object – an industrial metal die or template made from two parts, a T form and a U form, that interlocked to make a rectangle stamped with the number 2. Freeman says:

> Essentially the found object I am looking for produces a recognition that I can only describe as possessing something that relates to our deep memory – various shapes that have an identity – a character that we might refer to as archetypal.[23]

Das versteinerte Holz ermöglicht eine der Interpretation von Tiki Face ähnliche Lesart, was faktisch bedeutet, dass es als eine der Mundformen aus der Holzschnitzerei der Māori gedeutet werden kann – darum heißt es Mouth. Und das versteinerte Holz, nun, ich meine, ich hätte es aus Holz fertigen können, aber der Stein, so wie er jetzt ist, behält den Holzcharakter teilweise bei und verändert ihn nur um dieses kleine zusätzliche bisschen. Es ist nicht so, dass ich seine Quellen verschleiere, ich bewege nur etwas, ich frage die Leute: Seht ihr das auch? Könnt ihr das hier betrachten und sehen, was ich sehe? Verfügen wir über genügend gemeinsame Bildsprache, und wird diese gemeinsame Bildsprache nur von mir und einigen anderen Personen geteilt werden, die in Aotearoa leben? Es ist eine symbolische Sprache, die wir aufgrund unserer gemeinsamen gesprochenen Sprache verstehen können. Eigentlich reden wir hier von Formen als Währung.[18]

Eine frühere Arbeit mit dem Titel Bone Hook (Knochen-Haken, 1993, S. 243) nimmt sich der Vielschichtigkeit dieses Bedeutungsdilemmas aktiv an. Mitte der 1980er-Jahre waren *hei matau*[19] als Zeichen für die Māori-Kultur und den kollektiven Nationalstolz in Aotearoa Neuseeland groß in Mode. Ich erinnere mich, in einem Umfeld aufgewachsen zu sein, in dem offensichtliche Symbole unserer Kultur wie der *hei matau* selten waren und als begehrenswert galten. Viele Māori sahen in diesen größtenteils aus leicht verfügbaren Rinderknochen – und nicht wie viele Museumsstücke aus schwer erhältlichem Fischbein – hergestellten *taonga*[20] ein Bindeglied zu einer Abstammung, die vom Alltag oft sehr weit entfernt schien, vor allem dann, wenn man, wie die meisten von uns, in der Stadt lebte. *Hei matau* wurden auch von einigen Pākehā übernommen, die vielleicht das Gefühl hatten, dass diese Anhänger ihre Nähe und Verbundenheit zu Aotearoa Neuseeland und seiner indigenen Bevölkerung sichtbar machten.

Umgeben von Wasser hat Aotearoa Neuseeland eine starke Verbindung zur Fischerei-Industrie, aber mehr noch zum Angeln und Fischen als

Born from a curious but otherwise banal item, TU is nevertheless loaded with associations that, even more than Pink Monkey Bird, lend themselves to a diverse collection of readings. For instance, while many people will see the T and U made in contrasting materials as a clever play on words and symbols, *my* first reference point was Tūmatauenga, the Māori atua[24] whose name is often shortened to Tū and is connected with human pursuits such as war. I was surprised, then, to learn that there was also a nod in this brooch to iconic Aotearoa New Zealand painter Colin McCahon's series of works titled Necessary Protection (1971). These paintings specifically depict an area of coastline west of Tāmaki Makaurau Auckland, known as Muriwai. Its dynamic geological features are represented in McCahon's paintings as black silhouettes with the negative space between them picked out in white, yellow, or orange to represent the sky and ocean.

What is intriguing about TU, like many other later works by Freeman, is that the sensation of not knowing seems to have dissipated. The connections are multifaceted and diverse. They speak to combined histories rather than distinct cultures. There is no lingering question in the work of how to reconcile one's position in this place. There is no uncertainty around cultural dynamics from a Pākehā or Māori perspective. All of that tension in Freeman's practice, represented by those earlier works focused on the probing investigations of identity, has been replaced by something much more subtle and nuanced. Unlike the aforementioned Māori woman, I *do* see myself and my culture in this work. I bring to it my specific set of thoughts and experiences, and my particular 'aspects' informed by both sides of my whakapapa. I can see the TU and the Tū and know that both are valid and can hold equal status. The tension is still present in the works, but rather than it being a collision of meaning versus intention, it has now become a much more polite battle of reading versus form. Maybe this is a sign of both Freeman's and our nation's maturity – have we grown up or have we just moved on?

Freizeitbeschäftigung entwickelt. In den letzten Jahrzehnten kam es wegen der Einhaltung des *te Tiriti o Waitangi*,[21] dem Gründungsdokument der bikulturellen Beziehungen zwischen der neuseeländischen Regierung als Mitglied des Commonwealth und den Māori, zu erheblichen Spannungen. Begreift man Bone Hook als Teil dieses komplexen Dickichts aus Geschichte, Konnotationen und Erwartungen, dann übernimmt die aus Knochen geschnitzte Nachbildung eines modernen stählernen Angelhakens die undankbare Aufgabe, sowohl die Überschneidungen als auch die Konflikte innerhalb einer gemeinsamen Nationalgeschichte widerzuspiegeln. Warwick Freeman dachte in diesem Zusammenhang über die Genese von Bone Hook und einer weiteren, verwandten Arbeit namens 4 Bits of Fish (4 Stückchen Fisch, 1993, S. 242) nach. Zu seinen Erinnerungen an diese Stücke zählt die māorische *pūrākau*[22] von der Entstehung der Nordinsel Aotearoa Neuseelands als *Te Ika a Māui* oder Der Fisch von Māui:

> Der Landschaft einen Namen zu geben, ist Teil des Prozesses, sie auf die eigene Weise in Besitz zu nehmen. Der Mythos, dem die Nordinsel Neuseelands ihren Namen verdankt, ist ein māorischer Mythos, doch als kleines Kind aus einer Pākehā-Familie wurden mir diese Geschichten zusammen mit der europäischen Mischung von Erzählungen (König Arthur, Schneewittchen usw.) beigebracht. Ich erkannte den Platz an, den die Māori-Geschichten in meinem Verständnis von der eigenen Lebenswelt einnahmen – ich lebte in einem Māori-Land.[23]

Beide Arbeiten sind sehr viel mehr als ein nostalgischer Kommentar über Freemans Kindheit oder unsere maritime Vergangenheit. Beide beginnen zum Kern dessen vorzustoßen, was es heißt, in diesem Land zu leben, den Raum miteinander zu teilen und sich in der Würdigung von Standpunkten zu versuchen, die daraus erwachsen sind, dass man von hier stammt – und nicht von anderswoher an diesen Ort verpflanzt wurde.

Als ich Freeman vor Kurzem in seiner Werkstatt besuchte, stieß ich auf eine Arbeit, die dieses Gefühl, mehr als eine kulturelle Dichotomie zu sein, wirklich zum Ausdruck brachte und gleichzeitig die einmalige Eigenschaft aufgriff, in Aotearoa Neuseeland zu leben und aus diesem Land zu kommen. Wie viele Arbeiten Freemans wurde TU (2004, S. 108) von der Form eines gefundenen Objekts angeregt, einer metallenen Matrize oder Schablone aus der Industrie, deren zwei Teile, eine T-Form und eine U-Form, ineinander verschränkt ein Rechteck mit einer eingestanzten 2 ergaben. Freeman erklärt:

> Im Wesentlichen generiert das Fundstück, nach dem ich suche, eine Art Wiedererkennen, dessen Beschaffenheit, ich kann es nicht anders beschreiben, unser tiefes Gedächtnis anspricht – verschiedene Formen, die eine Identität besitzen – einen Charakter, den wir als archetypisch bezeichnen könnten.[24]

Geboren aus einem merkwürdigen, aber im Übrigen banalen Gegenstand, steckt TU gleichwohl voller Assoziationen, die sich – mehr noch als bei Pink Monkey Bird – für eine Vielzahl von Deutungen anbieten. Während zum Beispiel viele Menschen in den aus kontrastierenden Materialien geschaffenen Buchstaben T und U ein kluges Spiel mit Worten und Symbolen erkennen werden, fiel *mir* dazu als Erstes Tūmatauenga ein, der māorische *atua*,[25] der mit menschlichen Betätigungen wie dem Führen von Kriegen in Verbindung gebracht und oft einfach Tū genannt wird. Ich war daher überrascht zu erfahren, dass diese Brosche auch auf die Gemäldeserie Necessary Protection (Notwendiger Schutz, 1971) von Colin McCahon anspielt, Aotearoa Neuseelands Malerikone des 20. Jahrhunderts. Die Werke dieser Serie zeigen einen speziellen Küstenabschnitt westlich von Tāmaki Makaurau Auckland, der als Muriwai bekannt ist. Seine dynamischen geologischen Besonderheiten werden in McCahons Bildern als schwarze Silhouetten dargestellt und die Negativräume dazwischen in Weiß, Gelb oder Orange hervorgehoben, um den Himmel und das Meer wiederzugeben.

Das Faszinierende an TU ist – wie auch an vielen anderen Arbeiten Freemans aus neuerer Zeit –, dass sich das Gefühl der Unkenntnis aufgelöst zu haben scheint. Die Verbindungen sind facettenreich und vielfältig. Sie verweisen auf eine gemeinsame Geschichte und nicht auf getrennte Kulturen. Die unterschwellige Frage, wie sich die eigene Position auf diesen Ort abstimmen lässt, stellt sich hier nicht mehr. Die Unsicherheit im Hinblick auf die kulturelle Dynamik aus Pākehā- oder Māori-Perspektive ist verschwunden. All die Spannung aus Freemans früheren Arbeiten, deren Hauptaugenmerk auf der drängenden Erkundung der eigenen Identität lag, wurde durch wesentlich subtilere und nuanciertere Kräfte ersetzt. Anders als die oben zitierte Māori erkenne *ich* mich und meine Kultur in TU wieder. Ich begegne dieser Arbeit mit meinen spezifischen Gedanken und Erfahrungen und meinen persönlichen „Aspekten", die von beiden Seiten meiner *whakapapa* geprägt wurden. Ich sehe das TU und das Tū und weiß, dass beide schlüssig sind und auf einer Stufe stehen können. Die Spannung ist in den Arbeiten noch immer gegenwärtig, doch anstelle einer Kollision von Bedeutung und Absicht haben wir es jetzt mit einem ungleich höflicheren Gefecht zwischen Lesart und Form zu tun. Vielleicht ist das ein Zeichen – nicht nur für die Reife Warwick Freemans, sondern auch für die Reife unserer Nation: Sind wir erwachsen geworden oder bloß ein Stück vorangekommen?

WHEN IS A HOOK A HEI MATAU?

1
A Pākehā is a New Zealander of European descent. All translations of te reo Māori (Māori language) words in the footnotes are based on entries in Te Aka Māori Dictionary, https://maoridictionary.co.nz.

2
Whakapapa is genealogy, lineage, ancestry, or descent.

3
Moana Oceania is used here to describe the many island nations of the Pacific Ocean, as well as the ocean itself.

4
Damian Skinner, 'Seeing Pākehā.' Pākehā Now!, edited by Anna-Marie White. The Suter Art Gallery Te Aratoi o Whakatū, 2007, p. 50.

5
Warwick Freeman, quoted in Damian Skinner, editor, Large Star / Rangitoto Heart: A Birthday Book in Honour of Warwick Freeman, published on the occasion of Warwick Freeman's 55th birthday, 5 January 2008. Rim Books, Auckland 2008, p. 111.

6
Amanda Thomas, 'Pākehā and Doing the Work of Decolonisation.' Imagining Decolonisation, edited by Anna Hodge. Bridget Williams Books, 2021, p. 111.

7
Debra Hunt, 'Hey White Women: Māori Culture Is Not Your Birthright.' E-Tangata, 24 May 2020. https://e-tangata.co.nz/reflections/hey-white-women-maori-culture-is-not-your-birthright/ (15.10.2024).

8
A hei tiki is a figurative Māori adornment made from highly prized pounamu, and is the representation of a significant ancestor.

9
Pounamu is greenstone or nephrite, and a kuru is an ornament made of pounamu.

10
A tupuna is an ancestor.

11
Mauri is the life-force or essence of something, and mana is prestige or authority.

12
Rangihīroa Panoho, 'Maori: At the Centre, on the Margins.' Headlands: Thinking Through New Zealand Art, edited by Mary Barr. Museum of Contemporary Art, 1992, p. 124.

13
Warwick Freeman, quoted in Damian Skinner, editor, Large Star / Rangitoto Heart: A Birthday Book in Honour of Warwick Freeman, p. 103.

14
A manaia is a stylised bird-like figure seen in carvings.

15
Ludwig Wittgenstein, Philosophical Investigations, Trans. G.E.M. Anscombe, Basil Blackwell, (1953) 1978, p. 194.

16
A kapeu is a greenstone ornament with a curved end, worn in the ear or around the neck.

17
Warwick Freeman, quoted in Damian Skinner, editor, Large Star /

1
Pākehā sind Neuseeländer europäischer Abstammung. Alle Übersetzungen aus der māorischen Sprache oder te reo Māori in den Anmerkungen basieren auf Einträgen aus dem Onlinewörterbuch Te Aka Māori Dictionary (https://maoridictionary.co.nz).

2
Whakapapa bedeutet Genealogie, Abstammung, Herkunft oder Stammbaum.

3
Moana Oceania steht hier für die vielen Inselvölker im Pazifischen Ozean und für den Ozean selbst.

4
Damian Skinner, „Seeing Pākehā", in: Anna-Marie White (Hg.), Pākehā Now!, Ausst.-Kat. The Suter Art Gallery Te Aratoi o Whakatū, Nelson 2007, S. 50.

5
Warwick Freeman zit. n. Damian Skinner (Hg.), Large Star / Rangitoto Heart: A Birthday Book in Honour of Warwick Freeman, anlässlich des 55. Geburtstags von Warwick Freeman veröffentlicht, 5. Januar 2008, Auckland 2008, S. 111.

6
Amanda Thomas, „Pākehā and Doing the Work of Decolonisation", in: Anna Hodge (Hg.), Imagining Decolonisation, Wellington 2021, S. 111.

7
Debra Hunt, „Hey, White Women: Māori Culture Is Not Your Birthright", in: E-Tangata, 24. Mai 2020, https://e-tangata.co.nz/reflections/hey-white-women-maori-culture-is-not-your-birthright/ (15.10.2024).

8
Hei tiki sind figurative māorische Schmuckstücke aus hoch geschätztem pounamu (siehe Anm. 9), die bedeutende Vorfahren repräsentieren.

9
Pounamu bezeichnet Grünstein oder Nephrit, die langen, geraden kuru sind Schmuckstücke aus pounamu-Reststücken.

10
Tupuna sind Vorfahren.

11
Mauri ist die Lebenskraft oder Natur einer Sache, mana bedeutet Ansehen oder Autorität.

12
Rangihīroa Panoho, „Maori: At the Centre, on the Margins", in: Mary Barr (Hg.), Headlands: Thinking Through New Zealand Art, Ausst.-Kat. Museum of Contemporary Art, Sydney 1992, S. 124.

13
Warwick Freeman zit. n. Skinner 2008 (wie Anm. 5), S. 103.

14
Eine manaia ist eine stilisierte vogelähnliche Figur, die in Schnitzereien vorkommt.

15
Burmester-Schablonen sind Kurvenlineale, die u.a. beim technischen Zeichnen zum Einsatz kommen.

16
Ludwig Wittgenstein, Philosophische Untersuchungen, Werkausgabe, Bd. 1, Frankfurt a. M. 2014, S. 519–522.

Rangitoto Heart: A Birthday Book in Honour of Warwick Freeman, pp. 188-89.

18
A hei matau is a fishhook-shaped pendant.

19
A taonga is a treasure and is applied to anything considered to be of value, including socially or culturally valuable objects, resources, phenomena, ideas, and techniques.

20
Te Tiriti o Waitangi, or the Treaty of Waitangi, is New Zealand's founding document. Te Tiriti is an agreement, in Māori and English, that was made between the British Crown and about 540 Māori rangatira (chiefs). It takes its name from the place in the Bay of Islands where it was first signed on 6 February 1840.

21
A pūrākau is a historical or legendary story.

22
Warwick Freeman, from an unpublished set of notes prepared for Hiko Mizuno College of Jewellery, Tokyo, providing details about the seventeen pieces of his jewellery in their collection. Warwick Freeman archive, Works in Private and Institutional Collections, Box 1.

23
Warwick Freeman, lecture transcript, 'All About Me.' Delivered at the invitation of Die Neue Sammlung - The Design Museum at the Pinakothek der Moderne, Munich, 10 March 2013. Warwick Freeman archive, Lectures Folder, p. 13.

24
An atua is a god-like being.

17
Ein *kapeu* ist ein Schmuckstück aus Grünstein mit gekrümmter Spitze, das am Ohr oder um den Hals getragen wird.

18
Warwick Freeman zit. n. Skinner 2008 (wie Anm. 5), S. 188-189.

19
Ein *hei matau* ist ein Anhänger in Angelhakenform.

20
Als *taonga* werden Schätze im Sinne von gesellschaftlich oder kulturell wertvollen Objekten, Ressourcen, Ideen, Phänomenen oder Techniken bezeichnet.

21
Te Tiriti o Waitangi, der Vertrag von Waitangi, ist die Gründungsurkunde Neuseelands. Das in englischer und māorischer Sprache abgefasste Abkommen wurde zwischen der britischen Krone und rund 540 māorischen *rangatira* (Häuptlingen) geschlossen. Seinen Namen verdankt es dem Ort in der Bay of Islands, wo es am 6. Februar 1840 unterzeichnet wurde.

22
Eine *pūrākau* ist eine historische Geschichte oder Legende.

23
Warwick Freeman, unveröffentlichte Notizen für das Hiko Mizuno College of Jewelry, Tokio, mit Detailangaben zu den 17 von ihm gefertigten Schmuckstücken in der dortigen Sammlung, Archiv Warwick Freeman, Arbeiten in privaten und institutionellen Sammlungen, Schachtel 1.

24
Warwick Freeman, Abschrift des Vortrags „All About Me", gehalten in der Pinakothek der Moderne, München, 10. März 2013, Archiv Warwick Freeman, Vortragsmappe, S. 13.

25
Ein *atua* ist ein gottähnliches Wesen.

06
THE WORKS

OLD SCHOOL
EMBLEM
PĀKEHĀ
FLORA
FOUND
MUSEUM
BIRD
FACE
HEART
PILLOW
STAR
RING
CIRCLE
APPROPRIATION
WALL WORK
HAND
PLACE
ARM
HOOK
OLD BRAIN
BEADWORK
MYTH
PATTERN
SENTENCES

DIE WERKE 06

ALTE SCHULE
EMBLEM
PĀKEHĀ
FLORA
GEFUNDEN
MUSEUM
VOGEL
GESICHT
HERZ
KISSEN
STERN
RING
KREIS
ANEIGNUNG
WANDARBEITEN
HAND
ORT
ARM
HAKEN
ALTES GEHIRN
PERL-ARBEITEN
MYTHOS
MUSTER
SENTENZEN

OLD SCHOOL

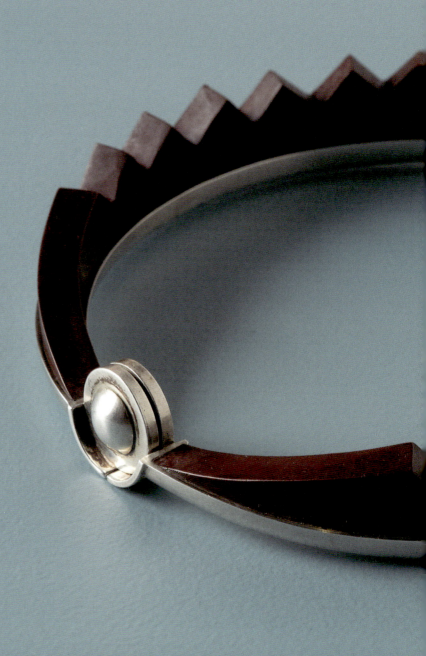

Choker
Trap, 1978
Rubber, silver
12.5 cm diameter

Halsschmuck
Falle, 1978
Gummi, Silber
Dm. 12,5 cm

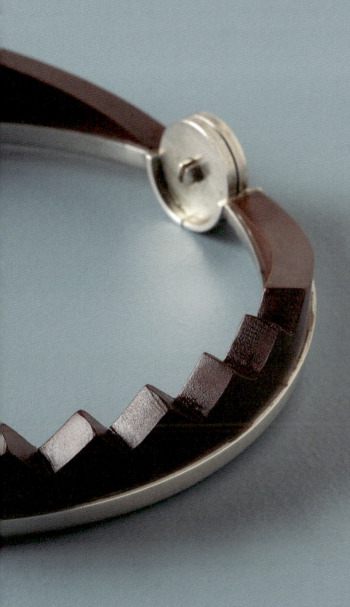

ALTE SCHULE

OLD SCHOOL

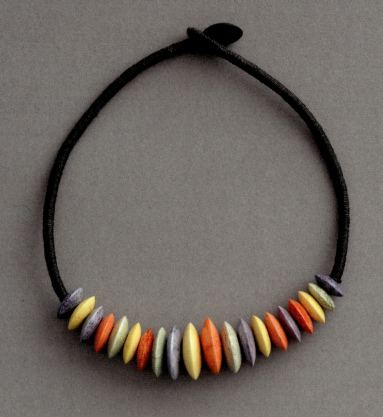

ALTE SCHULE

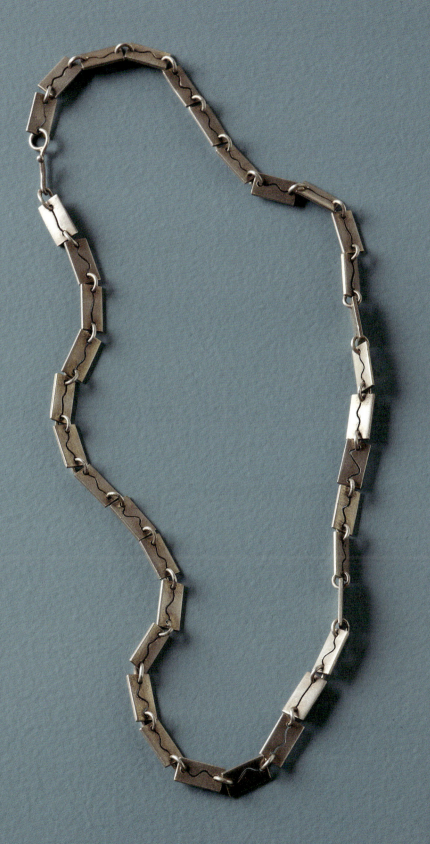

Left: <u>Lollipop Necklace and Kete</u>, 1980
Kete by Fine Motu
Dyed bone, cord, plastic strapping
Necklace: 40.3 cm;
kete: 10 × 16 × 4 cm
The Dowse Art Museum, Lower Hutt, purchased 1983

Links: <u>Lollipop-Halsschmuck und gewebtes Täschchen</u>, 1980
Täschchen von Fine Motu
Gefärbter Knochen, Kordel, Kunststoffbänder
Halsschmuck: 40,3 cm, Täschchen: 10 × 16 × 4 cm
The Dowse Art Museum, Lower Hutt, erworben 1983

Necklace
<u>Squiggle</u>, 1972
Silver
37 cm overall length

Halsschmuck
<u>Schnörkel</u>, 1972
Silber
Gesamtlänge: 37 cm

OLD SCHOOL

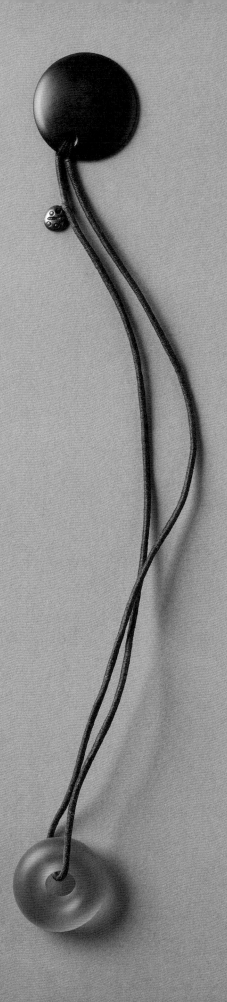

Pendant
<u>Nape Disc and Bead</u>, 1985
Lead crystal, argillite,
silver, cord
51 cm overall length

Anhänger
<u>Nackenscheibe und Perle</u>,
1985
Bleikristall, Argillit
(Tongestein), Silber,
Kordel
Gesamtlänge: 51 cm

Right: Pendant
<u>Cross</u>, 1985
Argillite, silver, cord
5 × 5 × 2.5 cm

Rechts: Anhänger
<u>Kreuz</u>, 1985
Argillit (Tongestein),
Silber, Kordel
5 × 5 × 2,5 cm

ALTE SCHULE

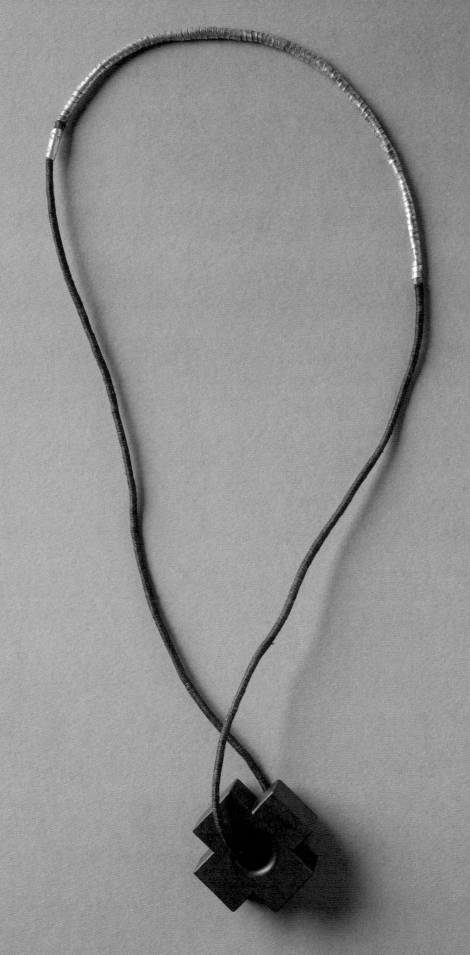

121

EMBLEM

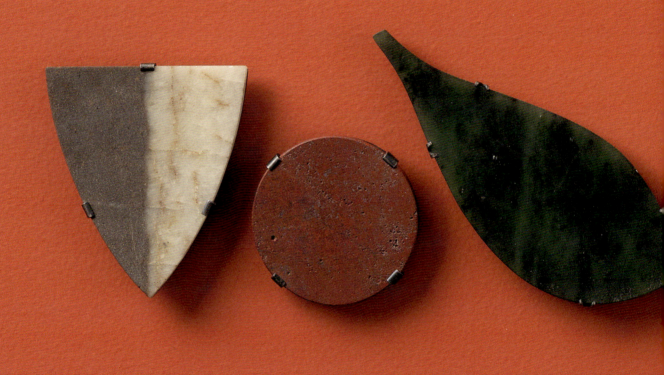

EMBLEM

Brooches
<u>Insignia</u>, 1997
Sandstone, quartz;
jasper; nephrite;
pearl shell; turtle
shell; bone; silver
Various dimensions
Warwick Freeman and
Schmuckmuseum Pforzheim

Broschen
<u>Insignia</u>, 1997
Sandstein, Quarz, Jaspis,
Nephrit, Perlmuschel,
Schildkrötenpanzer,
Knochen, Silber
Verschiedene Maße
Warwick Freeman und
Schmuckmuseum Pforzheim

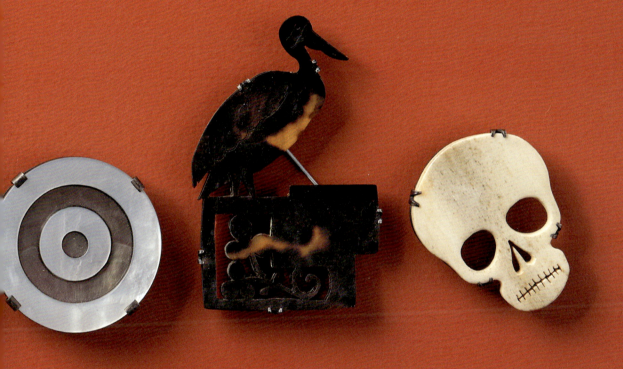

PĀKEHĀ

Brooch
White Butterfly, 2000
Silver, paint
1 × 2,1 cm

Brosche
Weißer Schmetterling, 2000
Silber, Farbe
1 × 2,1 cm

PĀKEHĀ

Brooch
Brown Butterfly, 2000
Oxidised steel,
oxidised silver
3.5 × 7.5 cm
The Dowse Art Museum,
Lower Hutt, purchased
2000

Brosche
Brauner Schmetterling,
2000
Geschwärzter Stahl,
geschwärztes Silber
3,5 × 7,5 cm
The Dowse Art Museum,
Lower Hutt, erworben 2000

PĀKEHĀ

Brooch
Pearl Tusk, 2003
Pearl shell
12 × 2 cm

Brosche
Perlmutt-Stoßzahn, 2003
Perlmuschel
12 × 2 cm

PĀKEHĀ

Pendant
Antlers, 2004
Bone
9.4 × 3.2 cm

Anhänger
Geweih, 2004
Knochen
9,4 × 3,2 cm

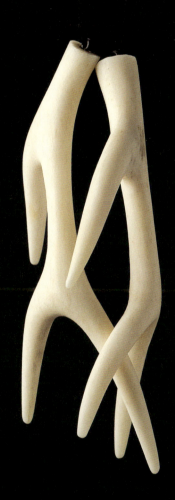

PĀKEHĀ

Pendant
T.T.2, 1994
Bone
11.5 × 6 cm

Anhänger
T.T.2, 1994
Knochen
11,5 × 6 cm

PĀKEHĀ

Bar Brooches, 2009
Basalt, opalized wood,
jasper, petrified wood,
oxidised silver
Each: 6.5 × 1.5 cm

Stab-Broschen, 2009
Basalt, opalisiertes
Holz, Jaspis,
versteinertes Holz,
geschwärztes Silber
Jede: 6,5 × 1,5 cm

PĀKEHĀ

Brooch
Spiral, 1992
Oxidised silver
6 × 7.9 cm

Brosche
Spirale, 1992
Geschwärztes Silber
6 × 7,9 cm

PĀKEHĀ

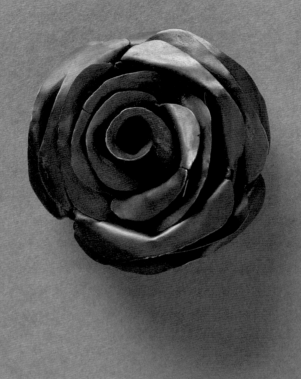

Brooch
<u>Black Rose</u>, 1990
Oxidised silver
5 × 4.7 cm

Brosche
<u>Schwarze Rose</u>, 1990
Geschwärztes Silber
5 × 4,7 cm

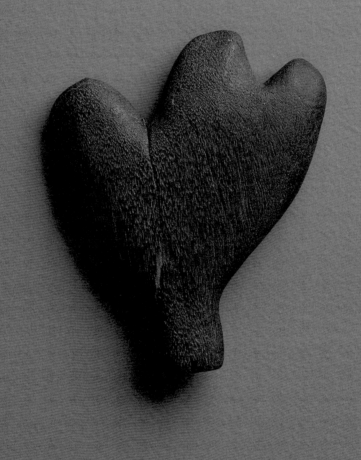

FLORA

Brooch
Black Leaf, 2004
Burnt wood
8 × 7 cm
Museum of New Zealand
Te Papa Tongarewa,
Wellington, purchased
2009

Brosche
Schwarzes Blatt, 2004
Verbranntes Holz
8 × 7 cm
Museum of New Zealand
Te Papa Tongarewa,
Wellington, erworben 2009

FLORA

Brooch
Scallop Blossom, 1994
Scallop shell, gold,
oxidised silver
8 × 8.1 cm
Warwick Freeman and
Schmuckmuseum Pforzheim

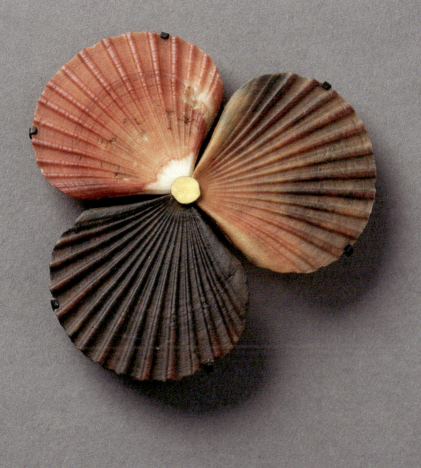

Brosche
Jakobsmuschel-Blüte, 1994
Schale der Jakobsmuschel,
Gold, geschwärztes
Silber,
8 × 8,1 cm
Warwick Freeman und
Schmuckmuseum Pforzheim

FLORA

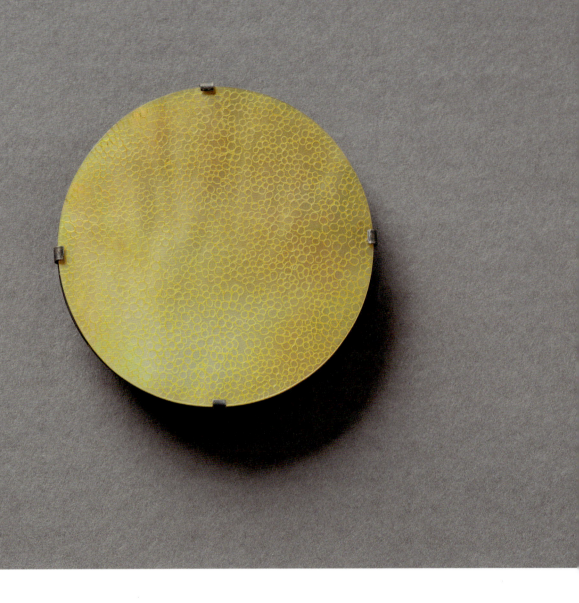

Brooch
Gorse, 2003
Pearl shell,
oxidised silver
6 cm diameter

Brosche
Ginster, 2003
Perlmuschel,
Geschwärztes Silber
Dm. 6 cm

Right: Pendant
Gold Leaf Zinc Leaf, 1992
Gold, zinc, paint
6.5 × 5 cm

Rechts: Anhänger
Gold-Blatt Zink-Blatt, 1992
Gold, Zink, Farbe
6,5 × 5 cm

FLORA

FLORA

Left: Drawing
Wallpaper, 1990
Ink, paper
50 × 65 cm

Links: Entwurf
Tapoto, 1990
Tinte, Papier
50 × 65 cm

Brooch
Leaf Cross, 1994
Gold, stainless steel
7 × 7 cm

Brosche
Blätter-Kreuz, 1994
Gold, Edelstahl
7 × 7 cm

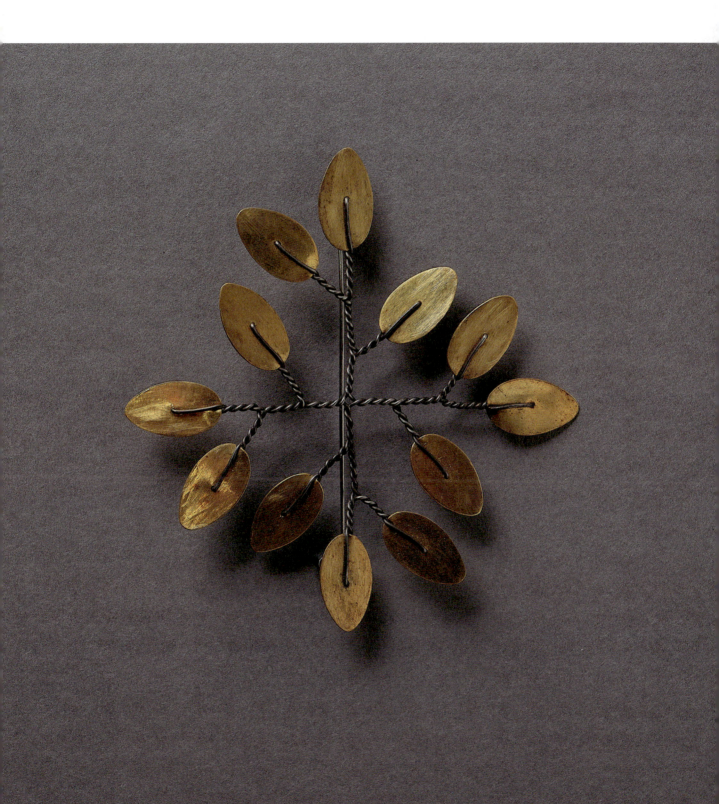

FOUND GEFUNDEN

Brooch
Biscuit Brooch, 1996
Pearl shell, gold
5.5 cm diameter
Private Collection
Katie Battersby and
Ben Corban, Auckland

Brosche
Biskuit-Brosche, 1996
Perlmuschel, Gold
Dm. 5,5 cm
Privatsammlung
Katie Battersby und
Ben Corban, Auckland

Right: Pendant
Holder, 2008
Black jade
10.7 × 4 cm
Private Collection
Anna Miles, Auckland

Rechts: Anhänger
Halter, 2008
Schwarze Jade
10,7 × 4 cm
Privatsammlung
Anna Miles, Auckland

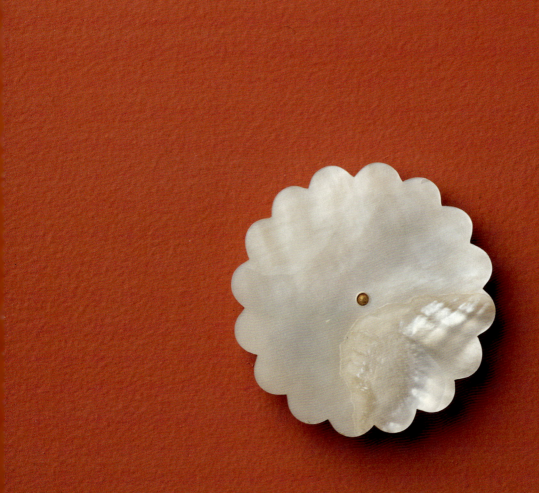

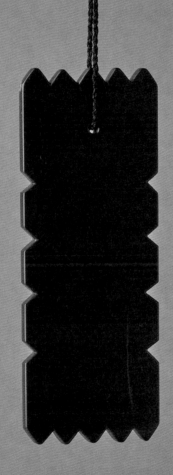

FOUND

Drawing
Box, 2008
Paint, paper
50 × 65 cm

Zeichnung
Box, 2008
Farbe, Papier
50 × 65 cm

Right: Pendant
Box, 2009
Jet
9.6 × 5.9 cm

Rechts: Anhänger
Box, 2009
Jet (Vorstadium von Steinkohle)
9,6 × 5,9 cm

GEFUNDEN

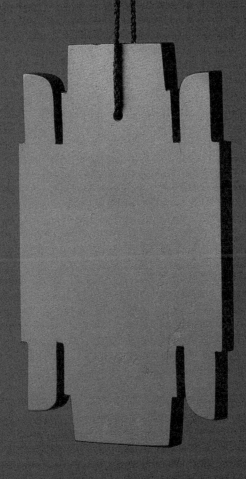

FOUND

GEFUNDEN

Left: Pendant Anchor, 2021 Pearl shell 6.2 × 4 cm	Links: Anhänger Anker, 2021 Perlmuschel 6,2 × 4 cm	Drawing Anchor, 2021 Bottle pull top, graphite, paper 50 × 65 cm	Zeichnung Anker, 2021 Kronkorken, Grafit, Papier 50 × 65 cm

FOUND

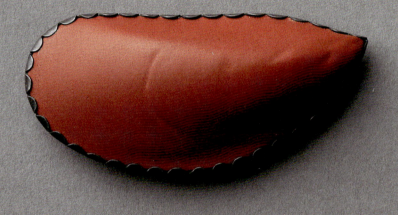

Brooch
Muscle, 2000
Mussel shell, paint,
oxidised silver
4 × 8.8 cm

Brosche
Muskel, 2000
Muschelschale, Farbe,
geschwärztes Silber
4 × 8,8 cm

GEFUNDEN

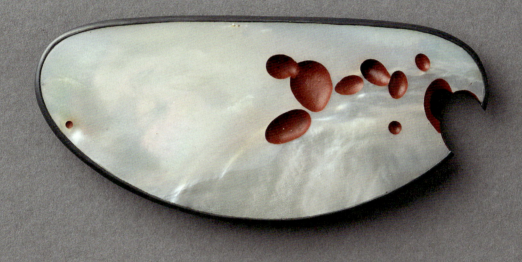

Brooch
Shell Carving, 2004
Pearl shell, paint,
oxidised silver
4.8 x 11 cm

Brosche
Muschel-Schnitzerei, 2004
Perlmuschel, Farbe,
geschwärztes Silber
4,8 x 11 cm

FOUND

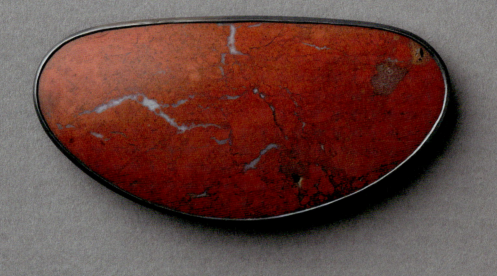

Brooch
Scraper, 2004
Jasper, oxidised silver
5.5 × 11 cm

Brosche
Schaber, 2004
Jaspis, geschwärztes
Silber
5,5 × 11 cm

GEFUNDEN

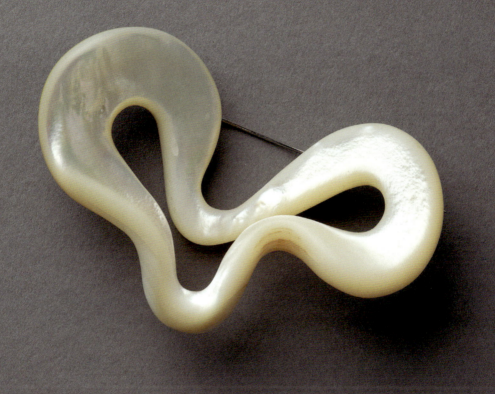

Brooch
Doodle, 2001
Pearl shell
6.5 × 10 cm

Brosche
Gekritzel, 2001
Perlmuschel
6,5 × 10 cm

FOUND

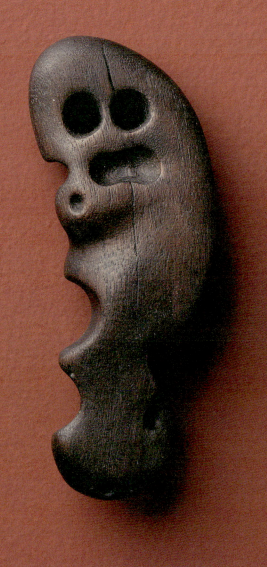

Brooch
Carving, 2000
Wood
9.1 x 3.3 cm

Brosche
Schnitzerei, 2000
Holz
9,1 x 3,3 cm

GEFUNDEN

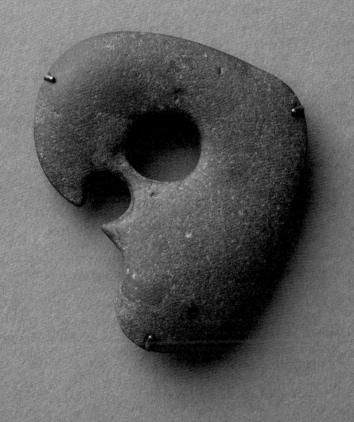

Brooch
Stone Carving, 2004
Found stone, silver
6.7 × 5.8 cm

Brosche
Steinschnitzerei, 2004
Gefundener Stein, Silber
6,7 × 5,8 cm

FOUND

Drawing
Lamp, 1997
Lightbulb box, tape,
graphite, paper
50 × 65 cm

Zeichnung
Glühbirne, 1997
Verpackung einer Glühbirne,
Klebestreifen, Grafit, Papier
50 × 65 cm

GEFUNDEN

Brooch
<u>Lamp</u>, 1997
Pearl shell, oxidised silver
6.2 × 2.8 cm
Warwick Freeman and Private
Collection Den Besten-Reekers,
Netherlands

Brosche
<u>Glühbirne</u>, 1997
Perlmuschel, geschwärztes Silber
6,2 × 2,8 cm
Warwick Freeman und Privatsammlung
Den Besten-Reekers, Niederlande

FOUND

Pendants
<u>Handle</u>, 2009
Various stones
Largest: 9 × 2.8 cm

Anhänger
<u>Griff</u>, 2009
Verschiedene Steine
Max.: 9 × 2,8 cm

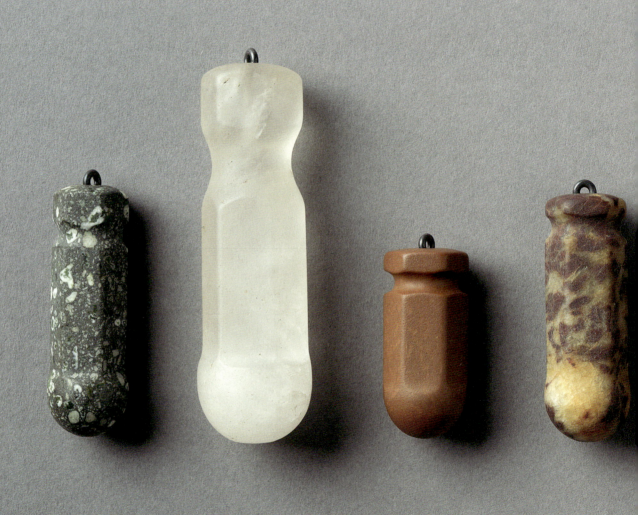

GEFUNDEN

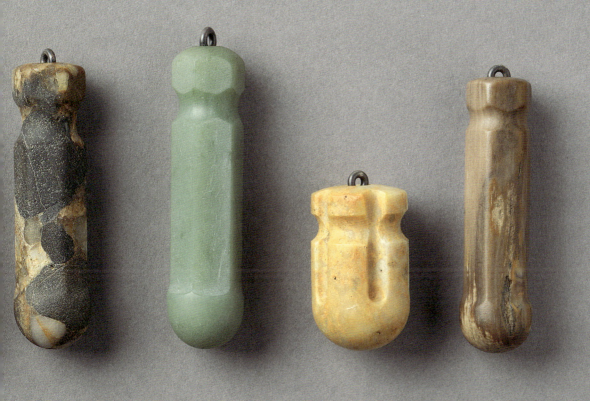

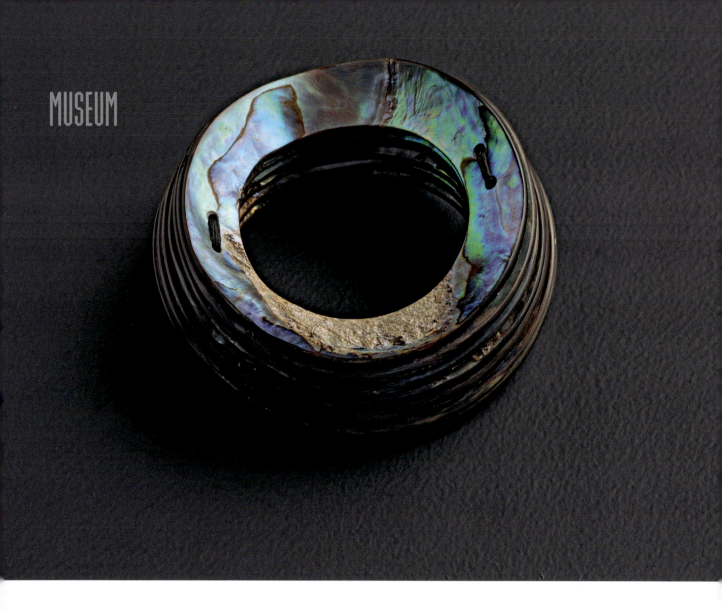

MUSEUM

Pāua Layer Bracelet, 1985
Pāua shell, cord
10.5 cm diameter x 5 cm depth
Auckland Museum Tāmaki Paenga Hira, Auckland, purchased with funds provided by the Charles Edgar Disney Trust, 1994

Pāua-Scheiben Armschmuck, 1985
Schale der Pāua-Schnecke, Kordel
Dm. 10,5 cm, T. 5 cm
Auckland Museum Tāmaki Paenga Hira, Auckland, erworben mit Mitteln des Charles Edgar Disney Trust, 1994

Right: Necklace Bone Bead, 1987
Chicken bone, oxidised silver
290 cm overall length
Museum of New Zealand Te Papa Tongarewa, Wellington, gift of the Friends of the Museum of New Zealand Te Papa Tongarewa, 1993

Rechts: Halsschmuck Knochen-Perlen, 1987
Hühnerknochen, geschwärztes Silber
Gesamtlänge: 290 cm
Museum of New Zealand Te Papa Tongarewa, Wellington, Schenkung Friends of the Museum of New Zealand Te Papa Tongarewa, 1993

MUSEUM

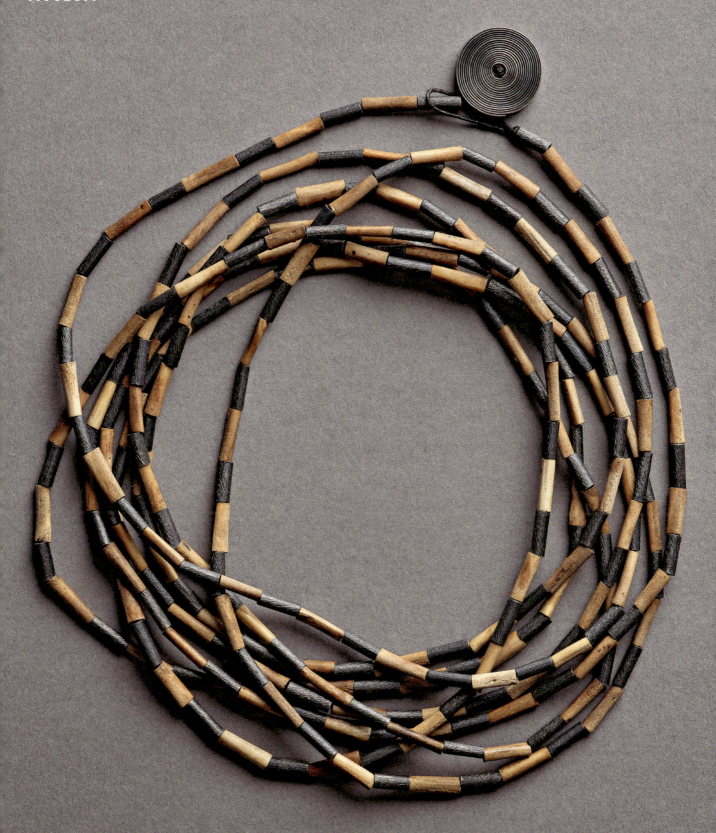

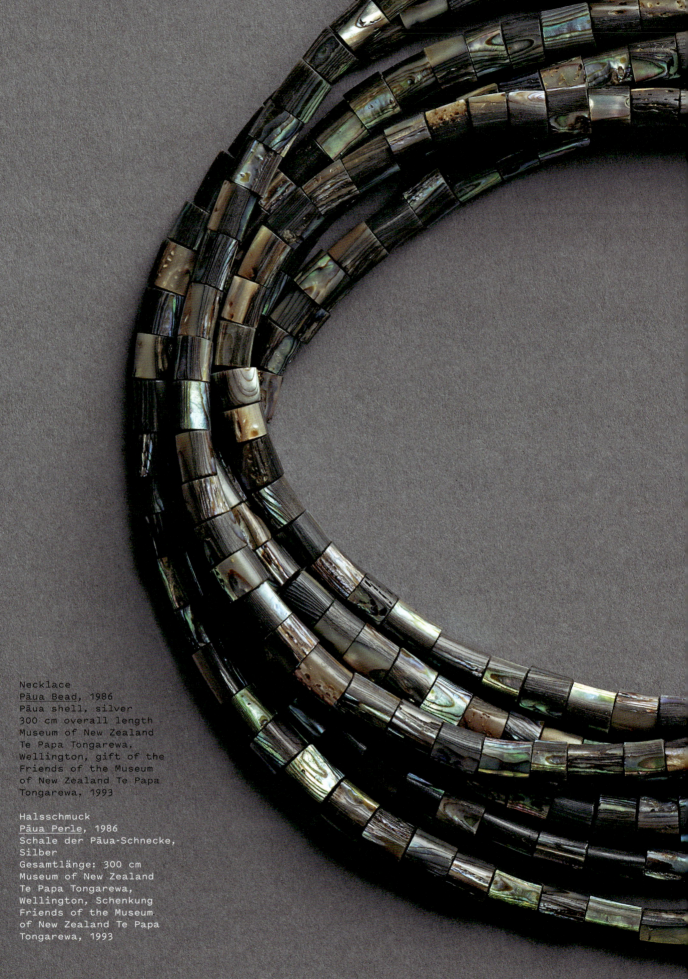

Necklace
<u>Pāua Bead</u>, 1986
Pāua shell, silver
300 cm overall length
Museum of New Zealand
Te Papa Tongarewa,
Wellington, gift of the
Friends of the Museum
of New Zealand Te Papa
Tongarewa, 1993

Halsschmuck
<u>Pāua Perle</u>, 1986
Schale der Pāua-Schnecke,
Silber
Gesamtlänge: 300 cm
Museum of New Zealand
Te Papa Tongarewa,
Wellington, Schenkung
Friends of the Museum
of New Zealand Te Papa
Tongarewa, 1993

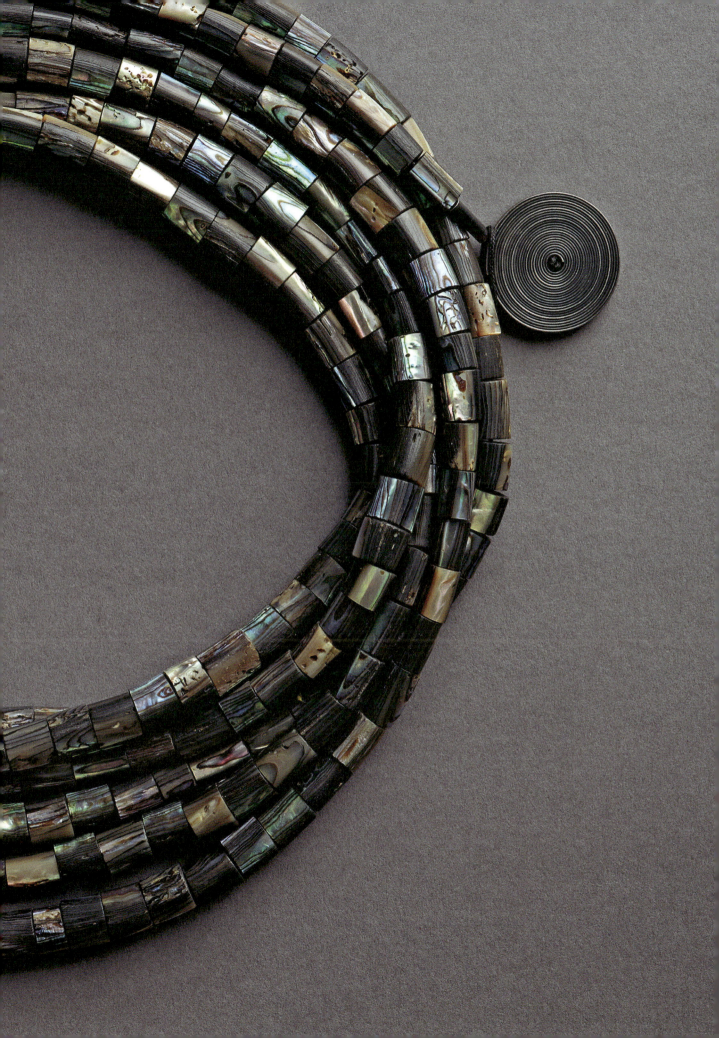

MUSEUM

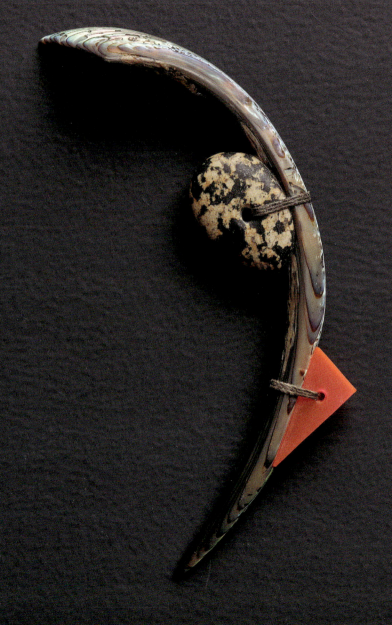

MUSEUM

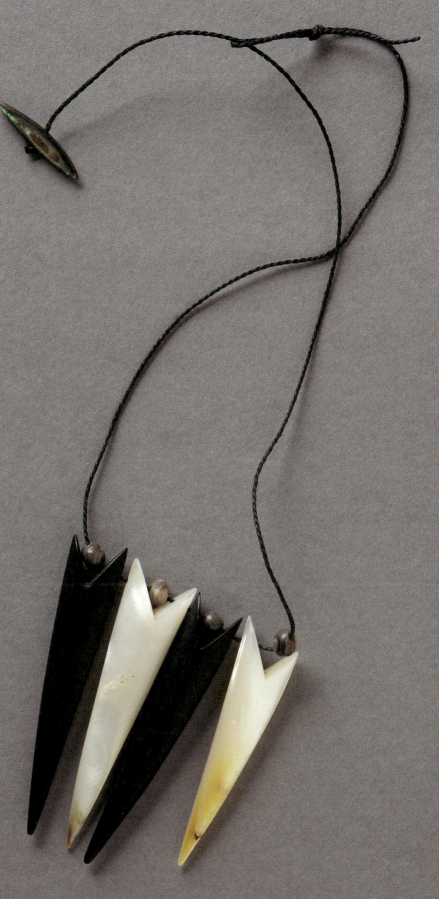

Left: Brooch
Lure, 1984
Pāua shell, pebble,
acrylic, cord
12.6 × 6 × 2.4 cm
Museum of New Zealand
Te Papa Tongarewa,
Wellington, purchased 2009

Links: Brosche
Köder, 1984
Schale der Pāua-Schnecke,
Kieselstein, Kunststoff,
Kordel
12,6 × 6 × 2,4 cm
Museum of New Zealand
Te Papa Tongarewa,
Wellington, erworben 2009

Necklace
4 Fish, 1986
Pearl shell, wood,
pāua shell, cord
7.2 × 6.6 cm

Halsschmuck
4 Fische, 1986
Perlmuschel, Holz,
Schale der Pāua-Schnecke,
Kordel
7,2 × 6,6 cm

MUSEUM

Circle Necklace, 1984
Pāua shell, turtle shell, pinna shell, pearl shell, acrylic, cord
Circles: 4 × 4 cm;
13 cm overall length

Scheiben-Halsschmuck, 1984
Schale der Pāua-Schnecke, Schildkrötenpanzer, Pinna-Muschel, Perlmuschel, Kunststoff, Kordel
Scheiben: 4 × 4 cm,
Gesamtlänge: 13 cm

Right: Pendant
Breastplate, 1985
Pearl shell, plastic, copper, cord
9.3 × 13.5 cm
Auckland Museum Tāmaki Paenga Hira, Auckland

Rechts: Anhänger
Brustplatte, 1985
Perlmuschel, Kunststoff, Kupfer, Kordel
9,3 × 13,5 cm
Auckland Museum Tāmaki Paenga Hira, Auckland

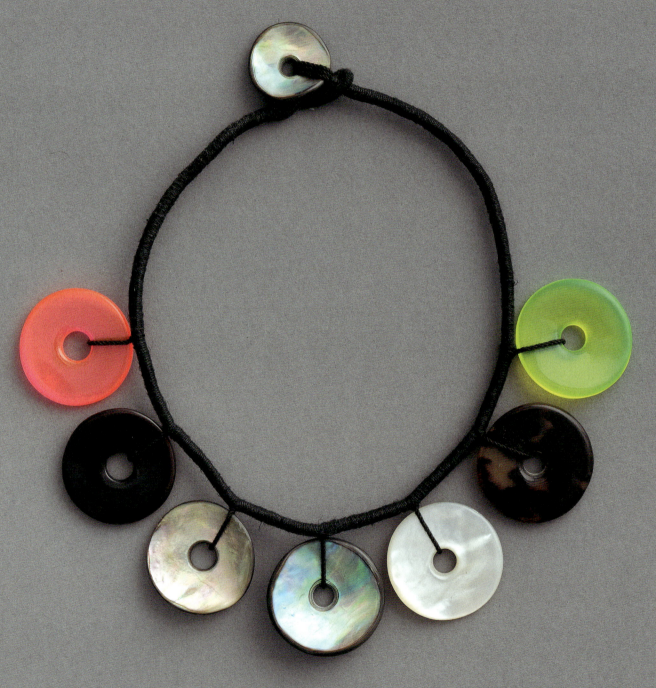

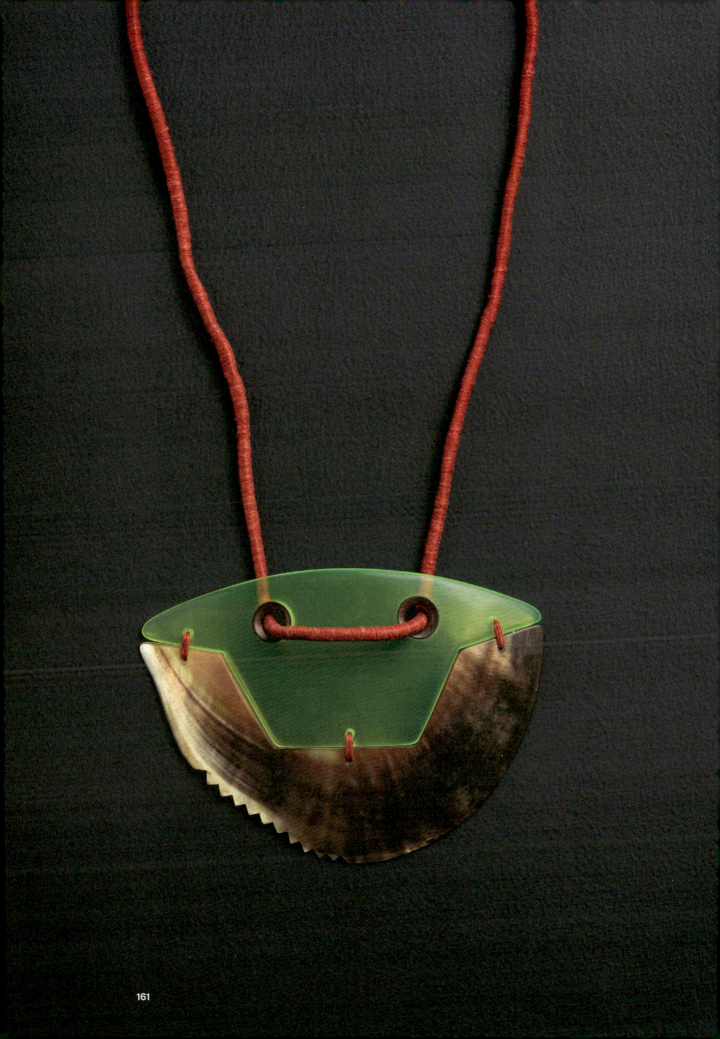

MUSEUM

Pin
Made in Fiji, 1983
Fish bone, seeds,
pebble, fibre
9.2 × 10.4 cm
The Dowse Art
Museum, Lower Hutt,
purchased 1983

Nadel
Made in Fiji, 1983
Fischgräte, Samenkörner,
Kieselstein, Fasern
9,2 × 10,4 cm
The Dowse Art Museum,
Lower Hutt, erworben 1983

MUSEUM

Earrings
Moth, 1986
Wood, turtle shell,
silver
9 × 4 cm

Ohrschmuck
Motte, 1986
Holz, Schildkrötenpanzer,
Silber
9 × 4 cm

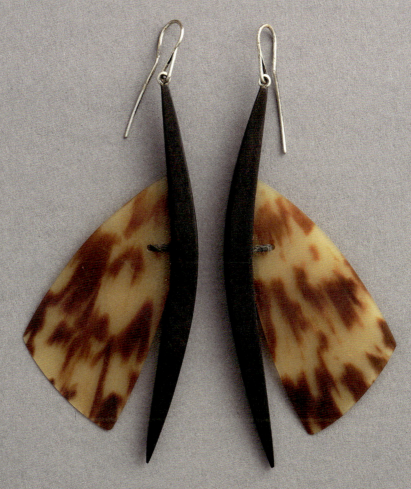

BIRD

VOGEL

Left: Gannet
Photo: Warwick Freeman

Links: Basstölpel
Foto: Warwick Freeman

Pendant
White Bird, 2004
Corian
8.5 × 8.3 cm

Anhänger
Weißer Vogel, 2004
Corian
8,5 × 8,3 cm

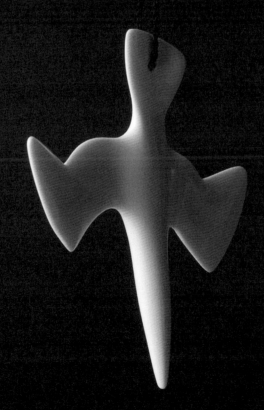

BIRD

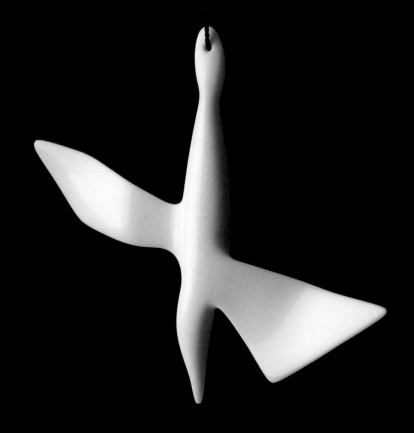

Pendants
White Bird, 2004
Corian
Left: 10.5 × 11.8 cm;
Right: 11.3 × 5.4 cm

Anhänger
Weißer Vogel, 2004
Corian
Links: 10,5 × 11,8 cm,
Rechts: 11.3 × 5.4 cm

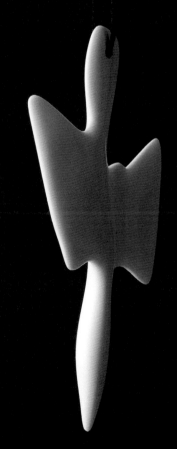

BIRD

Pendant
Small Bird, 2017
Carnelian
7 × 6.5 cm

Anhänger
Kleiner Vogel, 2017
Karneol
7 × 6,5 cm

Right: Pendants
Duck, 2019
Jade; concretion;
lapis lazuli
Left: 5.6 × 2.8 cm;
Middle: 7 × 3.6 cm;
Right: 7.2 × 4.2 cm

Rechts: Anhänger
Ente, 2019
Jade, Konkretion,
Lapislazuli
Links: 5,6 × 2,8 cm,
Mitte: 7 × 3,6 cm,
Rechts: 7,2 × 4,2 cm

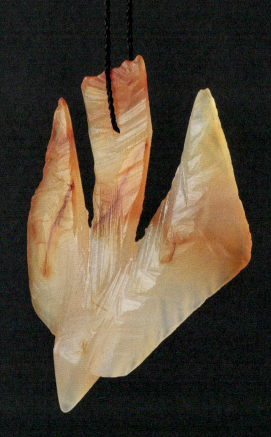

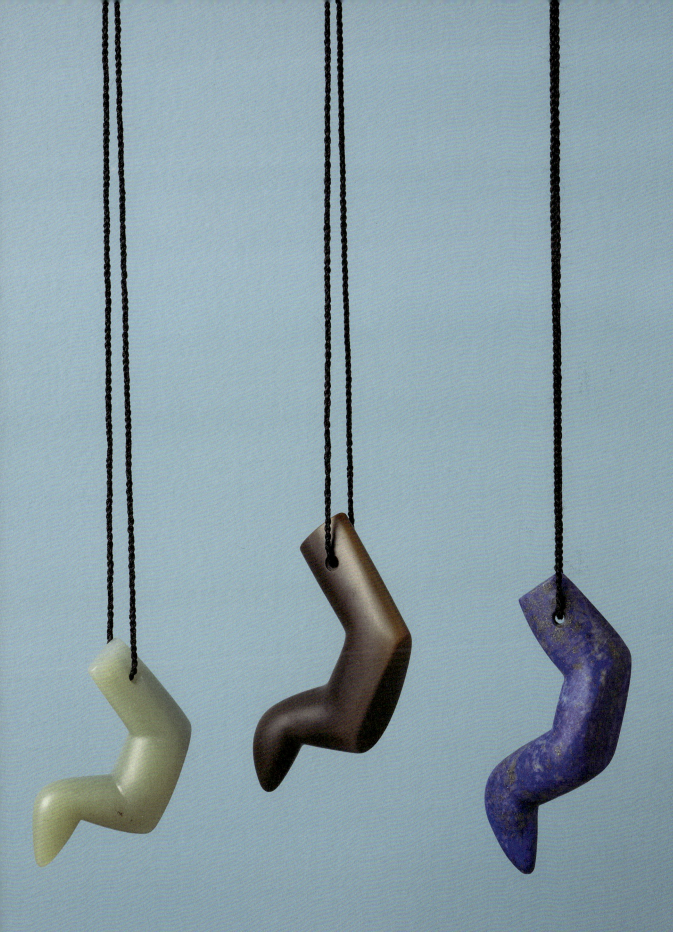

BIRD

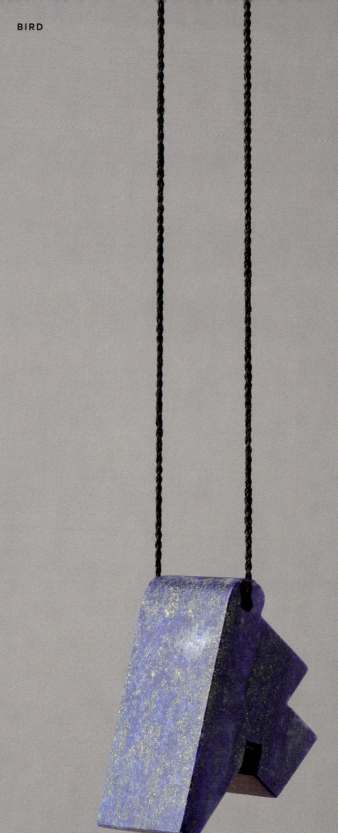

VOGEL

Left: Pendant
Bracket Bird, 2009
Lapis lazuli
5.3 × 3.1 × 3 cm

Links: Anhänger
Klammer-Vogel, 2009
Lapislazuli
5,3 × 3,1 × 3 cm

Brooches
Red Bird Black Bird, 2019
Basalt; jasper
Red Bird: 3.8 × 11 cm;
Black Bird: 5.8 × 10.5 cm

Broschen
Roter Vogel Schwarzer
Vogel, 2019
Basalt, Jaspis
Roter Vogel: 3,8 × 11 cm,
Schwarzer Vogel:
5,8 × 10,5 cm

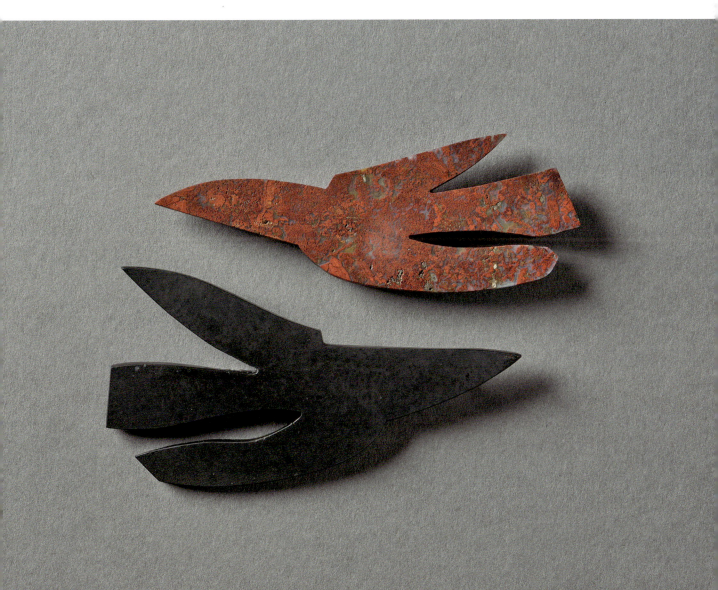

171

Brooch
<u>Ape</u>, 2003
Pāua shell,
oxidised silver
4.9 × 4.4 cm

Brosche
<u>Affe</u>, 2003
Schale der Pāua-Schnecke,
geschwärztes Silber
4,9 × 4,4 cm

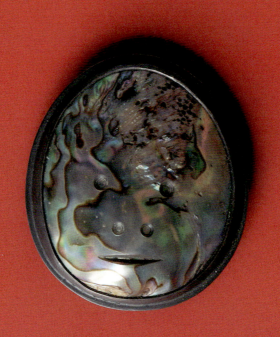

FACE

GESICHT

Brooch
Fetish Face, 2015
Jasper dust and binder,
oxidised silver, wood
8.5 × 7.5 cm
Private Collection Samuel
Holloway and Michael
Lett, Auckland

Brosche
Fetisch-Gesicht, 2015
Jaspis-Staub,
Bindemittel, geschwärztes
Silber, Holz
8,5 × 7,5 cm
Privatsammlung Samuel
Holloway und Michael
Lett, Auckland

FACE

Brooch
Mask, 2007
Gold
15 × 9.6 cm

Brosche
Maske, 2007
Gold
15 × 9,6 cm

GESICHT

Brooches
White Ghost, Green Ghost,
Orange Ghost, 2003
Corian
Various dimensions
Warwick Freeman and
Die Neue Sammlung – The
Design Museum

Brooches
White Ghost, Green Ghost,
Orange Ghost, 2003
Corian
Verschiedene Maße
Warwick Freeman und
Die Neue Sammlung – The
Design Museum

FACE

Brooches
Face Ache, 2007
Horse tooth,
oxidised silver
Various dimensions

Broschen
Gesichtsschmerzen, 2007
Pferdezahn, geschwärztes
Silber
Verschiedene Maße

GESICHT

Brooches Broschen
Fella, 2004 Kumpel, 2004
Scoria Vulkanische Schlacke
Various dimensions Verschiedene Maße

HEART

Brooch
Star Heart, 1989
Pearl shell, scoria,
gold bead, paint
6.6 × 3.8 cm

Brosche
Sternen-Herz, 1989
Perlmuschel, vulkanische
Schlacke, Goldperle, Farbe
6,6 × 3,8 cm

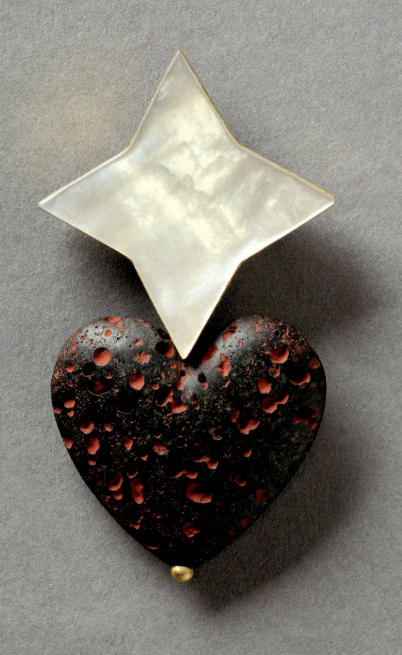

HERZ

Brooch
Rangitoto Heart, 1992
Scoria, paint, gold,
oxidised silver
5.2 × 5.7 cm

Brosche
Rangitoto Herz, 1992
Vulkanische Schlacke,
Farbe, Gold, geschwärztes
Silber
5,2 × 5,7 cm

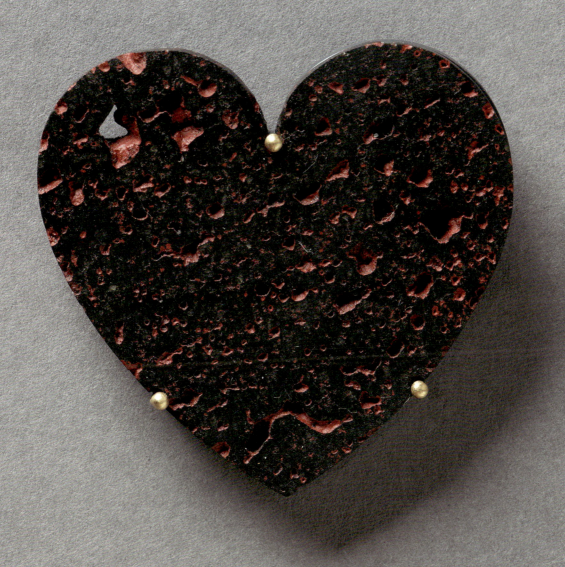

HEART

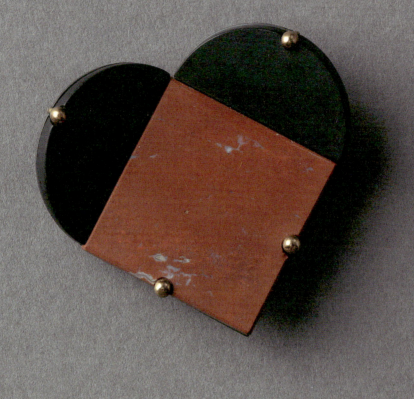

HERZ

Left: Brooch Folding Heart, 1997 Jasper, argillite, gold 4.5 × 4.7 cm Private Collection Ewan Brown and Judi Keith-Brown, Wellington	Links: Brosche Gefaltetes Herz, 1997 Jaspis, Argillit (Tongestein), Gold 4,5 × 4,7 cm Privatsammlung Ewan Brown und Judi Keith- Brown, Wellington	Drawing Folding Heart, 1997 Paint, ink, graphite, paper 50 × 65 cm	Zeichnung Gefaltetes Herz, 1997 Farbe, Tinte, Grafit, Papier 50 × 65 cm

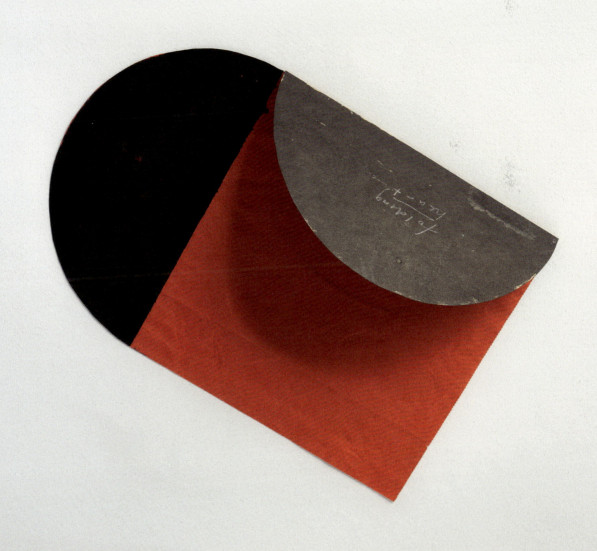

HEART

Brooch
Kawakawa Leaf, 2000
Nephrite, oxidised silver
6.5 × 6 cm
The Dowse Art Museum,
Lower Hutt, purchased
2000

Brosche
Kawakawa-Blatt, 2000
Nephrit, geschwärztes
Silber
6,5 × 6 cm
The Dowse Art Museum,
Lower Hutt, erworben
2000

HERZ

Brooch
White Heart, 1999
Scallop shell,
oxidised silver
9 × 4 cm
The Dowse Art Museum,
Lower Hutt, purchased
2000

Brosche
Weißes Herz, 1999
Schale der Jakobsmuschel,
geschwärztes Silber
9 × 4 cm
The Dowse Art Museum,
Lower Hutt, erworben 2000

PILLOW

Necklace
<u>Pearl Pillow</u>, 1992
Pearl shell,
oxidised silver
81.2 cm overall length
Private Collection
Barbara Kirshenblatt-
Gimblett, New York

Halsschmuck
<u>Perl-Kissen</u>, 1992
Perlmuschel, geschwärztes
Silber
Gesamtlänge: 81,2 cm
Privatsammlung Barbara
Kirshenblatt-Gimblett,
New York

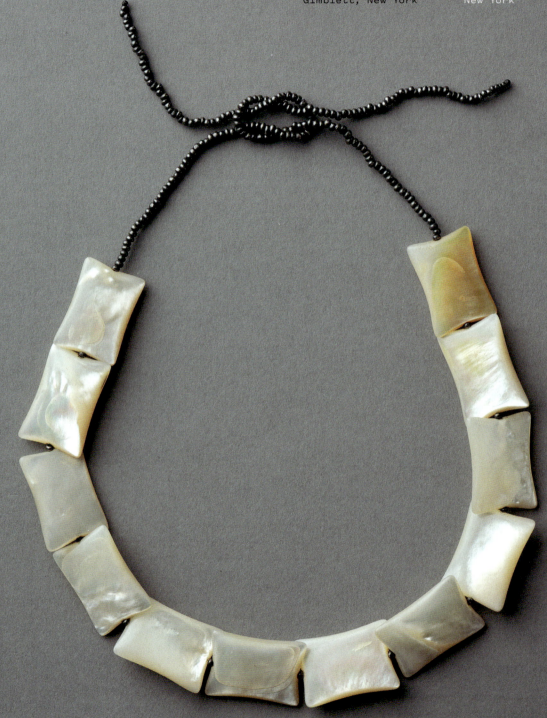

KISSEN

Necklace
Wood Pillow, 1992
Wood, oxidised silver
89 cm overall length

Halsschmuck
Hölzernes Kissen, 1992
Holz, geschwärztes Silber
Gesamtlänge: 89 cm

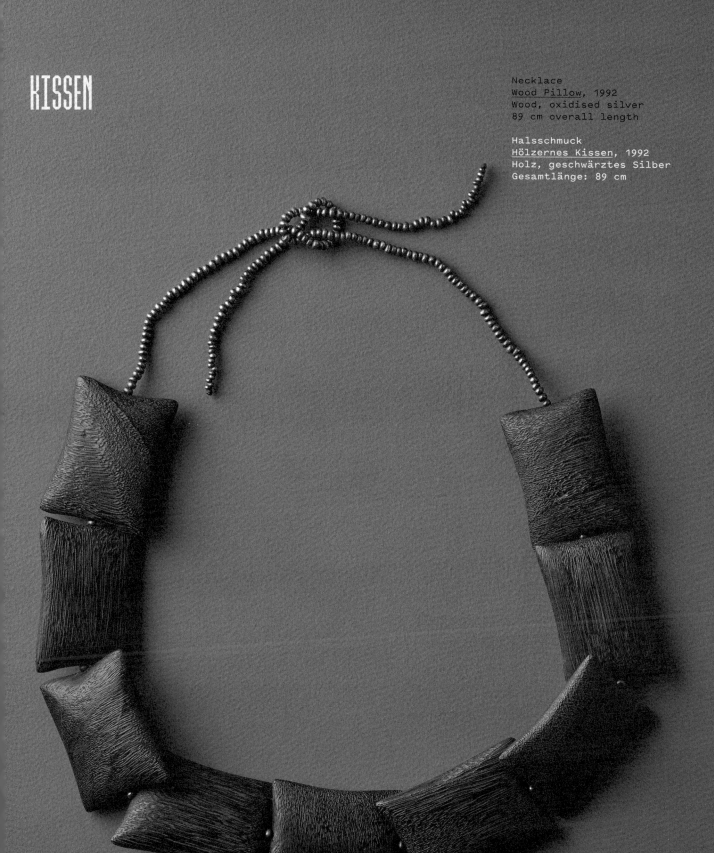

STAR

Brooch
Hard Star, 1991
Stainless steel
8.5 × 8.5 cm
Warwick Freeman and
Die Neue Sammlung – The
Design Museum. Permanent
loan from the Danner-
Stiftung Munich

Brosche
Harter Stern, 1991
Edelstahl
8,5 × 8,5 cm
Warwick Freeman und
Die Neue Sammlung –
The Design Museum.
Dauerleihgabe der Danner-
Stiftung München

STERN

Brooch
Soft Star, 1991
Pearl shell
8 × 8 cm
Warwick Freeman and
Die Neue Sammlung – The
Design Museum. Permanent
loan from the Danner-
Stiftung Munich

Brosche
Weicher Stern, 1991
Perlmuschel
8 × 8 cm
Warwick Freeman und
Die Neue Sammlung –
The Design Museum.
Dauerleihgabe der Danner-
Stiftung München

Drawing
Green Star, 1991
Pohutukawa leaf,
graphite, paper
50 × 65 cm

Zeichnung
Grüner Stern, 1991
Pohutukawa-Blatt,
Grafit, Papier
50 × 65 cm

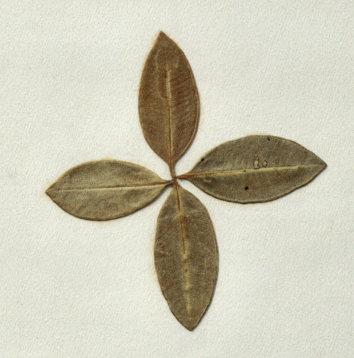

STERN

Brooch
Green Star, 1991
Nephrite, gold
6.5 × 6.5 cm

Brosche
Grüner Stern, 1991
Nephrit, Gold
6,5 × 6,5 cm

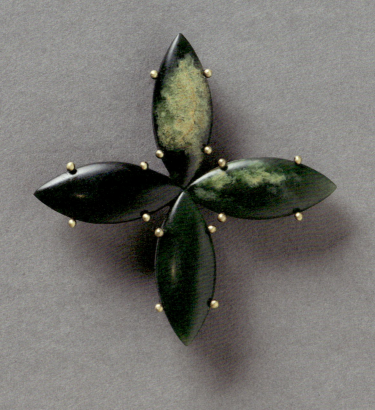

STAR

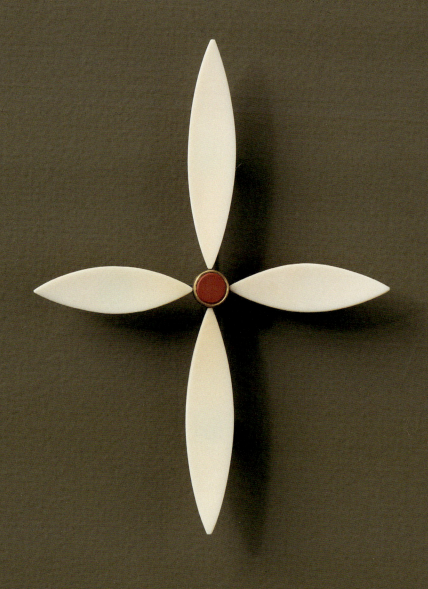

Brooch
<u>Flower Star</u>, 1992
Baler shell, gold,
jasper
12 × 8 cm
Warwick Freeman and
Die Neue Sammlung – The
Design Museum. Permanent
loan from the Danner-
Stiftung Munich

Brosche
<u>Blüten-Stern</u>, 1992
Gehäuse der
Melonenschnecke, Gold,
Jaspis
12 × 8 cm
Warwick Freeman und
Die Neue Sammlung –
The Design Museum.
Dauerleihgabe der
Danner-Stiftung München

STERN

Brooch
<u>Gull Star</u>, 1994
Pearl shell, jasper
10 × 9.8 cm

Brosche
<u>Möwenstern</u>, 1994
Perlmuschel, Jaspis
10 × 9,8 cm

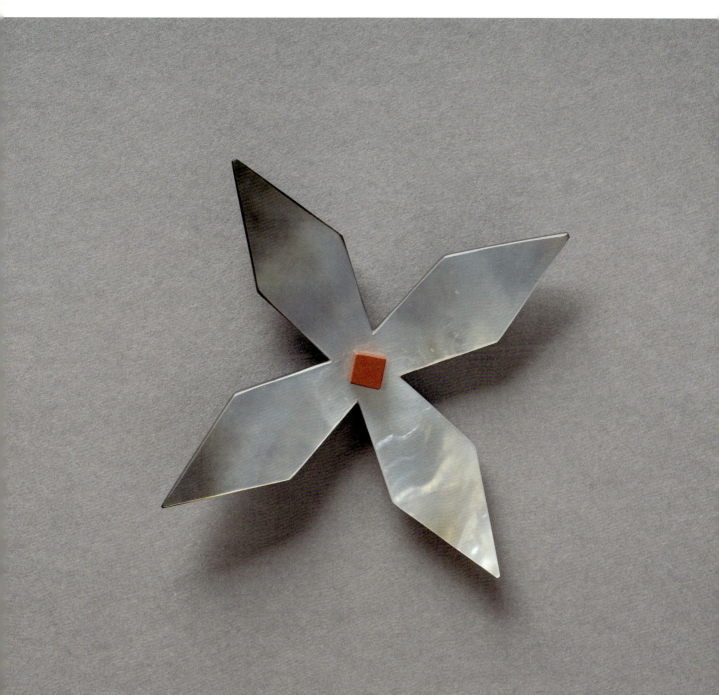

STAR

Brooch
<u>Winter Star</u>, 1997
Gold-lipped pearl
shell, obsidian
5 × 5 cm
Private Collection
Sarah McIntyre, Auckland

Brosche
<u>Winter-Stern</u>, 1997
Goldlippige Perlmuschel,
Obsidian
5 × 5 cm
Pivatsammlung Sarah
McIntyre, Auckland

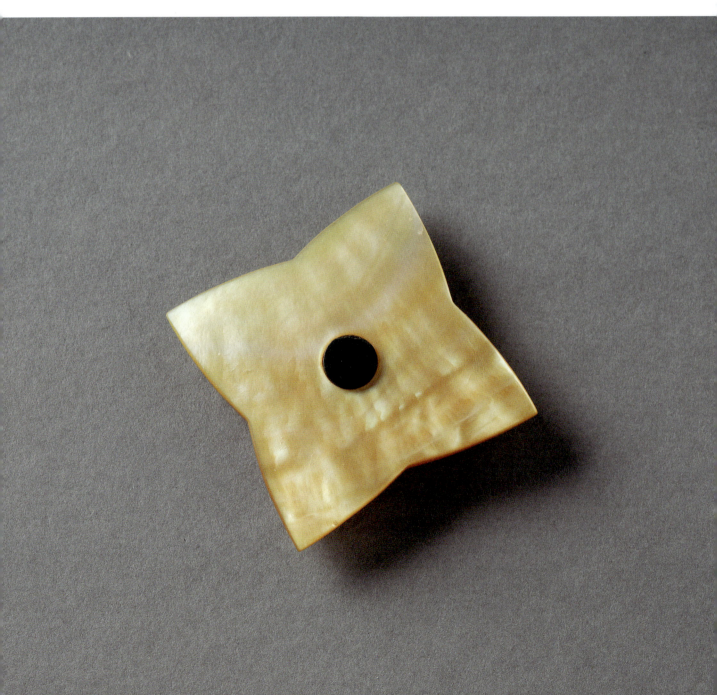

STERN

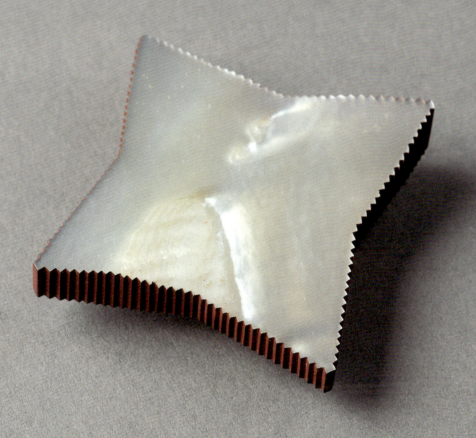

Brooch
Large Star, 1990
Pearl shell, paint
6.4 × 6.4 cm
Warwick Freeman and
Therese Hilbert, Munich

Brosche
Großer Stern, 1990
Perlmuschel, Farbe
6,4 × 6,4 cm
Warwick Freeman und
Therese Hilbert, München

STAR

Brooch
Shell Star, 1994
Turret shells
9 × 9 cm
Private Collection

Brosche
Muschel-Stern, 1994
Turmschnecken
9 × 9 cm
Privatsammlung

Right: Pendant
Kiss Star, 2021
Quartz
4.3 × 4.3 cm
Private Collection
Ewan Brown and Judi
Keith-Brown, Wellington

Rechts: Anhänger
Kuss-Stern, 2021
Quartz
4,3 × 4,3 cm
Privatsammlung Ewan
Brown und Judi Keith-
Brown, Wellington

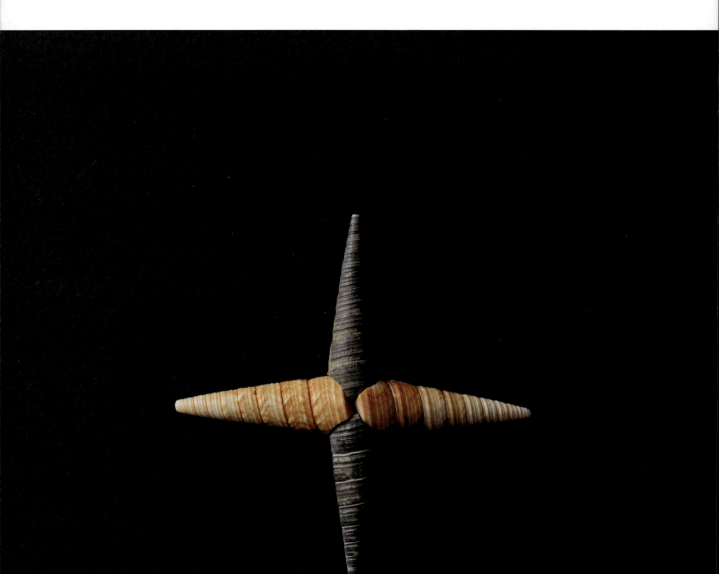

STERN

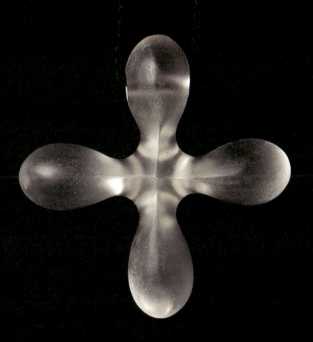

RING

Alphabet Rings, 2009
Oxidised silver
Each ring: 2.3 × 2 cm

Alphabet-Ringe, 2009
Geschwärztes Silber
Jeder Ring: 2,3 × 2 cm

Double Sphere Ring, 2019
Volcanic basalt,
oxidised silver
Sphere: 2.3 cm diameter;
band: 2.3 cm diameter

Gaze, 2021
Carnelian,
oxidised silver
Eye: 3.4 cm diameter;
band: 2.3 cm diameter

Double Jade Ring, 2018
Australian black jade,
Siberian green jade
Cube: 2 cm width; band:
2.5 cm diameter

Doppelkugel-Ring, 2019
Vulkanischer Basalt,
geschwärztes Silber
Kugel: Dm. 2,3 cm,
Ringschiene: Dm. 2,3 cm

Blick, 2021
Karneol, geschwärztes
Silber
Auge: Dm. 3,4 cm,
Ringschiene: Dm. 2,3 cm

Doppel Jade-Ring, 2018
Schwarze Australische,
Jade, grüne Sibirische
Jade
Würfel: 2 cm,
Ringschiene: Dm. 2,5 cm

RING

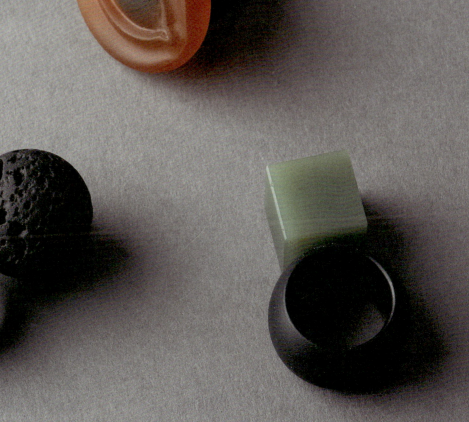

CIRCLE

Big Circles, 1992
Pearl shell discs, red
paint, linen thread
Each disc: 9 cm diameter
The Powerhouse Museum,
Sydney, purchased 1992
Photo: Ryan Hernandez

Große Scheiben, 1992
Scheiben der Perlmuschel,
rote Farbe, Leinenband
Jede Scheibe: Dm. 9 cm
The Powerhouse Museum,
Sydney, erworben 1992
Foto: Ryan Hernandez

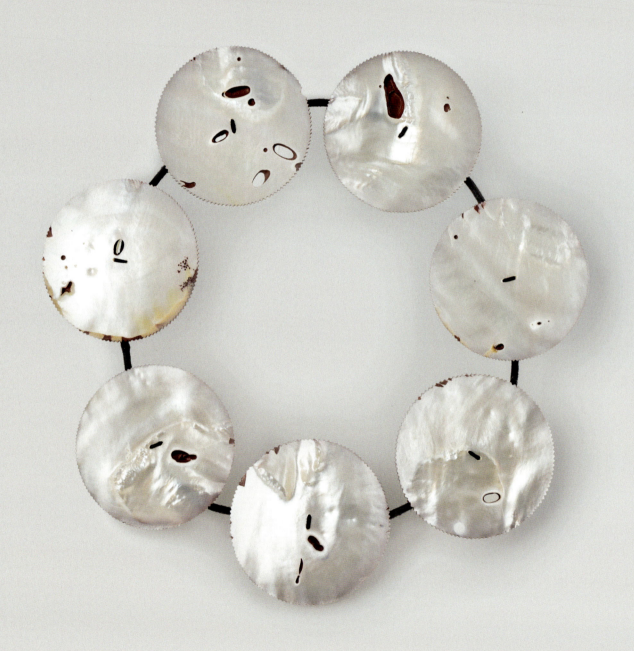

KREIS

Circle Necklace, 1995
Pearl shell, gold beads
25.5 cm diameter
Museum of New Zealand
Te Papa Tongarewa,
Wellington, gift of
Helene Quilter, 2011

Scheiben-Halsschmuck, 1995
Perlmuschel, Goldperlen
Dm. 25,5 cm
Museum of New Zealand
Te Papa Tongarewa,
Wellington, Schenkung
Helene Quilter, 2011

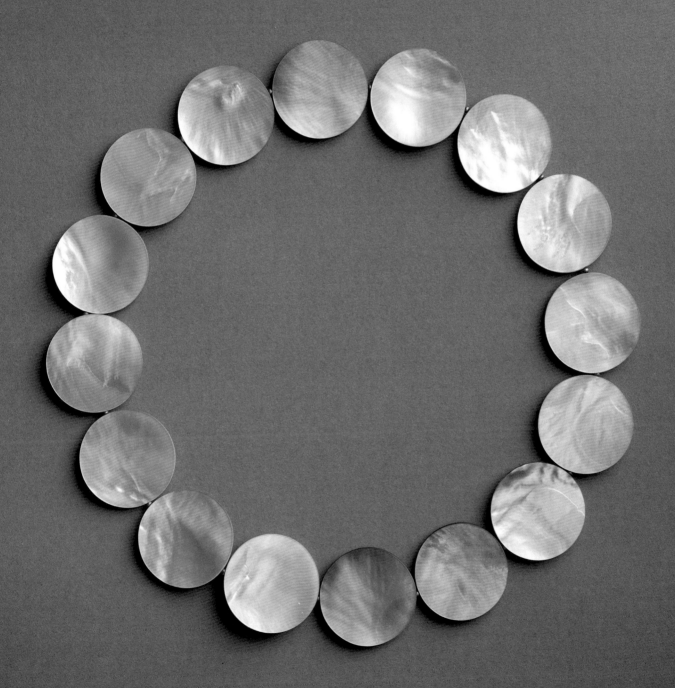

CIRCLE

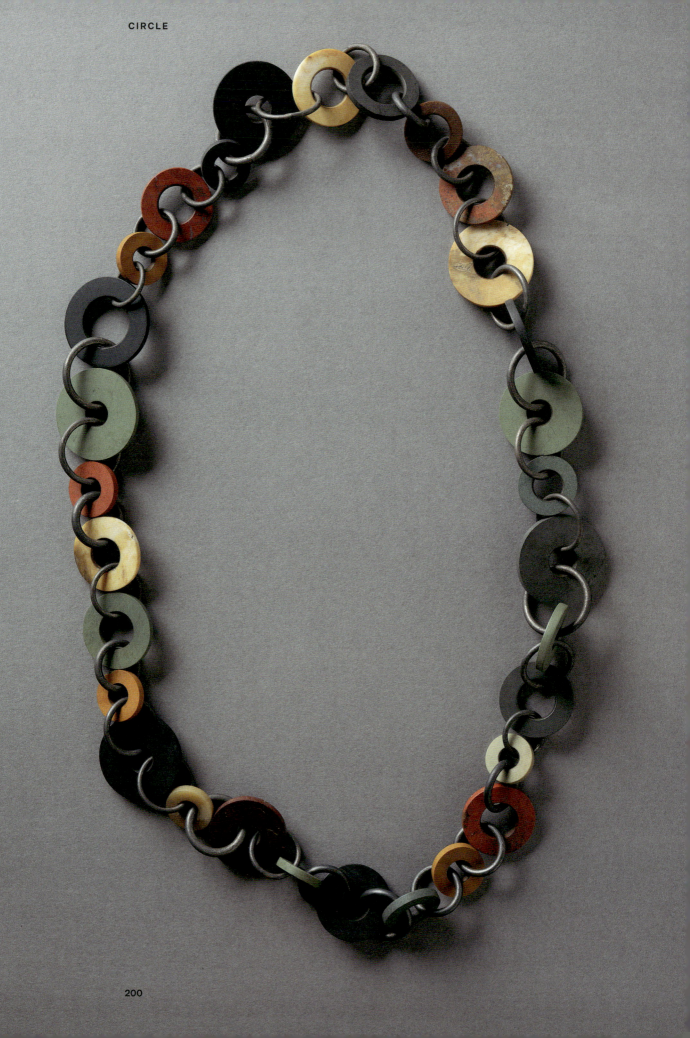

KREIS

Left: Necklace
Stone Circle, 2021
Various stones,
oxidised silver
100 cm overall length

Links: Halsschmuck
Stein-Scheiben, 2021
Verschiedene Steine,
geschwärztes Silber
Gesamtlänge: 100 cm

Necklace
Circle Chain, 2015
Pearl shell,
oxidised silver
Each disc: 4 cm diameter

Halsschmuck
Scheiben-Kette, 2015
Perlmuschel, geschwärztes Silber
Jede Scheibe: Dm. 4 cm

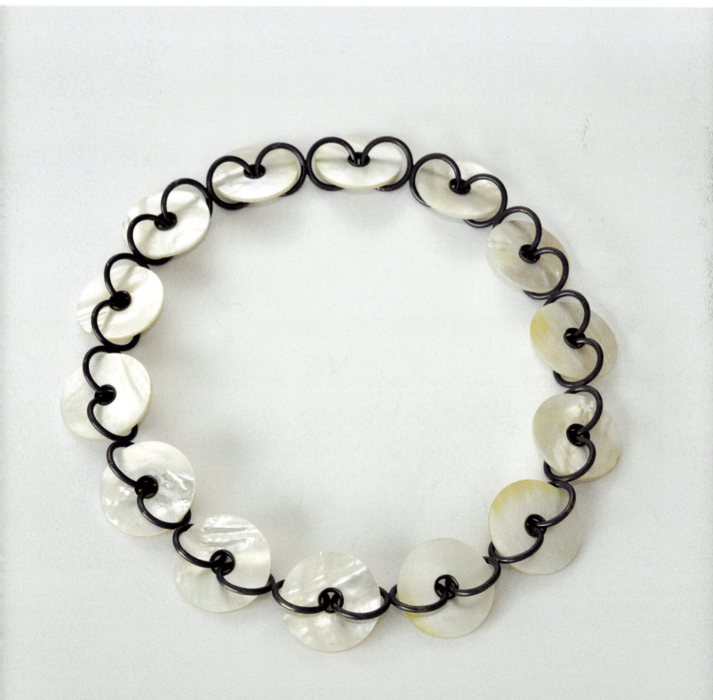

APPROPRIATION

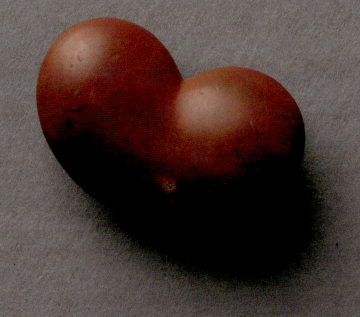

Brooch
<u>Tongue</u>, 2000
Jasper
3 × 5 cm
Warwick Freeman and
Private Collection
Den Besten-Reekers,
Netherlands

Brosche
<u>Zunge</u>, 2000
Jaspis
3 × 5 cm
Warwick Freeman
und Privatsammlung
Den Besten-Reekers,
Niederlande

Pendant
Koru Whistle, 1993
Lacquered wood
8.4 × 2 × 2.2 cm

Anhänger
Koru-Pfeife, 1993
Holz, Lack
8,4 × 2 × 2,2 cm

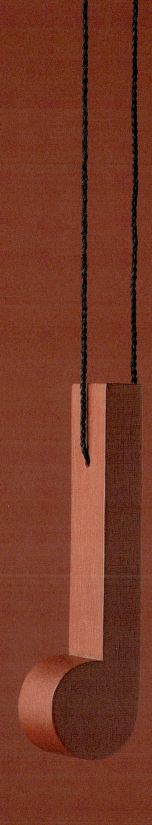

ANEIGNUNG

APPROPRIATION

Pendants
<u>Miki</u>, 2011
Argillite; quartz
6.8 × 5 cm

Anhänger
<u>Miki</u>, 2011
Argillit (Tongestein),
Quartz
6,8 × 5 cm

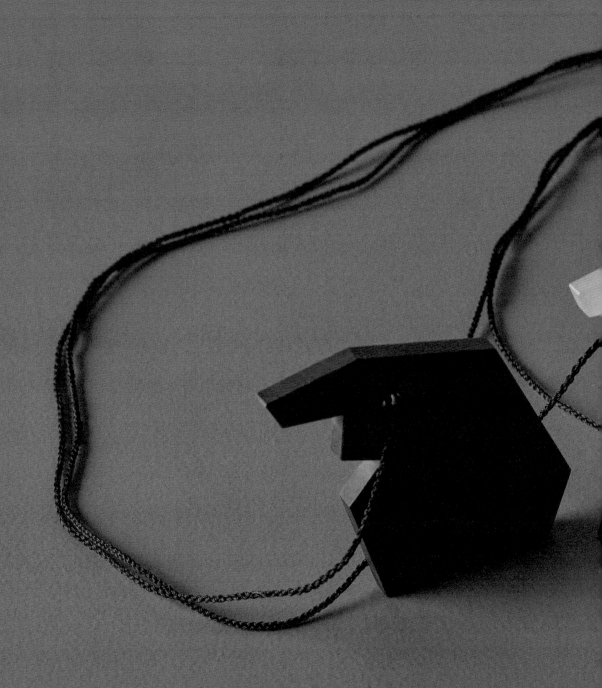

ANEIGNUNG

APPROPRIATION

Brooch
Green Face, 1998
Nephrite, resin
4 cm diameter
Museum of New Zealand
Te Papa Tongarewa,
Wellington
purchased 2009

Brosche
Grünes Gesicht, 1998
Nephrit, Hartz
Dm. 4 cm
Museum of New Zealand
Te Papa Tongarewa,
Wellington
erworben 2009

ANEIGNUNG

Necklace
Maori Ring, 2002
Nephrite
3 × 3.5 cm

Halsschmuck
Māori Ring, 2002
Nephrit
3 × 3,5 cm

WALL WORK

Installation
<u>Dust</u>, 2011
Plywood, synthetic, natural and metallic dusts, binder
100 × 120 cm

Installation
<u>Staub</u>, 2011
Sperrholz, synthetischer, natürlicher und metallischer Staub, Bindemittel
100 × 120 cm

Right: Pendants
<u>Big Work</u>, 2013
Oxidised steel, oxidised silver, plywood, silcrete dust, binder
Various dimensions

WANDARBEITEN

Rechts: Anhänger
<u>Große Arbeit</u>, 2013
Geschwärzter Stahl, geschwärztes Silber, Sperrholz, Silkrete-Staub, Bindemittel
Verschiedene Maße

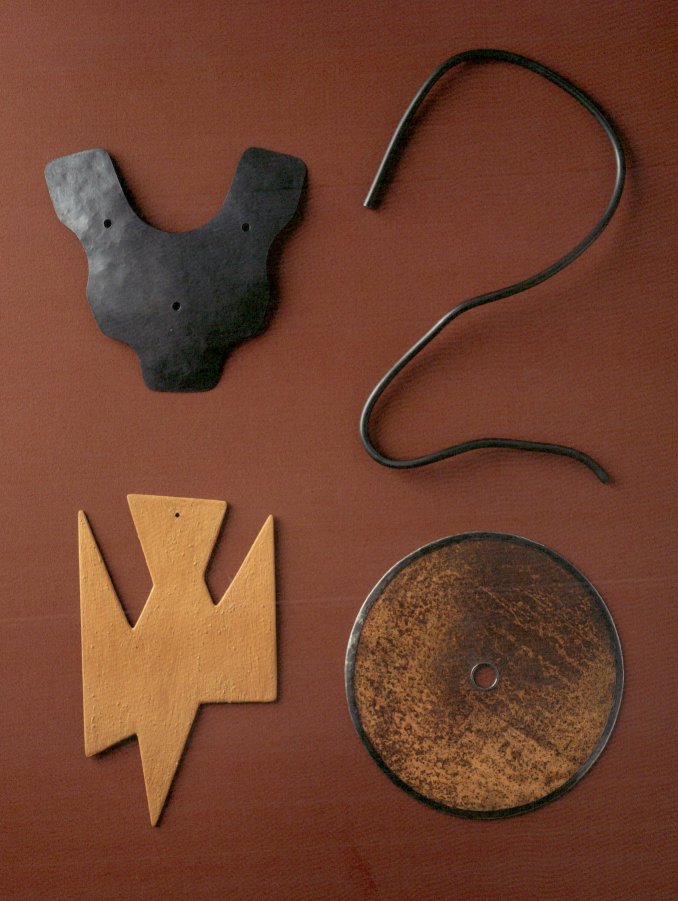

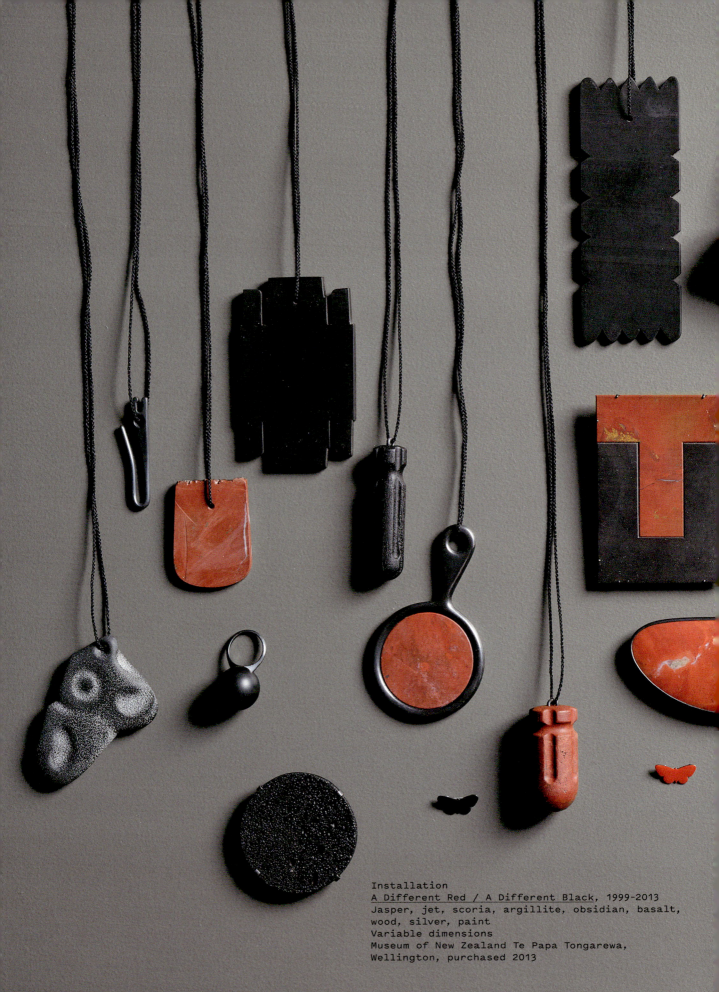

Installation
A Different Red / A Different Black, 1999-2013
Jasper, jet, scoria, argillite, obsidian, basalt, wood, silver, paint
Variable dimensions
Museum of New Zealand Te Papa Tongarewa, Wellington, purchased 2013

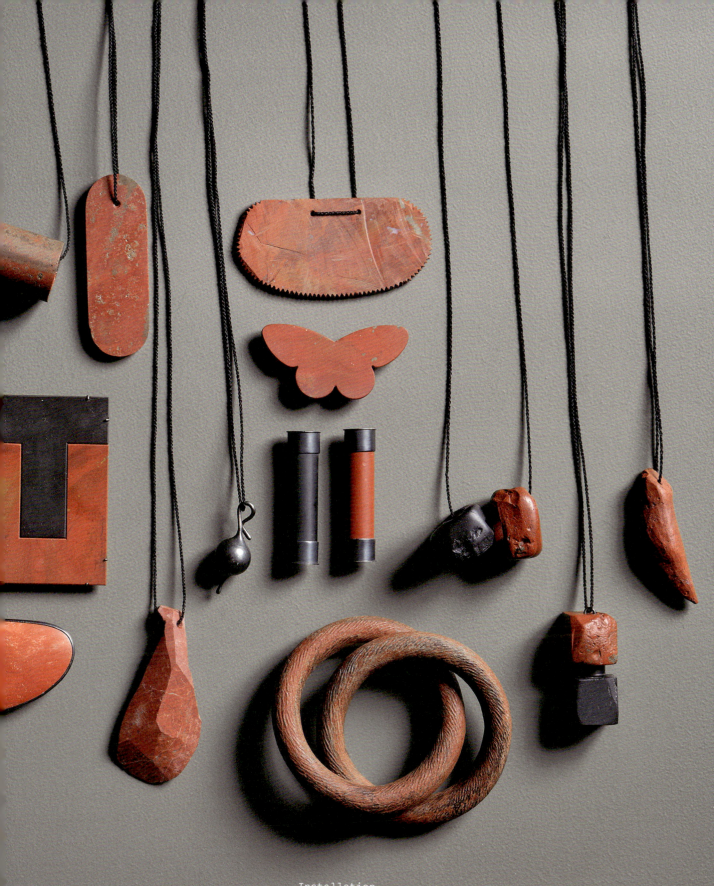

Installation
Ein Unterschiedliches Rot / Ein Unterschiedliches Schwarz,
1999-2013
Jaspis, Jet (Vorstadium von Steinkohle), vulkanische
Schlacke, Argillit (Tongestein), Obsidian, Basalt, Holz,
Silber, Farbe
Verschiedene Maße
Museum of New Zealand Te Papa Tongarewa, Wellington,
erworben 2013

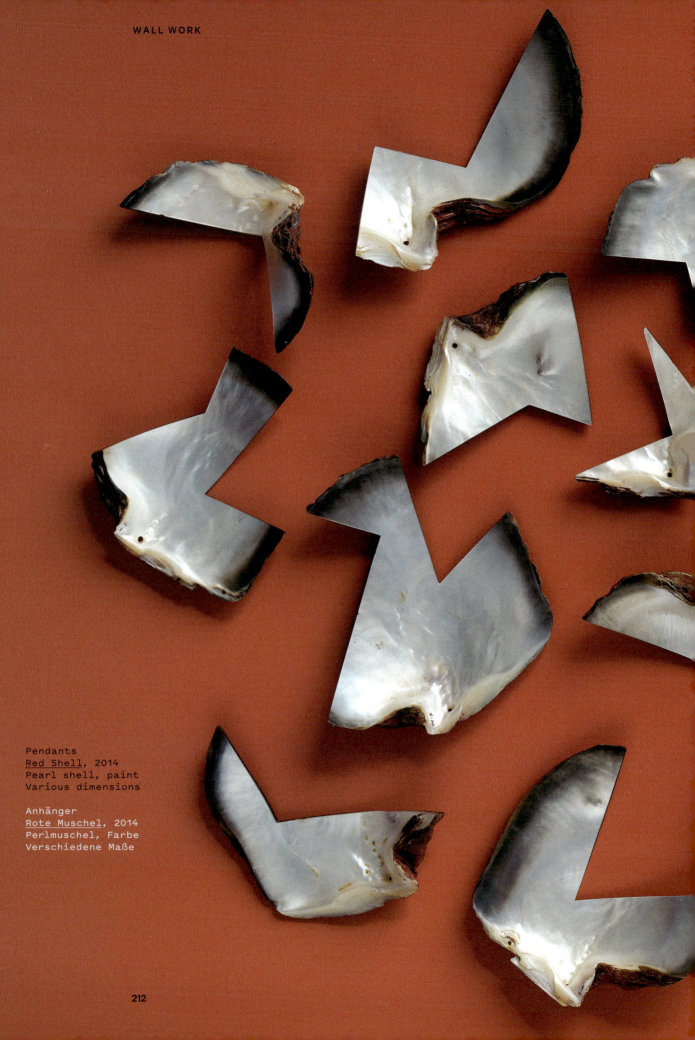

Pendants
Red Shell, 2014
Pearl shell, paint
Various dimensions

Anhänger
Rote Muschel, 2014
Perlmuschel, Farbe
Verschiedene Maße

WANDARBEITEN

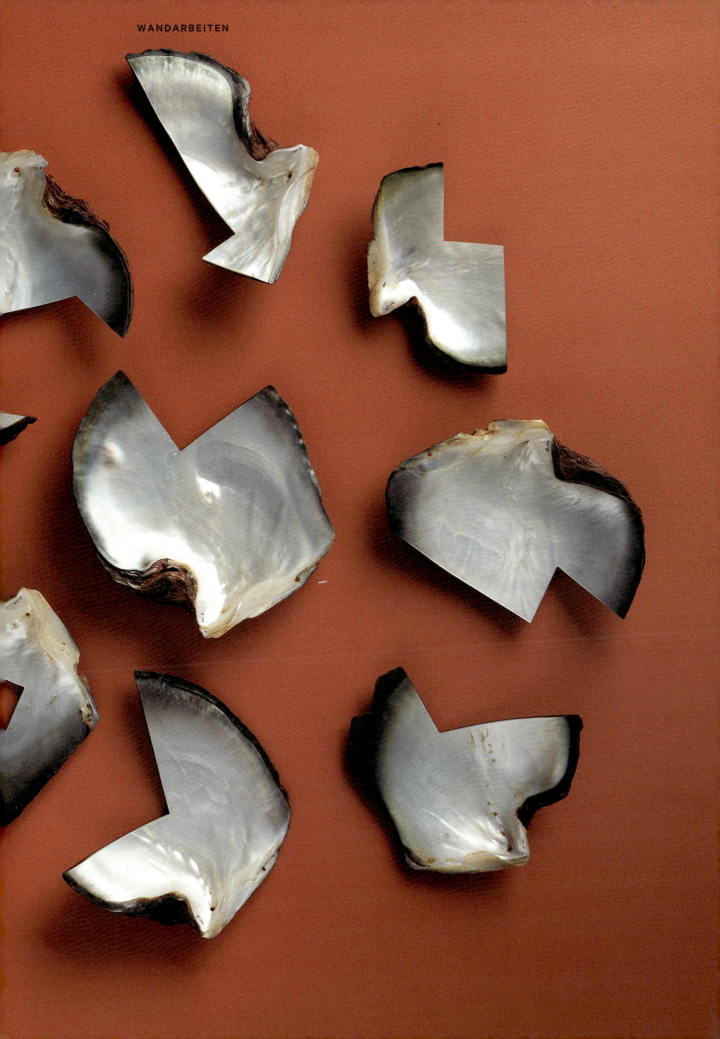

HAND

Pendant
Wing, 2021
Pig tusk
6 × 2 cm

Anhänger
Flügel, 2021
Schweinezahn
6 × 2 cm

214

Pendant
Handbird, 2019
Black jade
4.1 × 3.8 cm

Anhänger
Hand-Vogel, 2019
Schwarze Jade
4,1 × 3,8 cm

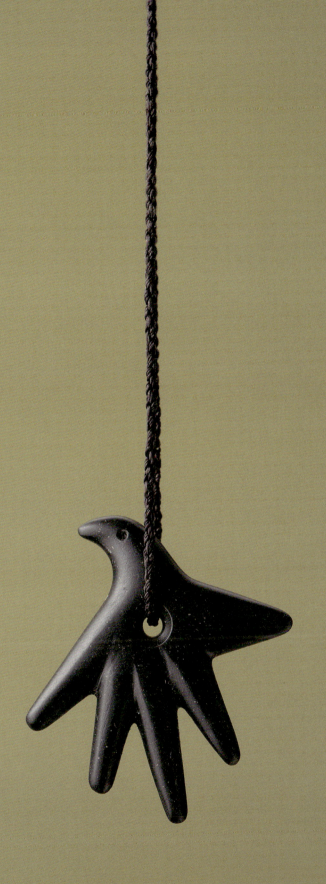

HAND

HAND

Pendants
<u>Serving Hand</u>, 1991
Burnt wood
16.8 × 6 cm; 16.3 × 5.9 cm

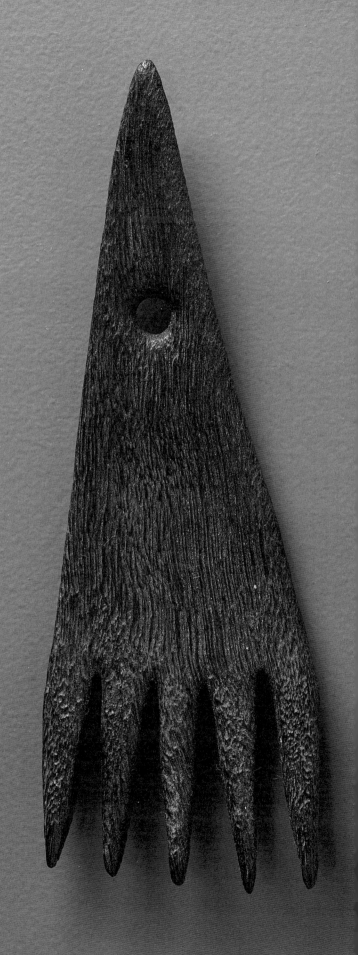

216

HAND

Anhänger
Servieronde Hand, 1991
Gebranntes Holz
16,8 × 6 cm und 16,3 × 5,9 cm

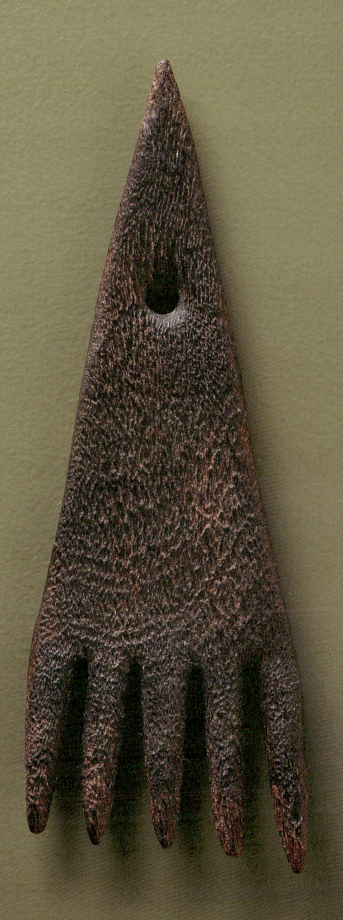

HAND

Pendant
Helping Hand, 2024
Carnelian
7 × 5.2 × 3.4 cm

Anhänger
Helfende Hand, 2024
Karneol
7 × 5,2 × 3,4 cm

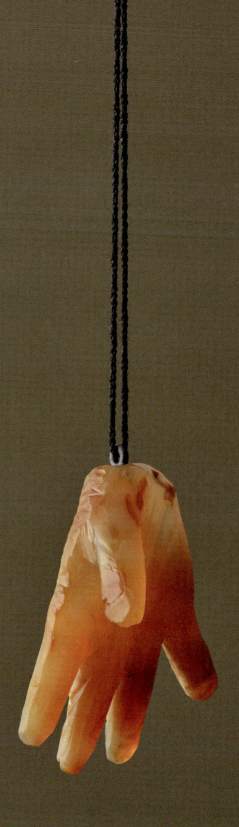

HAND

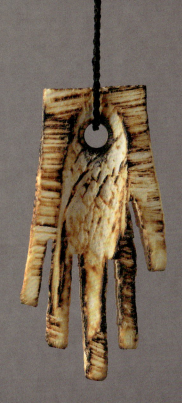

Pendant
Hand, 1992
Bone
6.4 × 3.6 cm

Anhänger
Hand, 1992
Knochen
6,4 × 3,6 cm

PLACE

Rings
<u>North Cape to Bluff</u>, 2007
Various stones, gold and oxidised silver
Each sphere: 2.2 cm diameter
Museum of New Zealand Te Papa Tongarewa, Wellington, purchased 2020

North Cape – Muri motu

Hendersons Bay

Kaipara via Cornwell

Ponui Island

via Ngatea

Sailors Grave

Kina Peninsula

Birdlings Flat

ORT

Ringe
<u>Vom Nordkap nach Bluff</u>, 2007
Verschiedene Steine, Gold,
geschwärztes Silber
Jede Kugel: Dm. 2,2 cm
Museum of New Zealand Te
Papa Tongarewa, Wellington,
erworben 2020

Hector | Kekerengu | Gore Bay | Te Anau | Kaka Point | Arrowtown | Livingstone Range | Bluff

PLACE

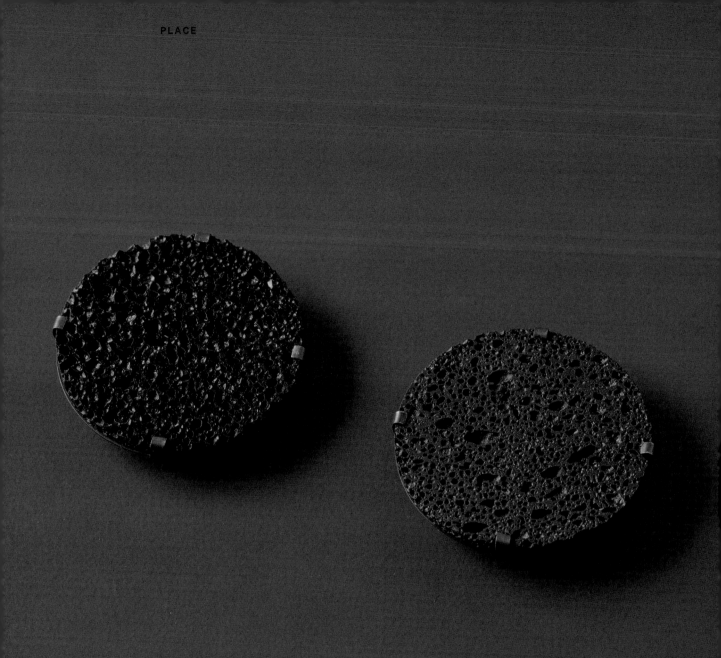

Brooches
Lava, 2004
Scoria, oxidised silver
Each: 6 cm diameter

Broschen
Lava, 2004
Vulkanische Schlacke,
geschwärztes Silber
Jede: Dm. 6 cm

Right: Necklace
Scoria Lei, 1989
Oxidised silver,
basaltic scoria
70cm overall length
Auckland Museum Tāmaki
Paenga Hira, Auckland,
purchased with funds
provided by the
Charles Edgar
Disney Trust, 1991

Rechts: Halsschmuck
Schlacke-Kranz, 1989
Geschwärztes Silber,
basaltische Schlacke
Gesamtlänge: 70 cm
Auckland Museum Tāmaki
Paenga Hira, Auckland,
1991 mit Mitteln aus dem
Charles Edgar Disney
Trust erworben

ORT

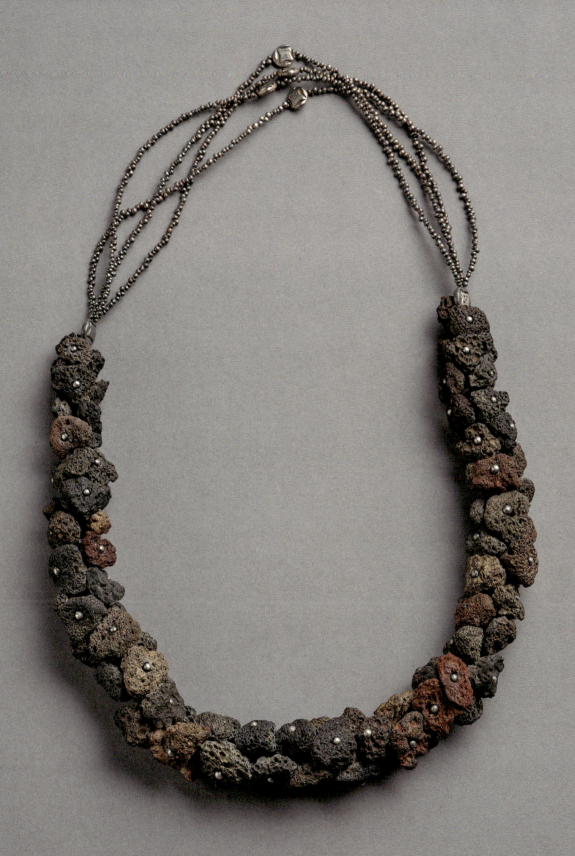

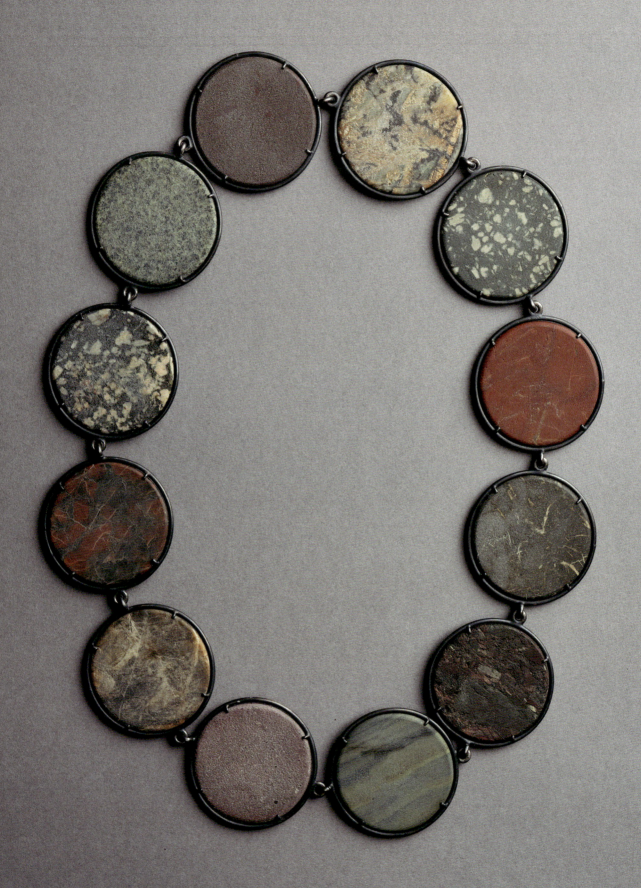

ORT

Left: Necklace
Tasman Bay, 2007
Various stones,
oxidised silver
26.2 cm diameter
Museum of New Zealand
Te Papa Tongarewa,
Wellington
purchased 2009

Links: Halsschmuck
Tasman Bay, 2007
Verschiedene Steine,
geschwärztes Silber
Dm. 26,2 cm
Museum of New Zealand
Te Papa Tongarewa,
Wellington
erworben 2009

Necklace
Torpedo Bay, 2015
Whale bone,
carbon electrodes,
braided cord
72 cm overall length

Halsschmuck
Torpedo Bay, 2015
Walknochen, Kohle-
Elektroden, geflochtene
Schnur
Gesamtlänge: 72 cm

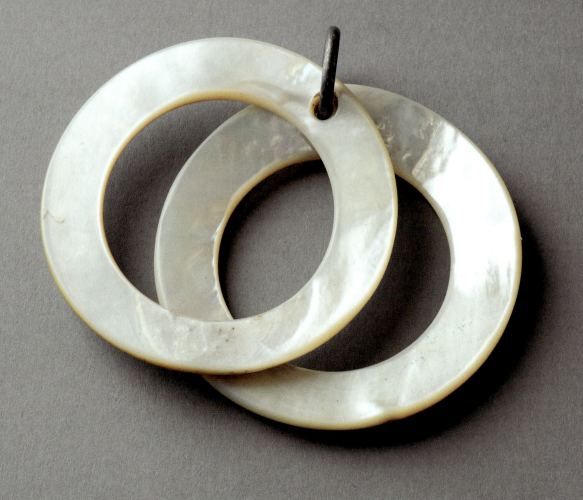

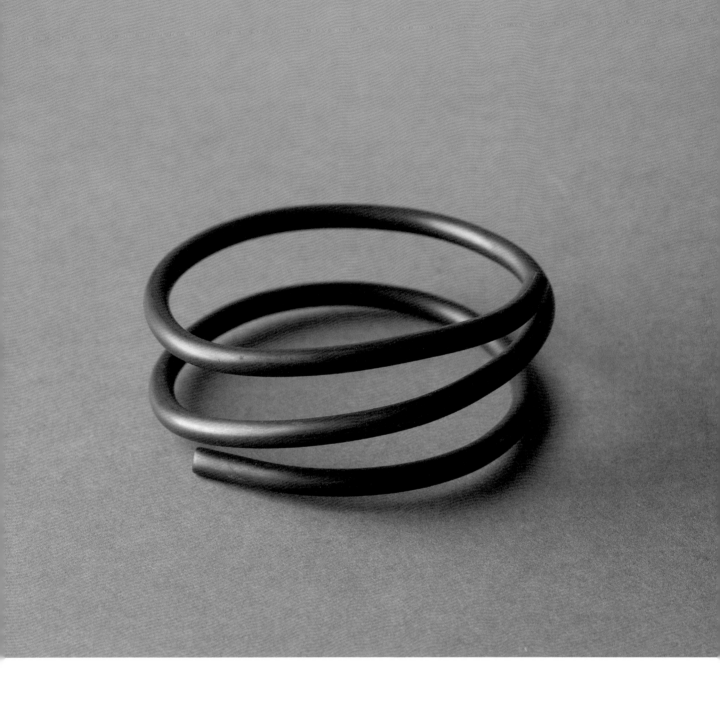

Left: Bangle 2, 2018 Pearl shell 9.5 × 10 × 0.8 cm	Links: Armschmuck 2, 2018 Perlmuschel 9,5 × 10 × 0,8 cm	Bangle Coil, 2012 Oxidised silver 7.5 cm diameter, height 3 cm	Armschmuck Spule, 2012 Geschwärztes Silber Dm. 7,5 cm, H. 3 cm

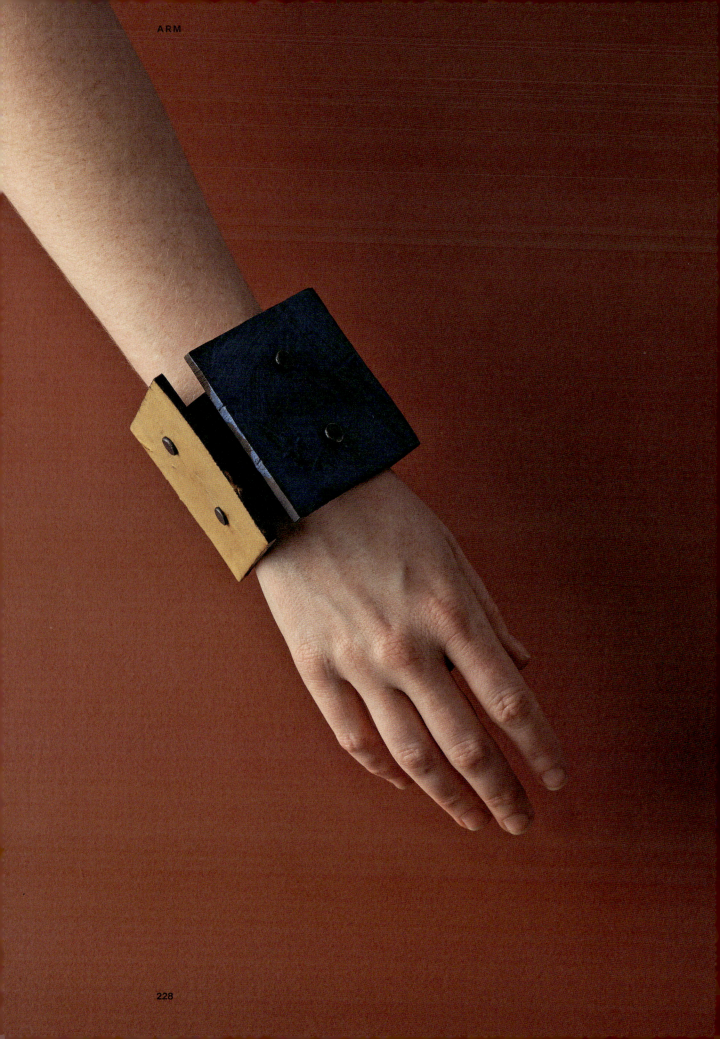

ARM

Left: Cuff
Triangle, 2013
Wood, silver, jasper,
lapis lazuli, silcrete
dusts and binder
Sides: 8 × 7.5 cm;
cuff: 6 cm diameter

Links: Armschmuck
Dreieck, 2013
Holz, Silber, Jaspis,
Lapislazuli-Staub,
Silkrete-Staub,
Bindemittel
Rechtecke: 8 × 7,5 cm,
Manschette: Dm. 6 cm

Bangles
Flat Reel and
Gold Hook, 2008
Oxidised silver,
cord, gold hook
Each reel: 8.5 cm
diameter; gold hook:
2.3 × 1.3 cm

Armschmuck
Flache Spule und
Goldener Haken, 2008
Geschwärztes Silber,
Kordel, Gold
Jede Spule: Dm. 8,5 cm,
goldener Haken:
2,3 × 1,3 cm

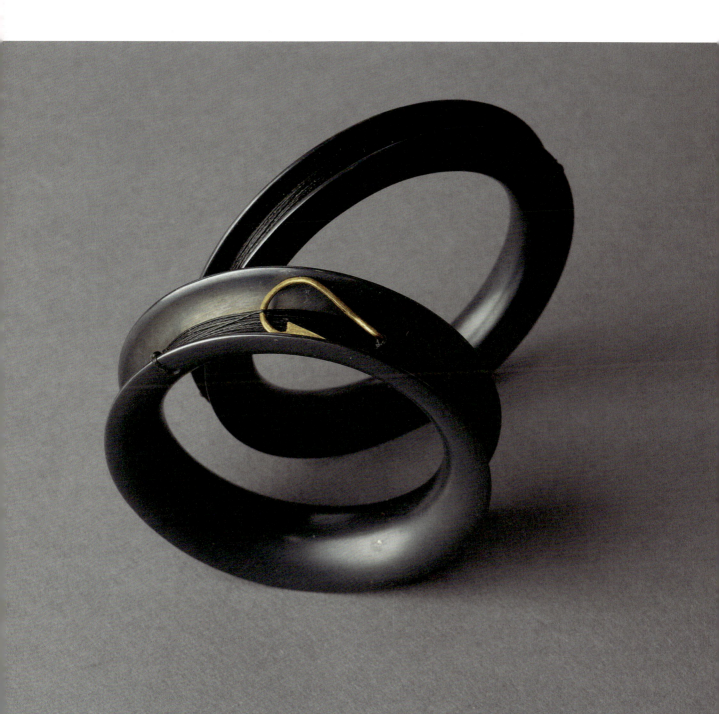

ARM

Bangle
Link, 2012
Wood, jasper dust
and binder
12 cm diameter
Private Collection,
Munich

Armschmuck
Verbindung, 2012
Holz, Jaspis-Staub,
Bindemittel
Dm. 12 cm
Privatsammlung,
München

Right: Cuff
Circle, 2011
Oxidised silver,
wood, jasper
Disc: 9cm diameter;
cuff: 6cm diameter

Rechts: Armschmuck
Scheibe, 2011
Geschwärztes Silber,
Holz, Jaspis
Scheibe: Dm. 9 cm,
Reif: Dm. 6 cm

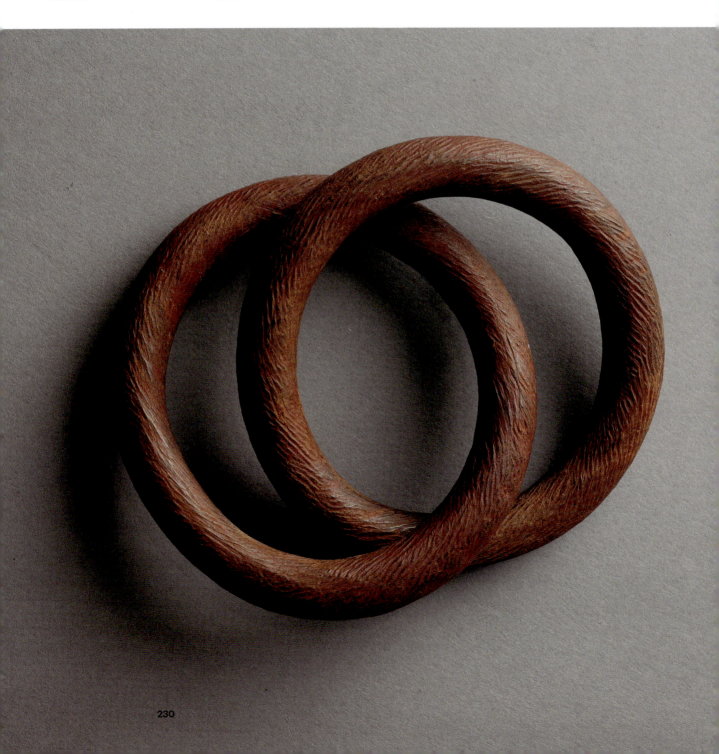

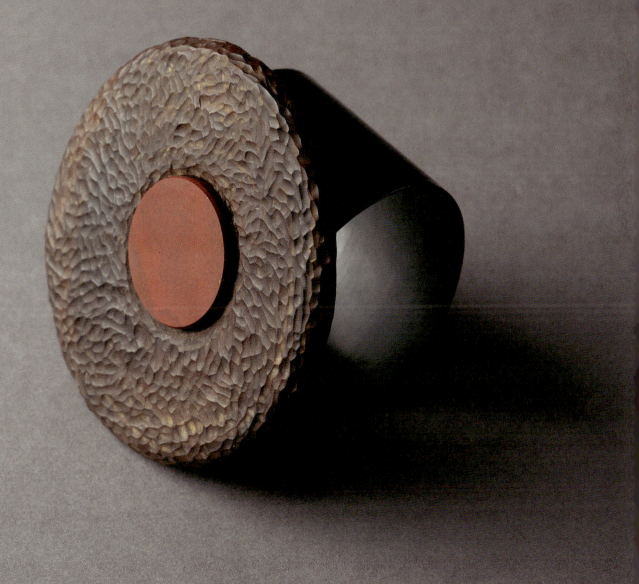

HOOK

Pendants
Story of the Hook, 2010
Silver, gold,
nephrite, whalebone
Various dimensions
Collection Gallery S O

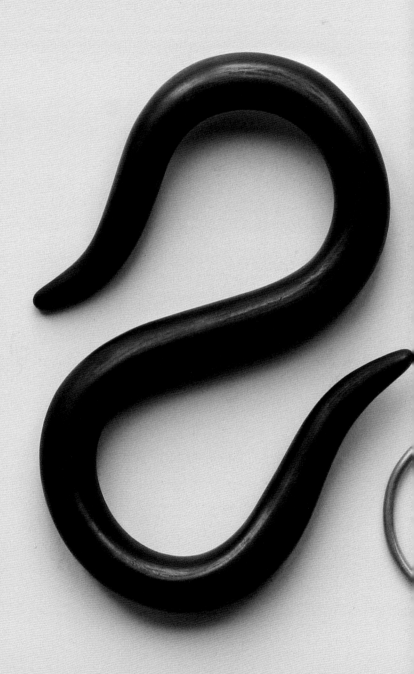

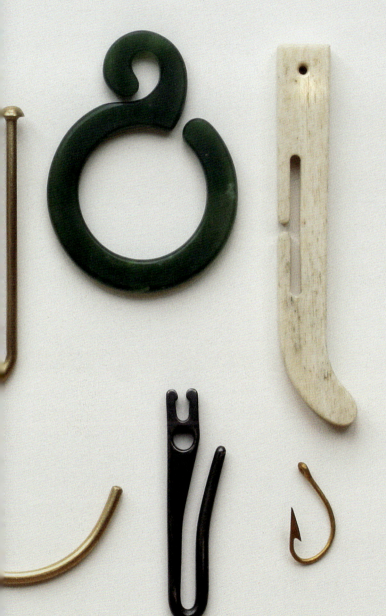

HAKEN

Anhänger
Geschichte des Hakens,
2010
Silber, Gold, Nephrit,
Walzahn
Verschiedene Maße
Collection Gallery S O

OLD BRAIN

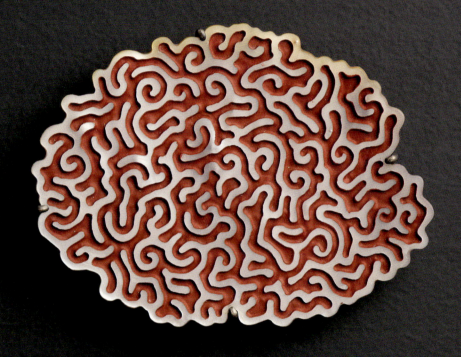

Left: Brooch
<u>Old Brain</u>, 2002
Pearl shell,
paint, silver
7.5 × 10.5 cm
Museum of New Zealand
Te Papa Tongarewa,
Wellington,
purchased 2008

Links: Brosche
<u>Altes Hirn</u>, 2002
Perlmuschel, Farbe,
Silber
7,5 × 10,5 cm
Museum of New Zealand
Te Papa Tongarewa,
Wellington,
erworben 2008

Necklace
<u>Sinker</u>, 2014
Jasper, lapis lazuli,
silcrete, silver
46 cm overall length

Halsschmuck
<u>Senker</u>, 2014
Jaspis, Lapislazuli,
Silkrete, Silber
Gesamtlänge: 46 cm

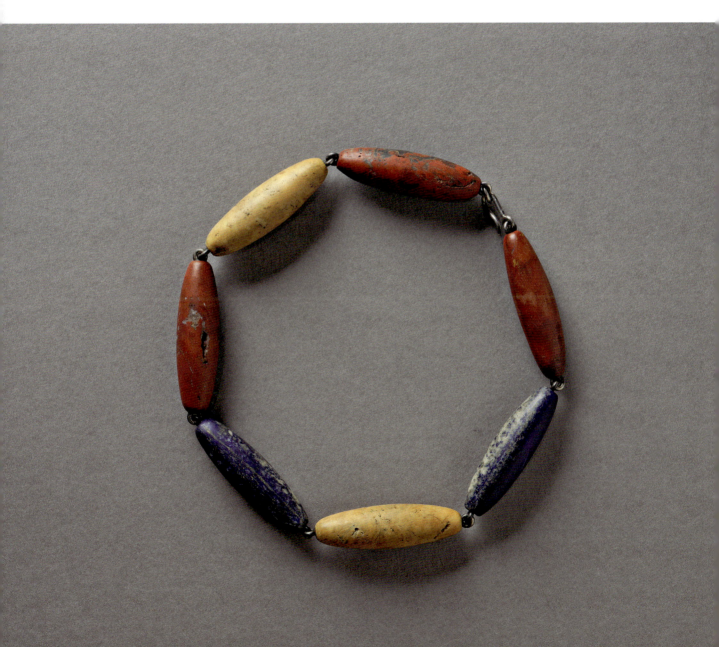

BEADWORK

Brooch
Southern Cross, 1989
Oxidised silver, paint
4.5 × 9.1 cm
Private Collection Anne
McLeod Crawford, Ngākawau

Brosche
Kreuz des Südens, 1989
Geschwärztes Silber,
Farbe
4,5 × 9,1 cm
Privatsammlung Anne
McLeod Crawford, Ngākawau

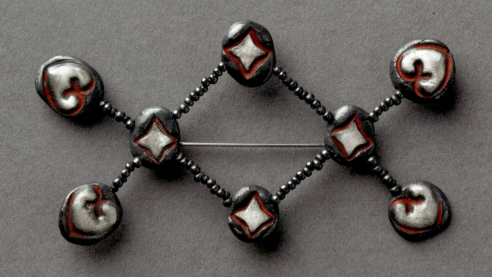

Bracelet
<u>Southern Cross</u>, 1989
Oxidised silver, paint
7.5 cm diameter

Armschmuck
<u>Kreuz des Südens</u>, 1989
Geschwärztes Silber,
Farbe
Dm. 7,5 cm

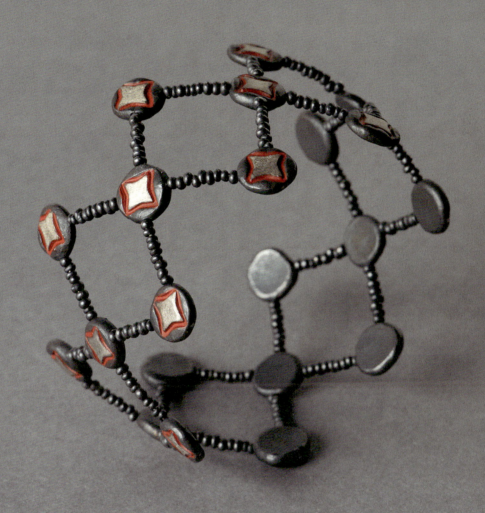

PERL-ARBEITEN

BEADWORK

Star and Bead
Necklace, 1990
Mother of pearl, silver,
paint
18 × 25 cm
Auckland Museum Tāmaki
Paenga Hira, Auckland,
purchased with funds
provided by Charles
Edgar Disney Trust, 1994

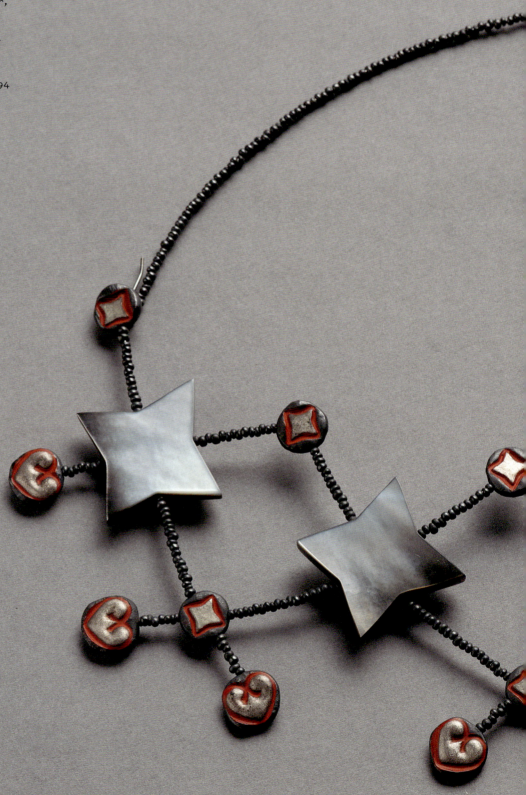

PERL-ARBEITEN

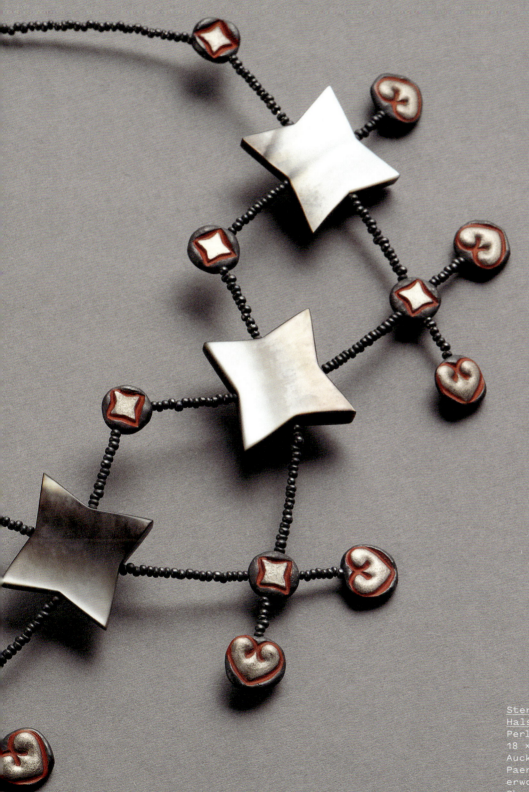

Stern und Perlen-
Halsschmuck, 1990
Perlmutt, Silber, Farbe
18 × 25 cm
Auckland Museum Tāmaki
Paenga Hira, Auckland,
erworben mit Mitteln des
Charles Edgar Disney
Trust, 1994

BEADWORK

Brooch
<u>Star and Beaded Heart</u>, 1989
Pearl shell, oxidised silver, gold
5 × 5.9 cm
Private Collection Anne McLeod Crawford, Ngākawau

Brosche
<u>Stern und Perlen-Herz</u>, 1989
Perlmuschel, geschwärztes Silber, Gold
5 × 5,9 cm
Privatsammlung Anne McLeod Crawford, Ngākawau

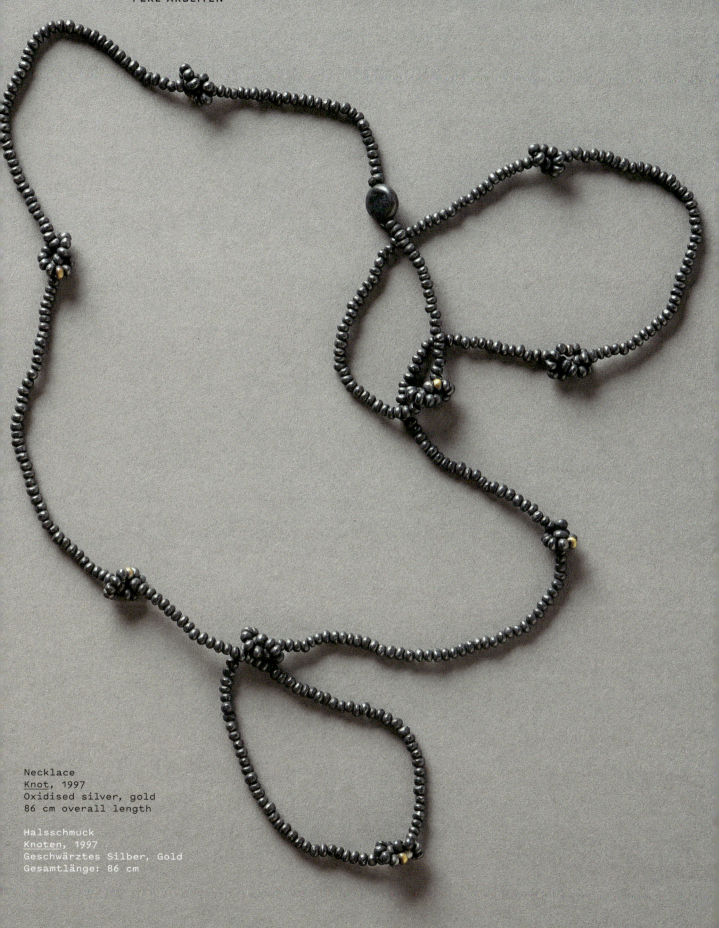

Necklace
Knot, 1997
Oxidised silver, gold
86 cm overall length

Halsschmuck
Knoten, 1997
Geschwärztes Silber, Gold
Gesamtlänge: 86 cm

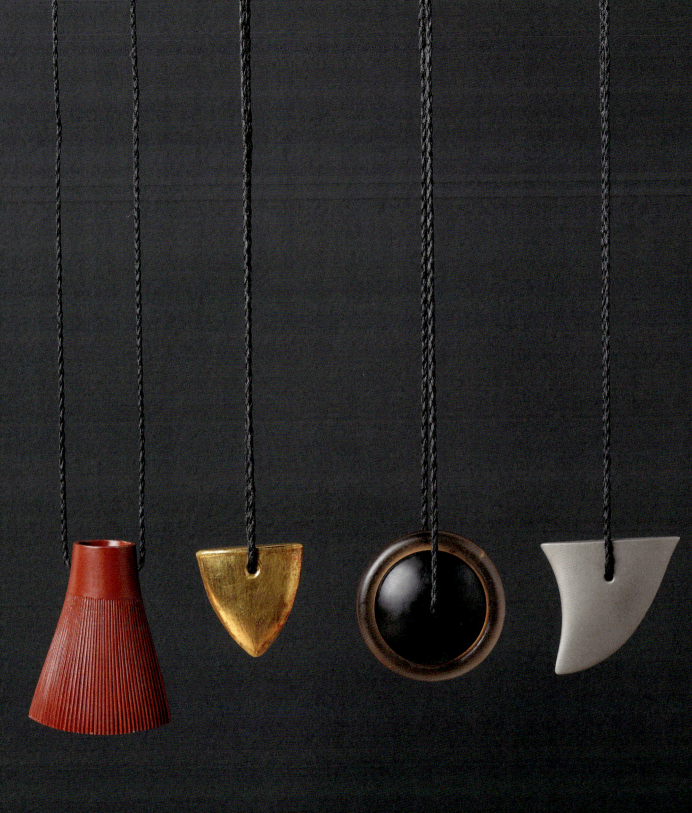

MYTH

Left: Pendants
<u>4 Bits of Fish</u>, 1993
Stainless steel,
bone, paint, glass,
obsidian, gold
Various dimensions

Links: Anhänger
<u>4 Fischstücke</u>, 1993
Edelstahl, Knochen,
Farbe, Glas, Obsidian,
Gold
Verschiedene Maße

Pendant
<u>Bone Hook</u>, 1993
Cow bone
6 × 2.7 cm

Anhänger
<u>Knochen-Haken</u>, 1993
Kuhknochen
6 × 2,7 cm

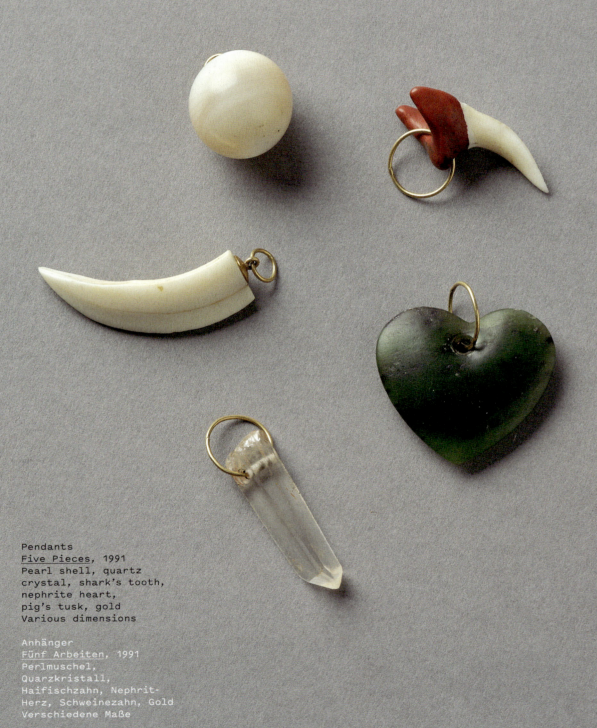

Pendants
<u>Five Pieces</u>, 1991
Pearl shell, quartz crystal, shark's tooth, nephrite heart, pig's tusk, gold
Various dimensions

Anhänger
<u>Fünf Arbeiten</u>, 1991
Perlmuschel, Quarzkristall, Haifischzahn, Nephrit-Herz, Schweinezahn, Gold
Verschiedene Maße

Foam Brooch, 2001
Pearl shell,
oxidised silver
7.3 × 7.3 × 1.8 cm
Art Gallery of South
Australia, Adelaide,
gift of Truus and
Joost Daalder through
the Art Gallery of
South Australia
Foundation, 2017
Photo: Grant Hancock

Schaumstoff-Brosche, 2001
Perlmuschel, geschwärztes
Silber
7,3 × 7,3 × 1,8 cm
Art Gallery of South
Australia, Adelaide,
Schenkung Truus und
Joost Daalder durch die
Art Gallery of South
Australia Foundation, 2017
Foto: Grant Hancock

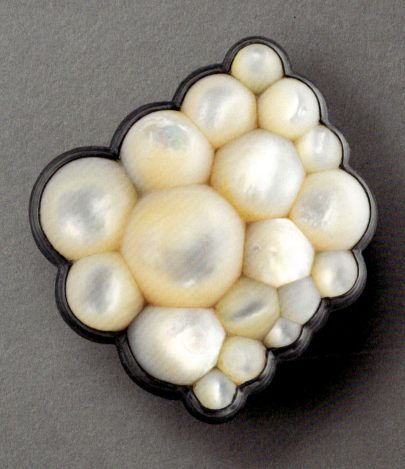

MYTH

Brooch
<u>Stone Mirror</u>, 1999
Obsidian, petrified wood
6 cm diameter
Private Collection Ewan
Brown and Judi Keith-
Brown, Wellington

Brosche
<u>Stein-Spiegel</u>, 1999
Obsidian, versteinertes
Holz
Dm. 6 cm
Privatsammlung Ewan
Brown und Judi Keith-
Brown, Wellington

MYTHOS

Pendant
<u>Pearl Mirror</u>, 1999
Mother of pearl, obsidian
Each disc: 5.7 cm
diameter
Private Collection
Barbara Kirshenblatt-
Gimblett, New York

Anhänger
<u>Perlen-Spiegel</u>, 1999
Perlmutt, Obsidian
Jede Scheibe: Dm. 5,7 cm
Privatsammlung Barbara
Kirshenblatt-Gimblett,
New York

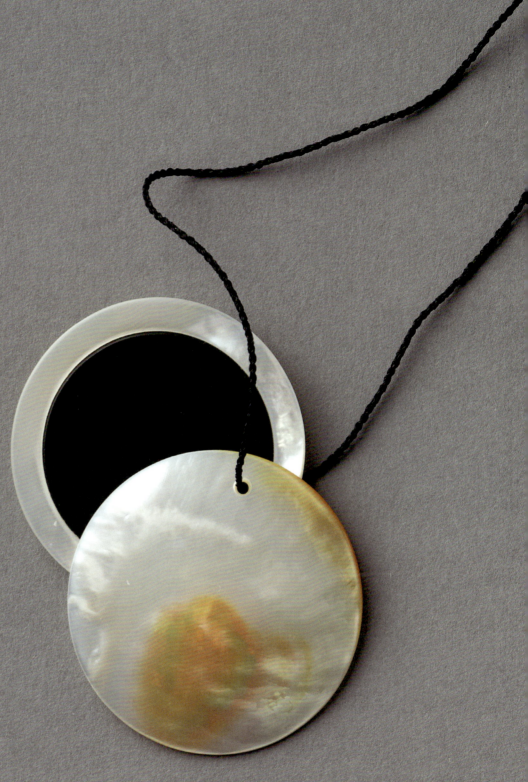

MYTH

Pendant
Pocket Mirror, 2000
Obsidian, gold, cord
10 × 6 cm
Private Collection
Bollmann, Vienna

Anhänger
Taschenspiegel, 2000
Obsidian, Gold, Kordel
10 × 6 cm
Privatsammlung Bollmann,
Wien

MYTHOS

Belt and pendant
<u>First Man</u>, 2003
Leather, oxidised
silver; wood, paint
Belt: 131 × 4.2 cm;
apple: 3.8 cm diameter

Gürtel und Anhänger
<u>Erster Mensch</u>, 2003
Leder, geschwärztes
Silber, Holz, Farbe
Gürtel: 131 × 4,2 cm,
Anhänger: Dm. 3,8 cm

PATTERN

Brooch
Lattice, 1994
Bone
6.5 × 6.5 cm

Brosche
Gitter, 1994
Knochen
6,5 × 6,5 cm

Brooch
Pebble, 1997
Pebbles, resin,
oxidised silver
4.7 cm diameter
Museum of New Zealand
Te Papa Tongarewa,
Wellington,
purchased 2002

Brosche
Kieselstein, 1997
Kieselsteine, Harz,
geschwärztes Silber
Dm. 4,7 cm
Museum of New Zealand
Te Papa Tongarewa,
Wellington,
erworben 2002

MUSTER

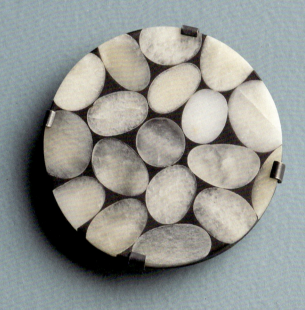

PATTERN

Brooch
<u>Pattern</u>, 1995
Bone, pinna shell
4.3 × 4 cm

Brosche
<u>Muster</u>, 1995
Knochen, Pinna-Muschel,
4,3 × 4 cm

Brooch
<u>Dotto</u>, 2001
Pearl shell, paint
3.9 × 3.9 cm
Museum of New Zealand
Te Papa Tongarewa,
Wellington, purchased
2009

Brosche
<u>Punkt</u>, 2001
Perlmuschel, Farbe
3,9 × 3,9 cm
Museum of New Zealand
Te Papa Tongarewa,
Wellington, erworben
2009

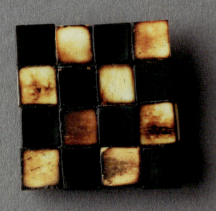

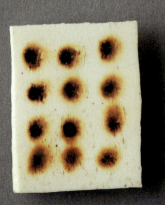

Brooch
<u>Zero</u>, 2001
Obsidian, paint
3.4 × 3.4 cm

Brosche
<u>Null</u>, 2001
Obsidian, Farbe
3,4 × 3,4 cm

Brooch
<u>Spot</u>, 1995
Bone
4.3 × 3.4 cm

Brosche
<u>Punkt</u>, 1995
Knochen
4,3 × 3,4 cm

MUSTER

Brooches
Scratch, 1995
Pinna shell;
pearl shell
Each: 4 × 4 cm

Broschen
Kratzer, 1995
Pinna-Muschel,
Perlmuschel
Jede: 4 × 4 cm

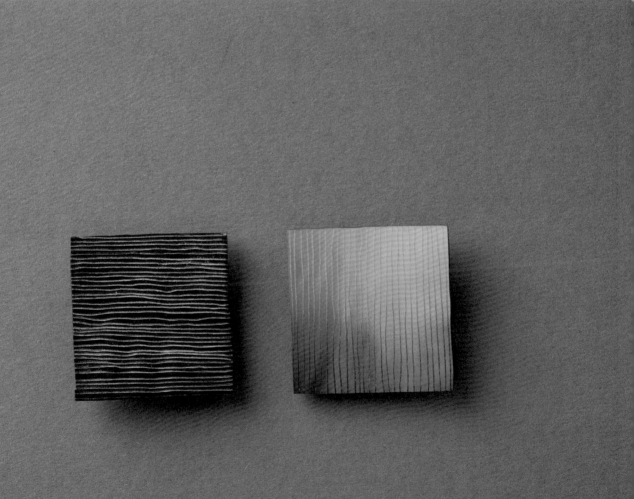

253

PATTERN

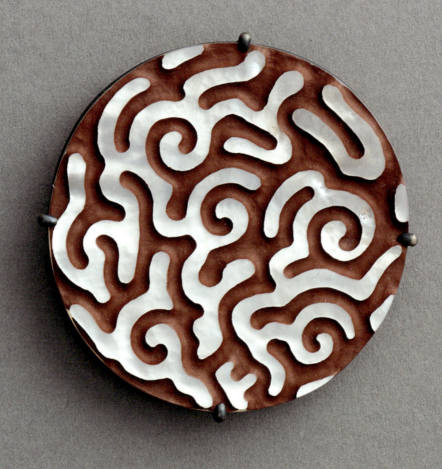

Brooch
Brain (carved), 2001
Pearl shell, oxidised
silver, lacquer
6 cm diameter
The Dowse Art Museum,
Lower Hutt, purchased
2001

Brosche
Hirn (geschnitzt), 2001
Perlmuschel, geschwärztes
Silber, Lack
Dm. 6 cm
The Dowse Art Museum,
Lower Hutt, erworben
2001

MUSTER

Brooch
Brain (pecked), 2001
Pearl shell,
oxidised silver
6 cm diameter
The Dowse Art
Museum, Lower Hutt,
purchased 2001

Brosche
Hirn (gehämmert), 2001
Perlmuschel, geschwärztes
Silber
Dm. 6 cm
The Dowse Art Museum,
Lower Hutt, erworben 2001

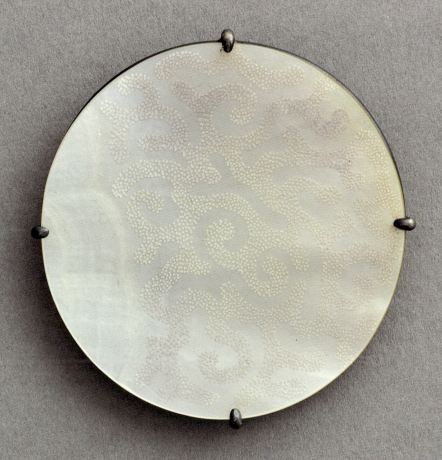

PATTERN

Brooch
Doodle Brain, 2001
Pearl shell, oxidised
silver, ink
6 cm diameter

Brosche
Hirn-Gekritzel, 2001
Perlmuschel, geschwärztes
Silber, Tinte
Dm. 6 cm

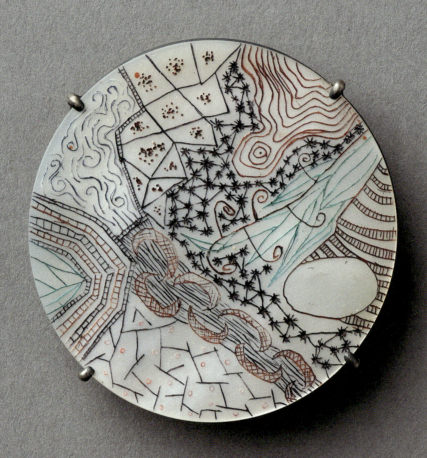

MUSTER

Brooch
Made in Fiji, 2009
Pinna shell
4 × 4 cm
Art Gallery of South
Australia, Adelaide,
gift of Truus and
Joost Daalder through
the Art Gallery of
South Australia
Foundation, 2017
Photo: Grant Hancock

Brosche
Made in Fiji, 2009
Pinna-Muschel,
4 × 4 cm
Art Gallery of South
Australia, Adelaide,
Schenkung Truus und
Joost Daalder durch
die Art Gallery of
South Australia
Foundation, 2017
Foto: Grant Hancock

SENTENCES

Installation
<u>Sentence</u>, 2024
Pink Monkey Bird, Face Ache, Poppy, Hanger Hook, Pāua Brooch, Red Butterfly, Apron Hook, Cross Bones, Lava Brooch, Lamp, Key (Yale), Gorse Brooch, Pearl Pillow, Fella, Starling
Various materials, various dimensions

Installation
<u>Sentenz</u>, 2024
Rosaroter Affenvogel, Gesichtsschmerzen, Mohnblume, Kleiderbügelhaken, Pāua-Brosche, Roter Schmetterling, Schürzenhaken, Gekreuzte Knochen, Lavabrosche, Glühbirne, Schlüssel (Yale), Ginster-Brosche, Perlen-Kissen, Kumpel, Star
Verschiedene Materialien und Maße

SENTENZEN

SENTENCES

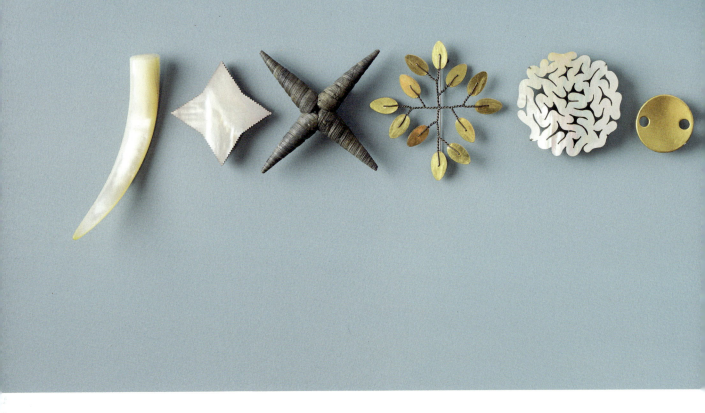

Installation
<u>Sentence</u>, 2024
Pearl Tusk, Large Star, Shell Star, Leaf Cross, Worm Brooch, Gold Face, Pebble Brooch, Leaf Face, Karaka Leaf, Shell Face, Tongue, Key
Various materials, various dimensions

SENTENZEN

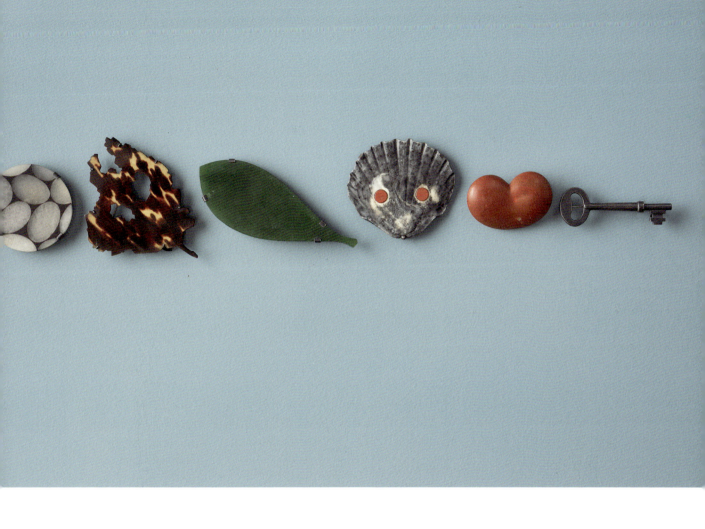

Installation
Sentenz, 2024
Perlmutt-Stoßzahn, Großer Stern, Muschel-Stern,
Blätter-Kreuz, Wurm-Brosche, Gold-Gesicht,
Kieselstein-Brosche, Blatt-Gesicht, Karaka-Blatt,
Muschel-Gesicht, Zunge, Schlüssel
Verschiedene Materialien und Maße

Installation
Sentence, 2024
Bone Hook, Spoon, Flame, Zinc Leaf, Red Man, Bulb, Scallop Blossom, Doodle Brooch, Mon (black), Mon (white), Black Leaf, Pāua Skull
Various materials, various dimensions

Installation
Sentenz, 2024
Knochen-Haken, Löffel, Flamme, Zink-Blatt, Roter Mann, Birne, Jakobsmuschel-Blüte, Kritzeleien-Brosche, Mon (schwarz, jap. für Emblem), Mon (weiß, jap. für Emblem), Schwarzes Blatt, Pāuamuschel-Schädel
Verschiedene Materialien und Maße

SENTENCES

Installation
Sentence, 2024
Snout, Pearl Beak, Water Cross, Black Butterfly,
Gold Star, Plane, Apron Hook, Tack, Pearl Pillow,
Carved Brain, Karaka Leaf, Key, White Butterfly
Various materials, various dimensions

SENTENZEN

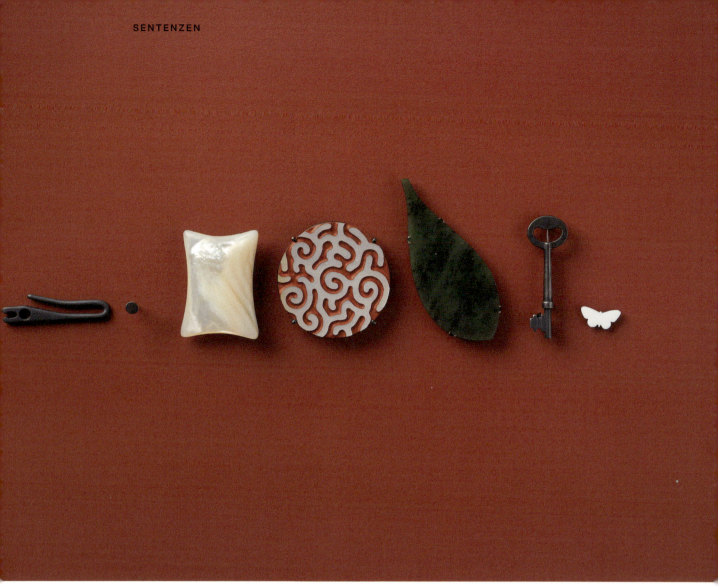

Installation
Sentenz, 2024
Schnauze, Perlen-Schnabel, Wasser-Kreuz,
Schwarzer Schmetterling, Goldener Stern,
Flugzeug, Schürzenhaken, Reißzwecke, Perl-
Kissen, Geschnitztes Gehirn, Karaka-Blatt,
Schlüssel, Weißer Schmetterling
Verschiedene Materialien und Maße

07
FREEMAN DAYS

BRONWYN LLOYD

FREEMAN-TAGE
07

Pendants
<u>Sunbird</u>, 2021
<u>Tool</u>, 2010
Concretion; jasper
9.5 × 2.4 cm; 7.7 × 3.4 cm

Anhänger
<u>Sonnen-Vogel</u>, 2021
<u>Werkzeug</u>, 2010
Konkretion, Japis
9,5 × 2,4 cm und 7,7 × 3,4 cm

One day a week for the past two years I have been assembling a catalogue raisonné of Warwick Freeman's jewellery. I call it my Freeman Day.

It would be easy to think of the job of putting together a digital archive as a straightforward data-entry role, but my Freeman Days have taught me that the role of archivist can be more than that.

An attentive and curious archivist invests in the project. She sees connections across bodies of work, she charts the development of ideas, she memorises pertinent quotations across several decades of research. Most importantly, she enters into a relationship with the work of an artist, and the success of that relationship should be reflected in the archive that is generated.

In many cases a catalogue raisonné is assembled posthumously, and dealing with the artist's estate is a necessity, which can sometimes be painful and vexed. The process of assembling an archive for a living artist who is still practising, however, and one who has a strong idea about what the archive should and shouldn't be, presents its own particular challenges.

During the intensive research that Damian Skinner engaged in with Warwick Freeman in the lead-up to the touring exhibition project Given (2004), which focused on his culturally appropriative works, Skinner noted candidly that he became 'incredibly aware of the artist's presence and the messy complexity that actively engaging with a maker brings to a project – especially one that asks loaded questions as Given did.'[1]

My experience as Warwick Freeman's archivist has not been especially messy, but it did require that I trust in the process, and one thing that he was adamant about from the start was that the archive should be compiled alphabetically

Seit zwei Jahren halte ich mir Woche für Woche einen Tag frei, um ein Werkverzeichnis über den Schmuck von Warwick Freeman zu erstellen. Ich nenne ihn meinen Freeman-Tag.

Man könnte meinen, der Aufbau eines digitalen Archivs bestünde in der einfachen Eingabe von Daten, doch meine Freeman-Tage haben mich gelehrt, dass die Rolle der Archivarin weit mehr sein kann als das.

Eine aufmerksame und neugierige Archivarin taucht tief in das Vorhaben ein. Sie sieht Verbindungslinien über Werkgruppen hinweg, dokumentiert die Entwicklung von Ideen und merkt sich relevante Zitate aus mehreren Jahrzehnten Forschungsarbeit. Das Wichtigste aber ist: Sie geht eine Beziehung mit dem Werk des Künstlers ein. Die Früchte dieser Beziehung sollten sich in dem erzeugten Archiv widerspiegeln.

Oft wird ein Werkverzeichnis posthum erstellt, sodass man sich zwangsläufig mit dem Nachlass des Künstlers beschäftigt, was mitunter schmerzhaft und schwierig sein kann. Ein Archiv für einen lebenden Künstler aufzubauen, der noch aktiv ist und eine feste Vorstellung davon hat, was das Archiv sein soll und was es nicht sein soll, stellt hingegen eine ganz eigene Herausforderung dar.

Während der intensiven Recherchen, die Damian Skinner im Vorfeld der Wanderausstellung Given (Gegeben, 2004) gemeinsam mit Warwick Freeman durchführte, merkte Skinner offen an, dass er sich „der Präsenz des Künstlers und der chaotischen Komplexität, die sich aus der aktiven Auseinandersetzung mit einem Schaffenden für ein Projekt ergibt – insbesondere für ein Projekt, das so aufgeladene Fragen stellt wie Given –, unfassbar bewusst"[1] wurde. Im Fokus der Ausstellung standen Werke, die sich respektvoll mit der indigenen Kultur auseinandersetzten.

Meine Erfahrung als Archivarin von Warwick Freeman war nicht besonders chaotisch, verlangte aber, dass ich dem Prozess vertraute. Eine Sache, über die er von Anfang an nicht mit sich reden ließ,

by title of individual works, rather than in a chronological arrangement.

The reason for this decision was primarily because the digital archive was also linked to Freeman's survey exhibition project, and his desire was to avoid an exhibition grouped by years and decades. The alphabetical arrangement of the archive, he felt, would encourage people to see connections across his practice that might otherwise have gone unnoticed were the archive to be arranged by date.

Initially I thought this seemed heavy handed on Freeman's part, but one of his responses to a question from Kellie Riggs during an interview for the 2015 issue of the contemporary jewellery magazine Current Obsession helped me to see the rationale behind this approach to the project of archiving his work. 'Within my practice,' Freeman said in the interview,

> one work begets another, and it's also connected by a family tree to other objects made both in my own time and before. And like the Māori experience of ancestry, that interest is not only in a vertical (old to new) order, but I also have a more horizontal sense of it. Using making as the means of expression, I like observing how objects can move across time rather than just backwards or forwards. Now that sounds a bit cosmic, but it manifests very practically; I often find objects that were made eons apart capable of lining up comfortably together.[2]

This comment enabled me to see that the idea of the horizontal axis was key to assembling the archive and that the arbitrariness of an alphabetical arrangement of works was a simple way of achieving this.

During a visit to Freeman's workshop one day, I came to understand more concretely what he meant by applying a horizontal axis to his work. When he opened the top drawer of a set of storage drawers, I saw the pendants Tool (2010)

war, dem Archiv eine alphabetische Ordnung nach Werktiteln zu geben anstelle eines chronologischen Aufbaus.

Dieser Entschluss lag vor allem darin begründet, dass das digitale Archiv auch mit Freemans Vorhaben einer monografischen Ausstellung verknüpft war und er diese auf keinen Fall nach Jahren und Jahrzehnten gegliedert sehen wollte. Er war der Ansicht, die alphabetische Struktur des Archivs würde die Menschen animieren, Verbindungen zwischen seinen Arbeiten zu sehen, die womöglich unbemerkt geblieben wären, hätte man das Archiv nach Daten sortiert.

Nachdem ich anfangs dachte, dass Freeman in diesem Punkt überzog, half mir eine seiner Antworten auf eine Frage von Kellie Riggs in einem 2015 geführten Interview für das zeitgenössische Schmuckmagazin Current Obsession, die Gründe für diese Herangehensweise an die Archivierung seines Werks zu verstehen. „In meiner Praxis", so Freeman in dem Interview,

> bringt eine Arbeit die andere hervor, und über einen Stammbaum ist sie außerdem mit anderen Objekten verbunden, die sowohl zu meiner Zeit als auch davor geschaffen wurden. Und wie bei der Wahrnehmung ihrer Vorfahren durch die Māori ist dieses Interesse nicht nur vertikal (von alt nach neu) ausgerichtet, sondern hat für mich immer auch einen eher horizontalen Aspekt. Mit dem kreativen Schaffen als Ausdrucksmittel stelle ich gerne fest, dass sich Objekte auch in Zeitsprüngen und nicht nur rückwärts oder vorwärts bewegen können. Das klingt jetzt ein bisschen kosmisch, äußert sich aber ganz praktisch: Ich nehme häufig wahr, dass Objekte, die eine Ewigkeit voneinander entfernt hergestellt wurden, in der Lage sind, sich mühelos aneinanderzureihen.[2]

Diese Äußerung machte mir deutlich, dass die Idee der horizontalen Achse für den Aufbau des Archivs von zentraler Bedeutung und die Beliebigkeit einer alphabetischen Werkanordnung eine einfache Methode war, um diese Idee zu verwirklichen.

and Sun Bird (2021) lying side by side on a piece of black felt (page 274).

'Unlikely friends,' Freeman commented, 'but they work together.'[3]

Tool is a roughly hewn pendant fashioned from a chunk of jasper. It has a bulbous body terminating in a narrow handle. Its function as a tool is indeterminate, although it looks as if it would be good as a beating or grinding implement. There is a small hole pierced in the neck for the cord to go through.

Sun Bird, sitting companionably beside Tool, is a bird form carved from a piece of gold concretion. Pared back to its barest essentials, Sun Bird is without wings, feathers, or legs. It has a perfectly smooth bulb-shaped body tapering to a long neck, a small head with a rounded beak, and a hole pierced through the head to represent the bird's eyes. The cord is threaded through a hole in its body so that Sun Bird is suspended head down when worn.

Eleven years separate Tool and Sun Bird, and yet they connect across the horizontal axis of Freeman's practice on many levels. The visually arresting combination of red next to gold, both primary colours, is certainly one aspect of their friendship.[4] Tool and Sun Bird connect, too, on a material level. Both jasper and concretion are formed over a long time within layers of sedimentary rock, so there is kinship in the manner of their creation.

They connect on the levels of form and technique. The bulb and neck shapes of the pendants nod to one another. They are both carved objects, and yet when they are placed side by side, Tool looks like a maquette for Sun Bird – the first phase of an idea being roughed out that later resolves into the smooth, refined, and elegant form of a bird.

Amid the array of connections between the two pendants, a notable point of difference

Während eines Werkstattbesuchs bei Freeman wurde mir noch konkreter bewusst, was er mit der Anwendung einer horizontalen Achse auf seine Arbeit meinte. Als er die oberste einer Reihe von Schubladen aufzog, in denen er Dinge aufbewahrt, sah ich die Anhänger Tool (Werkzeug, 2010) und Sun Bird (Sonnenvogel, 2021) nebeneinander auf einem schwarzen Stück Filz liegen (S. 274).

„Ungleiche Freunde", kommentierte Freeman, „aber sie funktionieren zusammen."[3]

Tool wurde grob aus einem Stück Jaspis herausgearbeitet. Der bauchige Körper des Anhängers endet in einem schmalen Griff. Seine Funktion als Werkzeug ist unklar, auch wenn er so aussieht, als wäre er gut zum Schlagen oder Mahlen geeignet. Ein kleines Loch im Hals dient zum Hindurchziehen der Schnur.

Sun Bird entstand aus einem Stück goldfarbener Konkretion (mineralischer Körper in Gestein) und liegt gesellig neben Tool. Der auf das Wesentliche reduzierte Anhänger in Vogelform hat weder Flügel noch Federn oder Beine. Sein vollkommen glatter, knollenförmiger Körper verjüngt sich zu einem langen Hals und einem kleinen Kopf mit abgerundetem Schnabel. Ein durch den Kopf gebohrtes Loch stellt die Augen des Vogels dar. Die Schnur wird durch ein Loch im Körper gezogen, sodass Sun Bird beim Tragen kopfüber hängt.

Zwischen Tool und Sun Bird liegen elf Jahre, und doch sind sie über die horizontale Achse des Freeman'schen Schaffens auf vielerlei Weise miteinander verbunden. Die optisch faszinierende Kombination der beiden Primärfarben Rot und Gold macht sicherlich einen Aspekt ihrer Freundschaft aus.[4] Die Verbindung der beiden Stücke erstreckt sich auch auf ihr Material. Sowohl Jaspis als auch Konkretionen werden über lange Zeiträume in Schichten von Sedimentgestein gebildet, sodass ein verwandtschaftliches Verhältnis in der Art ihrer Entstehung existiert.

Weitere Zusammenhänge zwischen Tool und Sun Bird bestehen auf formaler und technischer Ebene.

has to do with the conceptual space they each inhabit. Tool draws on Stone Age knowledge, speaking to the use of jasper as a cutting tool as far back as the Neolithic period. Sun Bird calls back to Greek antiquity and the story of hubris in the ancient myth of Icarus – the boy whose ambition got the better of him when he flew too close to the sun in a pair of wings held together with wax. Freeman's wingless concretion Sun Bird nosedives towards oblivion, like poor Icarus, saved only by the wearer holding the pendant aloft.

The game of identifying connections between works across the horizontal axis of Warwick Freeman's practice, and building this into the digital archive through a sometimes dizzying array of cross-references, has been one of the most enjoyable aspects of the project. Another has been learning about the process that Freeman describes as 'fattening' his works.

'My way of building the information around a piece has quite a deliberate process,' Freeman explains to Damian Skinner in the last of a series of interviews the pair recorded between 2001 and 2003:

> I start a manila folder and I throw everything into that folder that the piece feeds on. I write on the cover – sometimes it's the name of the piece, sometimes that manila folder will end up with six names and none of them will be the name of the piece when it's finally finished. And quite a lot of those manila folders don't ever have a piece connected with them but they will have names on them, or suggestions of what they contain. So one folder might say Tongue on it and in it will be images of tongues that I've found. That's the process. And in there will be collected little bits of writing, quotations, anything that might have in some way fed into the piece.[5]

I should point out that in the process of archiving Warwick Freeman's practice I was not privy to the contents of a number of what must be by

In ihren Knollen- und Halsformen reichen sich die Anhänger die Hände. Beides sind geschnitzte Objekte. Doch legt man sie nebeneinander, dann wirkt Tool wie ein Modell für Sun Bird – die erste Phase einer grob skizzierten Idee, die später in die glatte, verfeinerte und elegante Form des Vogels übergeht.

Aus dem Netz von Verbindungen zwischen beiden Anhängern sticht ein bemerkenswerter Unterschied hervor, der mit dem konzeptionellen Raum zu tun hat, in dem sie jeweils zu Hause sind. Tool greift auf steinzeitliches Wissen zurück und verweist auf die Verwendung von Jaspis als Schneidewerkzeug bereits in der Jungsteinzeit. Derweil knüpft Sun Bird an die griechische Antike und die Geschichte der Selbstüberschätzung im Mythos von Ikarus an – jenem Jüngling, dessen Ehrgeiz ihn das Leben kostete, als er mit seinen von Wachs zusammengehaltenen Flügeln der Sonne zu nahe kam. Freemans flügelloser Sun Bird stürzt wie der arme Ikarus der Vergessenheit entgegen und wird nur gerettet, weil der Hals der ihn tragenden Person ihn hält.

Das Spiel, über die horizontale Achse in Warwick Freemans Werk Verbindungen zwischen seinen Arbeiten zu erkennen und daraus mithilfe einer manchmal verwirrenden Vielzahl von Querverweisen das digitale Archiv aufzubauen, hat sich als einer der angenehmsten Aspekte des Projekts entpuppt. Ein anderer ist, sich mit dem Prozess vertraut zu machen, den Freeman als das „Nähren" seiner Arbeiten bezeichnet.

„Meine Methode, Informationen zu einem Stück zu sammeln, folgt einem wohlüberlegten Muster", erklärte er gegenüber Skinner im letzten einer Reihe von Interviews, die die beiden zwischen 2001 und 2003 führten:

> Ich lege eine Mappe an und werfe in diese Mappe alles hinein, was zu dem Stück beiträgt. Ich beschrifte den Deckel – manchmal ist es der Name des Stücks, manchmal landen sechs Namen auf der Mappe, von denen keiner zum Namen des Stücks wird, wenn es schließlich

now several hundred manila folders, but on many of my Freeman Days Warwick would bring along to the office bits and pieces extracted from the fabled files to assist me with the fattening process.

Early on in the project, for example, when I was cataloguing the letter B, and had reached Freeman's Button and Bead Necklace (1988; page 281), he gave me a scan of a page from Australian writer David Malouf's short story 'In Trust'.

The excerpt from the story described the way that the everyday objects in our lives, the 'paraphernalia of daily living', pass from hand to hand and become detached from their history over time until the only thing these objects assert is 'their own presence: *we are here*':

> None of our kind come to us down that long corridor. Only the things they made and made use of, which still somehow keep contact with them. We look through the cracked bowl to the lips of children. Our hand on the axe-handle fits into an ancient groove and we feel the jarring of tree trunk on bone. Narrowly avoiding through all their days the accidents that might have toppled them from a shelf, the flames, the temper trantrums, the odd carelessness of a user's hand, they are still with us. We stare and are amazed. Were they once, we ask ourselves, as undistinguished as the buttons on our jacket or a stick of roll-on deodorant? Our own utensils take on significance for a moment in the light of the future. Small coins glow in our pockets…[6]

Warwick Freeman and I talked that day about ephemera, throw-away things, the wee bits and bobs of a life, like the undistinguished buttons and beads that inspired his necklace and that travel through the generations of a family.

The object record for Button and Bead Necklace fattened again the following Freeman Day when he brought along the photocopied A4 pamphlet that accompanied his 1988 exhibition Buttons

fertig ist. Und ziemlich viele dieser Mappen besitzen nie eine Verbindung zu einem Stück, sind aber mit Namen oder Hinweisen auf ihren Inhalt versehen. Auf einer Mappe könnte also Tongue [Zunge] stehen, und ihr Inhalt würde aus Bildern von Zungen bestehen, die ich gefunden habe. Das ist das Muster. Und darin versammelt wären kleine Texte, Zitate und alles, was in irgendeiner Weise in das Stück eingeflossen sein könnte.[5]

Ich sollte betonen, dass ich bei der Archivierung des Gesamtwerks von Warwick Freeman den Inhalt zahlreicher dieser inzwischen wohl mehreren Hundert Mappen nicht kannte, doch an vielen meiner Freeman-Tage brachte Warwick dies und jenes aus den sagenhaften Mappen mit ins Büro, um mir beim beim Aufbau des Archivs zu helfen. Am Anfang des Projekts zum Beispiel, als ich den Buchstaben B katalogisierte und bei Freemans Button and Bead Necklace (Knopf und Perlen Halsschmuck, 1988, S. 281) angekommen war, drückte er mir eine gescannte Seite aus einer Kurzgeschichte von David Malouf in die Hand.

In dem Auszug aus der Geschichte mit dem Titel „Zu treuen Händen" schildert der australische Schriftsteller, wie die Gegenstände unseres Alltags, das ganze „Drum und Dran des täglichen Lebens", von Hand zu Hand gehen und sich im Laufe der Zeit von ihrer Geschichte lösen, bis sie nur noch eine Botschaft haben – die „ihrer eigenen Präsenz: *Wir sind hier*":

> Keiner von unserer Art kommt den langen Gang herunter zu uns. Nur die von ihnen geschaffenen und gebrauchten Gegenstände, die irgendwie noch immer Verbindung zu ihnen halten. Wir schauen durch die gesprungene Schale zu den Lippen von Kindern. Unsere Hand auf einem Axtstiel paßt in eine alte Rille, und wir spüren instinktiv, wie ein Baumstamm gegen einen Knochen schabt. Die Gegenstände sind immer noch bei uns, nachdem sie während all der Zeit nur knapp Unfällen entgangen sind, die sie von einem Regal hätten herunterstürzen können, Feuersbrünsten, Wutanfällen, der zeitweiligen

Button and Bead
Necklace, 1988
Oxidised silver
70 cm overall length

Knopf und Perlen
Halsschmuck, 1988
Geschwärztes Silber
Gesamtlänge: 70 cm

Brooch
Rose from Fern Fish
Feather Rose, 1987
Silver
5.2 × 5 cm

Brosche
Rose (aus der Gruppe
Fern Fish Feather
Rose), 1987
Silber
5,2 × 5 cm

Colin McCahon
(1919-1987)
Rosegarden V, 1974
Oil paint, hessian
91.8 × 76.8 cm
Hocken Collections
Uare Taoka o Hākena,
University of Otago
Ōtākou Whakaihu
Waka, purchased with
the assistance of
a subsidy from the
Queen Elizabeth II
Arts Council of New
Zealand, reproduced
courtesy of the
Colin McCahon Trust

Colin McCahon
(1919-1987)
Rosegarden V, 1974
Ölfarbe, Sackleinen
91,8 × 76,8 cm
Hocken Collections
Uare Taoka o Hākena,
University of Otago
Ōtākou Whakaihu
Waka, erworben mit
Unterstützung des
Queen Elizabeth II
Arts Council of New
Zealand, Courtesy
Colin McCahon Trust

and Beads at the cooperative jewellery gallery Fluxus in Dunedin. The excerpt from Malouf's story occupied one side of the pamphlet. On the facing page was a reproduction of a Colin McCahon painting, Rosegarden V (1974; page 282), in the Hocken Collections Uare Taoka o Hākena, University of Otago.

The painting has a half-circle of white beads, perhaps rosary beads, perhaps pearls, dangling from the top of an impenetrable black ground painted on unstretched hessian. Warwick mentioned how much he had wanted to borrow the McCahon painting for his exhibition at Fluxus and display his necklace alongside it. He wasn't given permission to do so then, although I suspect he would be now.

He talked about the raised eyebrows he received when he tried to introduce abstract ideas such as Malouf's story alongside his work. 'It's only jewellery, Warwick,' people said.

In a manila folder of Freeman's unpublished commentary about his work from the 1980s, I came across a hand-written account that shows the fattening process in action, creating a loop that draws together his Button and Bead Necklace, his silver Rose Brooch (page 281) from the four-piece suite Fern Fish Feather Rose (1987; page 42), and Colin McCahon's Rosegarden V:

> … it's another of those confirming connections that drives the existence of makers – it's nice that the hero (McCahon) found meaning in beads also, but I never promised you a Rose Garden (pun). I make a rose brooch for a rose garden in a rose city (Whanganui): rose, rosary beads, rose garden. Back and forwards the ideas bounce, or more accurately, into line they come, like beads. The circle connects.

The fattening process taught me that Freeman's Button and Bead Necklace is more complex than it appears – a statement that applies to every

Unachtsamkeit eines Benutzers. Wir schauen sie mit Staunen an. Wir fragen uns, ob sie jemals so gewöhnlich waren wie die Knöpfe an unserer Jacke oder ein Deodorantstift. Unsere eigenen Gebrauchsgegenstände und Geräte werden im Licht der Zukunft für einen Augenblick bedeutsam. Münzen leuchten in unserer Tasche.[6]

Warwick Freeman und ich unterhielten uns an jenem Tag über Ephemera, Wegwerfartikel, die Kleinigkeiten eines Lebens wie die gewöhnlichen Knöpfe und Perlen, die ihn zu seiner Halskette angeregt hatten und die von Generation zu Generation durch eine Familie wandern.

Der Objektdatensatz des Button and Bead Necklace wurde an meinem nächsten Freeman-Tag weiter „genährt", als Warwick die fotokopierte DIN-A4-Broschüre mitbrachte, die anlässlich seiner Ausstellung Buttons and Beads (Knöpfe und Perlen) in der Galerie der Künstlerkooperative Fluxus in Dunedin entstanden war. Der Auszug aus Maloufs Geschichte nahm eine Seite der Broschüre ein. Auf der Seite gegenüber war Rosegarden V (Rosengarten V, 1974, S. 282) abgebildet, ein Gemälde von Colin McCahon, das sich heute in den Hocken Collections Uare Taoka o Hākena der University of Otago befindet.

In dem Gemälde hängen vom oberen Rand eines undurchdringlichen schwarzen Hintergrunds, der auf ein nicht aufgespanntes Stück Jute gemalt wurde, oval weiße Kügelchen herab – vielleicht ein Rosenkranz, vielleicht Perlen. Warwick erwähnte, wie gerne er das McCahon-Bild für seine Ausstellung bei Fluxus ausgeliehen und seine Halskette direkt daneben präsentiert hätte. Damals blieb ihm die Genehmigung verwehrt, von der ich vermute, dass er sie heute bekäme. Er sprach von den hochgezogenen Augenbrauen, die er bei dem Versuch erntete, abstrakte Ideen wie Maloufs Geschichte Seite an Seite mit seinen Arbeiten auszustellen. „Es ist bloß Schmuck, Warwick", bekam er zu hören.

In einer Mappe mit unveröffentlichten Kommentaren Freemans über seine Arbeit aus den

piece of his jewellery that I have catalogued to date. Even though Freeman once made the wry comment to a student that not every object has a story attached to it, and that 'sometimes jewellery is just a pair of earrings',[7] this needs to be taken with a very large pinch of salt. The stories that his Button and Bead Necklace fed on led me to reflect on symbolism and meaning in jewellery; on time and memory; on what I myself value and why; and on what I choose to keep, and why.

The exchanges I have had with Warwick Freeman one day a week for the past two years have been the real prize of the archival project, and the insights I have gained into how a person sustains a creative practice for over fifty years have been valuable beyond measure. Of the many highlights along the way, however, perhaps the best of all was seeing a new edition of work come into being.

In 2022 I heard from a friend who shared Warwick's studio that he was working on a new pendant design. Intrigued, I asked him how it was going when I saw him next. 'Not well,' he said. 'I've put it aside.'

He explained that he does that a lot, because any new piece has to earn its place before being admitted into his corpus.

Warwick mentioned that two unfinished pieces from the planned edition of three were in his car and he offered to bring them in to show me. He returned with two wooden boxes. 'Moon Monkey' was written on the box lids with a brush dipped in black ink. He opened the lids, and there, lying on sheets of grey foam, were two extraordinary silver monkeys.

They had such beautiful faces, with benign expressions, bodies slightly textured to suggest fur, and each monkey had one elongated arm reaching downwards, and the other holding on to a branch of black coral, the last precious fragments from Warwick's supply. A luminescent

1980er-Jahren stieß ich auf eine handschriftliche Äußerung, die den „Nähr-Prozess" in Aktion zeigt. Sie verknüpft das Button and Bead Necklace mit Freemans silberner Rosenbrosche (S. 281) aus der vierteiligen Sentenz Fern Fish Feather Rose (Farn Fisch Feder Rose, 1987, S. 42) und Colin McCahons Rosegarden V zu einem geschlossenen Kreislauf:

> […] hier haben wir noch eine dieser bestärkenden Verbindungen, die den Schaffenden in seinem Dasein antreiben – es ist schön, dass auch für den Starkünstler (McCahon) Perlen eine Bedeutung hatten, aber ich hab dir nie einen Rosengarten versprochen (Wortspiel). Ich fertige eine Rosenbrosche für einen Rosengarten in einer Rosenstadt (Whanganui) an: Rose, Rosenkranz, Rosengarten. Die Ideen springen hin und her oder, genauer gesagt, sie reihen sich auf wie Perlen. Der Kreis schließt sich.

Der „Nähr-Prozess" führte mir vor Augen, dass Freemans Button and Bead Necklace vielschichtiger ist, als es scheint – was tatsächlich auf jedes Schmuckstück zutrifft, das ich bislang von ihm katalogisiert habe. Auch wenn er einem Schüler gegenüber einmal ironisch anmerkte, nicht jedes Objekt sei mit einer Geschichte gekoppelt und „manchmal ist Schmuck einfach nur ein Paar Ohrringe",[7] ist diese Aussage doch mit sehr großer Vorsicht zu genießen. Die Geschichten, die in sein Button and Bead Necklace eingeflossen sind, haben mich veranlasst, über die Symbolik und Bedeutung von Schmuck nachzudenken, über die Zeit und die Erinnerung, aber auch darüber, was ich selbst aus welchen Gründen schätze und was ich mich zu behalten entschließe und warum.

Der Gedankenaustausch, den ich seit zwei Jahren einmal in der Woche mit Warwick Freeman pflege, ist der wahre Lohn dieses Archivierungsprojekts, und die Einblicke, die ich in die Fähigkeit eines Menschen gewonnen habe, mehr als fünfzig Jahre lang einer schöpferischen Tätigkeit nachzugehen, sind unermesslich wertvoll. Doch von den vielen Höhepunkten aus dieser Zeit war der vielleicht beste, neue Schmuckarbeiten entstehen zu sehen.

mother of pearl sphere was attached to the back of each monkey's hand.

Warwick picked up the two monkeys, linked them together, and told me about the High and Low game he applied to the work:

> The 'low story' is the Barrel of Monkeys game, where you have to see how many monkeys you can link without the chain breaking. The 'high story' is the Buddhist fable about a monkey who sees the moon reflected in a well. Thinking it is within reach, he enlists a troop of monkeys to seize the moon. The branch the monkeys are dangling from breaks, as does the surface of the water when they fall in, and the plan to catch the moon fails.

He showed me Monkey Reaching for the Moon (ca. 1890–1910; page 287), by Ogata Gekkō,[8] that inspired his edition, which he first recalled seeing on a scroll in a temple in Kyoto.

Warwick described the story as an 'exercise in complete futility', and when I read the fable later at home, I learned that the Buddhist interpretation of it is that the monkey stands for unenlightened people who cannot distinguish between reality and illusion.

'At one stage,' Warwick said, turning a silver monkey over in his hand, 'I put the pearl sphere into the palm of one of the monkey's hands, as a symbol of hope, but I decided against it and shifted it to the back of its hand instead.'

When I expressed my dismay that a piece that looked to me so complete could be shelved, Warwick explained that at this stage he couldn't see the work as his.

I had come across this point in relation to an earlier piece that he had also set aside, the Globe Kapkap pendant (1989).[9] In that instance he commented that the meaning the work took from its original context as a recognised

2022 hörte ich von einer Freundin, die mit Warwick die Werkstatt teilte, dass dieser mit dem Entwurf für einen neuen Anhänger beschäftigt war. Fasziniert fragte ich ihn bei unserem nächsten Treffen, wie er damit vorankam. „Nicht gut", antwortete er: „Ich habe ihn zur Seite gelegt."

Das mache er häufig, erläuterte er, denn jedes neue Stück müsse sich seinen Platz erst verdienen, bevor es in sein Œuvre aufgenommen werde.

Warwick fuhr fort, dass draußen in seinem Auto zwei weitere unfertige Stücke einer geplanten dreiteiligen Serie lägen, und bot sich an, sie hereinzuholen, um sie mir zu zeigen. Er kam mit zwei Holzkästchen zurück. „Moon Monkey" (Mondaffe) war mit schwarzer Tusche auf die Deckel gepinselt. Er öffnete sie, und zum Vorschein kamen, in grauen Schaumstoff gebettet, zwei außergewöhnliche Affen aus Silber.

Sie hatten wahnsinnig hübsche Gesichter. Ihre Mienen waren freundlich, die Körper leicht strukturiert, um Fell anzudeuten, und bei beiden reichte ein lang ausgestreckter Arm weit nach unten, während sich der andere an einem Ast aus schwarzer Koralle festhielt, einem letzten wertvollen Rest aus Warwicks Vorrat. Auf dem Handrücken trug jeder Affe eine schillernde Kugel aus Perlmutt.

Warwick nahm die beiden Affen in die Hand, verband sie miteinander und erzählte mir von dem Himmel-und-Erde-Spiel, das er bei dieser Arbeit anwendete:

> Die „irdische Geschichte", das ist das „Barrel of Monkeys Game", dieses Spiel, bei dem man möglichst viele Affen aneinanderhängen muss, ohne dass die Kette reißt. Die „himmlische Geschichte" ist die buddhistische Fabel von dem Affen, der in einem Brunnen das Spiegelbild des Mondes erblickt. Weil er ihn in Reichweite glaubt, engagiert er einen Affentrupp, um den Mond zu ergreifen. Doch der Zweig, von dem die Affen herabhängen, bricht – genauso, wie sich das Spiegelbild auflöst, als sie ins Wasser fallen, sodass der Plan, den Mond einzufangen, scheitert.

Pendant
Moon Monkey, 2022
Mudstone, oxidised silver
19.6 × 5 cm

Anhänger
Mond-Affe, 2022
Schlammstein,
geschwärztes Silber
19,6 × 5 cm

Ogata Gekkō 尾形月耕 (1859-1920)
Monkey Reaching for the Moon,
ca. 1890-1910
Ink and colour on paper
24 × 24.8 cm
Robert O. Muller Collection,
National Museum of Asian Art,
The Smithsonian Institution,
S2003.8.1669

Ogata Gekkō 尾形月耕 (1859-1920)
Der Affe greift nach dem Mond,
ca. 1890-1910
Tinte und Farbe auf Papier
24 × 24,8 cm
Robert O. Muller Collection,
National Museum of Asian Art,
The Smithsonian Institution,
S2003.8.1669

jewellery form from Melanesia contributed 'too much to the understanding' and that his own contribution wasn't 'adequate to balance that'.[10]

I pointed out the narrative link between the monkeys and his recent Sun Bird (page 274) as an example of another tale about the folly and vanity of trying to surpass one's natural limits, but Warwick remained unconvinced about the piece he had made.

'Maybe I could release it under a different name,' he joked, tucking the failed monkeys back into their boxes.

Er zeigte mir Der Affe greift nach dem Mond (um 1890-1910, S. 287) von Ogata Gekkō,[8] der ihn zu seinen Entwürfen angeregt hatte und ihm rückblickend erstmals auf einer Hängerolle in einem Tempel in Kyoto begegnet war.

Warwick beschrieb die Geschichte als eine „Übung in völliger Sinnlosigkeit", und als ich die Fabel später zu Hause las, erfuhr ich, dass der Affe nach buddhistischer Auslegung für die Unerleuchteten steht, die nicht zwischen Wirklichkeit und Illusion unterscheiden können.

„An einem Punkt", sagte Warwick, während er einen der silbernen Affen in seiner Hand umdrehte, „legte ich einem Affen die Perlmuttkugel als Symbol der Hoffnung in die Handfläche, entschied mich dann aber dagegen und verschob sie stattdessen auf den Handrücken."

In Anbetracht meiner Bestürzung darüber, dass ein Stück, das mir so vollendet erschien, zurückgestellt werden konnte, erklärte mir Warwick, er könne das Werk in diesem Stadium nicht als das seine betrachten.

Mir war dieses Stadium im Zusammenhang mit dem Globe Kapkap (Globus-Kapkap, 1989),[9] einem früheren Stück schon einmal begegnet, das er ebenfalls beiseitegelegt hatte. In diesem Fall hatte er angegeben, die Bedeutung, die das Werk aus seinem Originalkontext als tradierte melanesische Schmuckform bezog, hätte „zu viel zum Verständnis" beigesteuert und sein eigener Beitrag nicht „ausgereicht, um das auszugleichen".[10]

Ich hob die narrative Verbindung zwischen den Affen und dem neueren Sun Bird (S. 274) hervor – als Beispiel für eine weitere Erzählung von der Unsinnigkeit und Eitelkeit des Versuchs, seine natürlichen Grenzen zu überschreiten, doch Warwick war von dem Stück, das er geschaffen hatte, weiterhin nicht überzeugt.

„Vielleicht könnte ich es unter einem anderen Namen herausbringen", scherzte er und legte die „misslungenen Affen" in ihre Kästchen zurück.

I didn't see the monkeys again, although, in truth, I thought of them often.

Imagine my surprise then, one year later, to encounter during my research into something else entirely two completed pendants from an edition of three called Moon Monkey (2022; page 286).

Gone were the beautiful silver monkeys I had been introduced to. What remained instead was a sizeable sphere of obsidian, and a variant pendant made from a sphere of mudstone, each with eerily long, thin, and bendy arms of oxidised silver extending from the sphere; one reaching downwards, the other reaching up to grasp the plaited cord. Monkey and Moon had become one: the desirous subject – the Monkey – and the object of its desire – the Moon – locked in a perpetual game of attainment and denial.

After my shock subsided it became clear to me that the edition of Moon Monkey in its final form is most definitely a Warwick Freeman. While all traces of prettiness had gone, the force of the narrative itself landed with far greater impact through the starkness and severity of the obsidian and mudstone spheres, and through the beseeching, desperate gesture of those over-long arms.

Seeing the Moon Monkey edition in its two distinct phases of becoming showed me that what makes a piece of jewellery recognisable as a Warwick Freeman is when the form, the material, the process, and the narrative all work together. Only he can decide when that marriage has succeeded and when he has done enough to call a work his own.

After many Freeman Days I am getting closer to understanding that.

Ich habe sie nie wiedergesehen, obwohl ich wirklich oft an sie denken musste.

Man kann sich daher vorstellen, wie überrascht ich war, als ich ein Jahr später bei meinen Nachforschungen nach etwas völlig anderem auf zwei fertige Anhänger aus einer dreiteiligen Serie namens Moon Monkey (Mond-Affe, 2022, S. 286) stieß.

Die wunderschönen silbernen Affen, die ich kennengelernt hatte, waren verschwunden. Freeman hatte sie durch eine ansehnliche Obsidiankugel und eine Kugel aus Schlammstein[11] ersetzt und beide mit unheimlich langen, dünnen und gewundenen Armen aus geschwärztem Silber versehen. Jeweils ein Arm reicht von der Kugel nach unten, der andere nach oben, um die geflochtene Schnur zu ergreifen. Affe und Mond waren eins geworden: das begehrende Wesen – der Affe – und das Objekt seines Begehrens – der Mond – verstrickt in ein ewiges Spiel aus Aneignung und Verweigerung.

Nachdem sich mein Schock gelegt hatte, wurde mir klar, dass die Serie Moon Monkey in ihrer endgültigen Form ein echter Warwick Freeman war. Während sich sämtliche Anzeichen von Schönheit in Luft aufgelöst hatten, kam die narrative Kraft der Stücke durch die Nüchternheit und Strenge der beiden Kugeln und die flehende, verzweifelte Geste der überlangen Arme umso stärker zur Geltung.

Diese Serie in den unterschiedlichen Stadien ihrer Entstehung zu sehen, ließ mich erkennen, was aus einem Schmuckstück ein Werk von Warwick Freeman werden lässt: das Zusammenwirken von Form, Material, Prozess und Narrativ. Nur Freeman kann entscheiden, wann diese Verbindung erfolgreich ist und wann er genug getan hat, um eine Arbeit seine eigene zu nennen.

Nach vielen Freeman-Tagen glaube ich, das immer besser zu verstehen.

FREEMAN-TAGE

1
Damian Skinner, 'Uncertain Moves.' Large Star / Rangitoto Heart: A Birthday Book in Honour of Warwick Freeman, edited by Damian Skinner, published on the occasion of Warwick Freeman's 55th birthday, 5 January 2008. Rim Books, 2008, p. 119.

2
Kellie Riggs, 'Distance from the Stars: An Interview with Warwick Freeman.' Current Obsession, issue 4, 2015, p. 92. https://www.currentobsession.com/distance-from-thestars/ (2.12.2024).

3
Conversation between Warwick Freeman and the writer in Freeman's Auckland workshop, 21 February 2024.

4
Warwick Freeman's exploration of combinations of coloured stone came to the fore in his exhibition Prime (2015) at Gallery Funaki, Melbourne, which brought together red, yellow, and blue works from across fifteen years of his practice. He has also stacked small coloured blocks of stone in his Blockhead pendants (2011), and larger blocks in utilitarian works such as his Stack Candleholder (2016).

5
Damian Skinner, editor, Large Star / Rangitoto Heart: A Birthday Book in Honour of Warwick Freeman, p. 192.

6
David Malouf, 'In Trust.' David Malouf: The Complete Stories. Knopf, 2007, pp. 434-35.

1
Damian Skinner, „Uncertain Moves", in: Ders. (Hg.), Large Star / Rangitoto Heart: A Birthday Book in Honour of Warwick Freeman, anlässlich des 55. Geburtstags von Warwick Freeman veröffentlicht, 5. Januar 2008, Auckland 2008, S. 119.

2
Kellie Riggs, „Distance from the Stars: An Interview with Warwick Freeman", in: Current Obsession, Nr. 4, 2015, S. 92, https://www.currentobsession.com/distance-from-thestars/ (2.12.2024).

3
Gespräch zwischen Warwick Freeman und dem Autor in Freemans Studio in Auckland, 21. Februar 2024.

4
Die Galerie Funaki im Melbourne rückte 2015 Warwick Freemans Erforschung von Kombinationen farbiger Steine in den Vordergrund, als in seiner dortigen Ausstellung Prime (Primär) Arbeiten in Rot, Gelb und Blau aus fünfzehn Jahren seines Schaffens vereinigt waren. Für Anhänger mit dem Namen Blockhead (Klotzkopf, 2011) stapelte er kleine farbige Steinquader aufeinander, die für Gebrauchsgegenstände wie Stack Candleholder (Stapelkerzenleuchter, 2016) entsprechend größer ausfielen.

5
Skinner 2008 (wie Anm. 1), S. 192.

6
David Malouf, „Zu treuen Händen" (1985), in: Ders., Südlicher Himmel: Erzählungen, aus dem Englischen von Adelheid Dormagen, Wien 1999, S. 170-172.

7
Warwick Freeman, 'Two-Headed Dogs. Making a Place for Making,' Lecture delivered at Röhsska Museum, Gothenburg, Sweden, 19 September 2009, which addressed the topic Reconsidering Identity - A Seminar on New Zealand Contemporary Jewellery, p. 15. Warwick Freeman archive, Unpublished Lectures, Folder 1.

8
Ogata Gekkō (1859-1920) was a painter and designer who is best known for his ukiyo-e woodblock prints.

9
A kapkap is a pendant featuring a piece of fretted turtle shell overlaid on a circlular disc of shell.

10
Warwick Freeman, excerpt from an unpublished report written to the Queen Elizabeth II Arts Council, 1990, following his solo exhibition Share of Sky at Galerie Ra, Amsterdam (5 May-2 June 1990). Warwick Freeman archive, Grant Reports.

7
Warwick Freeman, „Two-Headed Dogs: Making a Place for Making", Vortrag zum Thema „Reconsidering Identity: A Seminar on New Zealand Contemporary Jewellery", gehalten im Museum Röhsska in Göteborg, 19. September 2009, S. 15, Archiv Warwick Freeman, unveröffentlichte Vorträge, Mappe 1.

8
Ogata Gekkō (1859-1920) war Maler und Entwerfer, der vor allem für seine Ukiyo-e-Holzschnitte bekannt ist.

9
Ein kapkap ist ein Anhänger, bei dem ein Stück gesäumter Schildkrötenpanzer auf einer kreisförmigen Muschel-Scheibe liegt.

10
Warwick Freeman, Auszug aus einem unveröffentlichten Bericht an das Queen Elizabeth II Arts Council, 1990, im Anschluss an die Einzelausstellung Share of Sky (Teil vom Himmel) in der Galerie Ra, Amsterdam (5. Mai bis 2. Juni 1990), Warwick Freeman, Stipendienberichte.

11
Schlammstein ist ein fein bis sehr fein körniges, dickes, gemasertes Gestein aus Schlamm und Ton.

Warwick Freeman's
Ngataringa Bay workshop,
1978-2019
Photographs by Sam
Hartnett, 2019

08
A WORKSHOP
PORTRAIT

SAM HARTNETT

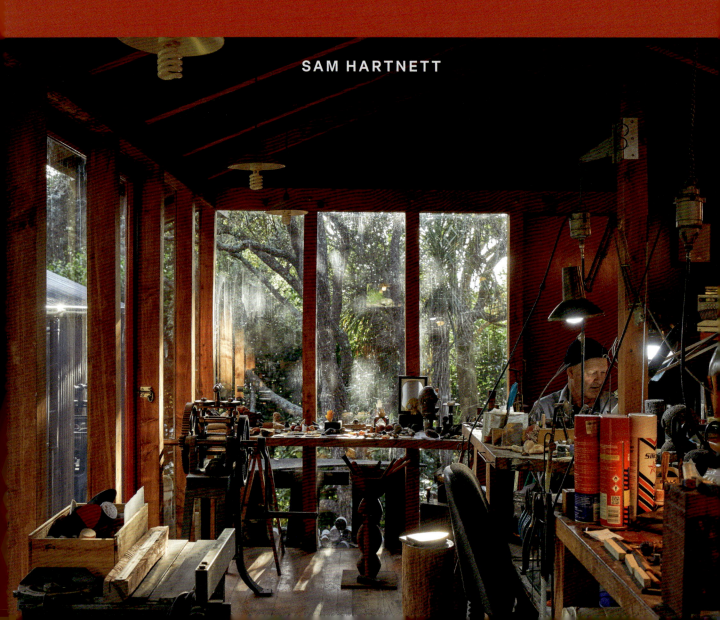

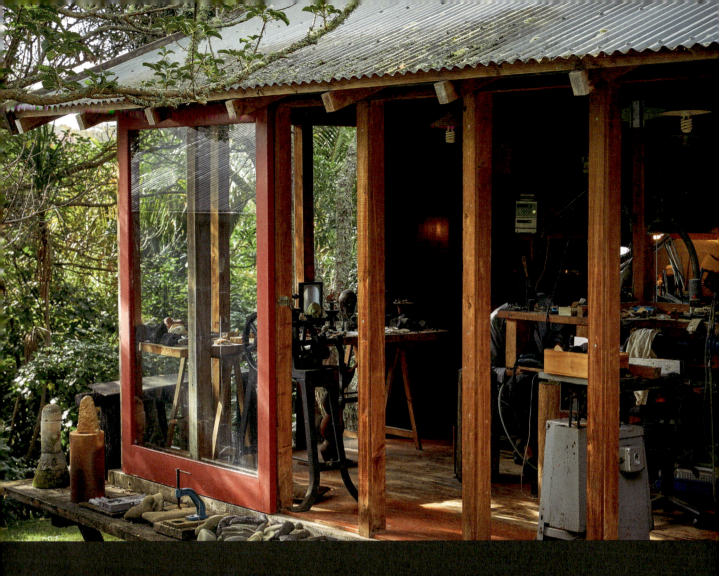

EIN WERKSTATTPORTRÄT 08

Die Werkstatt von Warwick Freeman an der Ngataringa Bay, 1978-2019
Fotografien von Sam Hartnett, 2019

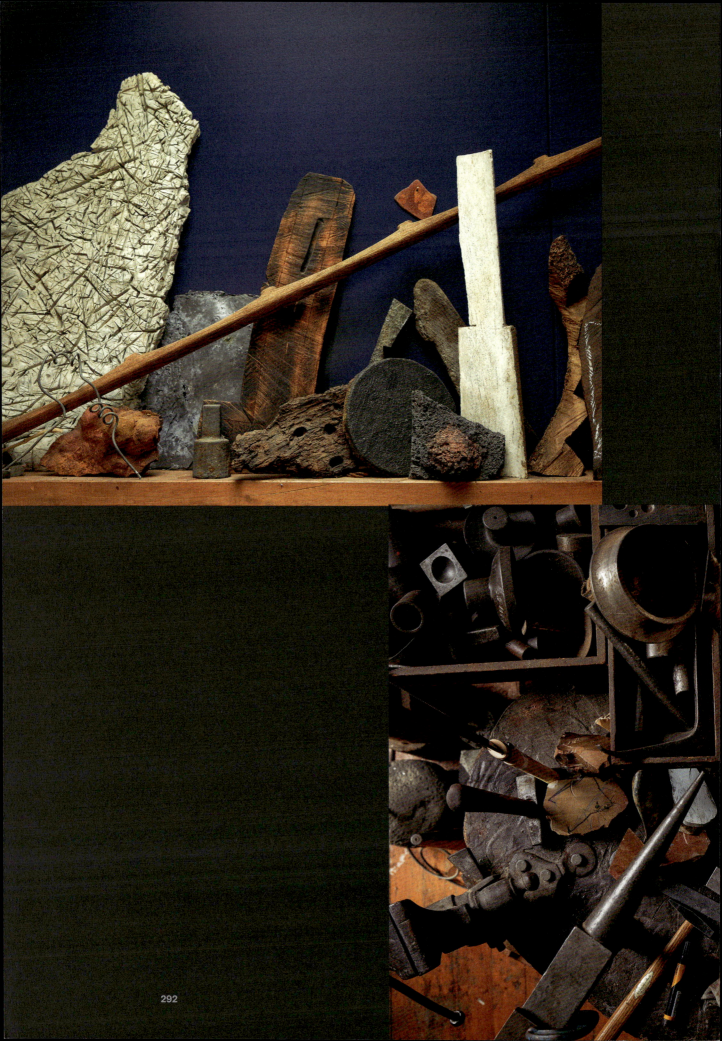

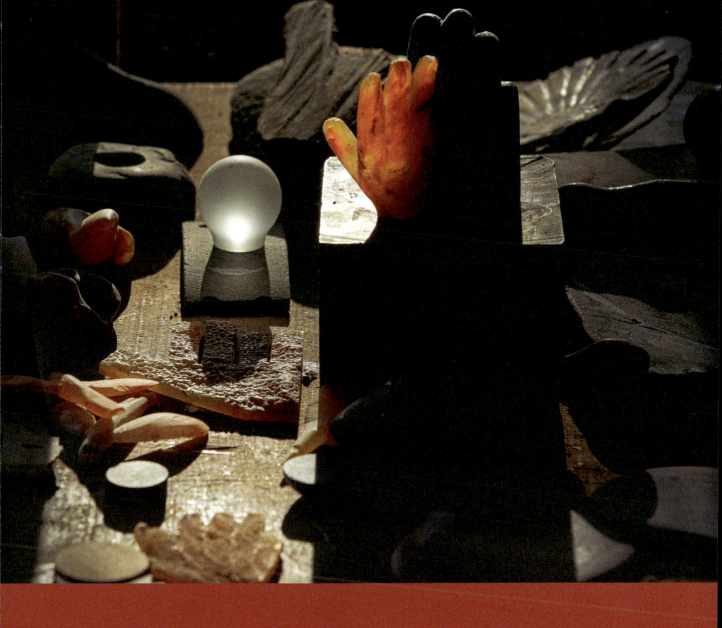

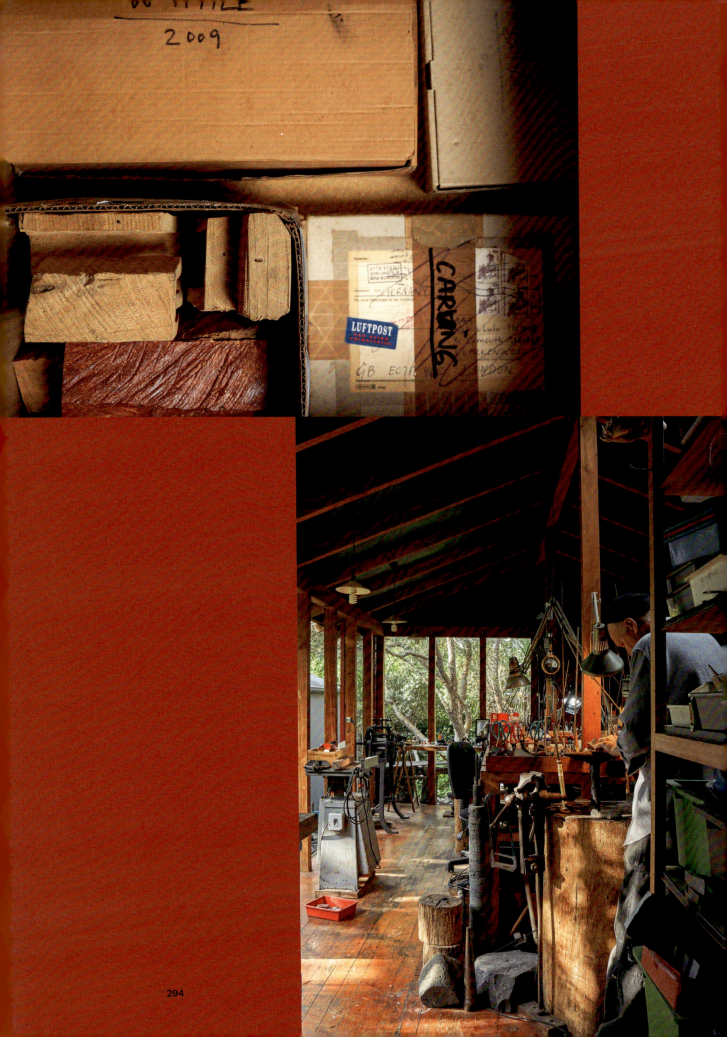

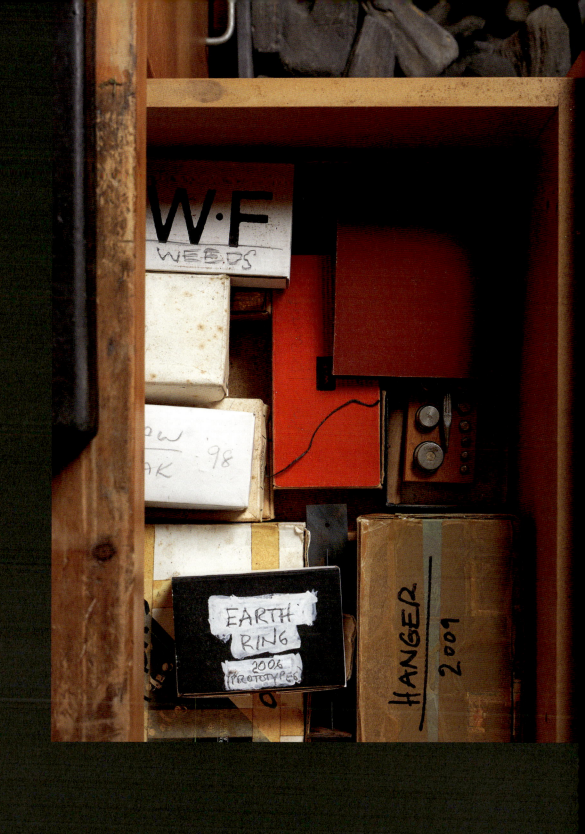

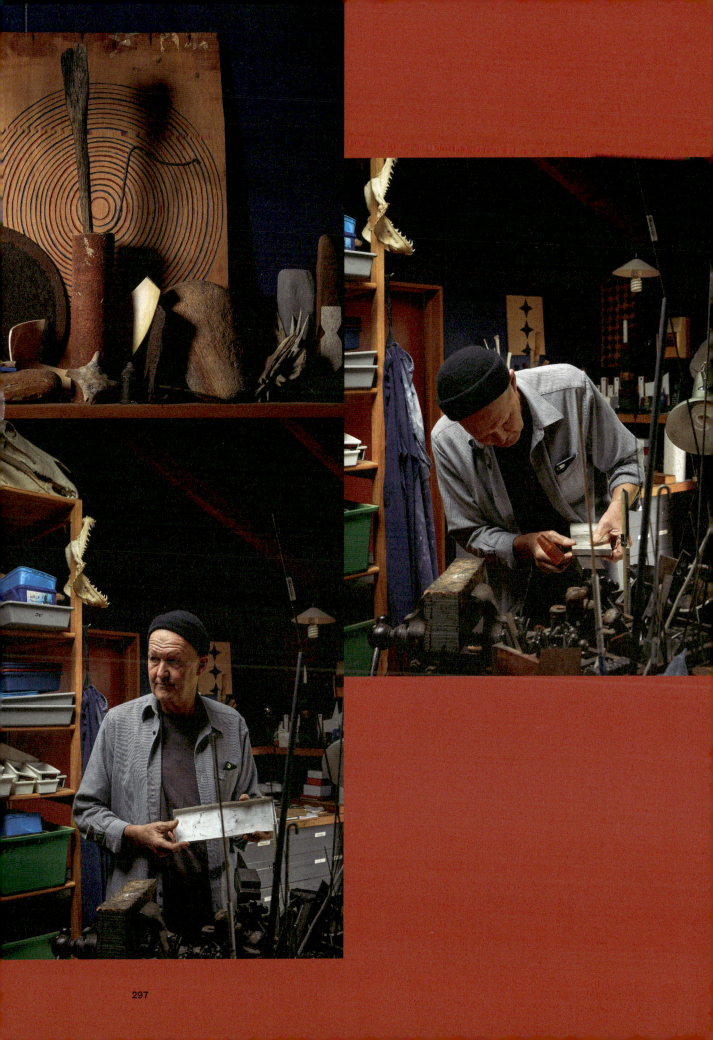

BIOGRAPHY
AWARDS AND PRIZES
EXHIBITIONS
SELECTED BIBLIOGRAPHY

COMPILED BY:
ZUSAMMENGESTELLT VON:
BRONWYN LLOYD

BIOGRAFIE
AUSZEICHNUNGEN UND PREISE
AUSSTELLUNGEN
AUSGEWÄHLTE BIBLIOGRAFIE

1953: Born in Nelson, New Zealand.

1971-72: Travelled in Europe and Asia.

1972: Started jewellery making in Perth, Australia, with Peter Woods.

1973: Returned to New Zealand and established workshop in Nelson with Ray Mitchell.

1975: Moved to Auckland and worked with Graham Shirley, manufacturing jeweller.

1977: Joined Lapis, a cooperative jewellery workshop started by Daniel Clasby.

1977: Married Natalie Adeane.

1977-78: Returned to Nelson and worked in Jens Hansen's workshop.

1978: Daughter Meg born.

1978: Returned to Auckland, established workshop in Devonport, and joined Fingers, a cooperative gallery for contemporary jewellery.

1979: Daughter Leonie born.

1982: Attended Hermann Jünger workshop in Nelson.

1983: Daughter Grace born.

1983: Conducted jewellery-making workshops in Fiji with Alan Preston.

1984: Attended Jewellers and Metalsmiths Group of Australia conference in Melbourne.

1986: Daughter Molly born.

1986: Attended Onno Boekhoudt workshop in Auckland.

1990: Travelled to Amsterdam for solo exhibition Share of Sky at Galerie Ra. Travelled around The Netherlands and Germany.

1990: Attended Otto Künzli workshop and jewellery symposium in Dunedin.

1991: Travelled to Japan to attend exhibition Bone Stone Shell: New Jewellery New Zealand at Tachikichi Gallery in Kyoto.

1993: Worked as visiting jeweller at Fluxus, Dunedin.

1995: Received Arts Council grant towards exhibition Owners, with accompanying publication Owner's Manual.

1995: Launched Owner's Manual catalogue and exhibition at Auckland War Memorial Museum.

1997-98: Chair of steering committee for The Persuasive Object, a conference on the future of crafts in New Zealand.

1998: Presented paper at Jewellers and Metalsmiths Group of Australia conference in Hobart.

1999: Presented lecture at Rhode Island School of Design.

1999: Guest Lecturer at Akademie der Bildenden Künste München, Germany.

1999: On organising committee for JAM: Jewellery Month 1999.

2000: On organising committee for JIM, the presentation and promotion of contemporary jewellery.

2000: Chair of working party to establish Objectspace in Auckland.

2003: Resigned from Fingers partnership.

2004: Travelled to Amsterdam for opening of solo exhibition and publication Given: Jewellery by Warwick Freeman at Tropenmuseum.

2004: Founding chair of Objectspace Board of Trustees.

2006: Travelled to Sydney to attend Jewellers and Metalsmiths Group of Australia Conference at Sydney College of the Arts.

2006: Guest speaker at Tasmanian Design Week forum, Beneath the Surface, Hobart.

2007: Guest speaker at jewellery symposium Zimmerhof, Bad Rappenau, Germany.

2007: Organised and presented at Permit: A Contemporary Jewellery Symposium, Manukau School of Visual Arts, Auckland.

2008: Sputnik Studio artist in residence at Unitec School of Design, Auckland.

BIOGRAFIE, AUSZEICHNUNGEN UND PREISE, AUSSTELLUNGEN, AUSGEWÄHLTE BIBLIOGRAFIE

2008: Guest tutor at Whitireia Polytechnic, Porirua.

2009: Artist in residence at Henderson House, Alexandra, Otago.

2009: Guest speaker at Reconsidering Identity – A Seminar on New Zealand Contemporary Jewellery, Gothenburg, Sweden.

2010: Guest lecturer at Hiko Mizuno College of Jewellery, Tokyo.

2010: Guest speaker at Jemposium, Wellington.

2013: Travelled to Ruthin, Wales, for exhibition and symposium Carving out Space.

2013: Klassiker der Moderne at Schmuck 2013. Sonderschau der 65. Internationalen Handwerksmesse, Munich.

2013: Lecture 'All About Me', invited by Die Neue Sammlung at Pinakothek der Moderne, Munich.

2014: Curated (with Karl Fritsch) the exhibition Wunderruma: Schmuck aus Neuseeland at Galerie Handwerk, Munich.

2014: Restaged Wunderruma: Schmuck aus Neuseeland as Wunderrūma: New Zealand Jewellery at The Dowse Art Museum, Lower Hutt.

2015: Restaged Wunderrūma: New Zealand Jewellery at Auckland Art Gallery Toi o Tāmaki.

2015: Restaged Owner's Manual (1995) at Objectspace, Auckland.

2019: Guest speaker at Radiant Pavilion, Melbourne.

2023: Workshop and residence in Westmere, Auckland.

Awards and Prizes

2002: Laureate, Francoise van den Bosch, Amsterdam, The Netherlands.

2002: Laureate, New Zealand Arts Foundation.

2013: Bavarian State Award, Internationale Handwerksmesse, Munich, Germany.

Works in Public Collections

Aberdeen Art Gallery, Aberdeen, Scotland – Alice and Louis Koch Collection, Schweizerisches Nationalmuseum/ Landesmuseum Zürich, Switzerland – Art Gallery of South Australia, Adelaide, Australia – Auckland Museum Tāmaki Paenga Hira, Auckland, New Zealand – Die Neue Sammlung – The Design Museum. Permanent loan from the Danner-Stiftung, Munich, Germany – Die Neue Sammlung – The Design Museum, Munich, Germany – Espace Solidor, Musée du Bijou Contemporain, Cagnes-sur-Mer, France – Los Angeles County Museum of Art, The Lois Boardman Collection, Los Angeles, USA – MTG Hawke's Bay Tai Ahuriri, Napier, New Zealand – Museum of Fine Arts, The Daphne Farago Collection, Boston, USA – Museum of New Zealand Te Papa Tongarewa, Wellington, New Zealand – National Gallery of Australia, Canberra, Australia – National Gallery of Victoria, Melbourne, Australia – Powerhouse Museum of Applied Arts and Sciences, Sydney, Australia – Rotasa Foundation Collection, San Francisco, USA – Schmuckmuseum Pforzheim, Pforzheim, Germany – Stedelijk Museum, Amsterdam, The Netherlands – Te Whare o Rehua Sarjeant Gallery, Whanganui, New Zealand – The Dowse Art Museum, Lower Hutt, New Zealand – The Hiko Mizuno Collection, Tokyo, Japan – The Museum of Fine Arts, Houston, USA – Victoria and Albert Museum, London, England

Solo Exhibitions

1984: Warwick Freeman. Bosshard Galleries, Dunedin, New Zealand

1985: Warwick Freeman. Contemporary Jewellery Gallery, Sydney, Australia

1987: Fern Fish Feather Rose. Fingers, Auckland, New Zealand

1987: Fern Fish Feather Rose. Contemporary Jewellery Gallery, Sydney, Australia

1987: Fern Fish Feather Rose. Janne Land Gallery, Wellington, New Zealand

1987: Fern Fish Feather Rose. Fluxus, Dunedin, New Zealand

1988: Buttons and Beads. Fluxus, Dunedin, New Zealand

1988: Buttons and Beads. Fingers, Auckland, New Zealand

1989: Share of Sky. Contemporary Jewellery Gallery, Sydney, Australia

1990: Share of Sky. Galerie Ra, Amsterdam, The Netherlands

1990: Share of Sky. Fluxus, Dunedin, New Zealand

1991: Share of Sky: Emblems 1985–90. The Dowse Art Museum, Lower Hutt, New Zealand

1991: Emblems 1985–1991. Fingers, Auckland, New Zealand

1991: Emblems 1985–1991. Fluxus, Dunedin, New Zealand

1992: Warwick Freeman. Crawford Gallery, Sydney, Australia

1992: Warwick Freeman. Bowen Galleries, Wellington, New Zealand

1995: Before Now. Gallery Funaki, Melbourne, Australia

1995: Owner's Manual. Jewellery by Warwick Freeman, photographs by Patrick Reynolds. Auckland War Memorial Museum, Auckland, New Zealand

1996: Owner's Manual. Jewellery by Warwick Freeman, photographs by Patrick Reynolds. Rotorua Museum, Rotorua, New Zealand

1996: Owner's Manual. Jewellery by Warwick Freeman, photographs by Patrick Reynolds. Govett-Brewster Art Gallery, New Plymouth, New Zealand

1996: Owner's Manual. Jewellery by Warwick Freeman, photographs by Patrick Reynolds. Sarjeant Gallery, Whanganui, New Zealand

1996: Owner's Manual. Jewellery by Warwick Freeman, photographs by Patrick Reynolds. City Gallery, Wellington, New Zealand

1996: Warwick Freeman. Bowen Galleries, Wellington, New Zealand

1996: Warwick Freeman. Crawford Gallery, Sydney, Australia

1997: Owner's Manual. Jewellery by Warwick Freeman, photographs by Patrick Reynolds. Manawatū Art Gallery, Palmerston North, New Zealand

1997: Owner's Manual. Jewellery by Warwick Freeman, photographs by Patrick Reynolds. Hawke's Bay Art Gallery and Museum, Napier, New Zealand

1997: Insignia. Bowen Galleries, Wellington, New Zealand

1997: Insignia. Gallery Funaki, Melbourne, Australia

1998: Weka. Bowen Galleries, Wellington, New Zealand

1998: Weka. Crawford Gallery, Sydney, Australia

1999: Free Gift. Jewelers' Werk Gallery, Washington DC, USA

1999: Free Gift. Galerie Ra, Amsterdam, The Netherlands

1999: Flutter. Gallery Funaki, Melbourne, Australia

2000: Flutter. Bowen Galleries, Wellington, New Zealand

2000: Flutter. Crawford Gallery, Sydney, Australia

2001: Ringa Ringa. Bowen Galleries, Wellington, New Zealand

2001: Pearler. Gallery Funaki, Melbourne, Australia

2002: Life Sentence. Fingers, Auckland, New Zealand

2002: Life Sentence. Bowen Galleries, Wellington, New Zealand

2002: Life Sentence. Gallery Funaki, Melbourne, Australia

2003: Sentence. Galerie Ra, The Netherlands

2004: Given: Jewellery by Warwick Freeman. Tropenmuseum, Amsterdam, The Netherlands

2004: Carve. Gallery Funaki, Melbourne, Australia

2004: If Nothing Happens. Starkwhite, Auckland, New Zealand

BIOGRAPHY, AWARDS AND PRIZES, EXHIBITIONS, SELECTED BIBLIOGRAPHY

2004: Given: Jewellery by Warwick Freeman. Schmuckmuseum Pforzheim, Pforzheim, Germany

2005: Frieze. Starkwhite, Auckland, New Zealand

2005: Given: Jewellery by Warwick Freeman. Auckland War Memorial Museum, Auckland, New Zealand

2005: Carve. Bowen Galleries, Wellington, New Zealand

2005: Given: Jewellery by Warwick Freeman. Hawke's Bay Art Gallery and Museum, Napier, New Zealand

2006: Given: Jewellery by Warwick Freeman. The Suter Art Gallery, Nelson, New Zealand

2006: Given: Jewellery by Warwick Freeman. Pātaka Art + Museum, Porirua, New Zealand

2006: Tooth and Nail. Starkwhite, Auckland, New Zealand

2006: 10 Things to Do Today. Gallery Funaki, Melbourne, Australia

2007: Given: Jewellery by Warwick Freeman. Dunedin Public Art Gallery, Dunedin, New Zealand

2007: It's Black or White. Starkwhite, Auckland, New Zealand

2008: Shadowboard. Bowen Galleries (Window), Wellington, New Zealand

2009: A Spring Collection. Gallery Funaki, Melbourne, Australia

2009: Warwick Freeman. Hnoss Gallery, Gothenburg, Sweden

2010: Colour Slides. Bowen Galleries, Wellington, New Zealand

2010: A Different Red. Gallery YU, Tokyo, Japan

2012: Room 22. Bowen Galleries, Wellington, New Zealand

2012: Making Dust. Gallery Funaki, Melbourne, Australia

2013: Klassiker der Moderne at Schmuck 2013. Sonderschau der 65. Internationalen Handwerksmesse, Munich, Germany

2013: Story of the Hook. The National, Christchurch, New Zealand

2014: Warwick Freeman. Galerie Wittenbrink, Fünf Höfe, Munich, Germany

2015: Prime. Gallery Funaki, Melbourne, Australia

2015: Warwick Freeman. The National, Christchurch, New Zealand

2015: The Family Jewels. Objectspace, Auckland, New Zealand

2016: The Family Jewels. The Dowse Art Museum, Lower Hutt, New Zealand

2016: The Family Jewels. MTG, Napier, New Zealand

2016: Lava Handles. Bowen Galleries (Window), Wellington, New Zealand

2016: Just Monkeys. Bowen Galleries, Wellington, New Zealand

2016: Just Monkeys. Anna Miles Gallery, Auckland, New Zealand

2018: In Praise of Volcanoes. Objectspace, Auckland, New Zealand

2019: Plinth. Anna Miles Gallery, Auckland, New Zealand

2019: Little Bird. Bowen Galleries, Wellington, New Zealand

2019: Little Bird. The National, Christchurch, New Zealand

2021: Closer. Bowen Galleries, Wellington, New Zealand

2021: Closer (to the sun). Anna Miles Gallery, Auckland, New Zealand

2022: Is It Any Wonder. The National, Christchurch, New Zealand

2023: Glance - A Sampling from the Archive. Anna Miles Gallery, Auckland, New Zealand

Group Exhibitions

1978: Punk Jewellery. Fingers, Auckland, New Zealand

1979: Bone. Fingers, Auckland, New Zealand

1979: Worn out Art. Fingers, Auckland, New Zealand

1981: Paua Dreams. Fingers, Auckland, New Zealand

1982: Skin Sculpture. Wellington City Art Gallery, Wellington, New Zealand

1982: Physique. The Dowse Art Museum, Lower Hutt, New Zealand

1983: Impulse and Responses: An Exhibition of Contemporary Jewellery. Goethe-Institut, Wellington, New Zealand

1984: Pacific Adornment. The Dowse Art Museum, Lower Hutt, New Zealand

1984: Warwick Freeman, Kobi Bosshard, Gillian Snadden. Bowen Galleries, Wellington, New Zealand

1985: Emblems. Fingers, Auckland, New Zealand

1985: Pakohe. The Dowse Art Museum, Lower Hutt, New Zealand

1986: New Zealand Contemporary Jewellery. Auckland War Memorial Museum, Auckland, New Zealand

1986: Warwick Freeman, Kobi Bosshard. Contemporary Jewellery Gallery, Sydney, Australia

1988: Bone Stone Shell: New Jewellery New Zealand. Crafts Council Gallery, Wellington, New Zealand

1988: Bone Stone Shell: New Jewellery New Zealand. Brisbane Library, Brisbane, Australia

1988: Bone Stone Shell: New Jewellery New Zealand. Meat Market Crafts Centre, Melbourne, Australia

1988: Bone Stone Shell: New Jewellery New Zealand. Crafts Council Gallery, Perth, Australia

1988: Bone Stone Shell: New Jewellery New Zealand. Blaxland Gallery, Sydney, Australia

1988: Bone Stone Shell: New Jewellery New Zealand. High Court, Canberra, Australia

1988: Details Group. Crafts Council Gallery, Wellington, New Zealand

1989: Schmuckszene '89. Internationale Schmuckschau. Sonderschau der 41. Internationalen Handwerksmesse, Munich, Germany

1989: The Human Touch. Rotorua Art and History Museum, Rotorua, New Zealand

1989: Australian Decorative Arts 1985-1988. Australian National Gallery, Canberra, Australia

1989: Versierd Symboliek in Het Moderne en Antieke Sieraad. Allard Pierson Museum, Amsterdam, The Netherlands

1990: Bone Stone Shell: New Jewellery New Zealand. Tachikichi Gallery, Kyoto, Japan

1990: Antipodean Dreams: Decorative Art of New Zealand. Auckland War Memorial Museum, Auckland, New Zealand

1990: Kiwi Eyes Cream. Galerie Cake, Dunedin, New Zealand

1991: Transit Zone. Ivan Dougherty Gallery, Sydney, Australia

1991: Te Moemoea No Iotefa: Pacific Art and Taonga. City Gallery Wellington, New Zealand

1991: Te Moemoea No Iotefa: Pacific Art and Taonga. Auckland Art Gallery, Auckland, New Zealand

1991: The Banqueting Table. Galerie Ra, Amsterdam, The Netherlands

1991: Neoteric Jewellery. Snug Harbour Cultural Center, New York, USA

1992: Helen Drutt Collection. Museum of Applied Arts, Helsinki, Finland

1993: Open Heart: New Zealand Contemporary Jewellery. The Dowse Art Museum, Lower Hutt, New Zealand

1993: Open Heart: New Zealand Contemporary Jewellery. Fisher Gallery, Pakuranga, Auckland, New Zealand

1993: Open Heart: New Zealand Contemporary Jewellery. Otago Museum, Dunedin, New Zealand

1996: Same but Different. The Dowse Art Museum, Lower Hutt, New Zealand

1996: Same but Different. Auckland War Memorial Museum, Auckland, New Zealand

BIOGRAFIE, AUSZEICHNUNGEN UND PREISE, AUSSTELLUNGEN, AUSGEWÄHLTE BIBLIOGRAFIE

1996: Schmuck im Schloss. Salzburg, Austria

1996: Beauty, Function and Art. Danner Award 1996. Die Neue Sammlung. Staatliches Museum für Angewandte Kunst, Munich, Germany

1996: Passion and Profession. Galerie Ra, Amsterdam, The Netherlands

1997: Same but Different. Otago Museum, Dunedin, New Zealand

2000: Bejewelled. Monash Gallery of Art, Melbourne, Australia

2001: Parures D'Ailleurs, Parures D'Ici: Incidences, Coïncidences? Musée de Design et D'Arts Appliqués Contemporains, Lausanne, Switzerland

2001: Grammar: Subjects and Objects. Fourth New Zealand Jewellery Biennale. The Dowse Art Museum, Lower Hutt, New Zealand

2001: Mikromegas. Dritte Ausstellung der Jubiläumsreihe 2001. Eine Ausstellung von Otto Künzli, Munich, Germany

2001: Parures D'Ailleurs, Parures D'Ici: Incidences, Coïncidences? Gewerbemuseum, Winterthur, Switzerland

2001: Good Work: The Jim Barr and Mary Barr Collection. Dunedin Public Art Gallery, Dunedin, New Zealand

2001: Good Work: The Jim Barr and Mary Barr Collection. City Gallery Wellington, New Zealand

2002: Maskerade. Galerie Ra, Amsterdam, The Netherlands

2002: Mikromegas. American Craft Museum, New York, USA

2002: Mikromegas. Musée de l'Horlogerie et de l'Emaillerie, Geneva, Switzerland

2002: Mikromegas. Gallery YU, Hiko Mizuno College of Jewellery, Tokyo, Japan

2003: Mikromegas. Powerhouse Museum, Sydney, Australia

2003: Lepels. Galerie Ra, Amsterdam, The Netherlands

2003: Schmuck 2003. Sonderschau der 55. Internationalen Handwerksmesse, Munich, Germany

2003: Design Museums of the World Invited by Die Neue Sammlung. Neues Museum für Kunst und Design, Nuremberg, Germany

2004: Opening exhibition Danner Rotunde at Pinakothek der Moderne by Hermann Jünger and Otto Künzli, Munich, Germany

2004: Cross Pollination. Craft Victoria, Melbourne, Australia

2005: Te Hei Tiki. Auckland Art Gallery, Auckland, New Zealand

2005: Parallel Practices. Hawke's Bay Museum, Napier, New Zealand

2005: Transformations: The Language of Craft. National Gallery of Australia, Canberra, Australia

2005: Inspired: Design Across Time. Powerhouse Museum, Sydney, Australia

2006: Luminaries. Sydney College of the Arts, Sydney, Australia

2007: Pacific Rim. The Scottish Gallery, Edinburgh, Scotland

2007: Collect 2008. Victoria and Albert Museum, London, England

2007: Making and Meaning. Object Gallery, Sydney, Australia

2007: Pākehā Now. The Suter Art Gallery, Nelson, New Zealand

2007: Ornament as Art. The Smithsonian, Washington DC, USA

2007: Reboot: Jim Barr and Mary Barr Collection. Dunedin Public Art Gallery, Dunedin, New Zealand

2008: Reboot: The Jim Barr and Mary Barr Collection. City Gallery Wellington, New Zealand

2009: Collect 2009. Saatchi Gallery, London, UK

2009: Far Far Away: Romance, Anxiety and the Uncertainty of Place. Hokianga Art Gallery, Rawene, New Zealand

2009: Lingam: Fertility Now. Konstfack, Stockholm, Sweden

2009: Multitude. SOFA, Christchurch, New Zealand

2009: Pocket Guide. Velvet da Vinci Gallery, San Francisco, USA

2010: Lingam: Fertility Now. Museum Catharijneconvent, Utrecht, The Netherlands

2010: Pocket Guide. The Society of Arts and Crafts, Boston, USA

2010: Lingam: Fertility Now. WCC-BF, Mons, Belgium

2010: Collect 2010. Saatchi Gallery, London, UK

2011: Collect 2011. Saatchi Gallery, London, UK

2011: The Ring. Galerie Hnoss, Gothenburg, Sweden

2011: Shed. Port Nelson, New Zealand

2011: Ontketend, Grenzelose Sieraden. Unleashed, Borderless Jewellery. Museum of Modern Art Arnhem, The Netherlands

2011: Ontketend, Grenzelose Sieraden. Unleashed, Borderless Jewellery. Museum Bellerive, Zurich, Switzerland

2012: Collect 2012. Saatchi Gallery, London, UK

2012: Unexpected Pleasures. National Gallery of Victoria, Melbourne, Australia

2012: Imagined Cartographies. Lake House Gallery, Auckland, New Zealand

2012: Covet. Sienna Patti Contemporary, Lenox, USA

2012: The Art of Collecting. Tallinn Applied Art Triennial, Tallinn, Estonia

2012: Unexpected Pleasures. Design Museum, London, UK

2013: Carving out Space. Ruthin Craft Centre, Ruthin, Wales, UK

2013: Collect 2013. Saatchi Gallery, London, UK

2014: Difference and Repetition. Next Level Galerie, Paris, France

2014: The Otherside. Gallery S O, London, UK

2014: Bone Stone Shell. Museum of New Zealand Te Papa Tongarewa, Wellington, New Zealand

2015: Fingers: Jewellery for Aotearoa New Zealand. Objectspace, Auckland, New Zealand

2016: Not too Precious. Ruthin Craft Centre, Ruthin, Wales, UK

2016: Not too Precious. National Craft Gallery, Castle Yard, Kilkenny, Ireland

2016: The Family Jewels. The Dowse Art Museum, Lower Hutt, New Zealand

2016: Chain. Gallery S O, London, UK

2016: Regard sur la Nouvelle-Zéland. Espace Solidor, Cagnes-sur-Mer, France

2017: Gdansk Baltic Amber Biennale. Gdansk, Poland

2017: 50 Secrets of Magic Craftsmanship. Scottish Goldsmiths Trust, Edinburgh, Scotland, UK

2017: I Am Here. Arts Council England, London, UK

2017: Vanished Delft. Pah Homestead, Auckland, New Zealand

2017: Containment. The National at Anna Miles Gallery, Auckland, New Zealand

2017: Beyond Bling: Contemporary Jewelry from the Lois Boardman Collection. LACMA, Los Angeles, USA

2018: IWA: New Zealand Makers, Schmuck. Munich, Germany

2018: Collect, sort, take care of. Rian Design Museum, Falkenberg, Sweden

2018: Shelf Life. Bowen Galleries, Wellington, New Zealand

2018: To Have and to Hold: The Daalder Collection of Contemporary Jewellery. Art Gallery of South Australia, Adelaide, Australia

2019: The National at Frame. 71. Internationale Handwerksmesse, Munich, Germany

2019: Charmed. Sienna Patti Contemporary, Lenox, USA

2019: Open Door. Craft Victoria, Melbourne, Australia

2019: Stone. Gallery S O, London, UK

2020: Steine - der letzte Schliff. Galerie Handwerk, Munich, Germany

2020: Frame at Home. The National, Christchurch, New Zealand

2020: Sympathetic Resonance. The Suter Art Gallery, Nelson, New Zealand

2021: Mark Work. COCA, Christchurch, New Zealand

2021: Mark Work. Objectspace, Auckland, New Zealand

2021: Ring Redux: The Susan Grant Lewin Collection. SCAD Museum of Art, Savannah, USA

2022: Is It Any Wonder. The National, Christchurch, New Zealand

2023: Glance - A Sampling from the Archive. Anna Miles Gallery, Auckland, New Zealand

Selected Bibliography

1983: Goethe-Institut New Zealand, editor, Impulse and Responses: An Exhibition of Contemporary Jewellery. Goethe-Institut New Zealand.

1985: James Mack, 'Warwick Freeman, Maker of Things.' New Zealand Crafts, Autumn.

1988: Patricia Anderson, Contemporary Jewellery: The Australian Experience 1977-1987. Millennium Books.

1988: Geri Thomas, editor, Bone Stone Shell: New Jewellery New Zealand. Crafts Council of New Zealand and Ministry of Foreign Affairs.

1989: The Human Touch: Contemporary New Zealand Craft at the Bath House. Rotorua Museum of Art and History.

1990: Mau Mahara: Our Stories in Craft. Crafts Council of New Zealand.

1991: The Banqueting Table. Galerie Ra.

1992: Neoteric Jewelry. Snug Harbor Cultural Center.

1992: Julie Ewington, Jade, Gold, Shell, Bone, Warwick Freeman. Object: Australian Design Centre.

1992: Eighteen Months Later. Fluxus, Goethe-Institut New Zealand.

1994: Open Heart: New Zealand Contemporary Jewellery. The Dowse Art Museum.

1994: Julie Ewington, Markers and Meanings: Kobi Bosshard and Warwick Freeman. Object: Australian Design Centre.

1995: Warwick Freeman, Patrick Reynolds, and Julie Ewington, Owner's Manual: Jewellery by Warwick Freeman. Starform.

1995: Reizstoffe: Positions of Contemporary Arts and Crafts. arnoldsche Art Publishers.

1995: Helen Drutt and Peter Dormer, Jewelry of Our Time: Art, Ornament and Obsession. Rizzoli Publishers.

1996: Kobi Bosshard, The Second New Zealand Jewellery Biennial: Same but Different. The Dowse Art Museum.

1996: Paul Derrez and Liesbeth den Besten, editors, Passion and Profession. Galerie Ra.

1998: Patricia Anderson, Contemporary Jewellery in Australia and New Zealand. Craftsman Books.

1998: Helen Schamroth, 100 New Zealand Craft Artists. Random House New Zealand.

2001: Deborah Crowe, 4th New Zealand Jewellery Biennale: Grammar: Subjects and Objects. The Dowse Art Museum.

2001: Marie Alamir and Carole Guinard, Parures D'Ailleurs, Parures D'Ici: Incidences, Coïncidences? Musée de Design et D'Arts Appliqués.

2001: Paul Derrez et al., Maskerade. Galerie Ra.

2001: Otto Künzli, Mikromegas. Dritte Ausstellung der Jubiläumsreihe 2001. Eine Ausstellung von Otto Künzli, Munich, Germany.

2002: Stephen Crafti, Request. Response. Reaction. The Designers of Australia and New Zealand. Images Publishing.

2002: Warwick Freeman, 'Can't You Read?', Object, issue 40, Australian Design Centre.

2002: Jelle Bouwhuis and Wil Njio, editors, Stedelijk Museum Annual Review. Stedelijk Museum.

2002-3: Lepels/Spoons. Galerie Ra.

2004: Florian Hufnagl, editor, Design Museums of the World Invited by Die Neue Sammlung. Neues Museum für Kunst und Design. Birkhäuser.

2004: Damian Skinner, Given: Jewellery by Warwick Freeman. Starform.

2004: Otto Künzli, Mikromegas: Around the World in 991 Days. Bayerischer Kunstgewerbeverein, Munich.

2005: Rebecca Roke, 'The Alchemist's Badge.' Monument, issue 67.

2005: Jivan Astfalck, Caroline Broadhead, and Paul Derrez, New Directions in Jewellery. Black Dog Publishing.

2005: Robert Bell, Transformations: The Language of Craft. National Gallery of Australia.

2006: Rhana Devenport, Luminaries. Sydney College of the Arts.

2006: Ralph Turner, Liesbeth den Besten, and Marjan Boot, Radiant: 30 Years Ra. Galerie Ra.

2006: Jonathan Mane-Wheoki, Toi Te Papa, Art of the Nation Museum of New Zealand Te Papa Tongarewa.

2006: Cornelie Holzach and Tilman Schempp, editors, Schmuckmuseum Pforzheim: Museum guide. arnoldsche Art Publishers.

2007: Takahiko Mizuno, Contemporary Jewellery. Kentaro Oshita.

2007: Karl Chitham et al., Making and Meaning. Object: Australian Centre for Craft and Design.

2007: Rudi Fuchs et al., Acquisitions 1993-2003 - Stedelijk Museum. Veenman Publishers.

2009: Takahiko Mizuno, 14 Jewellery Artists on Earth. Bijutsu Shuppan-Sha Company.

2011: Liesbeth den Besten, On Jewellery: A Compendium of International Contemporary Art Jewellery. arnoldsche Art Publishers.

2014: Warwick Freeman and Karl Fritsch, Wunderrūma - Tales of Wonderland. Hook and Sinker Publications.

2014: Damian Skinner and Finn McCahon-Jones, Fingers: Jewellery for Aotearoa New Zealand. 40 Years of Fingers Jewellery Gallery. David Bateman Ltd.

2014: Damian Skinner and Kevin Murray, Place and Adornment: A History of Contemporary Jewellery in Australia and New Zealand. David Bateman Ltd.

2017: Beyond Bling: Contemporary Jewelry from the Lois Boardman Collection. Los Angeles County Museum of Art.

2017: Amanda Game and Dorothy Hogg, 50 Secrets of Magic Craftsmanship. Scottish Goldsmiths Trust.

2018: Rebecca Evans, To Have and to Hold: The Daalder Collection of Contemporary Jewellery. Art Gallery of South Australia.

2019 : Beatriz Chadour-Sampson, Rings of the 20th and 21st Centuries: The Alice and Louis Koch Collection. arnoldsche Art Publishers.

2020: Danner-Stiftung, Die Neue Sammlung, editors, Jewelry. arnoldsche Art Publishers.

ACKNOWLEDGEMENTS

DANK

WARWICK FREEMAN

Die Neue Sammlung is the navel of contemporary jewellery; to be offered this exhibition by Director Angelika Nollert and Senior Curator Petra Hölscher is a highlight of my career. Thank you.

It has also given me an opportunity to reflect – to do some navel-gazing about how I came to end up in this European neighbourhood. As far as I can see, it all came down to fortuitous meetings with important people – people who generously opened their doors to me, let me know they could see I was trying, and most importantly gave me the encouragement to keep trying. Too many to mention, but here are just a few of the people who appeared in my working life from the other side of the world when I needed them: Hermann Jünger, Paul Derrez, Onno Boekhoudt, and Otto Künzli. Thank you, my friends.

My thanks to Objectspace, New Zealand's leading gallery dedicated to the fields of design, craft, and architecture. Objectspace is twenty years old in 2024, and as part of the team that helped found it I am immensely proud of how it has grown up. I am very grateful for the leadership and friendship of its current director, Kim Paton. Kim and her team have led the work in New Zealand to create this exhibition and publication. I am particularly grateful for the work of Bronwyn Lloyd, who shaped the fragments of my practice into an expansive archive.

My family is the most deserving of my thanks. My deepest gratitude and thanks to Natalie, my partner, especially for the beautiful family she made for us. That's real making.

Die Neue Sammlung ist der Nabel zeitgenössischen Schmucks – das Angebot von Direktorin Angelika Nollert und Oberkonservatorin Petra Hölscher, hier eine Ausstellung zu realisieren, ist ein Höhepunkt meiner Karriere. Danke.

Das bot mir auch die Gelegenheit, darüber nachzudenken – eine Art Nabelschau zu betreiben –, wie ich eigentlich in diesem europäischen Umfeld gelandet bin. Soweit ich das beurteilen kann, lässt sich das alles auf zufällige Begegnungen mit wichtigen Menschen zurückführen – Menschen, die mir großzügig ihre Türen geöffnet haben, die mich wissen ließen, dass sie meine Versuche sehen konnten, und am wichtigsten, die mich ermutigten, es weiter zu versuchen. Zu viele, um sie alle zu nennen, aber hier sind ein paar der Menschen, die von der anderen Seite der Welt in meinem Arbeitsleben genau zu dem Zeitpunkt auftauchten, als ich sie brauchte: Hermann Jünger, Paul Derrez, Onno Boekhoudt und Otto Künzli. Ich danke euch, meine Freunde.

Mein Dank gilt auch Objectspace, Neuseelands führender Galerie im Bereich Design, Kunsthandwerk und Architektur. Objectspace wird 2024 zwanzig Jahre alt und als Teil des Teams, das zur Gründung beigetragen hat, bin ich sehr stolz darauf, wie es sich entwickelt hat. Ich bin sehr dankbar für die Führung und die Freundschaft der aktuellen Leiterin, Kim Paton. Kim und ihr Team haben die Arbeiten in Neuseeland geleitet, um diese Ausstellung und die Publikation zu realisieren. Mein besonderer Dank gebührt Bronwyn Lloyd, die die Fragmente meines Schaffens in einem umfangreichen Archiv zusammengetragen hat.

Den größten Dank verdient meine Familie. Ich bin meiner Partnerin Natalie zutiefst dankbar, besonders für die wunderbare Familie, die sie für uns geschaffen hat. Das ist wahres Schaffen.

This book is published on the occasion of the exhibition Warwick Freeman: Hook Hand Heart Star, Die Neue Sammlung – The Design Museum, Pinakothek der Moderne, Munich; Objectspace, Auckland; The Dowse Art Museum, Lower Hutt.

© 2025 Die Neue Sammlung – The Design Museum, Munich, Objectspace, Auckland, the artist, the authors, the photographers and arnoldsche Art Publishers

All rights reserved. No part of this work may be reproduced or used in any form or by any means (graphic, electronic or mechanical, including photocopying and information storage and retrieval systems) without written permission from the copyright holders.
www.arnoldsche.com

Editors: Die Neue Sammlung – The Design Museum, Munich, Germany
Objectspace, Auckland, Aotearoa New Zealand

Concept: Warwick Freeman, Kim Paton

Authors: Geoff Chapple, Karl Chitham, Warwick Freeman, Petra Hölscher, Bronwyn Lloyd, Angelika Nollert, Kim Paton

Director of Photography: Victoria McAdam

Photographer: Sam Hartnett (unless otherwise stated), commissioned by Objectspace

Translation: Jeremy Gaines, Frankfurt a. M., Kurt Rehkopf, Hamburg, Alexandra Titze-Grabec, Vienna

Editorial Staff: Warwick Freeman, Bronwyn Lloyd, Victoria McAdam, Kim Paton

Archivist and Researcher, Objectspace: Bronwyn Lloyd

Copy Editing: Petra Hölscher (DE), Marie Shannon (NZ)

Book Design: inhouse.nz

Image Editing: Schwabenrepro, Fellbach

Project Management arnoldsche: Julia Hohrein-Wilson

Printed by: Schleunungdruck, Marktheidenfeld

Bound by: Buchbinderei Schaumann, Darmstadt

Typefaces:
Gaffa Display by Inhouse;
Die Grotesk and Pitch Sans by Klim Type Foundry

Paper: Magno Volume 150 gsm

Bibliographic Information Published by the Deutsche Nationalbibliothek:
The Deutsche Nationalbibliothek lists this publication in the Deutsche Nationalbibliografie; detailed bibliographic data are available at www.dnb.de.

ISBN 978-3-89790-732-4

Made in Germany, 2025

Aus Gründen der besseren Lesbarkeit verwenden wir das generische Maskulinum. Wir meinen stets alle Geschlechter im Sinne der Gleichbehandlung. Die verkürzte Sprachform hat redaktionelle Gründe und ist wertfrei.

The exhibition is presented in partnership between Die Neue Sammlung – The Design Museum in Munich, Germany, and Objectspace in Auckland, Aotearoa New Zealand.

Curators: Warwick Freeman, Petra Hölscher, Kim Paton, Bronwyn Lloyd

Exhibition Idea: Petra Hölscher, Die Neue Sammlung

Technical Manager, Objectspace: Stephen Brookbanks

Conservation Department, Die Neue Sammlung: Tim Bechthold, Julia Demeter, Christian Huber

Technical Department, Die Neue Sammlung: Michel Daume, Cornelius von Heyking, Florian Westphal

Press and Public Relations // Press Office of the Pinakotheken:
Tine Nehler, Jette Elixmann, Sarah Stratenwerth

Press and Public Relations of Pinakothek der Moderne (art | graphic | architecture | design):
Erick Dietenmeier, Anna Kraus, Sonja Nakagawa

Online Editorial Office, Die Neue Sammlung: Andrea Czermak, Theresa Gatarski, Rainer Schmitzberger

Alle nicht extra gekennzeichneten Objekte sind Eigentum des Künstlers.
All not specifically marked objects are the property of the artist.

Lenders
Public Collections:
Art Gallery of South Australia, Adelaide, Australia
Auckland Museum Tāmaki Paenga Hira, Auckland, New Zealand
Die Neue Sammlung - The Design Museum. Permanent loan from Danner Foundation, Munich, Germany
Die Neue Sammlung - The Design Museum, Munich, Germany
Espace Solidor, Cagnes-sur-Mer, France
Museum of New Zealand Te Papa Tongarewa, Wellington, New Zealand
Schmuckmuseum Pforzheim, Germany
The Dowse Art Museum, Lower Hutt, New Zealand

Private Collections:
Anna Miles, Auckland, New Zealand
Anne McLeod Crawford, Ngākawau, New Zealand
Barbara Kirshenblatt-Gimblett, New York, USA
Private Collection Bollmann, Vienna, Austria
Private Collection Den Besten-Reekers
Ewan Brown and Judi Keith-Brown, Wellington, New Zealand
Gallery S O
Katie Battersby and Ben Corban, Auckland, New Zealand
Therese Hilbert, Munich, Germany
Rae-ann Sinclair, Lake Hāwea, New Zealand, and Sydney, Australia
Rotasa Collection Trust, San Francisco, USA
Samuel Holloway and Michael Lett, Auckland, New Zealand
Sarah McIntyre, Auckland, New Zealand
And those who wish to remain anonymous.

This book and the exhibition have been produced with the generous support of:

Museumsstiftung zur Förderung der Staatlichen Bayerischen Museen - Vermächtnis Christof und Ursula Engelhorn

Objectspace Exhibiton Project Supporters:
Jo and Alistair Blair
Philip Clarke
Sue Fisher
Max Gimblett and Barbara Kirshenblatt-Gimblett
Marianne Hargreaves MNZM
Sonja and Glenn Hawkins
Hynds Foundation
Lizzie de Lambert
Catherine Marcus Rose
Pip Oldham and Quentin Hay
Deedie Rose
Kim Smith
And those who wish to remain anonymous.

OBJECTSPACE